266

*The catalog was designed in Los Angeles by
Ken Parkhurst. All text was set in Monotype
Bembo and the catalog printed in gravure
by Conzett and Huber of Zurich, Switzerland.
Photography is by William Pons,
Metropolitan Museum of Art; cover
photographs and pages 69, 109, 179, 225 are by
Malcolm Varon.*

The Art Institute of Chicago

Forewords

One of the aims of the Metropolitan Museum during its Centennial year is to give forth of its knowledge, its scholarship, its expertise and its works of art. Accordingly this exhibition *The Middle Ages: Treasures from The Cloisters and The Metropolitan Museum of Art* was formulated. It is the first time a major loan exhibition, entirely composed of objects coming from the Metropolitan Museum, including The Cloisters, has ever been mounted. It is particularly felicitous that a show of great medieval works of art was decided upon, for it surely is one of the strongest Departments in the Museum.

Most outstanding objects, worthy to represent the greatest collection of medieval art in the United States, were chosen to illustrate the different phases of the development of art in the Middle Ages. The Chalice of Antioch, the earliest of the masterpieces, is followed by such landmarks as the David Dishes from the Cyprus Treasure, and a Byzantine enamel made in Constantinople. The early Gothic statue of the Virgin from Strasbourg Cathedral, still preserving its original polychromy, introduces the monumental Gothic sculptures, and some of the best Limoges enamels, French fourteenth-century ivories, and fifteenth-century tapestries for which the Metropolitan Museum collections are famous.

In the later Gothic period, the tiny Book of Hours illuminated for a Queen of France by Jean Pucelle deserves to be singled out. The sensitively carved group of the Three Helpers in Need by Tilmann Riemenschneider, and finally, the gleaming Eagle Lectern from Louvain represent the last flourish of medieval art.

I hope those who visit this exhibition will agree that the Metropolitan has in its Centennial put its best foot forward.

Thomas P. F. Hoving
Director, Metropolitan Museum of Art

For the very first time a large number of major works from the Medieval Collection of the Metropolitan Museum of Art can be seen outside of the Museum and The Cloisters. As part of the Museum's Centennial activities, this exhibition has been carefully chosen from the treasures of the Collection. Any choice, however, is a personal one. What I have put together is grouped chronologically in a more or less homogenous manner—more or less, because even the Metropolitan Collections have gaps. The material will never-theless give an idea of the rich threads of cultures and civilizations which form the Western heritage. My idea was to show not only spectacular objects but also to illustrate the most characteristic steps in medieval art history as mirrored in our Collections from early Christian beginnings through the Middle Ages, to the emergence of the Renaissance. Necessarily, architectural monuments, frescoes, and mosaics were omitted.

Most of the works speak for themselves. The catalog gives all the necessary background information for the interested visitor. I am very happy to express my deep gratitude to my colleague, Mrs. Vera K. Ostoia. She kindly agreed to write this scholarly volume. Much of the research Mrs. Ostoia has done during her long and fruitful stay at the Metropolitan Museum is published here for the first time. Many of the entries will reappear in the official catalog of the Medieval Department. I have also to thank warmly other members of my staff for their help: William H. Forsyth, Curator; Michael Botwinick, Assistant Curator; Thomas Pelham Miller, Executive Assistant of The Cloisters; Bonnie Young, Senior Lecturer of The Cloisters; and Katharine Brown, who helped with the bibliography in this catalog.

Florens Deuchler
Chairman, The Medieval Department and
The Cloisters, Metropolitan Museum of Art

The experience offered by this exhibition is unique in the West and Middle West. There has never before been a medieval show in this area comparable to those at Worcester, Boston, Baltimore and Cleveland. While many of the museums here own distinguished medieval works, none can present the panorama of twelve centuries of medieval art—the dynamic interplay of Classical, Christian, Barbarian and indigenous elements—in such splendid examples as this exhibition does. It is a boon not only to the general museum visitor but even more to the thousands of students of medieval art who have never seen originals representing so many facets of the Middle Ages.

We feel highly privileged to be benefactors of the Metropolitan Museum's policy of being in President Arthur Houghton Jr.'s words "a truly national resource." We would like to express our manifold gratitude to the Board of Trustees, to Thomas P. F. Hoving and George Trescher who conceived the exhibition, to Florens Deuchler who gave it form, to Mrs. Vera K. Ostoia whose words will enhance its meaning, to William H. Forsyth, William D. Wilkinson, Miss Ronnie Rubin and the other members of the Metropolitan Museum staff named in Dr. Deuchler's Foreword who contributed their knowledge and skills. We should also like to cite for special appreciation in Los Angeles, Mrs. Jeanne Doyle, Mrs. Joseph Koepfli and Miss Barbara Rumpf for their editing of the catalog, and in Chicago, Allen Wardwell for his administration and presentation of the exhibition at the Art Institute.

Charles C. Cunningham
Director
Art Institute of Chicago

Kenneth Donahue
Director
Los Angeles County Museum of Art

Contents

Introduction

Early Christian and Coptic Art

The term Middle Ages derived from the desire to specify the time span between classical antiquity and the Renaissance.

Christian history commenced in Europe with the time of Constantine, the first Christian Emperor (311–337). The Italians of the fifteenth and sixteenth centuries actually used the term "the dark ages" to designate the era between antiquity and their own time. The phrase "dark ages" also illustrates the reaction of Renaissance man to his own immediate past. The word "Renaissance," meaning "rebirth" of ancient ideas, ancient thoughts and artistic forms, can actually be traced back to about 1200.

Even the highly sophisticated Romanesque and Gothic periods were thought of as barbaric (hence "Gothic") when compared with the achievements of antiquity. Serious study of the Middle Ages only commenced during the early nineteenth century when medieval art was finally re-established and appreciated. The generation of Goethe deserves full credit for the very necessary revision of taste, although the Romantics went too far in their zeal to break down long existing prejudices. Eventually a more just and balanced evaluation of medieval art has emerged and a firm and assured place in history has been established.

Paintings in catacombs and sculptural decoration on sarcophagi are among the earliest examples of Christian Art in Europe. Their symbolic decorations refer to Christ's life and his teaching, the cross serving as the sign of universal redemption. Frequently employed symbolic motifs illustrating the new Christian faith are: the fish and the dove, the vine, flowers and trees (the latter representing the Garden of Eden), and the lamb. Often Jesus is represented as the Good Shepherd.

The new Christian imagery did not "surface" until the fourth century when the Christian faith was officially recognized by Constantine in the Edict of Milan in 313 and proclaimed the state religion. The pagan temples were closed in 391. Christian churches began to be built above ground rather than in the catacombs.

From this moment on, art displaying Early Christian iconography becomes more frequent and more prominently displayed. Early Christian iconography developed very gradually out of motifs and forms that had long flourished around the shores of the Mediterranean, slowly establishing features distinct from those of the Greco-Roman culture out of which Christian art mainly evolved.

One of the most interesting Early Christian communities, the Copts in Egypt, produced an art very much its own which included textiles that date from the third to the eleventh centuries. The Copts produced a popular art, with roots in late antiquity, and its products for the most part were not extremely expensive. An impressive number of possible original owners of these fabrics are known, thanks to their beautiful mummy portraits which still astonish us by their classical vigor and Hellenistic realism.

After the division of the Roman Empire in 395, the two capitals—Rome and Constantinople—began to vie for supremacy. Byzantine art, particularly that made for the emperor and his entourage, is court art *par excellence* and of higher artistic quality than its western equivalent. Insisting strictly on the observation of traditions, works of art produced in the east show the deep influence of the classical heritage of the Hellenistic world and to a lesser extent of neighboring Asiatic cultures.

The impact of eastern art upon western Europe was sometimes so strong that we speak of recurrent waves of Byzantine influence, reflected in the minor arts as well as in monumental sculpture, wall paintings, and stained glass windows.

Many stylistic characteristics survived in Italy, evolving out of the eastern heritage. Later, Italian painters called this surviving style *maniera greca,* or Greek style, accurately identifying the ultimate Greek origin of Byzantine art.

The period in Europe which followed the Early Christian era, the period after the collapse of the Roman Empire, is often called the Dark Ages—one of the most annoying terms to medievalists. One calls this age "dark" partly to convey that the people who lived during these centuries of migrations, wars, and upheavals, were deeply plunged into cultural and political darkness and had little knowledge to guide them. The term "dark" also implies that we know little about these turbulent and confusing times.

The memory of various Germanic tribes—the Goths, the Vandals, the Saxons, the Danes, the Franks, the Alemans, the Burgundians, the Langobards, and the Vikings—is brought back to us by their works of art which are small in size but of great artistic impact. In the course of the twentieth century taste has undergone a major change. The tendency in modern art toward abstraction has taught us to appreciate the fabulously complicated decoration on buckles and brooches decorated with interlacing animals, or enhanced by circles, lines, and dots inlaid in niello.

Most of the migration material is found in burial sites. Many different artistic traditions and tastes prevail. Some objects show rich, overall linear ornamentation, while others stress gay polychrome decoration on their jewelry. Garnets and colored glass are used for color. Delicate filigree, composed of gold or silver threads, covers the surfaces of jewelry. Cloisons, framed in broad borders of interlace patterns, are also used. One even finds examples of champlevé, i.e., stones or enamel set into the depressed areas of the metal.

The Dark Ages end with the emergence of European countries roughly in the shape that we know them today. One of the main major architects of the modern world was Charlemagne (768–814), who regarded himself as the successor of the Roman emperors. His name is even used to designate a European culture of the eighth and ninth centuries, when the tradition of classical art and culture was eagerly revived, so that historians speak of the "Carolingian Renaissance." In this period forms and techniques were handed down from teacher to pupil, and from artist to artist, often across considerable distances, from the Byzantine East to the Latin West, that is to the countries of western Europe; and from south to north, that is from Italy to northern Europe.

Carolingian art gradually merged into Romanesque; in Germany this transitional period is called Ottonian after the great German emperors, the Ottos, who succeeded Charlemagne.

The art of the Middle Ages, from Carolingian and Ottonian right through the Romanesque and Gothic periods, cannot properly be understood without reference to the regional traditions which began to assume ever greater importance. Yet related works of art in one region often derive from models and forms common to other regions. Within each regional "school" fidelity to traditional forms is reflected in specific motifs that continually recur, although the forms themselves gradually evolve with time into new forms.

The Romanesque period, dating mainly in the eleventh and twelfth centuries, was so called because at a later date its often heavy architectural and rounded arches and vaulting were thought to resemble Roman architecture.

Looking at Romanesque and, in fact, at all medieval art, we must bear in mind that there was no such thing as a modern sense of individual expression. Works of art were usually unsigned, and with some exceptions their makers were anonymous. The artists' primary concern was fine workmanship, and their aim was to render familiar subject matter, such as the Last Judgment, in everchanging, imaginative variations. Religious fervor was expressed through deliberate distortions. Figures were elongated, poses twisted and gestures agitated, and the result was a very original art form, which conveys to us now the spirit of that time.

Art in church or monastery was pursued for the greater glory of God, under the careful supervision of the clergy. Most secular art has unfortunately disappeared. Royal and ecclesiastic patrons who commissioned works of art, whether the so-called minor arts of enamel, ivory, metalwork, manuscript illumination, embroidery or weaving, or whether the more monumental arts of painting, fresco, mosaic, or sculpture, also expected the artist to be more a craftsman than an original artist. He was to follow older models, sometimes mentioned in his work contract, or the work was carefully outlined in great detail. In spite of this conservatism, forms and models did change and kept on evolving.

Toward the end of the twelfth century Romanesque art gradually loses its severity. A gentle spirit animates figures which begin to move more freely and naturally, and sculpture becomes more humanized. Romanesque stiffness disappears entirely with the advent of Gothic art. The centuries of struggle to make the Christian faith supreme now belong to the past. The *Ecclesia militans* becomes gloriously the *Ecclesia triumphans* of the Gothic cathedral as a symbolic image of Jerusalem. A victorious Church dominates the entire life of the community, and the often represented Virgin, Nôtre-Dame, becomes the Queen of Heaven.

The social structure underwent a gradual change during the Gothic period. It is a period rich in tensions because, not only the Church or a single important patron commissioned works, but dukes, their ministers, courtiers—the nobility in general—all became patrons of the arts. Their ranks were swelled by the great merchants. Soon cities themselves and rich burghers began to rival one another in giving commissions to artists.

The beginnings of northern European painting are closely related to those varied patrons. From the fourteenth century we witness in book illumination and easel painting the gradual conquest of light and space—a shining spectacle that has its last act in a new era, the Renaissance.

Also by the fourteenth century tapestry weaving in northern Europe had developed to such an extent, especially in France and the southern Netherlandish country comprising modern Belgium, that large wall hangings made on big vertical looms were produced in great numbers to cover the walls of châteaux or other lordly dwellings.

The generation of artists around 1500 was influenced by classical antiquity, the Bible story, legends of the saints, and by contemporary political events. The late Gothic artist expressed a new world and his encyclopedic output included elements of sheer invention, lived experience, and borrowings from older works, all thoroughly remade to enhance their artistic qualities and clarify their meanings. Europe became slowly acquainted with Italian humanism and turned once more to the classical sources of antiquity. In the same generation a totally new conception of the world took place; with the discovery of America, all horizons were expanded.

EARLY CHRISTIAN AND COPTIC ART

16 *White marble. H. 28½, W. 12½ inches*
Early Christian, circa 250
Rogers Fund, 1918
Said to come from Asia Minor

This fragment is composed of two pieces of white marble which form the central bay of a sarcophagus front. The profile of a bearded male figure seated on a cushioned stool with lions' feet is carved in relief. The man is wearing a chiton and a himation, and is holding a partially unrolled rotulus in his left hand. W. Frederick Stohlman and Charles R. Morey identify the hair, beard, and face of the man as deriving from the "Imperial portrait type" of the period of the Antonine emperors and of Septimus Severus (circa 140–210). The figure, save for the character of the head, is almost a replica of the figures seated in the central bays on the fronts of the sarcophagi from Selfkeh and from Sidamara (Archeological Museum, Istanbul). It is from the latter sarcophagus, found near the site of ancient Sidamara at Ambar-Arassy in the province of Cappadocia, Asia Minor, that the name "Sidamara type" is derived, a name given to a group of related sarcophagi from Asia Minor to which the Metropolitan Museum fragment belongs. Morey subdivides the Sidamara sarcophagi group and places the Museum fragment in what he calls "sub-group C", of an "arcade type with Five Arches" on the fronts. He dates this about 250. The posture of the seated figure comes from a composition in Hellenistic art known as "poet and muse", and indeed, on the Sidamara sarcophagus the muse Thalia occupies the bay to the right of the central niche. The seated figure continues in Christian art as the "author portrait" type.

The arcade is supported on spiral columns and the conch shell which fills the space behind the head of the seated figures has the hinge at the base. According to Morey this is customary in eastern works, as distinguished from western ones, where the hinge of the shell is at the top. Spirally fluted columns, although not an exclusively eastern feature, recur constantly throughout the series and are often found in architectural figures on the coins of Asia Minor.

The Sidamara type of sarcophagus is an important link between classical and Christian art. One can see on these sarcophagi the disintegration of naturalistic ornament into abstract design. The capitals on the columns and the spandrels above are filled with coloristic foliage. The shapes of architectural components have been lost; influences from the east break up the logic of classical art. The pattern is created by shadows of a vague lacework, rather than by relief. The use of the drill, undercutting, and the purely decorative handling of the leaves in which only reminiscences of acanthus remain, are all characteristic of the Sidamara sarcophagi from Asia Minor. They were probably produced by a traveling workshop tentatively identified as coming from the north, northwest, or west of Asia Minor.

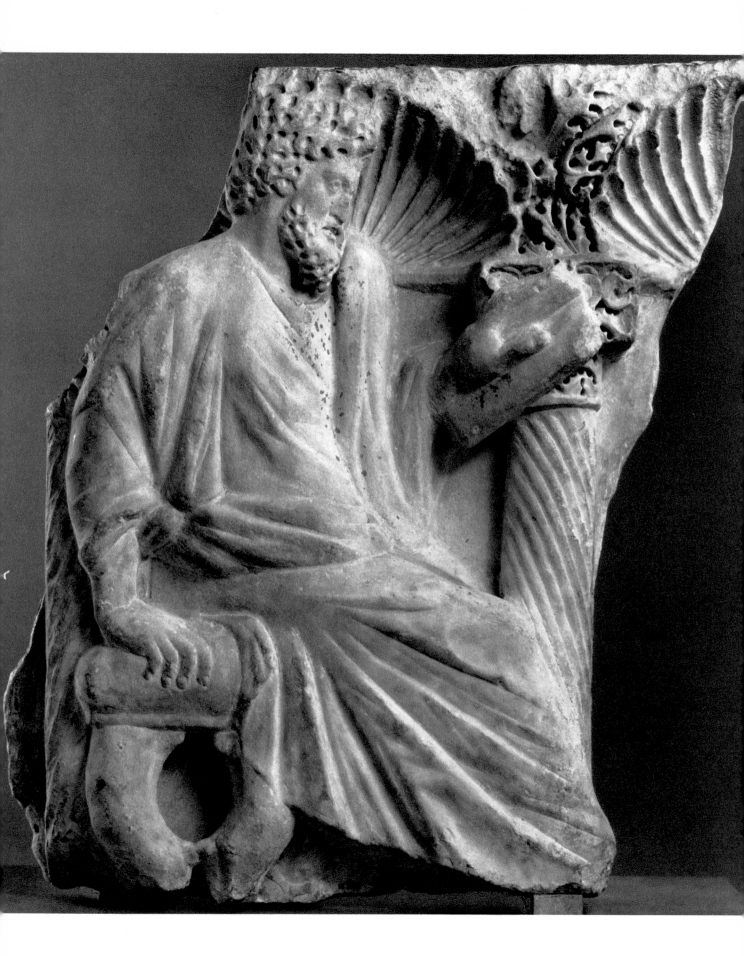

18 *Gold glass. Diameter 1⅝ inches*
Early Christian, III century
Fletcher Fund, 1926

Against a background of blue glass a frontal bust of a young man with his head slightly turned is executed in gold leaf. A small piece of drapery covers his left shoulder, leaving the rest of the torso bare. A finely executed inscription in Greek curves around the sides of the head and below the bust. It has been freely translated as: Gennadios the musician. The bust probably represents the portrait of a famous or popular musician. According to another reading, an unofficial one by Charles R. Morey, the name Gennadios could be that of the artist who signed his work. It would then read: Gennadios the Painter, and the word PAMMOUSSIOS under the bust would stand for an epithet of Apollo: Lord of the Muses. Unfortunately Morey never went back to this problem. Following an analysis of the inscription, the language was identified as a Greco-Egyptian dialect which corresponds to the attribution of the piece to an Alexandrian workshop. Still almost classical in style, the portrait has been dated in the third century.

The technique of so-called gold glass seems to have been developed in Hellenistic times. The oldest examples are probably two cups from Canosa in Apulia dated in the third century B.C. in the British Museum;

the fragmentary bowl from Gordion, Turkey, of approximately the same date; and a small fragment in the Metropolitan Museum recently published by Andrew Oliver, Jr. The secret of the technique has been lost, although the principles of it are known. Probably, the earliest reference to it in literature is found in the writings of Heraclius, circa 1000, in his *De Coloribus et Artibus Romanorum* (I, 5); Cennino Cennini, in his *Libro dell'Arte* also speaks of it. The technique consists basically in applying a design cut from a leaf of gold foil to the glass surface, protecting the decoration with another sheet of glass, and later fusing the two glass sheets together permanently so that the layer of gold foil is sandwiched between the layers of glass. After the gold foil has been attached to the glass by a transparent glue—sometimes honey is used—it can be engraved with a finely pointed instrument. Within the silhouette details will appear as dark lines on the finished object; but the scratched out or engraved lines would appear transparent if the glass were held to the light.

The technique used for the portrait of Gennadios is more elaborate and is found only on portraits. Morey calls it the brushed technique by which he means that the

design of the shadows producing the modeling is made with a moderately stiff brush, or by such a fine point that the results look as if a brush had been used. It appears to be a post-Hellenistic and post-classical invention. The best-known gold glass medallion with a portrait of a family group is attached to the cross in Brescia. The Metropolitan Museum collection includes another notable gold glass portrait known as the Ficoroni medallion. All gold glass executed in brushed technique is considered to be of Alexandrian workmanship, made by Alexandrian Greeks and Jews, either in Egypt or possibly by immigrant artists living in Rome. Some scholars believe that this type of gold glass portrait was painted on the glass in powdered or flaked gold foil, then covered by a protective layer of glass and the two fused together. Still others think that the protective layer of glass was blown over the gold surface or that this surface was dipped in molten glass.

The main difference between the Christian gold glass medallions, or bottoms of drinking vessels with gold foil decoration, and their pagan forerunners is the choice of subjects and the deterioration in style.

Gold glass. Diameter 4 inches
Early Christian (Rome?), IV–V century
Rogers Fund, 1916

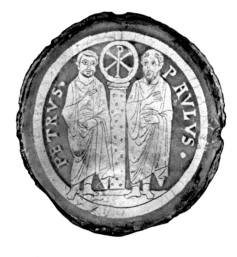

On a disc of light, greenish-white glass standing figures of the apostles Peter and Paul are portrayed in gold leaf, clad in tunics, mantles, and boots. Their names: PETRUS and PAULUS, are inscribed in well-formed gold letters at their sides. St. Peter's beard is short, rounded and curly, as is his hair; while the beard of the baldish St. Paul is long and pointed. From the fourth century on, such differentiation of the hair and beards of the two apostles remains constant, and serves to identify them. Both apostles have their left hands at their waists, and their right hands raised in the gesture of speech: the index and median fingers are extended and the others bent down to the palm. This gesture might imply that they are bearing witness for the Church.

The apostles stand, with their heads turned slightly inward, to face the column placed between them. The shaft of the column is decorated with an allover pattern of staggered circles. The column stands on a base and has a torus and fillet at the top. Supported by the column is the Constantinian monogram of Christ inscribed in a circle. The superimposed letters x and P (the Greek letters chi and rho of the name XRISTOS) of the monogram have symmetrical cross-strokes at the terminals.

A column surmounted by a monogram of Christ, standing between two apostles, is doubtlessly related to representations of Christ himself, or of a cross, standing in the same position (number 9). The column alone, in Christian iconography, may represent the Christian church. The apostles then would be speaking on its behalf. In similar compositions they sometimes hold scrolls. It has also been said that "a column with a monogram of Christ is a symbol of the unshakable stability that Christ gives to His Church and to the faithful, it is the affirmation of Truth and Faith." The style of the figures has been aptly described as showing Roman realism of Hellenistic derivation.

Christian gold glass discs are believed to have been made primarily as bottoms of drinking cups, but some of them might have been worn as pendants. Cups with gold glass bottoms sometimes were given or received as gifts on special occasions, such as marriage or baptism. Serving as drinking vessels during the lifetimes of their owners, many of them were then used to seal the owner's burial niches in the catacombs. This is why most of the gold glass discs come from the catacombs of Rome, and some of them are still found inserted in the plaster of the walls. In the catacombs the discs might have served to identify the tomb. They also might have been protective amulets for the dead, their Christian content protecting the peace of the deceased by warding off evil influences, or a sign that the dead rested in Christ and should not be disturbed.

When the Early Christians began to make gold glass during the fourth century, they continued to use the same technique practiced in Ptolemaic Alexandria in the third century B.C. Gold foil images were mounted between two layers of, usually, colorless glass which were later fused permanently together (see number 2). The secret of the technique has been lost and although there were attempts to revive it during the Italian Renaissance, and again in the nineteenth century, what has been achieved is not quite the same. The name given to the technique in the nineteenth century is *verre-églomisé,* deriving from the name of an eighteenth-century French framemaker, Jean-Baptiste Glomy (d. 1786), who used the related technique on frames.

The Early Christians added new subjects to those of pagan gold glass: images of Christ, his saints and apostles, scenes from the Old and New Testament, and Christian symbols and inscriptions. Among the Christian representations appearing in the fourth century, those of the apostles Peter and Paul were especially popular. Their earliest representations show them beardless and seated; the standing and bearded apostles are later in time; while the busts of apostles, usually shown in profile, come last. Several gold glass discs with representations of Peter and Paul are in the collection of the Vatican Museum.

Gold glass of the highest quality comes from the third and fourth centuries, while the use of Christian subjects on gold glass usually dates from the fourth or fifth. Some examples of the latter, however, have to be dated into the sixth century.

4 Dolphin

20 *Rock crystal. L. 6¼ inches*
Early Christian, III–IV century
Bequest of Mrs. William H. Moore, 1955
Provenance: Carthage, Tunisia
Ex colls. Percher, Carthage;
Mrs. William H. Moore

The rock crystal dolphin has a smoothly polished body and carved fluting on top of the head and on the fins; the eyes are hollowed out. The crystal shows internal flecks and cloudiness. The carving is of considerable quality and the preservation is quite good, although the tip of the tail and some edges are chipped off. A metal loop inserted through the tail suggests that the crystal was meant to be hung by its tail. The exact purpose or use of the dolphin remains uncertain, but one should point out that in the church of St. Severin in Cologne a small fish-shaped crystal reliquary is suspended from the arm of a cross.

This dolphin is one of ten crystal objects which came to the Metropolitan Museum as the bequest of Mrs. William H. Moore. She acquired them about 1910 in Tunisia from their previous owner, a Mr. Percher of Carthage, who said that he had found them in an empty Punic cistern on his land. J. M. E. Marquis d'Anselme de Puisaye published the find while the objects were still owned by Mr. Percher. His text confirms that they were found by their owner with other pieces of various dates, including several Christian objects such as terracotta lamps and a silver spoon with the handle ending in an equilateral cross. He dates the spoon later than the rest of the objects in the find. One must note that Puisaye's early datings for the crystals differ from the generally accepted date of the third to the fourth century. One opinion suggests that the ornamental, stylized character of the carving on the dolphin might indicate a date as late as the fifth century. The crystals from Carthage represent a continuation of the art of stone cutting inherited from Roman times and continued in Egypt especially under Fatimid rule.

Representations of dolphins played an important part in Early Christian iconography, and in the earliest times were considered interchangeable with those of the fish (ΙΧΘΥΣ), a symbol of Christ. One can find dolphins in Early Christian mosaics and in wall paintings of catacombs where they are often shown with their bodies wound around a trident, a cross, or an anchor—the latter interpreted as a hidden symbol of the cross and of salvation. According to a legend recorded by Sir Wallis Budge, dolphins were believed to guard the bodies of saints, and they are found represented on Coptic grave stelae guarding the body of St. Menas, a fourth-century saint highly venerated in the Near East.

Whether or not this dolphin was carved for Christian use, it is known that North African crystal objects were incorporated in Christian ecclesiastical vessels. For example, in the Treasury of St. Mark's in Venice, a Byzantine hanging lamp *(lampada pensile)* is made of a crystal bowl decorated with fishes carved in relief, mounted in an eleventh- to twelfth-century metal setting. A fragment of a similar crystal bowl was found with the dolphin shown here.

22

White marble. H. 19½, L. 23, D. 12 inches
Early Christian, IV century
Gift of John Todd Edgar, 1877
Provenance: From a tomb in ancient Tarsus,
Asia Minor; found in 1876

The complete pictorial sequence of the story of Jonah and the Whale consists of three scenes: Jonah cast to the Whale, Jonah spewed up by the Whale, and Jonah resting under a gourd vine. Jonah in distress over the wilting of the gourd plant can be added. In Early Christian art any of the three episodes may be omitted, or used alone, or two or three episodes combined into one composition.

Represented on this sarcophagus fragment owned by the Metropolitan Museum are Jonah cast to the Whale and the Whale disgorging Jonah. The ship's crew consists of a shipmaster and three sailors. The naked Jonah is lowered over the side of the ship feet first; his legs, up to the knees, are already in the jaws of the monster. The fish is usually represented as a serpent dragon rather than a whale on sarcophagi. Nearby the monster is disgorging Jonah who emerges head first with arms raised possibly in the posture of an orant, the soul of a deceased in prayer.

The style of the figures is rude, of the fourth or possibly the fifth century and they are finished only in the front. When the piece came to the Museum, almost one hundred years ago, it was described as Greco-Roman and miscalled a votive ship.

The sculpture was found in 1876 in ancient Tarsus, Asia Minor, the birthplace of St. Paul. Despite its somewhat fragmentary condition, it is very important as one of the few Early Christian sculptures from Asia Minor which has a known provenance. There seems to be only one parallel for the unusual detail of the whale swallowing Jonah feet first—a wall mosaic discovered in 1940 in Mausoleum M, under St. Peter's in Rome. In all other cases it is his head that disappears first into the monster's mouth.

The subject of Jonah and the Whale is an example of the relationship between Old and New Testament texts, both containing the promise of deliverance. As a reference to the words of Christ about Jonah (Matthew 12:39–41) the subject has an important place among Christian symbols; the parallel between the burial and resurrection of Christ and Jonah's three days inside the whale is evident. Jonah being disgorged stood for a figurative interpretation of Christ's resurrection and, at the same time, a promise for the resurrection of all mankind.

Tertullian supports the idea of the resurrection of the flesh at the Last Judgment; other theologians also speak of it. But the story of Jonah is found less often in Early Christian literature than in pictorial representations of the period. Several hundred representations in various media—sculpture, wall paintings in catacombs, etc.—can be counted. A prayer to Christ says: "Deliver us, as you have delivered Jonah from the belly of the whale"; and in the Apostolic Constitution (Book V) one finds the reassurance: "He.... who after three days brought forth Jonah living and unharmed from the belly of the whale. ... shall not lack power to raise us also."

Charles R. Morey and Edouard Stommelt point out that in the earliest Christian representations of Jonah, he is resting under the gourd vine; the scene with the ship develops later in the course of the third century, while the episodes with the whale are added still later.

Stommelt believes that the source for Jonah representations is not so much the actual text of the Bible as some non-canonical text, the remnants of which survive in certain rabbinical and Islamic writings. He suggests that it was the Diaspora Jews who created the apocryphal version of the story. After analyzing the wording of the Story of Jonah in the Hebrew Bible, the Greek Septuagint translations, and the later Latin version, Stommelt reaches the conclusion that the non-canonical story must have been close to that of the Septuagint.

In early versions, the Rest of Jonah was probably not meant to be a mere illustration of his story. Jonah's posture resting under the gourd vine was evidently taken over from the pagan composition of Endymion sleeping and was an allegory of "sleep" after death. The pagan representation of a sleeping Endymion, or of Dionysus resting under a grape vine as in the Campana terracotta plaque in the Louvre, could have struck the Early Christian carvers as easily adaptable to the Jonah story. The grape vines could simply be changed into gourds. Jonah was deemed as suitable for sarcophagi representation as was Endymion. Thus a pagan symbol of death (Endymion) was taken over into a Hebrew subject (Jonah), and later adapted for Christian burials.

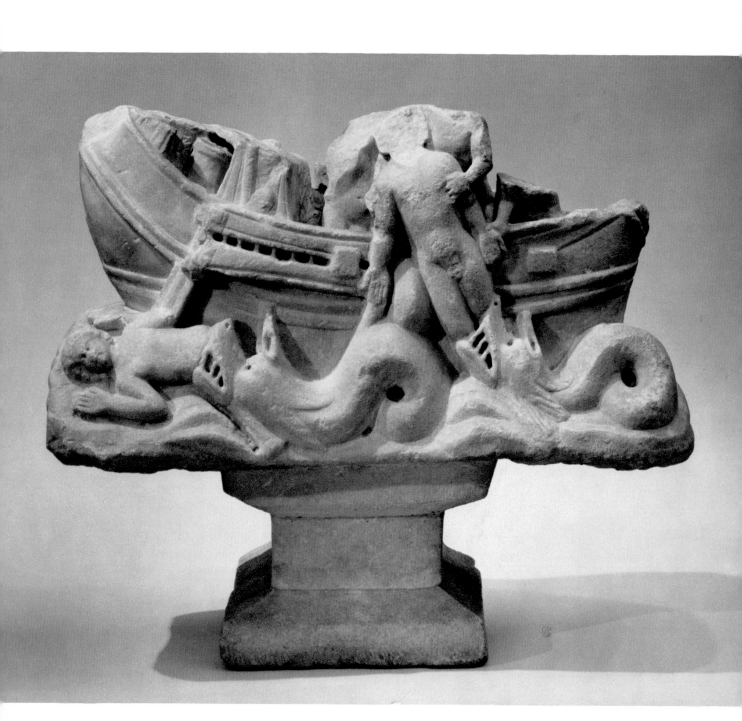

Silver, parcel gilt. H. 7½ inches
Early Christian, between 350 and 500
Provenance: Near Antioch on Orontes, Syria

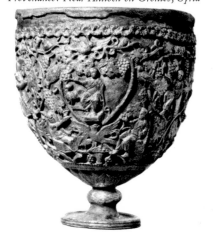

The Antioch Chalice is one of the earliest and most ornate Early Christian chalices known and can be dated between about 350 and 500. It was found with a number of other silver objects of the sixth century (see number 9). The surface shows scarring left after corrosion of the metal had been removed by Léon André in Paris shortly after the treasure was discovered in 1910.

The silver and parcel-gilt chalice has a plain silver inner cup fitted into a cast and carved openwork, footed outer shell. A wide frieze with the figures of Christ and the apostles, in a framework of interlaced grape vines peopled with animals, decorates the cup. The upper edge is bordered by a row of rosettes. The bottom of the cup is made in the shape of a lotus calix, and the foot, proportionately small, is connected to it by a flattened round knob incised with a pattern of imbricated leaves. At present an irregular oval shape, the chalice must have been partly crushed when buried.

The first impression of the whole is of ebullient richness, although the decoration follows a basic pattern. A youthful Christ, surrounded by five apostles, appears on both sides of the chalice. Attempts to identify each apostle have failed, but beginning in the fourth century St. Peter is usually given the place on the right of Christ.

On what is probably the principal side, but unfortunately the more damaged one, Christ is seated on a backless stool raised on a platform. Under his outstretched right arm stands a lamb. Bonnie Young suggests that a goat may have been under his now missing left arm. Under the platform an eagle, standing on a tall basket filled with fruit, spreads its wings. On the opposite side, the main composition is repeated with a few modifications: Christ enthroned holds an open scroll. His chair is similar to those of the apostles and it resembles the wicker chairs which became popular in the late Roman period. The postures of the apostles, with their right hands raised in acclamation, are derived from the "philosophers" or "author-portrait" figures common in Hellenistic art (see number 1).

Many details of the chalice, such as the eagle with outspread wings or the tall calathos of fruit, are thought to be Christian symbols derived from earlier Syrian origins. Originally they represented either offerings to divinities or objects used in pagan mysteries. The eagle represented the sun and like the phoenix was a symbol of the resurrection. It also was a symbol of immortality, and in the apotheosis of the Roman Emperor the eagle rises from the pyre of the dead ruler and bears his soul to heaven. Rosettes were also symbols of the sun and immortality. On Syrian tombstones one finds the eagle and the basket combined—again as a symbol of eternal life. In their Christian interpretation, the various symbols refer to the resurrection and life everlasting, while the grape is the symbol of the Eucharist.

A number of examples exist to illustrate the popularity of openwork in late Roman and early Christian art. On the sarcophagus of the Good Shepherd in the Lateran Museum, Rome, the figure of Christ is repeated three times standing against a background of dense vine scrolls peopled with *putti* gathering grapes. The vine is carved *à jour* in such a manner as to leave open space between the decoration and the wall of the sarcophagus. Other well-known examples are the *vasa diatreta* ("cut-through" vases) made of a single piece of glass carved in two layers joined by rods, the outer layer in lacy openwork. There are at least two instances of glass cups set into shells of openwork silver: a second- to third-century cup found near Tiflis (Caucasus) with rosettes similar to those on the Antioch Chalice, and another cup in Copenhagen found in Varpelev (Zealand) together with a coin of Probus (276–282). However, the silver inner cup of the chalice at The Cloisters appears to be the original one and not a replacement for one made of glass. The use of two layers of silver—the outer one chased, the inner plain—is not unique.

The posture of the young Christ on the first side is that of the Teacher. On the opposite side, Christ looks more mature and holds a scroll, and the figure has been interpreted as the "Giver of the Law." The composition on both sides of the chalice can be compared to that of Christ enthroned and surrounded by apostles on the ivory pyxis in the Staatliche Museen, Berlin; datable in the fourth century, it is believed by Volbach to be of Syrian workmanship.

26 *Bronze. H. 10 inches*
Early Christian, IV–V century
Fletcher Fund, 1947
Ex colls. Mme Edouard Warneck, Paris;
Arthur Sambon, Paris
Said to have been found in Rome

This Tyche, or personification of a city and its prosperity or its "destiny", is seated on a solid but simple throne. Over a chiton she wears a high-girdled peplos, held together at the shoulders by rosette-shaped fibulae. Her himation, or mantle, has slipped from her shoulders and lies around her hips and across her lap. The girdle is tied in front in a Hercules knot. The right arm of the Tyche is raised and originally held an object, the character of which cannot be defined from the present deformed and restored condition of the hand. In the left arm, resting against her thigh, she holds a horn of plenty. The drapery molds the body and forms a pattern of sharp folds, but lacks real relief and logic. Until 1914 there was a spear in the figure's right hand which was removed as an evident restoration or later addition.

The statuette, said to have been found in Rome, formerly and probably wrongly was called Felix Ravenna because the head of the figure was comparable to that on the coins of Theodosius the Great (fourth century) bearing the inscription FELIX RAVENNA.

Cornelius C. Vermeule, basing his conclusions on the study of Roman Imperial coins, sees in the statuette the Tyche of Constantinople, or possibly of Ravenna. The Tyche of Antioch has been suggested also. If this identification were correct, it would probably be a copy of the famous statue of the Tyche of Antioch commissioned in 300 B.C. by Seleukos Nikator. Made for Nikator in gilt bronze by Eutychides, pupil of Lysippos, the Tyche of Antioch stood over the river Orontes. The statue, possibly replaced by Trajan after an earthquake circa 115, is known to us in many variations from numerous copies and from Antiochinian coins. She wears a similar crown, but she sits in a highly animated Hellenistic posture and her feet are crossed which makes her very different from the Metropolitan Museum Tyche. The statuette was also tentatively identified as the Tyche of Rome, but judging again by coins, the latter was most often represented wearing a helmet and not a turreted crown. Tyches of cities with harbors often had one foot standing on the helm of a ship or, as the Tyche of Antioch, on the shoulder of a marine or river god; the left foot of this bronze Tyche placed on a pedestal might derive from such a composition.

The general type of Tyche is believed to have been created around the sixth century B.C. as a seated figure, and possibly derives from, or reflects, the iconography of the seated Oriental goddess of fertility and abundance (Cybele), combined with recollections of the representations of the Near Eastern Magna Dea, or Magna Mater (The Great Mother) of Phrygia. As symbols of desired prosperity for the city, it was customary to place sheaves of grain or, as in the case of the Museum figurine, a horn of plenty in the hands of the Tyche. Symbols of power or victory, such as statuettes of Victories (Nikes), spears and shields, or globes, were also used.

Later statues of Tyche may have been inspired by or copied from outstanding monumental statues, or statues of major deities. These have also been established as prototypes for many of the representations found on coins. The closest comparison in size and conception, although its style is somewhat different, is the bronze statuette in a private collection published by Vermeule. The Museum statuette is reminiscent of monumental statuary, possibly of the Minerva type. Its date is probably the fourth or fifth century, but an earlier date and provincial Roman or Gallo-Roman workmanship have also been suggested. At present the bronze figure remains, in the words of Kurt Weitzmann, an "enthroned city personification" of an unidentified city or region.

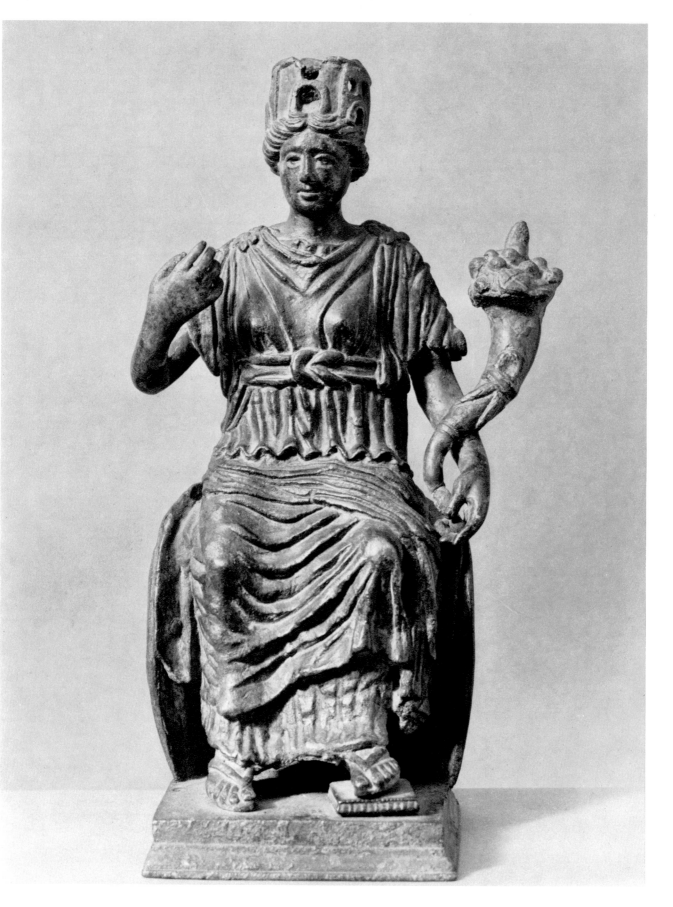

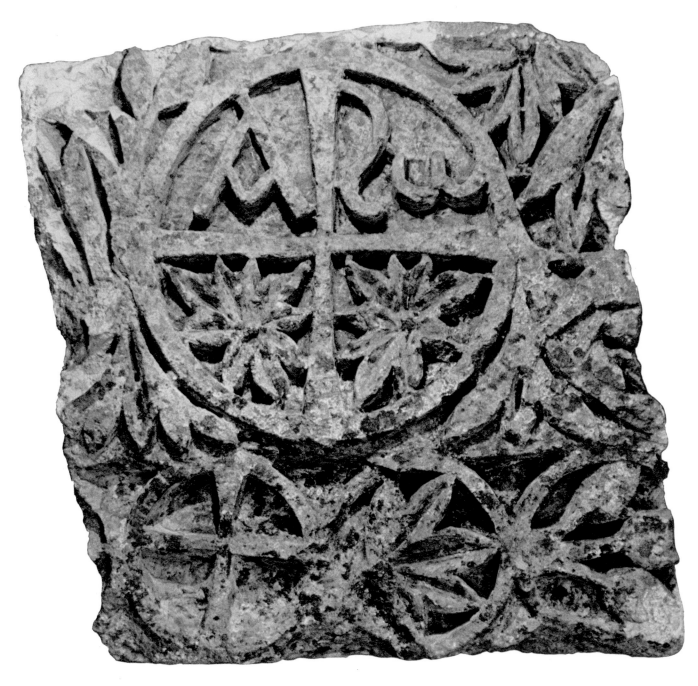

Limestone. H.20, W.19½, D.7 inches
Probably Syrian, late IV–VI century
Anonymous Fund, 1969

This limestone fragment, of an irregular square shape, has three rough sides which show traces of cutting down; the fourth side is smooth and probably shows the original condition of the stone *in situ*. Only the face of the fragment is decorated with carving in relief, but the surface is somewhat eroded and the corners have many small breaks. The flat undercut relief consists of a round medallion set against a background of interlaced leaves. The outline of the medallion circumscribes an equilateral cross, its upper branch ending in the Greek letter P (rho). This transforms the cross into a monogram of Christ, in the form known as a monogrammatic cross. In the other type of monogram, known as Constantinian or as the Christogramm, the Greek letter x (chi) has the letter P (rho) superimposed, thus combining the two first letters of the name of Christ in Greek— xpictos (Christos). Both forms existed in pre-Christian times but have been given a special religious connotation by the Christians. The letters A (alpha) and Ω (omega), the first and last letters of the Greek alphabet, are placed in the upper quadrants between the arms of the cross and the frame of the medallion. These refer to the text of the

Revelation of St. John (Apocalypse 1–8): "I am Alpha and Omega, the beginning and the ending saith the Lord…" In the lower quadrants are two irregularly-shaped leaf rosettes. Three smaller roundels filled with a cross and two varieties of leaf patterns are evidently part of a whole row of such roundels which ran the length of the architectural ornament. They are carved on a receding plane, on a lower level than the main decoration. The fragment might be the remainder of a lintel or a frieze on a façade, or possibly even from a sarcophagus. The presence of a cross in the ornamentation might denote, but does not prove, a provenance from a church.

Decorative round medallions filled with rosettes or crosses are found on pre-Christian Syrian monuments, where they were related to solar worship. For the Babylonians and the Assyrians a star or rosette, and sometimes the cross, were symbols of light and heaven. In the Early Christian period similar roundels continued to enjoy a great popularity in Syria, and were placed on friezes and on lintels in various arrangements: as a central theme, in pairs at the two ends of the decorative band, or in an interlace or continuous row, as on the lower part of the Metropolitan Museum fragment.

The date of the fragment is probably early Byzantine, and judging by a few comparable details on monuments with approximate datings, should be between the fourth and the sixth century. One finds a leaf rosette, almost identical to those filling the lower quadrants, on the Sculptor's House of the fifth to sixth centuries in Betoursa, Central Syria; and a similarly set back lower frieze on the church at El-Bahar of the fourth to the fifth centuries. Probably

many more could be found, but the study of the Museum fragment has not yet been completed.

In the period when the Museum fragment was carved, architectural decoration in Syria was undergoing a change from the classical Roman tradition to the so-called Byzantine manner in which the relief of the ornament is almost non-existent. Effectiveness was obtained not by plastic gradation but by the play of light and shadow achieved by removal of the background with a drill and chisel. In its finest manifestation, the Byzantine manner produced carvings of great beauty and perfection exemplified by the capitals of Hagia Sophia in Constantinople (sixth century). But the Museum fragment is probably from a provincial workshop and does not reach such a high level.

29

30

Silver. H.11⅛, W.9⅛ inches
Early Christian (Syria), VI century
Fletcher Fund, 1947
Provenance: The Antioch Treasure

Two beardless, haloed saints, tentatively identified as evangelists or apostles, are represented on this silver plaque from a book cover. Wearing tunics and mantles, each holds a book, and they support a large cross with flaring terminals. A border of vine scrolls enclosing grape clusters, leaf forms, birds, and a tall basket frames the plaque. The repoussé work is skillfully executed, but without the refinement of the metropolitan workshops. Part of the border is restored. A small fragment from the corresponding second plaque of the same book cover is in the Louvre, Paris. Etienne Coche de la Ferté dates it from the fifth to the sixth century, and speaks of the book it comes from as an Evangeliary. The book cover is one of the objects found with the Antioch Chalice.

The long tubular shapes of the limbs and the simplified abstract faces with wide, staring eyes are typical of the rejection of classical standards of beauty in the style of sixth-century Syria. In the attempt to represent the symbolic and transcendental—the world of faith and the spirit—the artist of the Early Christian epoch rendered the figures in an ethereal and stylized manner. The faces, with orientalized features and ears placed high at the temples, are characteristic of the Syrian style of the period, and are not too dissimilar to some of the figures in the Syrian Rabula Gospels of the sixth to the seventh century. They are also related to some of the faces in the Mount Sinai mosaics in the apse of the church of St. Catherine.

The meaning of the cross acquired its great importance after the discovery of the True Cross by the Sts. Constantine and Helena in the fourth century. It became the symbol of Christ, of the Christian church, and of the redemption of man. The composition of the cross supported or accompanied by two figures developed under Syrian influence and has been used since Theodosian times, especially in the eastern Mediterranean part of the Byzantine Empire. The two figures may be those of evangelists, apostles, angels, or saints. They either support the cross or just flank it as an honor guard. André Grabar points out that a similar composition dated circa 450 existed in the lost mosaic from the apse of the Basilica Apostolorum in Ravenna.

Among the best-known comparable compositions are the apostles (?) with the cross on the two ends of the Princes' Sarcophagus of the fourth century in the Archeological Museum, Istanbul, and the evangelists flanking the cross on the back of the stone reliquary chair in the Treasury of St. Mark's, Venice, dated by André Grabar in the sixth century and attributed by him to an eastern Mediterranean workshop. There is also a cameo of the sixth century in the Bibliothèque Nationale, Paris, with two angels flanking the cross, and a Byzantine onyx gem (inset in a chalice for Catherine the Great of Russia) with a cross between two archangels and the representation of the young Christ above, in the Cathedral of the Assumption, Moscow. In addition, there is the famous silver dish from the Stroganoff Collection in the Hermitage, Leningrad, dated in the sixth century, with two angels supporting the cross, and a more humble example, a Coptic wooden carving in low relief in the Berlin Museum. Here the angels support a cross standing on a mound, evidently illustrating the belief or legend pointed out by Oskar Wulff: that in the center of the earth, the Golgatha-Cross is being guarded by two angels.

32 *Purple wool woven over undyed linen warp*
8⅞ inches square
Coptic (Egyptian), IV or early V century
Subscription Fund, 1889

In the central medallion Dionysus is riding in a chariot drawn by three panthers, with Ariadne (?) at his side. The scene might be the Triumph of Dionysus after his legendary conquest of India, a subject created in imitation of the victorious wars of Alexander the Great. On the other hand the scene might portray Ariadne's marriage to Dionysus. Xenia Lyapunova suggests that the scene may be part of a Bacchanalian procession, as the two main figures have also been identified as Bacchus and Cybele, and the beasts as lions. Often a participant in Dionysiac processions, Heracles marches at the side of the chariot with a club in his hand.

The medallion is inscribed in a square, framed with scenes of the Twelve Labors of Heracles. Decorative interlace patterns in white on purple fill the corners while the rest of the design is executed in purple on a white background. The complex of subjects is treated as a uniform, purely decorative pattern, and the compositions of scenes and attitudes of figures are chosen or adapted to interlock with the adjoining designs. While parts of scenes (10) and (12), and scenes (1), (2), (3) are missing, the Labors can be reconstructed following the less fragmentary square with the same subject in the Hermitage, Leningrad (no. 11337, acquired in 1888–89). The Hermitage square may be a mate to the Metropolitan Museum piece, coming from the same tunic, pallium, or shroud. The squares would have been placed symmetrically, either on the shoulders or near the hem at the bottom of the clavi (vertical decorative bands running from the shoulders downward).

All subjects have been tentatively identified by several scholars. Beginning with the upper left corner, counter-clockwise, the scenes are:

(1) Wrestling with the Nemean lion (Heracles is strangling the lion)
(2) Victory over the Queen of the Amazons, Hippolyta (Heracles grasps the bridle of her mount, while she raises her arm against an imminent blow)
(3) Capture of the Ceryneian Hind
(4) Destruction of the Lernean hydra (a snake "with nine heads")
(5) Shooting the Stymphalian birds
(6) Taming the mares of Diomedes
(7) The three-headed Cerberus, held by the scruff of his neck, is led from Hades to the upper world
(8) Contest or struggle with an unidentified adversary
(9) Capture of the Cretan bull
(10) Cleaning the stables of Augeias
(11) Capture of the boar of Erymanthus (Heracles carries the boar on his shoulder)
(12) In the garden of the Hesperides (two variants are combined: Heracles holds a club, and at the same time the dragon-snake, coiled around the tree it was guarding, is killed by an arrow)

Heracles is bearded in some of the scenes, and beardless in others. For the whole arrangement, as well as for each scene, prototypes or parallels can be found on various Greco-Roman objects of the second to the third centuries. But none of the scenes are exact copies. The most suitable versions have been selected or adapted to the spaces to be filled.

Among the exhibited Coptic textiles this is the only one executed in monochrome purple wool. The true royal-purple dye was obtained from certain sea molluscs, but chemical analyses have shown that in Coptic textiles, as a rule, purple vegetable dyes obtained from the madder plant were used. The shades vary from a very dark blue-purple that is almost black through brownish tints to reddish-violets. The wool in this square is a reddish-violet purple.

The use of monochrome wool, the Hellenistic-Roman subject, and the animated design in which the classical ideas of beauty have been abandoned but not forgotten, point to a date of the fourth or early fifth century.

Occasional attempts were made to explain the Coptic use of purely pagan mythological subjects by attributing hidden Christian symbolism to them. The Triumph of Dionysus was compared to Helios, the Sun, in his chariot; Helios, in turn, was likened to Christ, and the whole scene to Christ's resurrection. In the later Middle Ages the Twelve Labors of Heracles were used to illustrate Christian moralities. However, this piece probably represents nothing more than a survival of favorite pagan subjects of Alexandrian-Hellenistic inheritance. One must also assume that not all textiles were made for Christians, even though they were used in Christian burials. As late as the sixth century, Dionysos, wearing a wreath and carrying a torch in a chariot drawn by panthers, can be seen on two Coptic ivory (or bone) pyxes: one in the Metropolitan Museum and another in the Vienna Museum.

34

Polychrome wool on linen warp
Each 7¼ × 6¾ inches
Coptic (Egyptian), IV–V century
Gift of George F. Baker, 1890
Ex coll. Emil Brugsch (Bey), Cairo

The design of these two tunic squares is identical in general conception, although it differs in certain details. The pattern is woven in tapestry technique, using colored wool for the weft over linen warp. The central figures face each other in mirrored symmetry, and the sizes and colors are identical, leaving little doubt that the two pieces are a pair from the same tunic or mantle. Their provenance is almost certainly a grave in a Coptic cemetery. Interest in Coptic textiles became widespread about 1880, when the Egyptian fellahs discovered that there was a market for the textiles they obtained from clandestine diggings on burial sites. They never gave the exact location of their finds and very often destroyed the basic textile, selling only the decorative parts.

(11 A) A male figure, facing to his right in the posture of a warrior, stands in the center wearing a Phrygian cap and a short belted tunic. He holds a sword and a pelta-shaped shield. The red and blue of his clothing contrast with the tan background. This central motif is surrounded by a purplish-black circle with eight small medallions containing, alternately, portrait heads and tall baskets filled with flowers and fruits. In the whole composition there is a noticeable absence of shading or modeling.

(11B) The design of this square is almost a mirror reflection of the first, with the figure of a warrior in a Phrygian cap holding a sword and a shield of pelta shape, facing left rather than right.

Representations of warriors and hunters as the central motif on medallions are frequently found on Coptic textiles of genre subjects. Generally, the warriors are on horseback, but in this rare case they are on foot. The horsemen usually hold spears, bows and arrows, or simple stone-like mis-

siles. The swords depicted here suggest that the figures represent soldiers in some variety of gladiator-like contest. The costumes reveal a strong influence from the east—Persia (?) or Asia Minor. The fact that the shields are pelta-shaped supports the probability of influence from Asia Minor, because neither the Persians, the Romans, nor the Egyptians used this type of shield, while one often finds it in the hands of barbarian soldiers or Amazons.

A wall painting of Three Young Men in the Fiery Furnace, from Wadi Sarga (South of Assiut) in the Thebaid—in which all three wear the so-called Persian costume with short cloaks and Phrygian caps—may be used for comparison. It is dated fifth or sixth century.

Portrait-like heads enclosed within medallions or arranged alternately with baskets of fruit or flowers on borders and frames were a popular theme which Coptic weavers inherited from the Hellenistic world.

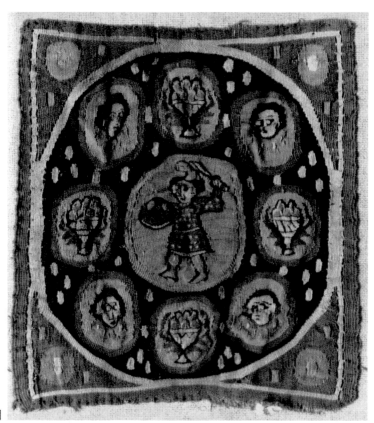

[11A]

[11B]

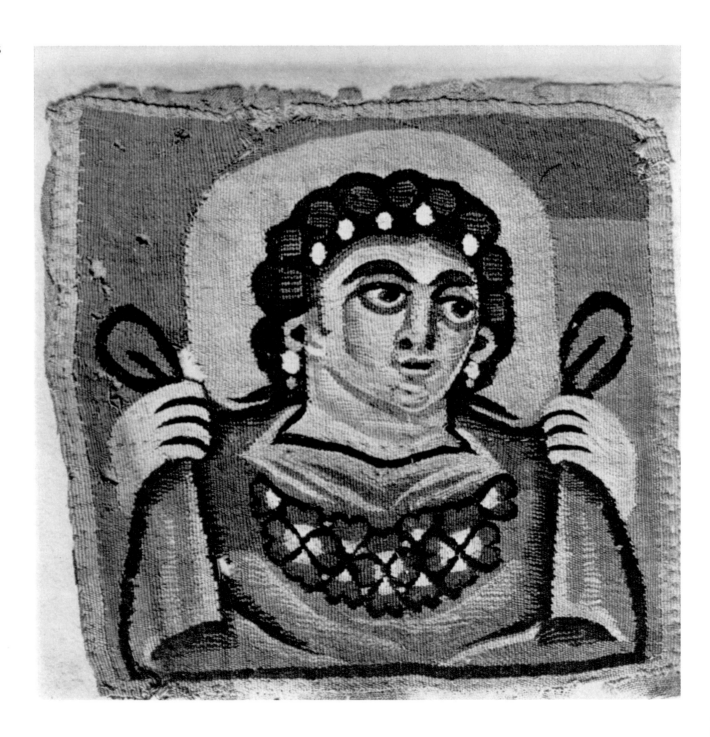

Polychrome wool and linen
About 9½ × 8¹¹/₁₆ inches
Coptic (Egyptian), IV–V century
Gift of George F.Baker, 1890
Ex coll. Emil Brugsch (Bey), Cairo
Said to be probably
from Akhmim (ancient Panopolis)

Against a light-blue background, a portrait bust of a woman is woven in a polychromy of natural colors: light tan, pink, red, purple, and brown, with a nimbus of yellow. The bust represents most probably the goddess of earth, abundance, and fertility who usually holds in her arms either sheaves of grain, fruits, or flowers. On this rectangle rosettes of fruits or flowers are placed in a cloth *(mapula)* which the goddess is holding by its bunched ends. Seasons may also carry fruits or flowers (e.g., in the floor mosaic of a private villa in Daphne, fourth century). L. Matzulevitch identifies a comparable figure on a fragment of a sixth-century silver plate as Euthenia, or as the personification of autumn or September. But it seems preferable to identify the figure on this textile as the goddess of earth and abundance, either under the Greek name Gaia (ΓΗ) or the late Egyptian name Euthenia.

Euthenia holding a cloth filled with fruit is found a number of times in Coptic art on objects from the fourth through the sixth centuries. One example is a Coptic limestone relief in the Cairo Museum (no. 44070) from the underside of an arch of an aedicula from Ahnas. Georges Duthuit describes this Euthenia: "the Coptic Gaia is represented full-face rising from the depths

of the earth. In the posture of a Christian *orans* she raises her arms, offering to the human race the fruits of the soil gathered in a piece of cloth… which she firmly grasps by the bunched ends, thus supporting the heavy load of her riches."

Another textile from a Coptic grave which is very close in style and size to the Metropolitan Museum piece was formerly in the Albert Figdor Collection, Vienna. Earlier, it belonged to Theodor Graf in Vienna, one of the first collectors and dealers in Coptic textiles in the 1880's. In the sale catalog of the Figdor Collection the figure, wearing a wreath and carrying fruit in a cloth, is arbitrarily called "Bacchus" and the textile dated fifth to sixth century. If one accepts the Museum figure as the personification of a season, one would be tempted to consider the Figdor textile as its mate in a pair—another season. However, the "Bacchus" (Dionysus) identification would not prevent the pairing of the two textiles as representations of the god and goddess of abundance. Although the Figdor textile is succinctly described in the catalog, the background is given as "light-blue" like that of the Museum's textile, and its size, 9⅞ inches square, is comparable. Closer comparison is not possible because the present whereabouts of the Figdor piece is not known.

One should also mention the two famous medallions with representations identified by inscriptions in Greek as Gaia (ΓΗ) and Nile (ΝΕΙΛΟΣ) in the Hermitage, Leningrad, and the Pushkin Museum, Moscow, respectively. Gaia here carries the fruit in a horn of plenty, but Duthuit states that the Coptic Euthenia more often carried the fruit in a cloth.

Heads and busts of personages from pagan mythology are very numerous on

Coptic textiles of the Early Christian period. Comparable representations on medallions can be found earlier in Greco-Roman mosaics of Hellenistic derivation, e.g., in Antioch, Syria, or from Thmins (Greco-Roman Museum, Alexandria). The woven "portraits" follow the harmonious Hellenistic designs rather closely and the coloristic treatment of the subject can be compared to that of the nineteenth-century impressionists. But the large, almond-shaped eyes with much of the white showing (similar to those found on Fayum encaustic paintings), the heavy eyebrows, and the strong colors are typically Coptic.

Iconography of Greco-Hellenistic origin influenced the interpretation of the original Egyptian subjects connected with the Nile. In this guise the subjects are incorporated first in Hellenistic and Alexandrian, and later in Roman artistic vocabulary and from there are taken over by the Copts. Although the Egyptian Copts were Christians, there was little conflict between their religion and their use of pagan representations, despite some loud complaints of cenobites at times. The presence of a nimbus does not indicate sainthood.

The provenance from Akhmim is not documented, but there is no reason to doubt it. The earliest finds in the newly discovered graves at Akhmim were made in the 1880's, and heretofore little appreciated Coptic textiles aroused serious interest among collectors. Emil Brugsch (Bey) of Cairo "had extraordinary facilities in acquiring the then little cared for finds of textiles recovered from Early Christian tombs of Akhmim". This was also the period when W. v. Bock brought Coptic textiles from Egypt to Russia, and Theodor Graf brought them to Vienna.

38 *Wool and linen. About 38½ × 25½ inches*
Coptic (Egyptian), V–VI century
Gift of George F. Baker, 1890
Ex. coll. Emil Brugsch (Bey), Cairo

In its original condition the hanging consisted of two panels stitched together at the top, with a wide border running the entire width of the upper part. The badly damaged border has been theoretically reconstructed: a simple garland with three rows of laurel leaves at the top, followed underneath by a row of roundels formed of interlaced circles and twisted loops. In each roundel, set against a dark-blue background, is a portrait bust with wings and nimbus. Within each intercolumnium of a richly decorated arcade a rider is mounted on a galloping horse. The riders, originally ten in number, are of two types. Alternating in the row, the first type holds a bow in a raised hand behind his head and is accompanied by a running dog; the other holds a poised missile and is accompanied by a lion. All wear Phrygian caps and short cloaks. They appear to be a cavalcade of hunters similar to those found singly as central motives on numerous Coptic medallions. The arcade rests on a garland of leaves identical to that at the upper edge, and the whole border ends at the bottom with a festoon of interlaced garlands with a jewel at the bottom of each swag. The spandrels above the arcade are filled with vases containing colorful fruit. Under this wide border, in the middle of the hanging, two winged figures (genii or Victories) in horizontal floating positions

hold between them a wreath of leaves enriched with jewels which encloses two standing portrait-like human figures.

The hanging then divides into two halves covered by a rhythmically arranged allover semé diaper pattern. This pattern divides the entire surface into lozenge-shaped fields by diagonal rows of small rosettes; a large rosette accents the crossing points. Each lozenge contains either a tall basket *(kalathos)*, or a roundel enclosing a variety of mythical or historical figures.

The Copts were very talented in arranging decorative patterns consisting of staggered serial rows of alternate subjects, as the baskets and roundels in this fragment. The possible monotony of rows and pattern repeats was eliminated by the great variety of arrangements within each serial row and by never placing identical figures next to each other, the whole being a highly sophisticated serial repetition in alternate rows.

A closely related fragment from an identical hanging exists in the Hermitage, Leningrad (inv. no. 11643). It is larger than the Metropolitan Museum piece, but the upper decorative border is almost entirely lacking, showing nevertheless the remains of the group of genii or Nikes holding the central wreath. In a thorough study of the two fragments, by Militza Matthieu and Xenia Lyapunova, a reconstruction of the original appearance of the hanging (148 × 111 inches) has been made. They have concluded that the pieces do not come from the same hanging, but from two different ones woven as a pair for an occasion such as the wedding of the two persons portrayed in the garlanded medallion held by the winged figures. The hangings were probably used later as burial shrouds.

The design is woven in varicolored wool in Gobelin tapestry technique over linen warp. The same technique of woven-in decoration was already known in Ptolemaic times. The colors of the wool are strong and clear, but in tonal harmony: the red is a rosy-red, the yellow an old gold or chamois; the riders, horses, and dogs are an almost black dark purple, possibly purple-indigo, which silhouettes effectively against the neutral background. The design is vigorous and lively, but more realistic than refined. The winged figures as usual in Coptic art are probably pagan genii or Nikes rather than angels. A little later, the whole composition, taken over from classical prototypes popular in the late Roman period, becomes an important part of medieval Christian iconography in which angels support or carry medallions or mandorlas containing Christian symbols, crosses, or figures of Christ in Majesty, etc.

On another Coptic textile of the fifth century (Victoria and Albert Museum, London), flying figures support a wreath encircling a jeweled cross with alpha and omega under its arms. A similar theme is used in the mosaic in S. Vitale, Ravenna. One also should compare the sixth-century frieze painted around the chapel walls at Bawuit, consisting of baskets of fruit alternating with winged figures in medallions. Here the winged figures are not intended to represent angels, but personifications of virtues such as Faith and Hope, and of phenomena of nature, one of which is the Morning Dew. Peirce and Tyler suggest a smaller original size (about 1½ × ¾ yards) for the hanging as well as a later date—the sixth or the beginning of the seventh century—but the reasons for this do not seem conclusive.

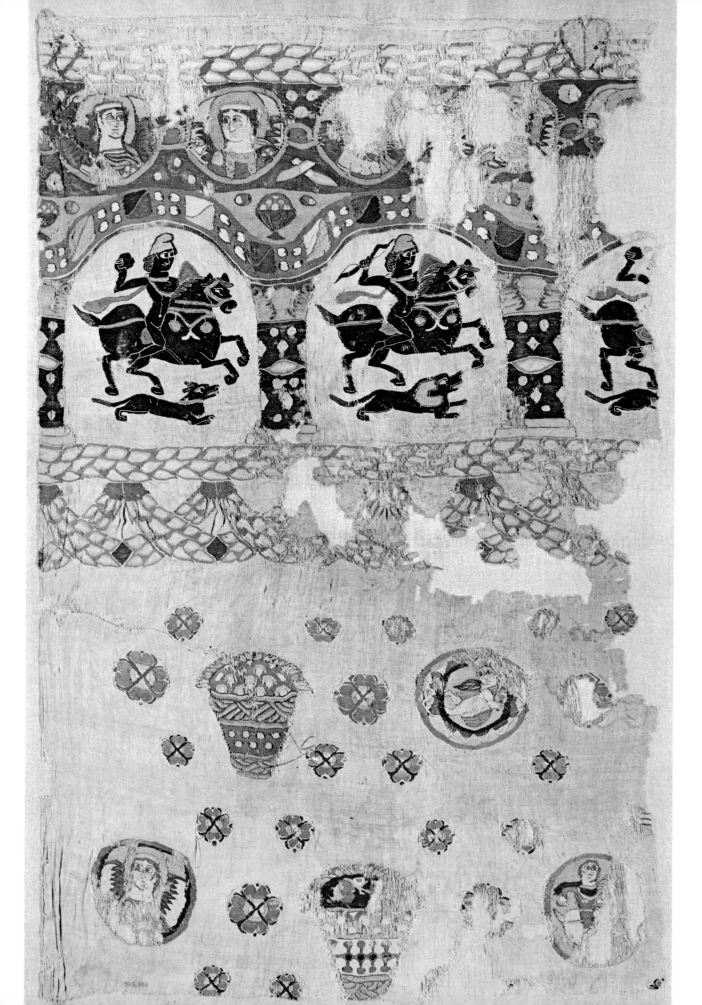

40

Wool and undyed linen
35$^{13}/_{16}$ × about 60 inches
Coptic (Egyptian) V–VI century
Gift of Edward S. Harkness, 1931
Provenance: Antinöe or Akhmim

Vines or leaf garlands interlace three tiers of medallions which originally surrounded fifteen human heads representing various personalities of the Dionysiac festivals. The spaces between the medallions are filled alternately with bunches of grapes and with grape leaves. Parts of a wide border which originally framed the tapestry on all sides are preserved. The border pattern is a modification of the ivy-leaved garland, widely used in antiquity; an almost identical garland, but without the side leaves, decorates the shoulders of an Etruscan vase (hydria?) of about 500–490 B.C. with a centaur chasing Pegasus, (British Museum, London).

The retinue *(thïasos)* of Dionysus, a nature god of fruitfulness and vegetation, usually included Pan, Silenus, Priapus, some goat-legged satyrs, dancing menads, centaurs, and other minor divinities of nature. Nevertheless, an identification of the twelve characters on the fragments of the hanging presents difficulties. One might tentatively call the horned heads satyrs, and the bald, bearded head with a shepherd's crook in the bottom tier Priapus (?). Could the head directly above him, with the so-called Isis' knot at the neckline and a snake in her hair, possibly be Isis? All of the female heads might be simply garlanded menads. Menads often carry snakes in their hair,

because snakes were included in the Dionysiac mysteries and had chthonic implications.

The cult of Dionysus in Ptolemaic Egypt had special meaning and importance, because the god was considered to be the ancestor of the Ptolemies, and the popularity of Dionysiac myths continued under Roman and Byzantine rule.

Much has been said about the Hellenistic and Alexandrian inheritance in Coptic art, especially in textiles which are often compared in style to classical wall paintings and mosaic floors. This influence is undeniable here, not only in the subject matter but also in the composition and color scheme. The free-flowing design, the varied, animated postures of the protagonists, and the extraordinary harmony of colors denote knowledge of Hellenistic-Alexandrian prototypes which have been adapted by local Coptic weavers with great liveliness and expressiveness, and with coloristic effects inherent to them.

The workmanship of the tapestry is of the highest quality; the wool is so fine that it looks almost like silk which is rather unusual for Coptic textiles. The colors: the rosy-red of the background, and against it the almond-greens and yellows of the vine leaves, the light golden yellow of the medallion background, the raspberry-red of the heart-shaped leaves or petals in the borders, with the blue-green of the tendrils and edging combined with the subdued blues, reds, and tans of the garments, make this Coptic tapestry one of the most beautiful that has survived. In a recent publication Dorothy Shepherd includes it with five or six other outstanding Coptic textiles, and dates the group into the sixth century. All are attributed to the same workshop in the neighborhood of Akhmim because several of

these textiles were found in that region. She compares the colors used in the textiles to those of impressionist painting, pointing out the masterful arrangement of the weft threads which give shape and outline to the figures without employing additional colors. According to an old tradition the Metropolitan Museum tapestry was found in Antinöe.

Dorothy Shepherd's grouping and the dating are very persuasive. In fact, the late Professor Albert M. Friend of Princeton has compared the design of this hanging, which he dated about 500 to the illuminations of the Book of Minor Prophets (Gr. MSS., Turin, B.I.2), dated by its colophon 535 and probably copied from an Egyptian original. The survival of ancient gods so long after the adoption of Christianity is not astonishing, and, as Dorothy Shepherd indicates, the facial features of the Dionysiac followers on this textile are found again in the heads of the apostles and evangelists on the beautiful tapestry with purely Christian content in the Cleveland Museum: the Virgin and Child enthroned, surrounded by angels, and framed by medallions with heads of apostles and evangelists.

The hanging shows a considerable number of losses and minor repairs and only very recently a rearrangement of the medallions has revealed its original length, and its proportions of three horizontal tiers of five medallions each. The figure formerly occupying the uppermost left corner was transferred to the new central location between the second and third medallions of the same tiers. This move has revealed that the vertical fifth (central) row, entirely missing in the previous mounting of the fragments, was all that was needed to complete the length of the hanging.

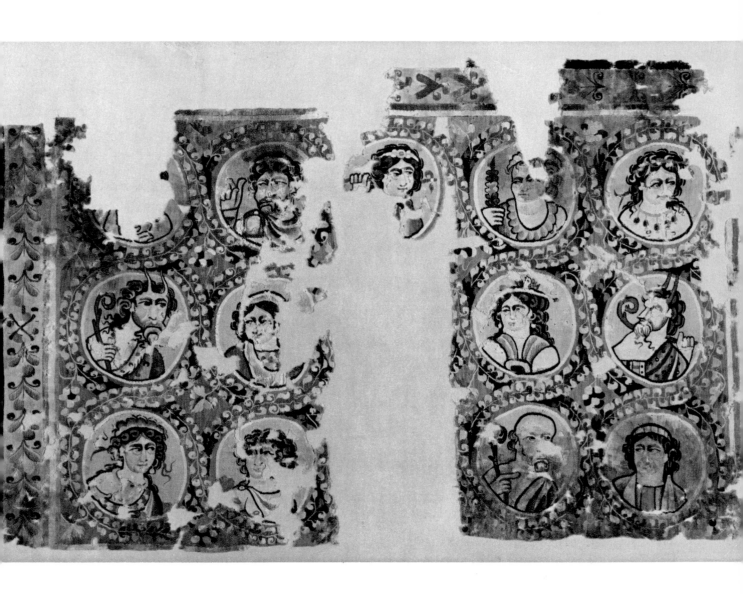

42 *Ivory.* H.9⅛, w.4⅛ *inches*
Early Christian, probably V century
Gift of George Blumenthal, 1941
Provenance: Abbey of Mettlach
(Valley of the Saar)

The full-length figure on this rectangular plaque has been identified as St. Peter, although, before the ivory came to the Museum it was referred to several times as St. Paul. The figure is stocky, that of a peasant or a poor fisherman, as St. Peter was according to the Gospels. The keys of St. Peter are not represented which may explain why the apostle was occasionally identified as St. Paul. However, the facial type is definitely that of a St. Peter. While the relief is rather low, a great effort was made to model the figure and drapery by the use of light and shadow.

Many details of the plaque's iconography point to its derivation from or relation to a late classical, and more specifically, probably eastern Mediterranean prototype. The tunic and mantle, the curtains drawn aside in the background, the representation of a frontal, full-length standing figure of an important personnage are all found on late Roman diptychs. The subject of a Roman diptych—a consular or imperial portrait—has been replaced by a figure from Christian repertory, an apostle (see number 3).

The localization of the workshop which might have produced this carving, and even its dating and original use, have not been agreed upon by various specialists in the field. In the Museum it is labeled Early

Christian, probably fifth century. Its provenance does not supply any decisive information.

According to available information published by Friedrich Schneider in 1887, the ivory plaque was found "some scores of years earlier" in a smoke house of the former Abbey of Mettlach (Saar) on property then owned by Eugen Boch's family. It was therefore concluded that the plaque must once have been the property of the Abbey which was founded, according to legend, in the seventh century and dedicated to St. Peter in 713. Mr. Blumenthal acquired the plaque from Eugen Boch's family, possibly through an art dealer. Nothing else is known of its former history.

Various locations for the workshop which made the plaque have been suggested by a number of specialists: Liège (or the Meuse region, or the Lower Rhine), Gaul (more specifically northeast Gaul), and Alexandria, Egypt. Originally it could have been a diptych leaf; a plaque for a bookcover; or, according to majority opinion, part of a Bishop's throne similar to the famous one of Maximianus in Ravenna. The last opinion stipulates that the throne must have been one of two known to have existed in Trier. At present this suggestion seems to be the most acceptable.

Several existing plaques carved in ivory are related to the Museum's St. Peter: (1) a St. Paul in the Treasury of the church of Nôtre-Dame at Tongres, (2) a St. Peter in the Musée du Cinquantenaire, Brussels—ex coll. Spitzer, (3) a plaque with a figure identified by inscription as St. Paul, Cluny Museum, Paris, also from the Spitzer Collection, (4) two plaques each representing two evangelists with scenes from the New Testament above, Fitzwilliam Mu-

seum, Cambridge. The plaques on the chair of Maximianus in Ravenna show the same general aspect but definitely do not belong to the same group. The closest similarity in the treatment of the face and beard is found on the plaques in the Fitzwilliam Museum. Only the Museum's St. Peter is depicted wearing sandals; all of the others wear slipper-like shoes over stockings.

The general aspect of the head in the Museum ivory reminds one of the face, practically erased but with sufficient details discernible, on a carved wooden pier from Bawit (Coptic Museum, Cairo) dated by Strzygowski in the seventh or eighth century. The general composition is similar but instead of the curtained background the figure stands in an arched niche and the mantle is differently draped. Among the earlier ivories, the closest comparisons for the use of curtains drawn aside and tied in knots are in the diptych leaf of the Consul Flavius Felix, 428 (once in Limoges, and now in the Cabinet des Médailles, Paris), and the leaf of a diptych with the portrait of Ariadne (Bargello, Florence) of about 500. These curtains *(vela)* are themselves an inheritance from antiquity. It was customary for emperors, when they showed themselves to the people, to appear from behind curtains drawn aside at the right moment. Also curtains sometimes accompany "portraits of Evangelists" in various early manuscripts.

Tentative datings given to the Museum's St. Peter and to the related plaques vary from the fifth or sixth centuries, through the Carolingian period (especially related to the Ada group) to as late as the tenth or twelfth centuries. But a date close to that of the Ravenna Maximianus throne of the mid-sixth century, and probably earlier, is most logical.

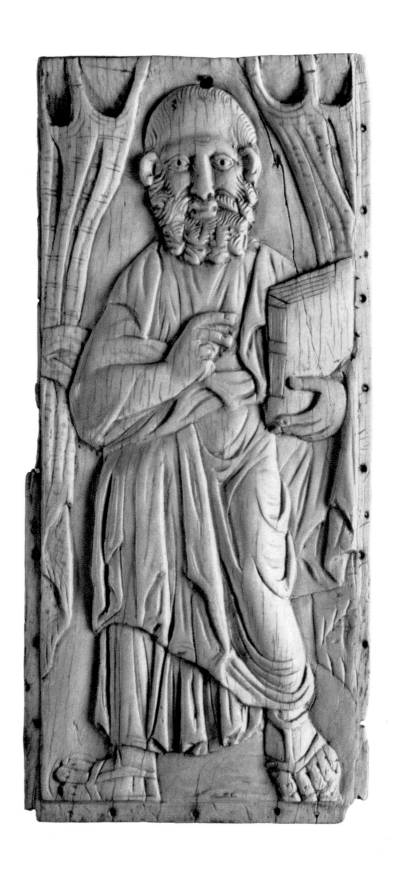

44 *Polychrome wool on unbleached linen warp*
11 ¼ × 9 ⅝ inches
Coptic (Egyptian), III–V century
Gift of Helen Miller Gould, 1910
Ex coll. Dr. Chauncey Murch, Luxor

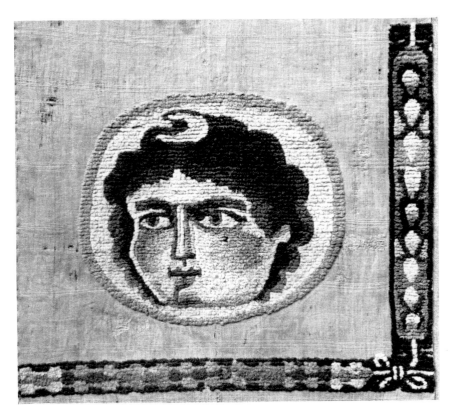

This decorative insert or *orbiculus* from a Coptic tunic or cloak is made in looped weaving technique with wools of elaborately scaled, pleasant shades of bright colors. The yarn is rather thick and the loops create a surface not unlike that of a rug, while the general effect is similar to that of a mosaic. Because an ornament in the shape of a crescent moon is worn in the dark hair, the portrait-like head of the woman has often been referred to as Luna (possibly the goddess of the moon). However, the same ornament may be worn by Selene or by other goddesses.

The head, rendered in Hellenistic style, is essentially Greek in naturalism, grace, and refinement, but combined with a vigor characteristic of Coptic art. In its pictorial qualities it is related to Roman pavement mosaics. The combination of colors has been compared to those in Renoir's paintings: the strong red blush on the cheeks, the dark hair, contrasting with an almost white background of the roundel with its rose border, wide-open shiny eyes with much of the white sclera showing, and heavy eyebrows meeting over the bridge of the nose.

A narrow galloon-like decorative border frames the roundel on two sides, forming a right angle or *gammadia*. It indicates that the insert was used as a right corner decoration above the hem of a tunic, a cloak, or possibly a hanging or shawl. Such decoration usually encloses the two ornamental medallions near the hem, with its horizontal side sometimes running the width of the hem. A similar arrangement may be seen on several other textiles. One is the so-called shroud of Aurelius Collutus and his wife Tisoia (Musées Royaux, Brussels), practically the only Coptic textile which can be dated (mid-fifth century, or 454–455) by the parchment document found with it in the excavations at Antinöe; another is a child's tunic from the Walters Art Gallery, Baltimore (inv. no. 83.484), dated sixth to eighth century; and a third is the "shawl" of Sabina, in the Musée Guimet, Paris.

BYZANTINE ART

46 *Bronze. H. 11 ½ inches*
 Byzantine, IV century
 Edith Perry Chapman Fund, 1961

This bronze bust of Athena, an aegis with a gorgoneion surrounded by four snakes on her chest and a helmet with a trilobed crest on her head, is a Byzantine weight. Weights of this kind were used as counterpoises on a *statera,* or Roman scale, which closely resembles the modern steelyard. Such scales have one weighing pan or hook and a single arm with marked divisions along which the suspended weights are moved to balance the scale. The ring at the top of the helmet served for suspension of the weight from a special hook sliding along the arm.

The bust is mounted on a truncated pyramid with three steps. Decorative motifs and an inscription in Greek are incised in dotted lines on the walls of the steps. When the weight came to the Museum it was heavily encrusted with corrosion. This was removed as far as possible, and the letters of the inscription which were barely visible before became legible to a certain degree. However, several remain unidentified, and the inscription still presents problems. The beginning of the legend on the front is the only part that is more or less clear: ΚΥΡΙΕ ΒΟΗΘ (Ε)Ι, the standard expression "Oh Lord, preserve…", is followed by ΤΟΝ or ΤΟΥ… From a possible combination of the other almost illegible letters, one might presume to guess that the meaning of the inscription was: "God preserve… the owner of the weight." ΚΥΡΙΕ ΒΟΗΘΙ ΤΟΝ ΕΧΟΙ ?ΑΥΤΟ? Β?ΡΟΥ?Α ??????? The legend sounds somewhat impersonal without a proper name, but a mention of the owner would be possible. An inscription on another weight, found in a sunken ship near Halikarnassos, included the name of its original owner, the captain of the ship.

Classical in its conception, this bust of Athena is completely unclassical in its style: rigid in its frontality, block-like in construction, abstract in form, its modeling reduced to patterns, it is typical of the disintegration of late Roman art which begins in the second half of the third century.

The weight is said to have been dug up not far from Istanbul near the Dardanelles. It has been suggested that it was dredged from the sea, but no details of the find are available.

Figures used as weights were of different sizes and shapes. The sizes vary according to the heaviness desired, and this bust of Athena is among the largest. Some figures are solid; others, as in this case, are hollow inside and were possibly cast in the *cire-perdue* process. Sometimes the open space was filled with lead to add weight; if any was used in this bust, none remains. The shapes range from simple to representational: figurines of all kinds, or busts of deities or rulers. Two types became especially popular in the course of the fourth century: the emperor (or empress) and the Athena, goddess of wisdom and thus of good balance. The emperor type became predominant in Constantinian times while that of Athena began to disappear. Two explanations are possible for the representation of the pagan Athena as late sometimes as the end of the fourth century: the survival of a classical type, or the revival of paganism under Julian Apostata, especially among certain groups of Roman citizens.

A very similar weight, with a bust of Athena 9¾ inches high in the Sophia Museum, Bulgaria, is dated in the second or third century, but is more likely to be of the early fourth. Silvio Ferry calls it Minerva and finds in it the expression of the approaching Byzantine mentality. In Madrid there is a weight of the fourth century, 8¾ inches high. Another of the same type is in the Louvre.

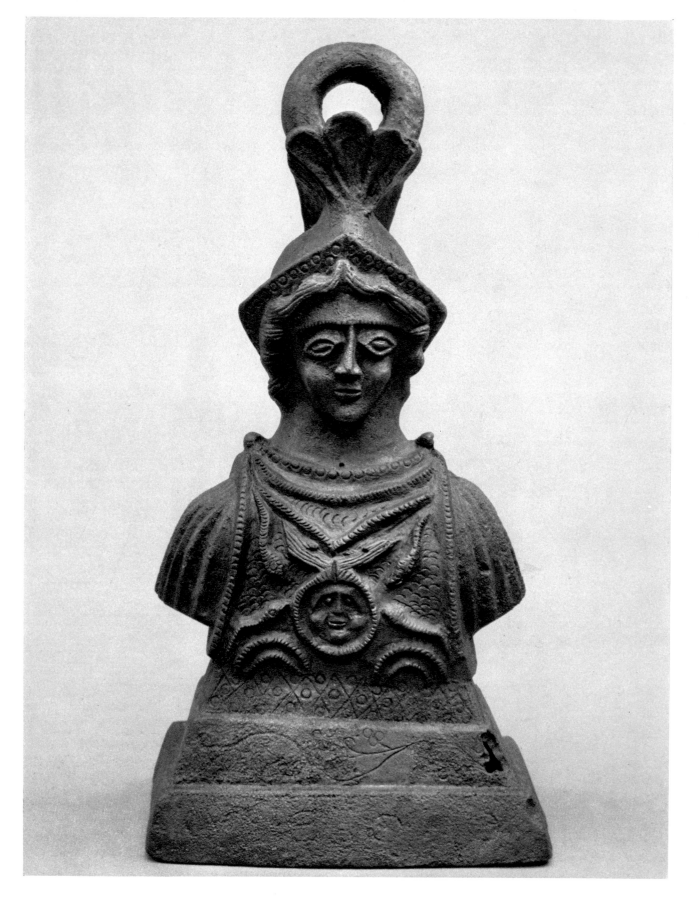

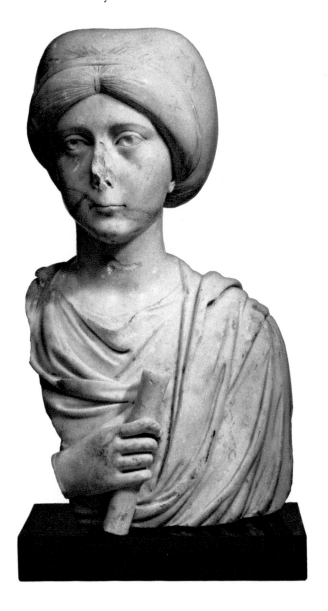

48 *Marble. H. 20⅞ inches*
Byzantine, second half of the V century
The Cloisters Collection, Purchase 1966
Said to be from Asia Minor

This sculpture, carved of fine-grained marble, is one of the finest surviving from the early Byzantine period. It may be an actual portrait but is more likely part of a grave monument. Three-quarters life-size, it represents the bust of an unknown lady of rank. She wears a tunic and a mantle that envelops the left arm completely. Her head-dress, in many respects similar to that of an empress but lacking an imperial diadem, may imply that she belonged to the royal household. Although there are strong reminiscences of the Theodosian Renaissance of the fourth century, the bust is probably not datable before the second half of the fifth century or, in the opinion of Elisabeth Alfoldi-Rosenbaum, even after the turn of the century. The sophisticated modeling of the face and the subtle folds suggest a court workshop in Constantinople; the carving is so fine that it can support an identification of a lady in the imperial entourage. The scroll in the woman's right hand could indicate that she was a person of literary distinction, but it also could be a standard detail for a tombstone. A papyrus scroll in the hands of the deceased could be based on the Egyptian after death ritual, popular in Alexandria, and could easily have influenced an artist of Asia Minor or Constantinople. A lost companion bust, possibly that of the lady's husband, could once have adjoined this piece. This would account for the cutting off of the right shoulder and the arm of the lady which is not the result of accidental breakage, as well as for the slight turn of her head to the right. It is impossible to say whether the bust originally stood in a niche. When found, the head was broken in two sections, but, except for the loss of the end of the nose, the sculpture is in remarkable good condition.

Bronze. H.3⅜, L.4⅝ inches
Byzantine, IV–V century
Fletcher Fund, 1962
Said to be from Syria

49

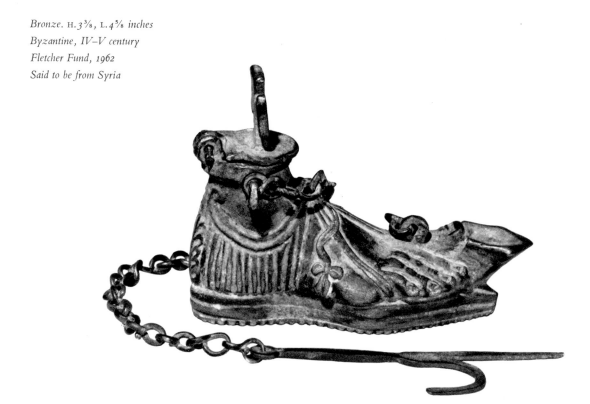

Among the numerous bronze lamps which have come down to us from Early Christian and Byzantine times there are endless varieties of shapes, most of which have been taken over by the Christians from Roman prototypes.

This particular oil lamp has the shape of a sandaled human foot, with the large toe resting against the spout. The thongs of the sandal tie at the ankle and at their tips are trefoil-shaped decorations exactly like those on another oil lamp of similar shape in the Bristish Museum. An opening at the ankle served for filling the lamp with oil. It has a flat cover, hinged at the base, surmounted by a Greek cross which identifies the lamp as a Christian object.

Three chains are attached—one at either side of the oil cup, and one at the central thong of the sandal near the large toe of the foot. They converge into a single chain, ending in a hook for suspension. The sole of the sandal is decorated on the bottom with a swastika design formed by a series of broken lines in relief. The bronze of the lamp is covered with a greenish-brown patina.

Oil lamps appeared rather late in antiquity and were a great improvement on torches and bits of wood which were used previously. It is said that in ancient Greece, when lighted lamps were brought in at night, one used to greet them with the words: "phos agathon" (blessed light!). The meaning of light might have been just daylight in pagan times, but in Early Christian times it also acquires the meaning of spiritual enlightenment and immortality. Therefore, lamps were sometimes lighted near tombs and terracotta ones are found in grave excavations. Their use as offerings in pagan temples and later in churches is well known. It has been suggested that the use of a foot-shaped lamp in the Christian period might have been symbolically connected with the words of Psalm 119:105, "The word is a light to my feet, and a light unto my path."

50 *Gold. 36 inches*
Byzantine, probably Syrian;
mid–VI–mid-VII century
Gift of J. Pierpont Morgan, 1917
Provenance: Karavás, near Kyrenia, Cyprus

The necklace, found with other jewelry and silver objects as part of the so-called Second Cyprus Treasure in 1902, consists of two parts: a chain with filigree heart-shaped links and ten hollow hexagonal cylinders strung on a swiveled chain. Eleven pendants are hung between the cylinders, and a solid gold cast cross is suspended in the center. It is flanked by two hollow leaf-shaped repoussé ornaments and eight hollow repoussé amphorae of three different shapes, decorated with ornamental patterns and cross-hatchings in relief. The clasp of the necklace, an openwork circle, is of a type found on many other Byzantine necklaces.

The vases and the leaf motif (probably deriving from the Indo-Persian ornament known as ficus indica) are eastern, but their use was not uncommon in various parts of the ancient world including Byzantium. "Cyprus trees" of a shape very similar to the leaves on the necklace often flank a cross in slightly later Byzantine representations. The earliest "leaved cross"—so named by D. Talbot Rice—appears on a stone slab of about the sixth century where the "leaves" still have the earlier acanthus shape. The openwork designs on the necklace are done with extreme delicacy and care, and demonstrate the best features of the craftsmanship of the period.

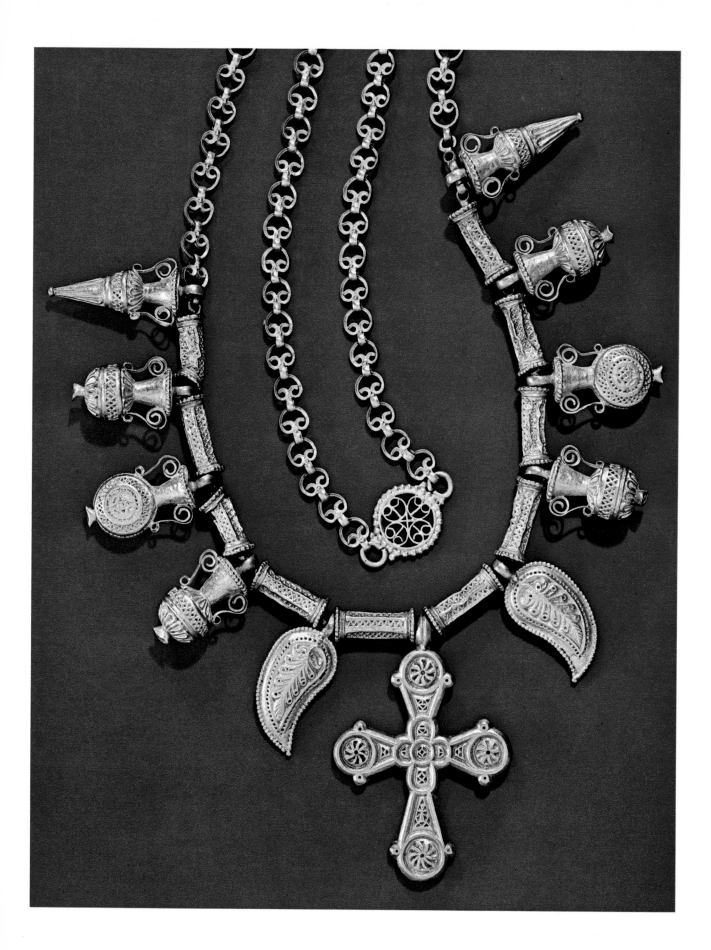

52

Silver. Diameter 10 7/16 inches
Byzantine (Constantinople),
circa 613–629/30
Gift of J. Pierpont Morgan, 1917

The scene on this silver dish illustrates the biblical text (I Sam. 17:36) in which the Prophet Samuel under divine guidance anoints David. David's arms are half open in a gesture of submission; behind him stands his father Jesse and at the far sides are his two older brothers. All are in Roman costume. David is represented smaller than the other men to emphasize his youth and humility. In low relief, the group stands in front of a portico-like structure. In the exergue, allegorically related objects are represented: an altar with burning fire, two sacrificial animals, a sword, and a club.

This seventh-century plate belongs to the period 565–726 which E. Kitzinger defines as "between the two 'Golden Ages', of Justinian and of the Macedonian and Comnenian dynasties" when Hellenistic and abstract styles existed side by side. Another plate, David Slaying the Lion (see number 22), is an example of the first, secular Hellenistic art; and this one represents the second style, actually more hieratic than abstract, probably chosen because of the solemnity of the event. The subject had religious and dynastic implications, and in Byzantium Christianity was upheld and represented by the Basileos (Emperor). The composition is solemn and monumental; the figures are arranged in a well-balanced rhythmical sequence, as they would be on a sarcophagus. A similar arrangement is found on the badly damaged wood panel from the door of S. Ambrogio in Milan (late fourth century).

In the background of the plate, the arcaded façade described by Donald Brown as an arcuated lintel and called by Ejnar Dyggve a "glorifying façade," emphasizes the royal prerogatives of David. The arcuated lintel, usually found on façades, in this case probably represents the inside of a palace or an *aula regia*. Dyggve compares it with the palatium (identified by inscription) in the mosaics in S. Apollinare Nuovo (Ravenna) dated circa 500–526, depicting the palace of Theodoric; and to the still more similar façade on the Palace of Diocletian in Spalato. This David Dish is one of four plates from the Second Cyprus Treasure which deal with the courtly investiture of David, and the same architectural detail is repeated on all four. On another, Saul enthroned, sits under a similar *arco sacro*. This architectural detail might derive from the tripartite division of the templon, or of a three-naved basilica, like the palace of Theodoric mentioned above. A similar, but gabled, façade is seen on the *missorium* (dish) of Theodosius of the fourth century in the Archeological Museum, Madrid.

Emperor Heraclius was known as the "new David"; he was also conscious that he was not "born in Purple" (of royal blood). The David scenes on the Cyprus silver plates might have an allegoric or symbolic connection with Heraclius' victory over the Persians (629) after long and troublesome wars with Chosroes II. The cycle might have been made to please him by suggesting parallels to the biblical hero and king David.

The large silver dishes, called *discaios* in Byzantium and *clipea* in Latin, have been referred to as *missoria* since the fourth century. First mentioned by Gregory of Tours, *missoria* could serve as imperial presents,

especially if they portrayed the emperor. Such gifts also often included gold coins "for the need of the people"; the custom was connected with the cult of sovereigns and heroes, just as the consular diptychs were intended to remind the recipient of the importance of the donor. The largest among the Cyprus silver dishes, David slaying Goliath, easily could be a *missorium*, the most important plate of the lay ceremonial service for which the Cyprus dishes were made.

The two silver dishes, David Slaying the Lion and David Anointed by Samuel, are part of the Second Cyprus Treasure found in 1902, in Karavás, near Kyrenia (Cyprus). They are from a set of nine dishes with scenes from the life of David. Six came to the Metropolitan Museum as a gift of J. Pierpont Morgan, in 1917. The remaining three are in the Cyprus Museum, Nicosia (Cyprus). A. and J. Stylianou published the whole find and give details of its discovery.

The question of how the plates were made remains open. The dishes have a thick plain border and are made of a single sheet of silver, while the Stylianou publication states that the repoussé of the scenes was executed on one sheet, and the outside of the dishes covered with a second sheet of silver to hide the hammered work. But a careful examination of the dishes in the Museum has not revealed two layers. It has been suggested that the plates were cast, the control stamps applied to them, and then the details carved, chased, punched and engraved. Others believe the stamps were applied on raised plates before their decoration. It is agreed that the details were added at the very last, over the low relief. There is some damage by corrosion and the silver may contain some copper.

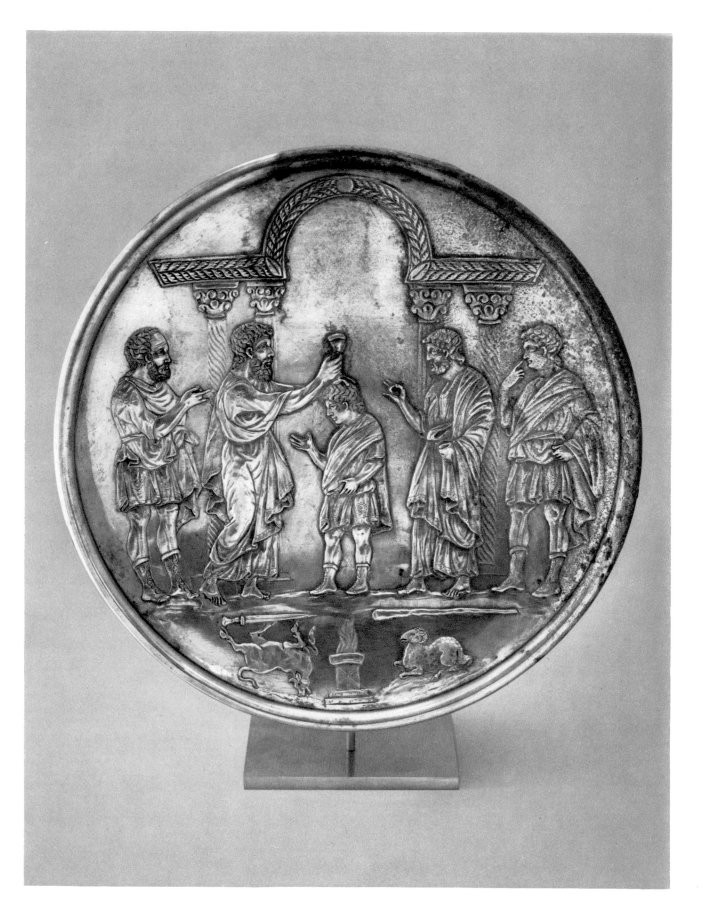

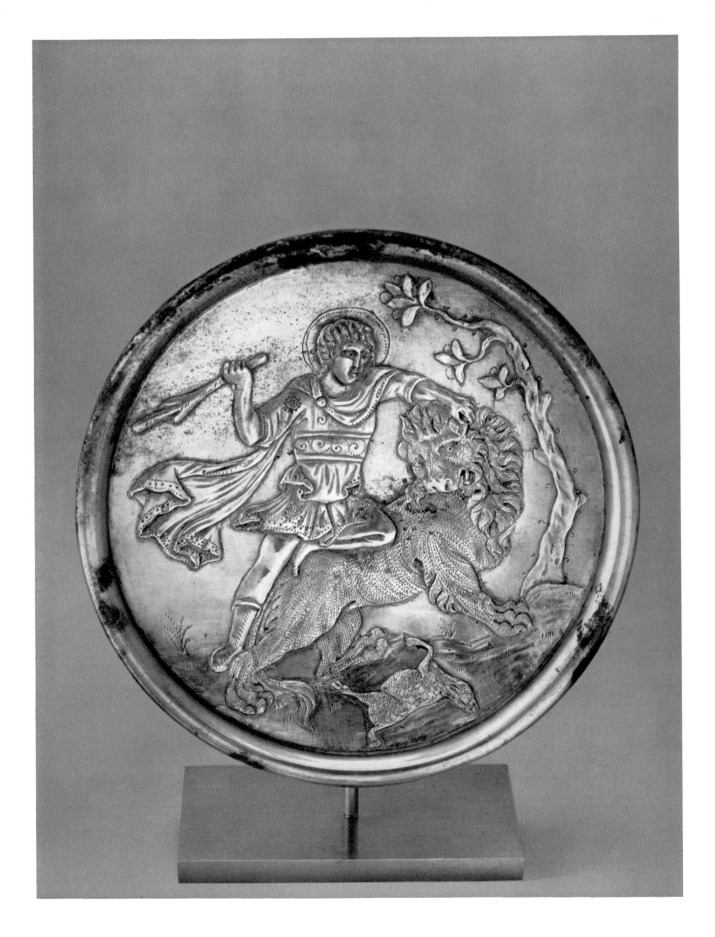

Silver. Diameter 5½ inches
Byzantine (Constantinople),
circa 613–629/30
Gift of J. Pierpont Morgan, 1917

This biblical scene of David and the Lion (I Sam. 17:34–36) derives from that of Heracles slaying, or strangling, the Nemeian lion. The posture of David also repeats that of Mithras killing the sacred bull, an oriental subject popular in Asia Minor as well as in western Europe in Roman times. The same posture was used in representations of Samson killing the lion as well (silk textile, Syrian?, seventh or eighth century, Vatican Museum, Rome). David's halo might suggest that the scene is not entirely secular and direct the mind of the spectator to its symbolic or mystical meaning. On the underside of the dish, five control stamps of about 613–630 identify the plate as the finest Constantinopolitan silver of the time of Emperor Heraclius (610–641) and probably as the product of an imperial workshop.

The style of the plate reflects the survival of Hellenistic traditions in Constantinople at the time of Heraclius, rather than the revival of the trends of the so-called Theodosian Renaissance (fourth century). Judging from the few surviving silver objects, silversmiths in seventh-century Constantinople had several styles from which appropriate choices could be made. In the case of David slaying the lion, a pastoral or hunting scene deriving from a classical mythological subject, the choice of the "classical" style in its Hellenistic aspect appears appropriate.

The classically inspired style of the dish differs from the classical style, as well as from the style of the "Theodosian Renaissance". Nordhagen notices its remarkable freshness, that of a living and not an imitative style. Outstanding characteristics of Cyprus plates are: increased emphasis on decorative effect and on the pattern of outlines, forceful movements, and the tension of figures not actually in motion. In this seventh-century representation the classical style has lost its true relief and three-dimensionality. It has been mellowed and stylized by oriental influences from Persia and Palmyra. This classicizing style of the composition gives the dish a most important place in the history of Byzantine art. Kurt Weitzmann states that this plate and the others in the same set from the Cyprus Treasure are rare surviving examples of the "aristocratic" and courtly branch of Byzantine art of the pre-iconoclastic period.

Cycles of the life of David in later illuminated manuscripts of the so-called "aristocratic group" such as the Paris Psalter (MS. Gr. 139, Bibl. Nat., Paris) of the ninth century, or the Psalter of Basil II (976–1025; Biblioteca Marciana, Venice), lead scholars to conclude that an earlier cycle in a psalter served as prototype for the later ones. The silver plates, then, represent an intermediate point in the development of the scenes. The existence of an earlier prototype might be supported by the late fourth-century wooden doors carved for S. Ambrogio in Milan with scenes repeated on the silver plates: the Anointing of David (Metropolitan Museum), and David Summoned to Samuel (Cyprus Museum). A silver dish found in the Kama region in Russia shows David struggling with a beast. Matzulevitch relates it to the Museum's David plate and attributes it to seventh century, Constantinople, although it is inferior in quality and bears no stamps. In Russia, an almost identical composition to that of the plate is found on a Coptic textile dated by Wolfgang and Volbach in the fourth and fifth century. A silver plate of the sixth century in the Cabinet des Médailles, Paris, with Herodes strangling the lion, shows a tree like that on the Cyprus plate.

The subject of a hero slaying a lion goes far back into antiquity; the hero is Heracles (see number 10) of pagan mythology or Samson of the Old Testament. In Mesopotamia, the contest with the lion on cylinder seals goes back some 3000 years before Christ. In Assyria, the King assumes the role of the mythological hero and the subject appears as a lion hunt. On the relief of the North-Palace of King Assurbanipal (British Museum, London), the King holds a very indignant captured lion by the tail. The victory symbolism of the scene can be seen very explicitly on a silver Cypro-Phoenician bowl of circa 600 B.C. (Louvre, Paris); in the center a victorious king slays kneeling captives, while on the frieze two scenes of Heracles and the lion are repeated. The symbolism of victory could also underlie the scene on the Cyprus David plate. Beginning with the third century and especially in the fourth, the figure of Heracles and his deeds acquire a mystical interpretation of moral forces overcoming evil, and thus become connected to Christianity. In the fourth-century wall paintings in the catacombs of the Via Latina, Rome, Heracles is haloed. He does not slay the lion here; this is done by Samson in a purely Early Christian rendering. David, on the other hand, is an antetype of Christ, thus, representations of Heracles can parallel representations of David in Christian art.

As late as 1926 Wilpert, who suspected that every silver treasure was a forgery, expressed his opinion that the Cyprus plates were not authentic. In support of his statement he said that the Metropolitan Museum David Slaying the Lion was a modern copy from the Paris Psalter mentioned earlier. Today, this opinion must be discarded.

23 Cup, or Chalice

56

Gold. H. 6⅝ inches

Byzantine, V–VII century, possibly 431–647

Gift of J. Pierpont Morgan, 1917

Provenance: From the Treasure found near Durazzo, Albania

Possibly a chalice, this gold cup on a conical foot was found in the vicinity of a Roman road near Durazzo, Albania, together with several other gold and silver objects. It is decorated in repoussé with four symbolic female representations of imperial cities and metropolitan sees of Byzantium, derived from Tyches, pagan goddesses of the good fortune of cities. On the chalice they are identified by inscriptions in Greek, under the rim, as Constantinople, Cyprus, Rome and Alexandria. There never was a "city of Cyprus," the capital of the island was Constantia (earlier called Salamis). It has been suggested that the presence of Cyprus as a city on this cup may supply a clue for its dating. After the Council of Ephesus, in 431, the Metropolitan See of Cyprus declared its independence from that of Antioch, and the name of Cyprus was probably used here to emphasize its importance. The figures may not be Tyches but may represent local "churches". In such a case the cup might have been made on Cyprus before 647 when the Arabs invaded the island and destroyed Constantia.

Constantinople, illustrated here, holds a staff in one hand and an orb in the other, and her crown is formed of a city wall, typical of city personifications. Her wings might be a symbol of victory. The design represents the survival of classical subject matter in the early Christian era; the workmanship shows the inexorable debasement of the classical style in the provinces.

There were four gold cups in the find. Two of these, with a simple allover decoration of fish-scales in relief, are also in the Metropolitan Museum. The fourth, with decoration consisting of birds and dragons within linked medallions, is in the Archeological Museum, Istanbul. There it is called a goblet because of the secular nature of the decoration, possibly allegorical, and is dated in the ninth century. Among other objects from the find now in the Museum are two silver vessels with Byzantine silver marks of the seventh century, two gold drinking cups with side handles for suspension which probably belonged to a tribe of horsemen (possibly Avars), and a series of gold objects of a style usually considered Avaric (sixth to eighth centuries). The appearance of the treasure in Albania might have a connection with the Byzantine campaigns against the Balkan Slavs and Avars in the last decade of the sixth century.

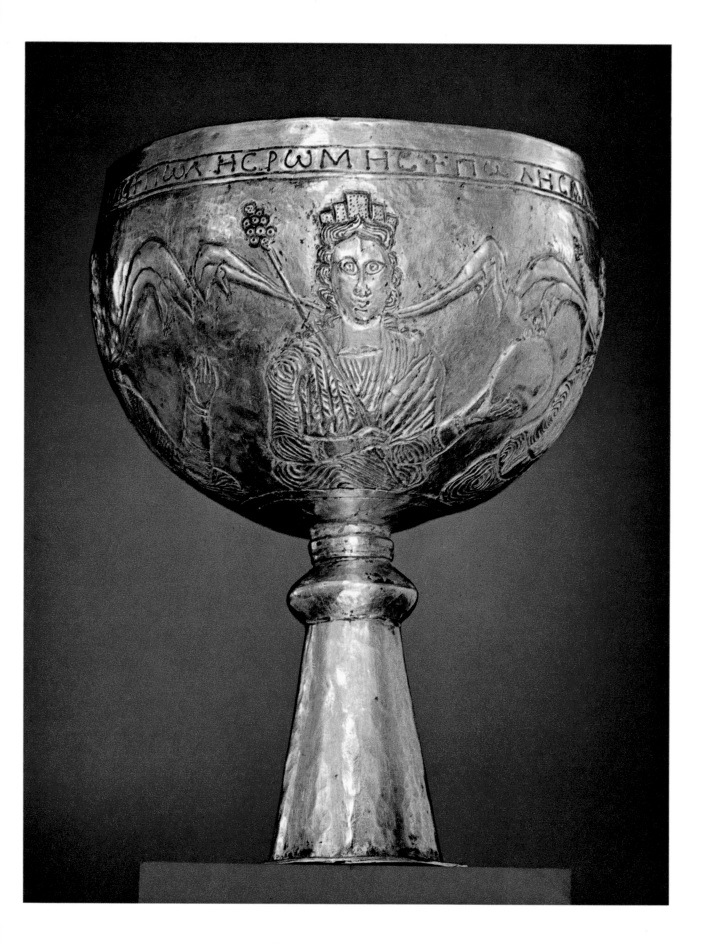

58 *Cloisonné enamel on gold*
H. 6⅝, w. 5 ½ inches
Byzantine style of the X–XII century
Gift of the Estate of Mrs. Otto H. Kahn, 1952
Ex coll. Mikhail P. Botkine,
St. Petersburg, Russia

This plaque from the Botkine Collection shows the Deësis, a composition characteristically Byzantine and eastern in conception. It represents Christ in Majesty (Pantocrator or Almighty) enthroned with the Mother of God on His right and St. John the Baptist (the Precursor) on His left, both interceding for mankind on the day of the Last Judgment. All three figures wear dark-blue mantles. The chiton of the Virgin is green, that of Christ light-blue, and that of St. John light-grey. The haloes of the Virgin and of St. John are of translucent green enamel bordered in red, while that of Christ is light-blue with a white cross bordered in red. The background is reserved in gold. The initials (or momogram) of Christ, IC XC, are white inscribed on quatrefoils with a dark-blue ground and red borders dotted in white.

Probably the most important tenth- and eleventh-century Byzantine Deësis groups in cloisonné enamel are those of the Reliquary of the True Cross in the Cathedral Treasury in Limburg on the Lahn (of Constantinopolitan workmanship, about 955–963); and a Byzantine eleventh-century plaque on the silver reliquary casket of St. Praxeda from the Sancta Sanctorum,

now in the Vatican Museum, Rome. It appears that the Deësis from the Botkine Collection goes back, with certain modifications, to the plaque in the Vatican.

Mikhail P. Botkine, an enthusiastic collector, wanted Byzantine enamels well represented in his collection. It has even been said that his passion for such enamels was so great that he obtained from the Zvenigorodskoi Collection, by rather devious ways, one of the enamel medallions (St. Theodore) coming from the Djumati silver icon (see number 25). Several scholars, now dead, have said that an unidentified art dealer provided Mr. Botkine with excellent imitations of Byzantine enamels made by a craftsman in western Europe. Kurt Weitzmann, in 1947, wrote about the Botkine Collection enamels: "many pieces... have... been questioned as to authenticity... yet... it seems by no means impossible that some... will eventually be reinstated as genuine." He expressed regrets that connoisseurship in this extremely difficult field had not yet developed reliable criteria by which to recognize with absolute certainty genuine and faked enamels.

After Botkine's death the periodical *Russkaya Ikona,* published by a group of Russian art historians, printed the following statement: "...M. P. Botkine... left a rich collection of monuments of art... Among his objects... are well known the enamels, although the greater part of these are of doubtful authenticity... Still, the authentic, precious enamels... in his collection... number up to twenty." Later, a group of western European specialists decided that the authenticity of only nine enamels in the Botkine Collection was beyond doubt, while the number of "Byzantine" cloisonné enamels on gold from the Botkine

Collection is considerably more than twenty. The Metropolitan Museum Deësis plaque is one of eleven Botkine pieces given to the Museum by the Estate of Mrs. Otto H. Kahn. In the Botkine Collection catalog they were called: Byzantine, X–XII century. The label for these enamels in the Museum was written by the late James J. Rorimer in 1952, and reads as follows: Byzantine Style. These enamels, when in the Botkine Collection, were attributed to the tenth through the twelfth centuries. They are now generally considered to be later in date.

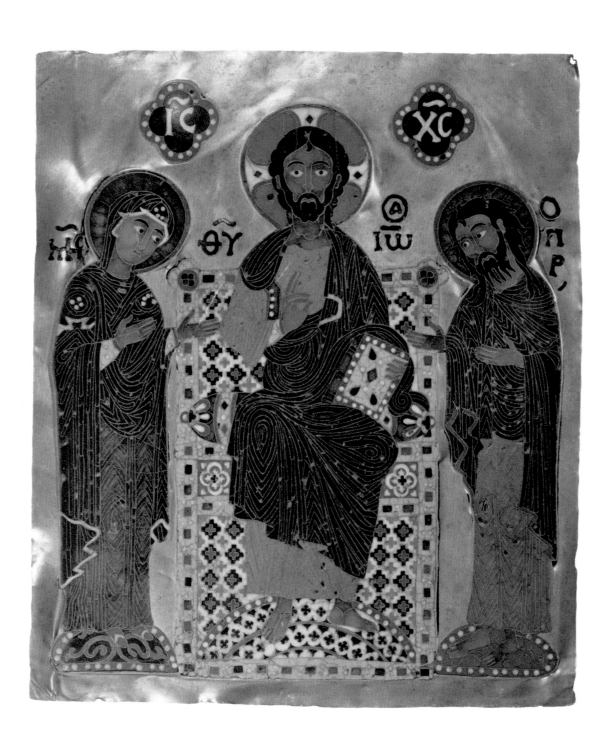

60 *Cloisonné enamel on gold*
Diameter 3¼ inches
Byzantine (Constantinople),
end of XI century
Gift of J. Pierpont Morgan, 1917
Provenance: The monastery church
in Djumati, Georgia (Caucasus)
Ex colls. Alexander Zvenigorodskoi (Russia);
J. Pierpont Morgan

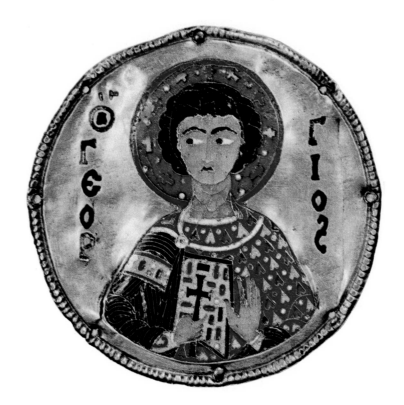

The half-length figure of a youthful St. George is shown full-face, wearing a narrow tunic with richly decorated shoulder bands and cuffs under his cloak. The allover pattern of heart-shaped petals on his red cloak might represent ivy leaves (kissophylla) used on Constantinopolitan textiles of the eleventh century. The fashion starts under Basil II (d. 1025) and develops under Nicephoras Botaniates (1078–1081). Similar leaves decorate the dress of Truth (ALEETHIS) on the Crown of Constantine X Monomachos (1042–1055) in the Budapest Museum, as well as the textiles found in the sarcophagus of Bishop Gunther (d. 1064) in Bamberg. A jeweled tablion (clavus latus) is applied to the front border of St. George's cloak fastened by a small disc fibula at the saint's right shoulder. A white line, possibly a string of pearls, runs from the fibula to the opposite shoulder. The inscription reads: SAINT GEORGE.

In his right hand the saint holds a cross (called a "cypress-wood" cross by Kondakov), either as an attribute of a martyr-saint, or in reference to similar crosses given by the Emperor to high dignitaries at a Byzantine court ceremony on Palm Sunday. The whole attire of the saint is that of a high-ranking patrician and military dignitary of the Byzantine court, indicative of St. George's high standing among the Byzantine saints. He is similarly represented on three roundels (eleventh and twelfth centuries) attached to the Pala d'Oro, St. Mark's, Venice. When the saint is represented as a warrior, he usually wears armor and carries a shield and a spear, or sword. St. George was the protector of the Byzantine Empire and on certain coins is shown with the Emperor supporting a tall cross.

The medallion is one of nine in the

Metropolitan Museum from the silver repoussé icon of the Archangel Gabriel, which was at one time in the monastery church of the Archangels Michael and Gabriel, in Djumati, Georgia (Caucasus). Originally there were twelve in the set decorating the frame of the icon: Christ, the Mother of God, and St. John the Baptist (Deësis group); the Apostles Peter and Paul; the four Evangelists; and three warrior saints: George, Demetrius, and Theodore. In a deplorably dilapidated condition, the icon was removed from the church sometime around 1880. In the following years, eleven enamel roundels (the twelfth had been lost earlier), one by one, came into the collection of Alexander Zvenigorodskoi. Prior to their exhibition in Aachen in 1884, one of the medallions, the St. Theodore, had found its way into the collection of Mikhail P. Botkine (now: National Museum of Fine Arts, Tbilisi, USSR). The whole set was magnificently and thoroughly published by Bock in 1886, by Kondakov in 1892, and by other authors more recently.

Sometime after 1894, the year in which an offer for purchase of the Zvenigorodskoi Collection was refused by the Archeological Institute in St. Petersburg, the ten medallions appeared on the art market in Paris and were sold to J. Pierpont Morgan who gave the St. Demetrius to the Louvre (now shown in the Cluny Museum). The remaining nine medallions came as a gift of J. Pierpont Morgan to the Metropolitan Museum in 1917. They usually are referred to as the Zvenigorodskoi enamels, and not Djumati, to prevent a confusion with another set of enamel roundels from the same monastery but from a different icon—of St. Michael, with an inscription in Georgian, and probably of local workmanship.

A photograph of the icon of St. Gabriel with the medallions in place was made by Ermakov before its removal from the Caucasus. The St. Mark enamel was already lost, and the St. Luke was stuck into a crack in the icon (its present whereabouts is unknown). Neither the negative nor an original print from it could be located in the Tbilisi archives, according to a message from Prof. Tshubinashvili orally transmitted a few years ago. The photograph is published in Kondakov's book of 1892.

Gold in addition to its esthetic appeal possesses certain physical advantages over silver such as pliability, resistance to oxidation, and a higher melting point allowing a wider range of enamel colors with varying melting points. In no other metal could such delicacy in cloisonné be achieved as that on the Zvenigorodskoi medallions.

There are various methods of preparing a gold plaque for cloisonné work. Here the whole area to be decorated is depressed, thus forming a receptacle for the enamels. The sheet of gold is sufficiently heavy to forego the need for backing or other reinforcing. On some of the roundels, edges around the depressed area show occasional cracks, but there is no doubt that each is made of a single piece of gold. The colors are separated by thin, narrow ribbons of gold (cloisons) standing on edge and outlining the design. A rough tracing or sketch of the design in punched, dotted lines, is evident on the back of the depressed area. It served only as a guideline for the enameler, and the final design of the cloisons does not necessarily follow it. The medallions are edged in repoussé "beading" possibly in imitation of strings of seed pearls. Such pearls often surround enamel medallions applied to sumptuous ecclesiastical vessels or rich book covers. Four holes near the border were provided for attachment to the background; the four additional holes, carelessly punched, were probably added at a later date.

The style of the roundels from the St. Gabriel icon, and their extremely fine workmanship, indicate the hand of a metropolitan master. Their date is the end of the eleventh century. The designs of the cloisons still retains the outline quality and has not yet become primarily ornamental, as it does a little later. The silver icon they enriched has been dated variously late eleventh to fourteenth century, according to different interpretations given to its ancient Georgian inscription. The enamels might have come to Georgia from Constantinople, as did other Byzantine objects, as gifts exchanged between two friendly countries. Two examples are: the enamel plaque of about 1075 attached to the icon of Our Lady of Khakuli, Christ Crowning Emperor Michael VII Ducas and his Wife (Maria of Alania, born of a Georgian princess); and the ivory triptych (similar to number 26) brought to Georgia by Helen, a niece of the Byzantine emperor, who married King Bagrad IV about 1030–1032.

62 *Ivory.* H.6⅛, W.5⅛ *inches*
Byzantine, end of the X or early XI century
Gift of J. Pierpont Morgan, 1917
Ex colls. Durillon, Lyons; Chalandon, Paris

In this representation of the Deësis, Christ holds a book in his left hand and blesses with his right; at his sides are the Mother of God and St. John the Baptist, with their arms outstretched in gestures of supplication. The figures are placed between two slender, twisted columnettes which support a projecting openwork canopy of which only small fragments in the shape of leaf forms remain. Busts of archangels with open wings and slightly bent heads occupy the two upper corners above the canopy. Like many other ivories, it could have been used at some time to decorate a bookbinding.

The plaque belongs to a stylistically related series of ivories which Adolph Goldschmidt called the triptych group, because all of the surviving plaques evidently had once been parts of triptychs. Their compositions usually show a tendency toward equilibrium and the desire to overcome a two-dimensional frontality. In the Deësis, the heads of the Virgin and of St. John bend toward Christ and their outstretched hands tend to express their inner feelings. The elongated proportions of the figures are emphasized by flat drapery folds whose verticality is relieved only by an outward flutter of the hem around the ankles of the figures. The sharply drawn faces with elongated eyes and aquiline noses, the hair drawn in separate wavy strands, are details common to the whole series. The desire for realism is further expressed by careful indications of the furry surface of the Baptist's clothing. But all enlivening details also become part of a standardized style peculiar to the triptych group. The ivories belonging to it are products of craftsmen, rather than of creative artists. They were probably made in one of several workshops for wealthy clients without exacting aristocratic tastes. A slightly later group of ivories called Romanos by Goldschmidt were created for more demanding clients. They show many of the characteristics of the triptych group greatly refined.

The choice of subjects within the triptych group is quite limited. Among the surviving pieces, listed by Goldschmidt, the Deësis is repeated at least four times with hardly any variations in detail. The best-known Deësis plaque is in the Treasury of the Hildesheim Cathedral: it has no canopy, and all three figures stand on pedestals; on the plaque in London, only Christ stands elevated. No angels appear in the upper corners on these two. But they are present again, with wings still in place, on the complete triptych from a church in Okona, Georgia (Caucasus). The fourth is the Metropolitan Museum plaque. All have the same composition, following a strictly prescribed scheme.

The ivories of the triptych group date from about the last twenty years of the tenth century and continue into the eleventh century. These dates are supported by those of the bookbindings they decorated, by an inscription added to the panel on the Hildesheim binding (a gift from Bernward), or by historical tradition. Thus, the ivory in Georgia was brought here by Helena, the niece of the Byzantine Emperor, who married King Bagrad IV about 1030–1032.

Deësis in Greek means prayer and in Christian iconography is applied to the composition, characteristically Byzantine and eastern in conception, of Christ with the Virgin Mary and St. John the Baptist at his sides interceding for man. The idea of such intercession probably came into existence in the second half of the fifth century.

After the Council of Ephesus (431) decreed that the Virgin be called the Mother of God, she became in the minds of the faithful an intermediary between her Son and man. Beginning with the end of the fourth century, the importance of St. John's personality increased in a parallel development to monasticism and hermitism.

Written texts on the subject preceded pictorial representations of the Deësis. Ephraim the Syrian (d. 373) mentions the intercession of the Mother of God before Christ. Gregory the Great promoted the veneration of St. John the Baptist. In 602 Agelulf, the Lombard King, dedicated the Cathedral of Turin to Christ, to the Virgin, and to St. John. St. Sophronius of Damascus, Patriarch of Jerusalem (629–638), mentions a dream in which he saw Christ flanked by the Mother of God and St. John the Baptist. In the hymns on the Last Judgment, of about 900, praises are sung to the Mother of God and St. John together with those to Christ and the Holy Trinity. And, the Mother of God and St. John the Baptist are venerated above all the Christian saints.

The earliest representation of a Deësis, not yet a very definite one, is believed to be found in the Manuscript of Cosmas Indicopleustos (MS Vat. no. 699) of about the sixth to the ninth centuries; this particular illumination is probably of the seventh or the eighth century. The Deësis composition later is given the meaning of the Last Judgment—in an abbreviated form.

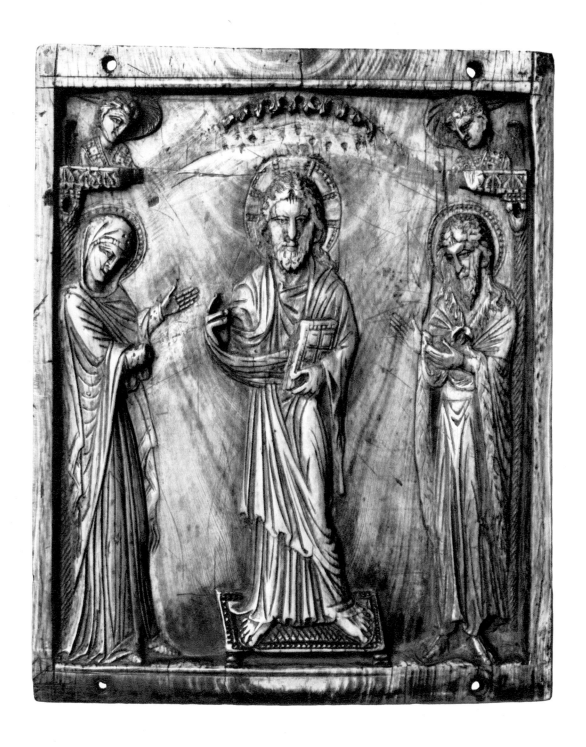

THE MIGRATION PERIOD

66

Bronze and silvered bronze
Diameters 2⅞; 2¾; 2¼ inches
Frankish, end of VI, beginning of VII century
Gift of J. Pierpont Morgan, 1917
Provenance: Northern France

Most of the flat, openwork, disc-shaped plaques found in Frankish and Alemannic burials of the sixth and seventh centuries show a design based on concentric circles connected by spoke-like bars. These bars can radiate from a smaller circle in the center (number 27C), or connect several concentric circles in a variety of manners forming a cross in the center (number 27B). In both cases one can note that the number of radiating bars is divisible by four. Some other openwork discs (number 27A) have three short bars connecting the outer circle to a triskele. (A triskele, or triskelion, is a variation of a swastika which is also encountered on openwork discs, both representing the whirling symbol of the sun, an adaptation of the "solar wheel" with three spokes.) The ends of the triskele are formed in the shape of dragon-like heads of snakes with open mouths. The triskele disc is the only one of the three which has rounded bars rather than flat ones.

After being cast in an openwork pattern, the discs were ornamented on the surface by roughly executed, punched, circle-and-dot prick marks or they have engraved "stepped" designs. In some isolated cases, the discs were silver-plated as was the disc with three concentric circles around a central cross. Except for a few animal forms, the ornaments were usually of purely geometric design, a diversified play of circles and radiating connecting bars very often containing a cross but probably without its Christian connotation.

Most, if not all, of the known openwork discs of the above type were found in graves of women, usually lying near the knee or the shinbone. They must have been worn hanging from the belt, suspended by leather straps or strings. Some of the discs were found framed in metal or bone rings, some of them with an outer small ring for suspension. The actual use or meaning of the discs is not yet known. They are sometimes referred to as "châtelaine" plaques, because one of their suggested uses was for the suspension of implements or possessions of their owners. Some scholars give them a symbolic meaning, others think that their purpose was purely ornamental.

Their distribution is limited to the Rhineland (from the Netherlands to South Germany) and to northeast France, and to Frankish and Alemannic graves of about 500 to 600. The main flowering of these discs seems to be in the second half of the sixth and, possibly, early seventh century. But in isolated locations and very limited numbers, they are also found in the graves on Burgundian grounds and in Thuringia. The Alemans settled first in the Main region and moving later to the Rhine and the territory of present Württemberg, remained in close contact with the Franks. Alemannic objects date up to the seventh century, but their style is often almost undistinguishable from the Frankish. The Thuringian objects are similar to the Alemannic ones. (For a discussion of the Franks see number 31.)

A subdivision of openwork discs with human figures, mostly riders, are encountered in the finds in northeastern France, in Belgium, and in the Rhineland; those with riders carrying spears (sometimes identified as the Germanic god Wotan) are restricted to Alemannic finds in southern Germany and Switzerland. A Coptic derivation has been suggested by Herbert Kühn for the pattern of riders holding a spear. But whether the Coptic influence was reaching the Germanic tribes in western Europe directly, or through the Langobards, has not been definitely established. It is also possible that the Copts, as well as the Frankish and other Germanic tribes in western Europe, were influenced by a common source somewhere farther east.

The above discs, and most of the other pieces of the migration period, from the Metropolitan Museum, are part of the most comprehensive collection of this material in the United States. The collection was a part of the very important group of medieval objects which came to the Museum as a gift of J. Pierpont Morgan in 1917. Many of the Frankish (or "Merovingian" objects as they are sometimes called) as well as those which belonged to other Germanic tribes, were bought by Mr. Morgan from Stanislas Baron, a dealer and former wine merchant who gathered the finest objects available from the many Frankish finds in the north of France. Another group of objects had belonged at one time to a postmaster named Queckenberg who excavated a large Frankish cemetery near Niederbreisig, on the west bank of the Rhine between Koblenz and Bonn. After the latter's death, the objects he discovered were offered for sale and Mr. Morgan bought an important part of them. Another is at present in the Mainz Museum.

The Museum collection of migration material was very summarily catalogued by Herbert Kühn in the 1930's; certain pieces have been studied individually by other scholars from time to time. At present, Stephen Foltiny is entrusted with a completely new and final re-cataloguing of all these objects.

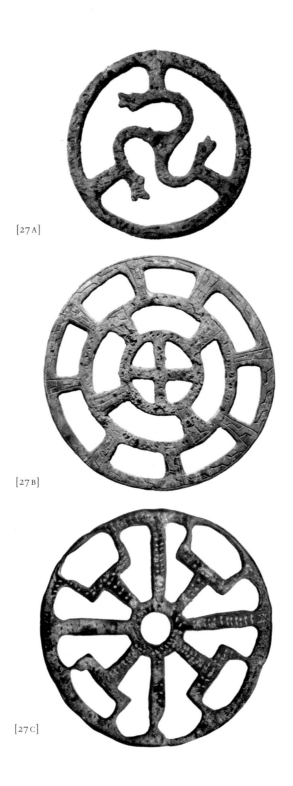

[27 A]

[27 B]

[27 C]

68　*Gold leaf over silver core, and jewels*
L. 6¾ inches
Ponto-Gothic type, late IV or V century
Fletcher Fund, 1947
Ex coll. R. Martins Reay,
Brooklyn, New York
Provenance: Possibly Transylvania
(Szilágy-Somlyó?)

This fibula (pin), with its head and foot plates connected by an arched bow, has a silver core covered with heavy gold leaf on the front side. Only fragments remain of a double-spiral spring coil of the pin proper which originally was attached to its back. On the obverse, the fibula is decorated with cabochons of almandines, or garnets, each box setting surrounded by a thin hatched wire; a heavier hatched wire outlines the borders.

Fibulae of this type, decorated with almandines, either cabochons or flat plaquettes, in settings or cloisons, are found mostly in Hungary and in South Russia, but have also been encountered as far west as Airan in Normandy where they probably were imported from the two regions mentioned. The workmanship is believed to be of Greco-Hellenistic derivation mixed with influences of Sarmatian taste. The closest parallels are the fibulae of the Second Szylágy-Somlyó Treasure from Transylvania in the National Archeological Museum of Budapest. The latter were formerly dated in the late fourth century on the basis of coins found with them, none of which was later than 383 (Gratian). At present the dating has been moved by certain scholars into the beginning and even into the second half of the fifth century.

The question has been raised lately as to whether the treasures of Szilágy-Somlyó could have belonged not to Goths, as believed earlier, but to Vandals. No definite conclusion has been reached as yet on this point. Such variability in attribution of the so-called Barbaric, or Migration, material of the pre-Carolingian period is due to the scarcity of documentation.

Bow fibulae were often worn in pairs, attached to the two borders of the mantle near the neck and connected by a chain. Several of such pairs have come from tombs of women.

According to recent non-official information a pair of fibulae of a very similar style has been excavated in Hungary.

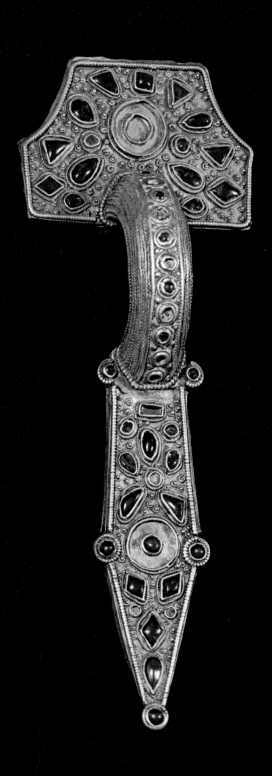

70　*Glass.* H. *2½, Diameter 3⅛ inches;*
H. 2¾, Diameter about 4 inches
Frankish, V–VII century
Gift of J. Pierpont Morgan, 1917

These low glass cups are representative of the two types usually found in Frankish burials. The short, almost hemispherical cup or beaker has a thin rim bent outward, a very slight squeeze at the neck, and a convex body. The bottom of the cup has a shallow "kick" (depression) which forms a base. There is no trace of a foot ring. Blown of pale, yellowish-green bubbly glass, it shows irregular spiral striations due to the uneven distribution of the glass mass during its manufacture.

The second cup has an inverted conical shape, a hollow tubular rim formed by folding the lip outward and downward, and a sharply convex bottom without a base ring which makes it impossible for the cup to stand by itself. As it was held in the palm of the hand, it is often called a palm cup. The glass shows beautiful iridescence.

The shapes of the cups derive from Roman prototypes, for Frankish glass is a direct, if inferior, continuation of a craft introduced into western and northern Europe by the Romans. Although it was imported from the south, glass was known and highly valued in prehistoric central and northern Europe as early as 1000 B.C. The early Romans north of the Alps also had to import glass vessels. Gustavus Eisen suggests an Italian source (bubble-blown glass may have been invented in Italy). Glassmakers' workshops were started in Gaul and later in the Rhineland, where the first artisans from Gaul settled in Trier, Worms, and Cologne about the middle of the first century. It was here, especially in the Cologne region, that they found sites which could supply the material necessary for glass making: potash obtained from wood and a certain type of sand. Remains of their workshops have also been found in Belgium and in the Netherlands. These shops soon started competing with those of Syria and Italy, making further imports unnecessary, and the superior Cologne glass was even exported.

Roman glass was made until about 400 and attained its height in the fourth century. But when the Roman armies withdrew provincial Roman culture suffered a setback; Germanic tribes pushing west beyond the Rhine destroyed much of the Roman inheritance and with it the glassblowers' workshops. It is believed that many artisans migrated to Gaul and Belgium.

Many finds of Roman glass have been made in Belgium and the southern Netherlands as well as in Gaul; those in the Cologne region are especially numerous. Early Christian glass has also been found in the Cologne region, including painted and gold glass ("fondi d'oro", cf. numbers 2 and 3) which evidently were made here as well as in Rome at that time.

Frankish glass declines steadily in quality in the period from about 400 to 700 despite the fact that Frankish jewelry is quite remarkable. The deterioration in quality is accompanied by a marked reduction in number and variety. This was due to the changing demands of new masters, as well as to the decline in craftsmanship. The need in the Rhineland for glass vessels in Frankish times was evidently felt; records have been found showing that efforts were made to import skilled glass blowers who could make "vasa vitrea" from Gaul and Britain.

Of all the rich variety of glass, only simple beakers and plain bottle shapes remain. The two cups shown here are representative examples. Most of the surviving Frankish glass dates from the fifth or sixth centuries, and very little of it can be attributed with certainty to the seventh or eighth centuries.

[29 A]

[29 B]

30 Belt Buckle

72 *Bronze. L. 5⅛ inches*
 Ostrogothic, V–VII century
 Administrative Funds, 1895

This bronze belt buckle has a rectangular moulded plaque with a profile of a head and neck of a bird of prey projecting at one end. The bronze was originally gilt. The eye of the bird is inlaid with a small cabochon of red stone or glass paste; similar cabochons decorate the four corners and the center of the rectangular plaque. The surface of the latter is decorated with a geometrical design of scrolls and double scrolls, cast in imitation of the provincial Roman technique of chip carving. The tongue is fashioned in the shape of a bird's beak and ends in a diminutive bird's head.

The belt buckle is Ostrogothic, dated in the fifth to seventh centuries. The Goths, a group of barbarian tribes, came down from southern Scandinavia to the southern shores of the Baltic Sea sometime in the first century and appeared about 230 in Scythia—the southern plains of today's Russia. The Visigoths (Western Goths), or Terwingi, settled west of the "river" (Dnieper) up to the Danube, the Roman frontier; while the Ostrogoths (Eastern Goths), or Greutungi, occupied the plains east of the Dnieper River, spreading almost as far as the Caucasus. From the earlier settlers of the region, the Scytho-Sarmatians, and from the goldsmith shops in the Greek colonial towns on the northern shores of the Black Sea (such as Kertch, the ancient Panticapeon) the Goths learned the use of fine jewelry and stone inlay. As noted above, they also imitated such provincial Roman techniques as chip carving.

When the Huns invaded the southern plains in 374, most of the Goths, especially the Visigoths, were pushed west; they had to ask for admission into east Roman provinces on the Balkans. Later they moved farther west and finally settled in northern Spain. Part of the Ostrogoths, after the suicide of their king Hermanaric, remained under Hunnic domination. Some Ostrogoths invaded Italy in the fifth century, where Theodoric made Ravenna his capital, only to be pushed out of Italy by later arrivals—the Langobards—in 568.

Some of the Ostrogoths did not move west but retreated to the Crimean peninsula, where they remained until the eighth or ninth century. It is primarily in the Crimea that one finds belt buckles comparable to the one shown here. Their characteristics are well represented by this one: the usually rectangular plaque, the oval loop, and a beak-shaped, hook-like tongue; the decoration which includes a cast geometric design of chip-carving type, stone inlay limited to a few small settings, and an increase in the use of the so-called animal-style—feline and birds' heads—probably inherited from the east. Some belt buckles are hammered in silver, others are cast in bronze.

The closest comparisons are a belt buckle from Kertch in the Ashmolean Museum, Oxford, England, and two other buckles, from Gursuf (Crimea) and Nikopol (eastern part of southern Russia), all three dated in the fifth to seventh centuries.

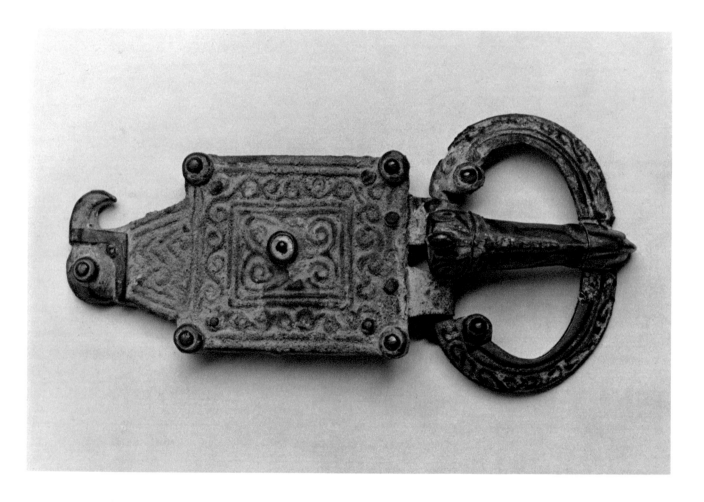

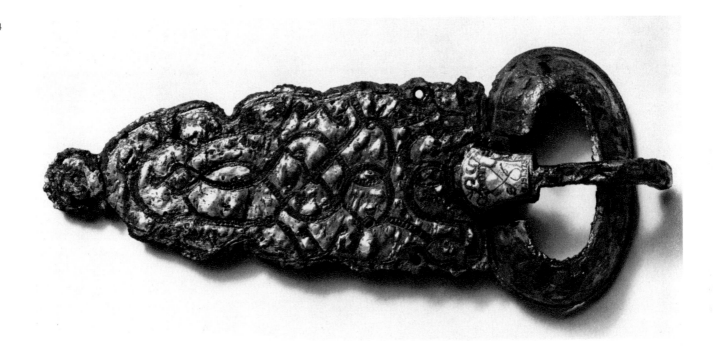

Iron, latten, and silver. L.8¾ inches
Frankish, VII century
Gift of J. Pierpont Morgan, 1917

The decoration on this large iron belt buckle consists of an interlace design executed in latten (a brass-like copper alloy) inlay against a background of silver-foil plating. A complete set of belt furnishings of this type usually consists of the actual buckle with the plate, like the present example, another identical counter plate (without a loop) for the opposite end of the belt, and a smaller squarish plate, sometimes referred to as dorsal. Such large buckles were made for wide, heavy leather belts, probably of the "balteus" type, from which a sword was suspended. It has been established from finds in burials that women also wore wide belts with similar iron buckles.

Buckles with damascening (metal inlay decoration) are found as costume accessories in great numbers in Frankish burials as far west of the Rhine as Paris and in northern France, as well as in graves of the Burgundians in southern Germany, Switzerland, and Savoy. Nevertheless, the information about them does not suffice to establish their chronological development, although one can say that they appear in the sixth century, and that belt buckles with very long plates and shields at the base of the tongues belong to the seventh and eighth centuries—when the buckles and plates become enormous in size.

Edouard Salin, author of the most thorough study of Frankish ironwork, feels that these iron belt buckles basically do not belong either to the Germanic or to the Roman tradition, but derive, as does their ornamentation, directly or indirectly from Pontine (a Black Sea region) and Mediterranean imports and, possibly, depend on influences coming steadily in the fifth to eighth centuries from certain cultures of the eastern steppes. The abstract ornament on the buckles is combined with the animal style which tends to be absorbed into their decorative pattern beginning about 600. The animal style includes interlaced dragons and helps support Salin's theory. Abstract interlace designs could well stem from Coptic Egypt, as a design identical with the hatched latten inlay on the interlace of this buckle can be seen on Coptic textiles. The theory of Coptic influence is supported by the identification of several Christian subjects of Coptic origin found on other Burgundian artifacts.

Decoration of inlaid metal on metal is sometimes referred to as damascening because the technique was used and made famous in Damascus, Syria. Actually, inlaying metal surfaces with another kind of metal had been practiced for centuries in the ancient Far and Near East (as early as 1450–1365 B.C. for the Mesopotamian bronze axe with gold inlay from Ugarti, in the Aleppo Museum). The technique consists of cutting a deep groove with a sharp instrument in the basic metal, fitting a strip or wire of another metal into the groove, and hammering it down, so that it is held firmly in the groove. Salin believes that the art of damascening in western Europe could be of Syrian origin, probably brought to Gaul by the *barbaricarii* during the Roman occupation.

The technique of plating with a sheet of silver foil, as described by Salin, consists of roughening and scoring the surface of the iron and then hammering the silver foil onto it, which usually forms the background for the inlaid pattern. On some iron buckles one can see the roughness of the iron through the silver foil now worn thin. The decoration of the buckles usually includes latten bosses or knobs—heads of the rivets which fasten the metal plates to the leather of the belt. On this particular belt buckle the bosses are missing, but one can see two holes left for the rivets as well as traces of the third boss.

The Franks, originally a confederation of several tribes, were settled on both sides of the Rhine, along the Roman Limes. After the departure of the Roman armies early in the fifth century, they moved west under their ruler Merovig, who gave the name Merovingians to a whole dynasty, which included such outstanding Frankish kings as Childeric (d. 481) and Clovis (d. 511). Charles Martel (d. 747) crushed the Saracens at Poitiers in 732, saving Christian civilization and the West from Moslem subjugation. He was followed by his grandson Charlemagne (742–814), who became emperor and with whom the Carolingian period begins.

The Burgundians came from the northeast to the southern Rhineland during the fourth and fifth centuries and ruled in southeastern France and present-day Switzerland until the tenth century. Their most important objects are datable in the seventh century and denote close contact with Byzantium and with eastern Mediterranean regions, including Coptic Egypt. The Epic of the Nibelungen was created around the history of the Burgundians, and they gave their name to the land later ruled by the French Dukes of Burgundy.

76 *Silver over bronze, and glass paste*
Diameters $^{13}/_{16}$ *and* ¾ *inches*
Frankish, VI century
Gift of J. Pierpont Morgan, 1917
Provenance: Northern France

[32 A] [32 B]

Fibulae were in wide use throughout the Merovingian period (about the fourth to the mid-eighth centuries) and have been found in great numbers and in a variety of shapes and sizes in burials in northern France and western Germany. Originating in ancient times primarily for use as pins to fasten articles of clothing such as cloaks or mantles, they soon became definitely ornamental. Whether the Frankish ones were bow-shaped, similar to those used by other Germanic peoples (see number 28), s-shaped, disc-shaped as these fibulae are, or were given animal shapes their makers tried to emphasize their decorative value.

The flat Frankish disc fibulae with their faces completely covered by cloisonné inlay, are of the type sometimes referred to as "buttons" because of their small size. Nevertheless, they are pins or brooches. The round fibula shown here is built over a bronze core on the back of which can still be seen the remains of a coil pin. The bronze is overlaid with silver; the cloisons radiating from a small central circle and dividing the face of the brooch into eight compartments are also of silver. The sections between the cloisons are inlaid with triangular pieces of red glass (or glass paste) imitating the semiprecious stones, almandines or garnets,

found on richer fibulae. A sheet of foil, placed between the bronze core and the glass inlay, reflects the light which passes through the glass and adds brilliance to the latter. The small central circle probably contained a bead of colored glass or silver, or a chip of mother-of-pearl.

The rosette-shaped disc fibula is almost exactly the same size as the preceding one. The eight petal-shaped pieces of red glass-paste inlay here surround a central bead of blue glass. Other rosette fibulae of comparable shape have a pearl in the center, or a mother-of-pearl chip, or additional colored glass cloisonné inlay. The rosette-shaped fibulae are thought to be a development from the round ones and to be slightly later in date, although both are of the sixth century. This piece is from the collection of Stanislas Baron, the wine merchant who became a collector of Frankish antiquities from his native part of northeastern France. In general, Frankish disc fibulae of this type date from the second half of the fifth and the first half and middle of the sixth centuries. They are found throughout northeastern France, while their distribution extends through the north of France and into western Germany.

It is believed that cloisonné inlay of

stones started in India and was brought to Europe by the Sarmatians when they occupied southern Russia. There it was practiced later by the Goths, who possibly carried it to western and northwestern Europe in their migrations. Surfaces completely decorated with a mosaic of cloisonné glass or garnets appear on disc fibulae in about the fifth century, and on the Frankish pins from the second half of the fifth century. The cloisons become progressively thinner and less significant, while the rosette shape joins the round one by the mid-sixth century.

The design of abstract ornamentation on certain objects of this period allows several manners of reading (sometimes designated as positive and negative) according to which part of the decoration one identifies as the main design and which part as background. In the case of the two small disc fibulae discussed above, with inlay between eight cloisons, the design may be read as a star or rosette, or as two superimposed crosses with splayed ends.

Gold on bronze, and glass paste
Diameter $1^{13}/_{16}$ inches
Frankish, about 550–650
Gift of J. Pierpont Morgan, 1917
Ex coll. Stanislas Baron, Paris
Provenance: Northern France

The bronze core of this fibula is covered by a rosette-shaped raised gold boss with slanting sides, made by hammering a sheet of gold into a form. The front surface of the boss is studded with nine imitation jewels of colored glass and decorated with applied ornaments of gold wire filigree. The spiral pin, formerly attached to the back of the bronze core, is missing.

This disc fibula belongs to a type which differs from that of the two preceding examples—their faces completely covered with cloisonné inlay—by its decoration of filigree wire and stones or glass in box settings. On fibulae of this type there is always a central accent like a boss on a shield. The French sometimes refer to them as "umbo-type" fibulae. The rest of the ornament is based on a symmetrically radiating pattern. In this case it consists of eight settings arranged in a circle, corresponding to the eight scallops of the rosette. Four triangular settings of brownish paste create the effect of a cross. The surface between the settings is covered with filigree wire

twisted into various shapes, including the double volute, or pelta. Every design decision is calculated to heighten the effect produced by the play of light on gold and color.

Fibulae of this type were common about 600. Most are round or rosette shaped, with some quadrilobed ones appearing a little later. Their abstract decoration remains orderly, in contrast to the restless decoration deriving from debased animal forms encountered on objects used by Germanic tribes in western Europe. Some of the larger gold disc fibulae are famous for their beauty and workmanship, and foreshadow the more sumptuous and elaborate Carolingian brooches.

It is believed that such fibulae were made by local silversmiths. One of them—St. Eligius (d. 660)—is well known. These Merovingian silversmiths, usually moneyers at the same time, must have lived near the palace of the king and worked for the king and the church. The moneyer, who struck the coins, was probably the head of the workshop.

Most fibulae of this type are Frankish or Frankish-Burgundian, found in the Rhineland, present-day Belgium, Luxemburg, and northeast France, or in the Burgundian region of western Switzerland. For the most part their datings are within the Merovingian period. Marked changes take place in design and technique in Carolingian times: the use of filigree is reduced, and the stone settings become richer. Frankish round fibulae deriving ultimately from earlier provincial Roman ones appear about the third quarter of the sixth century. In the course of the seventh century, the decoration becomes poorer—stones are replaced by pastes or glass of various colors. In time, the filigree becomes more and more degenerate and pressed or stamped relief appears on the ornament.

Two closely related fibulae, one from Gersheim, now in the Speyer Museum, and another dated in the seventh century from northern France, formerly in the Berlin Museum für Vor- und Frühgeschichte, may be compared with this piece.

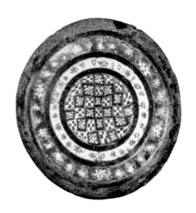

Bronze, glass, and enamel
Diameter 1¾ inches
Provincial-Roman or Gallic, II–III century
Rogers Fund, 1966

78

This roundel may have been a fibula of some kind or it may have been a decoration on the top of another object. Françoise Henry states that fibulae from the region of Dinant, Belgium, were sometimes fitted with a shank such as the projection on the back of this piece.

The decoration on the slightly raised boss (about one-eighth of an inch high) is incorrectly designated "millefiori enamel". In fact, it is not the usual enamel made of a powdered glass-like substance which melts at a certain temperature, but is produced by a special combination of techniques. The millefiori pattern is achieved by clustering glass rods of various colors in a chosen order and fusing them together. Later, the bunches of glass rods are cut into thin slices and the resultant cross section suggests a checkerboard or star-shaped pattern. These sections, in turn, are arranged and combined to form a more extensive design. They are then placed in the desired order in a scooped out depression in the bronze which has been previously lined with a thin layer of the powdered material used to make true champlevé enamel. When the latter is

heated to its melting point, a temperature lower than the melting point of the glass rods, it fuses the millefiori decoration permanently to the bronze and fills the empty interstices. The two concentric rings surrounding the central medallion were evidently made by dropping the small crosscuts of glass rod clusters onto the powdered enamel substance, lining the depression in bronze and filling the spaces between the glass crosscuts as well, before the firing process. The result is a combination of millefiori inlay and champlevé enamel.

The piece is similar to the top of a bronze pyx in the Metropolitan Museum. A similar disc fibula labeled Cologne, second century, was seen in the Römisch-Germanisches Museum, Cologne, by Katharine Brown. Although its colors differ, the basic system of the decoration is very similar. Numerous other roundels could be listed. Many comparable objects of the period with millefiori inlay, or with champlevé enamel are called Gallo-Roman and come from Belgium.

While enameled fibulae are found in graves throughout the outer regions of the

Roman world, from Britain to the Caucasus and Syria, the largest concentration of the finds and the greatest number of these fibulae are centered in Belgium, between the Sambre and Meuse rivers, and in the Rhineland. Enamel on bronze enjoyed great popularity in Gaul as well.

Remains of an enamel and metal workshop have been discovered not far from Dinant. Others might have existed in Mainz, Trier, and Cologne. A few similar enameled bronzes have been found in southern Russia and in the Danube provinces. These fibulae might have been worn both by the Roman legionaires and the native population of the border provinces.

Millefiori glass decoration found in combination with champlevé enamel, but not the true enamel itself, was probably introduced into Gaul from southeastern countries soon after the Roman conquest. At that time the Romans introduced the glass industry into Gaul and with it the knowledge of the "millefiori enamel" technique. The rods themselves are believed to have been imported into Gaul from Italy and Alexandria (Egypt).

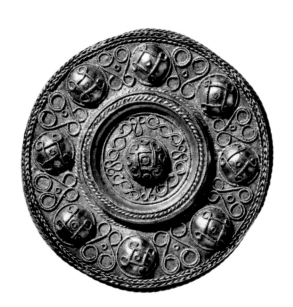

Gold. Diameter 3 inches
Langobardic, mid-VI–VII century
Dick Fund, 1952
Ex coll. Sieck, Munich

This is believed to be the face of a gold disc fibula, originally with a silver core bearing a pin; the core and the pin are missing. The decoration consists only of repoussé and various gold wire (filigree) ornaments without the addition of colored inlay or jewels. The effect is achieved exclusively by the play of light and shadow on various reflective surfaces of pure gold.

The central repoussé boss and the eight bosses forming a concentric ring along the border of the disc are separated by a raised semi-cylindrical ridge. The whole structure of the decoration is clearly defined and built up symmetrically around the central umbo-like motif. Each boss is ornamented by applied filigree wires twisted in the shapes of spiraled squares and circles, those on the central boss made more prominent by the use of double wire and an increased number of small circles. s-shaped scrolls of filigree wire arranged in lyre shapes and small circles fill the spaces between the outer bosses. Filigree wire forming patterns of lyre shapes and interlaces surround the central boss. Heavy twisted wires, accompanied by thinner ones, decorate and outline the raised ridge. Twisted and plaited

wires form a border at the edge of the disc.

The decoration appears to be similar on several Langobardic disc fibulae found in burials at Castel Trosino in Umbria, Italy. On some of the latter fibulae one finds a restricted use of colored stone or glass in the form of cloisonné inlay.

As a rule, the exclusive use of gold in Langobardic jewelry is more widespread than in any other contemporary jewelry with the possible exception of that from Byzantium. Influences from the east Mediterranean regions and from Byzantium are more evident than in other Germanic metalwork. It has even been suggested that Byzantine influence in general was reaching the Frankish regions through the Langobards, but this is being questioned at present.

Langobardic disc fibulae of this type appear to have a definite relation to discs found in earlier cultures. One can compare them to certain falerae or ornamental discs such as the silver ones from the Thorsberg Moor finds. These are dated in the third century, and were probably worn by West Roman warriors. These discs have a central openwork medallion in which the larger central boss is surrounded by nine smaller

ones, each with a human head in repoussé (J. Werner calls them "medusa" heads). These in turn probably go back to the Celtic discs found in Gaul decorated with a circle of nine heads, the so-called Gallic *Têtes coupées* also seen on the silver disc in the Museo Romano, Brescia. One must also mention the so-called gold sun discs found both in Germany and in Celtic Ireland, as well as discs from Irish gorgets of the Bronze Age. They too are decorated with a central boss, concentric circles, and an outer ring of bosses, an arrangement that can also be found in the ancient Near East.

The Langobards came from the lower Elbe region to Hungary and Bohemia in the fourth century, but did not become prominent in art history until they invaded Italy in 568. Their individuality, strongly penetrated by Byzantine influence from the East Roman regions, is evident through the seventh century. They were annihilated by Charlemagne in 774, and ceased to exist as a kingdom. Lombardy derives its name from the Langobards, and the pre-Romanesque Lombard style carries on some of their artistic traditions.

ROMANESQUE ART

Ivory. 9 ¼ × 5 ⅜ inches
North Italian (Dalmatian?), XI century (?)
Gift of J. Pierpont Morgan, 1917

82

The Lamb of God (Agnus Dei) framed by a wreath is placed in the center of the cross. Between the arms of the cross are four anthropomorphic symbols of the evangelists: the angel of St. Matthew, the lion of St. Mark, the ox of St. Luke, and the eagle of St. John. The representation of the four symbols is based either, as in this case, on the words of St. John in the Apocalypse (Rev. 4:6), or on those of Ezekiel (1:10). The lamb symbolizes Christ, adored by Early Christians *"sub specie agni"* in accordance with the words of St. John the Baptist (John 1:29): "Behold the Lamb of God, which taketh away the sins of the world."

The Lamb has a plain halo and no attributes. Its head is up and its front left leg is raised as if to step forward, or as if to support a cruciferous staff. Each of the four evangelists has wings and holds a book, the angel's held in veiled hands. Each wing top is accented by an ornamental design. The books of the angel and the eagle are diagonally crosshatched and their haloes outlined with a circle-and-dot design; the books of the lion and the ox are similarly patterned, while their haloes, like the Lamb's, are outlined by a double line. Such diagonal contraposto is frequent in Coptic decorative systems.

It is believed that the plaque was intended to decorate a book cover and that the holes, probably filled with ivory plugs, were for its attachment. The ivory has no frame; its edges were probably enclosed by the metal of the book cover.

The Lamb or Christ in Majesty surrounded by the symbols of the evangelists is often found on book covers, especially Evangeliaries; it also occurs on plaques of portable altars. In manuscript illuminations Christ in Majesty usually occupies the center. The idea of surrounding a cross with the symbols of the evangelists may derive from an earlier composition of a cross with rosettes, stars, birds, animals, or plants in the spaces between the arms. The representation of the Lamb as Christ is of Early Christian origin, from a time when it was considered improper to represent Christ in human form. The use of symbols might also have been prompted by the period of iconoclasm in Byzantium.

The style of the carving evolved from a combination of influences: the so-called Lombard or North-Italian style (cf. number 35) which included classical elements, Byzantine elements incorporating contributions from the eastern Mediterranean world, and elements of abstract Germanic and the more primitive Coptic art. The fusion of these various elements achieves its highest point in Carolingian times.

The crisp carving of the Agnus Dei plaque is not unlike that of contemporary or slightly earlier North-Italian ivories or stucco decorations. The ornament on the horizontal arms is similar to a frieze at Sta. Maria del Valle in Cividale. It is also related to a ciborium in S. Giorgio at Valpolicella decorated with rope borders popular in Lombard decorative carvings of the seventh to tenth centuries. A pattern related to the ornaments on the vertical arms is found on a Coptic wood carving in the Berlin Museum.

The shape of the cross with splayed ends includes elements found on eighth- to tenth-century crosses from Ravenna and Rome. The same details are found on a cross of 830, on a fragment of a transenna from the former church of St. Aurelius in the monastery of Hirsau (Württemberg Museum, Stuttgart). The latter is called Carolingian, a rare example of northern carving which derived from North-Italian prototypes.

In northern Dalmatia, where influences from northern and central Italy were strong in this period, one finds an eleventh-century transenna with a related composition, an enthroned Virgin and Child surrounded by the symbols of the evangelists. The decoration on the tops of the wings of the angel and the eagle is almost identical to that on the ivory. It may be that such decoration derives from Byzantine examples which in turn follow those from the Near East. Ivo Petricioli lists the characteristics of Dalmatian pre-Romanesque carvings: "weak relief... the lambs... having rounded muzzles, and thick necks with two transversal parallel lines... wings decorated with a border, showing the influence of oriental textiles." All these statements could be made also for the Museum ivory plaque. An interesting parallel is found in a manuscript, Gospels written in 754 by Gundohinus, probably near Luxeuil (Autun Municipal Library, MS. 3, Fol. 12-v). Here Christ in Majesty is seated within a wreath of imbricated leaves, and the symbols of the evangelists are placed in the same order as on the ivory plaque. In the opinion of J. Porcher, the manuscript's iconography and style derive from North Italy. It could be that the Autun manuscript and the Museum ivory both have some important, but now unknown North-Italian or Langobardic prototype.

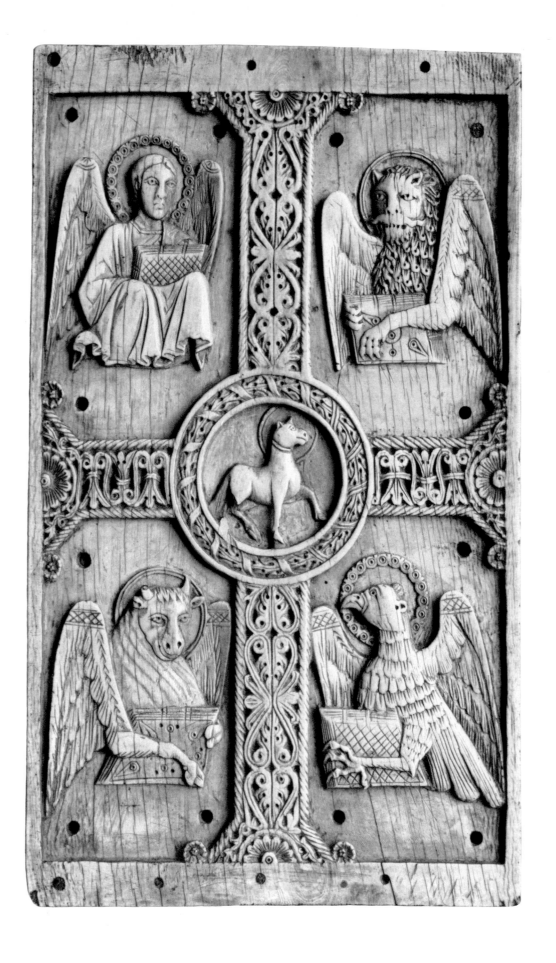

84 *White marble. H.15, W.14 inches*
French (Roussillon),
second half of the XII century
The Cloisters Collection, Purchase 1925
Provenance: Abbey of St.Michael and
St.Germain, Cuxa (Pyrénées-Orientales)
Ex coll. George Grey Barnard

The bell-shaped capital is surrounded by two rows of highly stylized acanthus leaves surmounted by confronted volutes under the projecting corners of the abacus. Flower bosses are placed under the volutes, and at the concave centers of the abacus are bosses of various shapes. This type of capital is a derivation from the Roman Corinthian order, and the arrangement of two rows of leaves follows the classical example. The leaves have lost the realism of the classical acanthus, and are composed of row upon row of parallel sharp ridges.

All of the capitals coming from the cloister of the Cuxa Abbey are vigorously carved; the planes are simple and clearly defined, creating a play of light and shadow. The architectonic arrangement of decorative motifs creates strong support at the corners of the capital for the abacus block above. Each decorative element is carefully built upon the one below it in order to provide a unified structural transition from shaft to abacus. The stone came from quarries between Ria and Villefranche, Languedoc.

The ancient Benedictine monastery of St-Michel de Cuxa near Prades at the foot of Mount Canigou was in Romanesque times one of the most important abbeys of southern France and northern Spain. In the course of the eleventh and twelfth centuries it assumed a position of superiority over the religious and artistic life of what is now the province of Roussillon in France. Important sculptural elements of this abbey were salvaged from possible destruction when they were brought to the United States by George Grey Barnard. Numerous elements from Cuxa have been erected at The Cloisters as an ensemble known as the "Cuxa Cloister." Some of the capitals from the Cuxa Cloister are fashioned in simplest block forms; others are carved with stout acanthus leaves or rinceaux with a central motif of rosettes, pine cones, and heads of various types. The figurative capitals are cut in a wide variety of fanciful motifs. The capitals of Cuxa are closely related to similar elements at the nearby church of Serrabona consecrated in 1151.

St-Michel de Cuxa was founded in 878 when the Benedictines abandoned the monastery of St-André d'Exalada in Haut Conflent destroyed by a disastrous flood the year before. At the suggestion of Charles the Bold the Abbot of Cuxa placed his "fifty monks and twenty servants, his already numerous lands, the thirty volumes of his library, and his five hundred sheep, fifty mares, forty pigs, two horses, five donkeys, twenty oxen, and one hundred other large animals with horns" under the protection of Count Miron, first of the counts of Conflent and Cerdagne. Under this auspicious patronage the monastery was finished in 883, and dedicated to the archangel Michael, the favorite saint of a great patron of Cuxa, Count Sénioford of Cerdagne, and to St.Germain, titular saint of the earlier church. In time Michael became the sole patron saint. The cloister of Cuxa was built shortly before the middle of the twelfth century, and might date within the years 1130–1145. In any event it would have been finished before 1188.

The monastery was sacked in 1654 by the troops of the local count, and after many subsequent years of despair, the monks in 1791 fled the abbey. In 1835 the roof of the deserted church collapsed. Finally the monastery was sold in three parts to several inhabitants of the region. Ten of the cloister arcades were removed to a bathing establishment at Prades and most of the other stonework was dispersed throughout the countryside. In addition to the considerable number of capitals at The Cloisters, two are in the Louvre collections, one is in the Boston Museum of Fine Arts, and a fourth is in the Pitcairn Collection at Bryn Athyn, Pennsylvania. A partial reconstruction of the cloister of Cuxa is being attempted *in situ,* and the problem of the distribution of capitals within it is a subject of important studies in France at present.

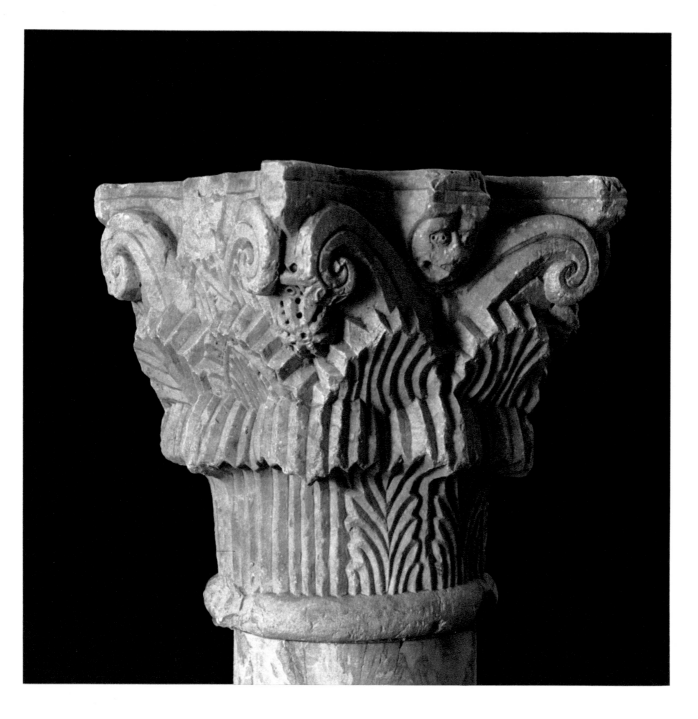

86 *Cloisonné enamel on copper gilt*
4⅞ × 3⅛ inches
French, late XI or early XII century
Gift of J. Pierpont Morgan, 1917
Ex colls. Bardac, Hoentschel

This plaque, probably part of a portable altar or book cover, represents Christ in Majesty flanked by Alpha and Omega. This scene illustrates the text of the Apocalypse (Rev. 1:8): "I am Alpha and Omega, the beginning and the ending, saith the Lord, which is, and which was and which is to come, the Almighty." In accordance with this text, Christ in Majesty enthroned represents the Lord of the Last Judgment, called in Greek Christ *Pantokrator* or Ruler of the Universe. Christ has a cruciferous halo, and his right hand is raised in the gesture of speech while his left holds a closed book. His bare feet rest on a raised platform.

The lozenge-shaped enamel is executed in cloisonné technique on copper. Although some twelfth-century Mosan and Rhenish examples of copper enamel show the combination of cloisonné and champlevé, it is unusual to find cloisonné by itself. (Cloisonné may indicate Byzantine inspiration.) The style of the plaque is unrefined. The disproportionately large hands are an early Romanesque peculiarity and were probably a barbaric (possibly Visigothic) inheritance. The hieratic posture of Christ shows Byzantine influence, often apparent in Visigothic works of art. Drapery folds on the upper part of the tunic and over Christ's left leg are indicated by V-shaped cloisons,

used extensively in Byzantium. The choice of sophisticated tints, in preference to primary colors, is rather unusual. The reds are cinnabar or brick-hued; the greens are brilliant, especially when used against extremely dark backgrounds. The nimbus of Christ is emerald-green with a red cross. His tunic is peacock-green and his mantle a very dark blue. The book in Christ's hand and the platform under his feet are red. The flesh tones are almost white and his long hair is pitch black. Scattered over the background are bicolored decorative roundels.

A roundel in the Metropolitan Museum with the Latin inscription LVNA is closely related by style and color to the Christ in Majesty. The personified bust of the moon with a crescent in her hair is placed in a chariot drawn by lions and panthers. The composition is evidently derived from pagan Near Eastern examples. (See the Coptic textile, *Head of the Goddess Luna,* number 16).

O. K. Werckmeister, in a study of the pre-Carolingian figure style draws parallels between Spanish Visigothic figures in sculpture and the miniatures of the *Beatus Manuscripts.* The latter in his opinion serve as models for the sculptures, and the manuscript illuminations derive from "North African" (Coptic) prototypes. Among the reliefs in the Visigothic church of Quintanilla de Las Vinas in the province of Burgos, Spain, is a carving of a bust of the moon within a medallion carried by two flying angels. Angels similarly carry representations of the Agnus Dei, the Christ in Majesty, or the monogram of Christ. In the carving above, and in the Museum textile the subject is identified by the crescent on the head and the inscription LVNA with the same distribution of letters. Helmut Schlunk

compares this carving with a representation found in Bawit (Coptic Egypt). Two further related enamel plaques representing busts of saints are in the Louvre, Paris. Their execution is cruder than that of the Museum plaque, but the same V-shaped cloisons indicate drapery folds.

Mme Marie-Madeleine S. Gauthier believes that cloisonné enamels in the west derive from the cloisonné glass inlay introduced by barbarian conquerors and executed in local workshops in the sixth and seventh centuries. She suggests the possibility of a local enamel workshop at Conques, tentatively attributes the Louvre plaques to this workshop, and dates them about 1100. If her attribution to the Conques workshop is correct, the two Metropolitan plaques may also be attributed to it. All had once been attributed to Limoges.



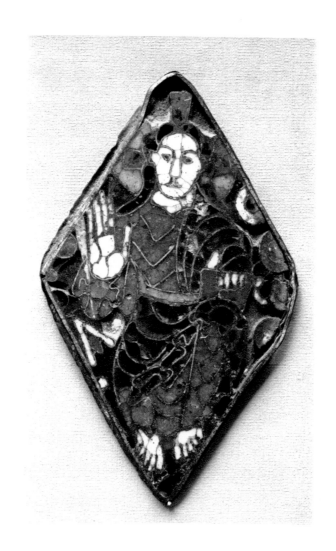

88 *Champlevé enamel on copper gilt*
H. 4, W. 2⅝, D. 5 inches
Danish or North German, circa 1100–1150
Gift of J. Pierpont Morgan, 1917

Five copper plaques decorated with champlevé enamel are attached to the wooden interior of this rectangular casket. Each is framed by a copper-gilt border studded with rows of decorative spherical bosses, probably simulating nailheads, and the edges of the plaques show indentations imitating beading. The casket stands on four flattened spherical feet. The hinges of the cover are a later addition.

The enamel covers the entire surface of each plaque. Such extensive enameling in the twelfth century reveals skillful and accomplished craftmanship. Only the frames, the faces and hands, and the outlines of the design are reserved in copper gilt.

On the top Christ in Majesty is represented, not enthroned as usual, but standing and raising a book in his left hand while blessing with his right. He is surrounded by the four symbols of the evangelists placed in the corners within quarter circles. In the center of the plaque a rectangular opening cut through the figure of Christ is covered by a plaque with openwork palmettes and a keyhole cut in the border. Poul Nørlund thinks that the technique of openwork is typical of this period and is similar to that employed in the Saxon workshops of Rogkerus of Helmershausen. Therefore he concludes that the openwork plaque, even if not contemporary with the manufacture of the casket, is an early addition of the later twelfth century. The lock on the casket is of the seventeenth century.

The Crucifixion with the sun and the moon above is on the front of the casket. On the back plaque five figures holding books, and usually identified as apostles, stand separated by a row of unconnected columns with rectangular bases and capitals. On each of the two side plaques are three standing figures, also separated by columns, one of whom might be an ecclesiastic or cleric.

The color effect of the casket is striking. It includes a magnificent lapis lazuli blue for the backgrounds; an off-white for flesh tones, columns, books, and some minor details; a turquoise-blue and several other tones of blue and green for the clothing; some touches of yellow on the haloes; and a brick-red, used sparingly except on both chasubles of ecclesiastics on the side walls. The style of the casket is also striking and the design crude in its directness. Every unnecessary detail has been omitted, but with the few reserved copper-gilt outlines and a simple and unusual choice of colors the craftsman has achieved an impressive effect.

This piece belongs to a small group of ten almost identical caskets, one of them represented by a single plaque. They share the same style, shape, and size; the same color scheme and design; and the same iconographic repertory. All are decorated with rows of spherical bosses or nail-heads along the borders of the plaques, and they stand or originally stood on spherical feet. Most appear to have been made as reliquaries and were not meant to be opened easily. All hinges are later additions and thus other ways to open them must have been provided. Whether any of them were originally intended to be portable altars is not certain.

The other related caskets are in Lucca (discovered in 1948) in the sarcophagus of San Ricardo, Church of San Frediano; in Monte Cassino; in the Palazzo Venezia, Rome; in the Treasury of the Hildesheim Cathedral; in the Staatliche Museen, Berlin, from the Guelph Treasure; a fragment, also in Berlin, a single plaque possibly from the "Hallische Heiltum" treasure; in the National Museum, Copenhagen, found in Frøslov Bog, in Denmark; in the Wernher Collection, in Lutton Hoo; and in the Cleveland Museum of Art, formerly in the Hermitage, Leningrad. One of the ten has a hip roof while all others are flat. One casket in Copenhagen and another in the Wernher Collection were no doubt used as portable altars because of slits in the top plaque for the insertion of metal crucifixes.

The probable date of their manufacture, according to Nørlund, appears to be the first half of the twelfth century, because the whole group is homogeneous and certain details on some of the caskets make 1100 the earliest and 1150 the latest possible dates. The place of manufacture is usually believed to be somewhere in northern Europe, either Denmark or northern Germany. Nørlund prefers the former, although only one of the caskets was found there, at Flensburg near the Danish-German border. On the other hand at least two of the caskets were found in Italy, in Monte Cassino and in Lucca, and two or three come from places in northern Germany— the Guelph Treasure, Hildesheim Cathedral, and possibly the "Hallische Heiltum". Therefore, this question has to remain unsolved for the present. Regardless of their origin this group of caskets deserves a place of equal importance with other twelfth-century groups of enamels such as these of the Meuse or the Rhine regions of Limoges and Spain, or of England.

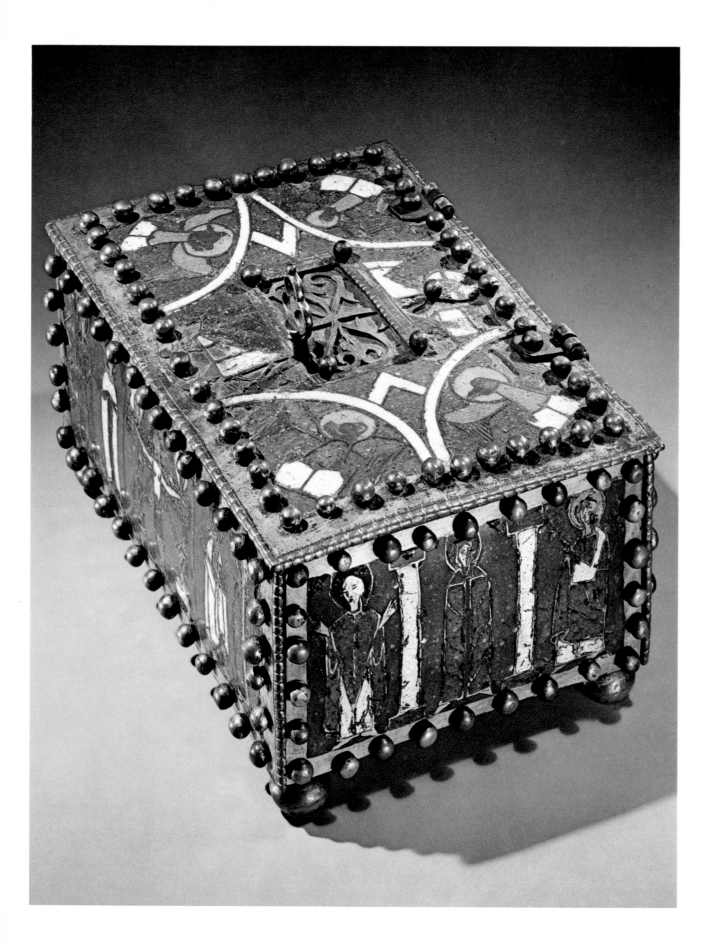

90 *Ivory.* H. 5½, W. 4⅝ *inches*
Spanish, XII century
Gift of J. Pierpont Morgan, 1917
Ex colls. Count August de Bastard;
Sigismond Bardac, Paris

The evangelist St. Mark is seated in full profile at a writing desk, bent low over a large sheet of vellum on which he is probably writing his gospel. In his right hand he holds a calamus, a writing reed or quill pen, and in his left an erasing knife or rasorium. Barefoot, he sits on a chair with a back in the shape of a church façade with twin towers. His desk faces another architectural structure which was probably meant to be a large cabinet.

The winged lion, symbol of the evangelist, in the upper half of the plaque holds a scroll in his claws. Its inscription VOX CLA-MANTIS... could be a quotation from St. John (1:23): "Ego (sum) vox clamantis in deserto Dirigite viam Domini, sicut dixit Isaias propheta." ("I am the voice of one crying in the wilderness. Make straight the way of the Lord, as said the prophet Esaias.") On the other hand it has been suggested that "vox clamantis" could refer to the roar of the lion, and it has been used in this manner elsewhere in connection with the lion of St. Mark. One of the front feet of the lion seems to stand on the evangelist's head, and one of his hind legs rests on the tallest tower below. Like the chair, the architectural motif to the right resembles a

church façade, especially of the type found on Rhenish reliquary caskets made in the shape of a basilica.

Beside it is a punched stamp of a later date with what could be the coat of arms of one of the previous owners of the plaque: an eagle with wings displayed dimidiated with a fleur-de-lis surrounded by the motto CUNCTIS NOTA FIDES. The carving is skilled, but the style is not very refined. The evangelist has large hands, an elongated face and chin, and his ears are placed very high. The ivory plaque was probably made for a book cover.

The composition of the Museum plaque is quite similar to that of an earlier ivory of about 1100 also representing St. Mark, tentatively attributed by A. Goldschmidt to Liège and said to come from Münster Cathedral in Westphalia. It is now in the Westfälisches Provinzialmuseum. Goldschmidt relates the Münster ivory plaque to another plaque portraying St. John the Evangelist in the Treasury of Halberstadt Cathedral where it is attached to a book cover of 1263. The main compositional differences between the two St. Mark plaques are that in the Münster piece the left half of the space above the figure of the writing evangelist is occupied by an architectural landscape, and in the lower right corner an entire walled city replaces the "façade". The winged lion on the Münster ivory is reduced in size to fill only the upper right quarter of the plaque, but it has the same curled-up tail with a stylized tassel at the tip. The Münster plaque has a decorative frame, while the borders of the Museum plaque are left plain.

Goldschmidt compares the curling locks on the lion's mane to those of the lions on a twelfth-century Spanish ivory in the col-

lection of Raymond Pitcairn, Bryn Athyn, Pennsylvania. On the latter plaque, St. Peter as the Bishop of Rome is seated on a bishop's throne supported by lions. The same type of highly stylized curls on a lion's mane appears much earlier on a relief in Cimitile, South Italy. The relief is described by Haseloff as of "very barbaric" workmanship, probably Lombard. A similar stylization occurs on the eleventh-century North Italian Agnus Dei Ivory (number 36).

In his monumental work, *Die Elfenbeinskulpturen aus der romanischen Zeit,* 1926, Adolph Goldschmidt was unable to give a definite place of origin within Spain for the several Spanish Romanesque ivories he included. However, he suggests that they were made in the workshops of one of the Benedictine monasteries in northern Spain.

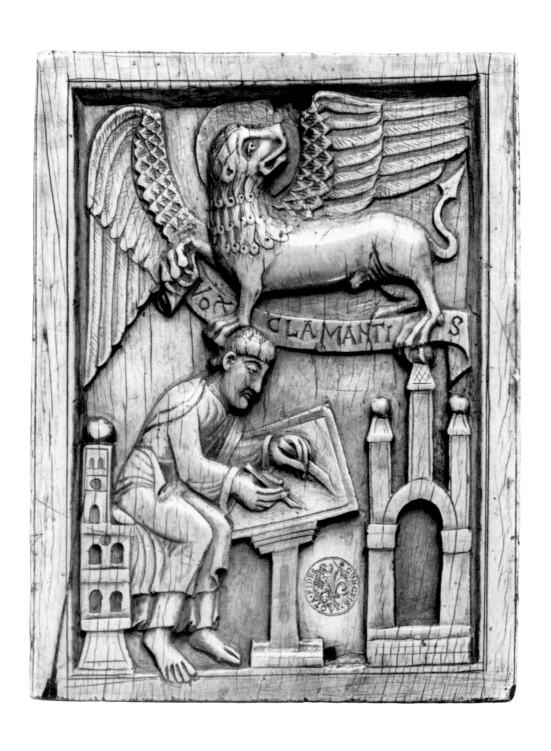

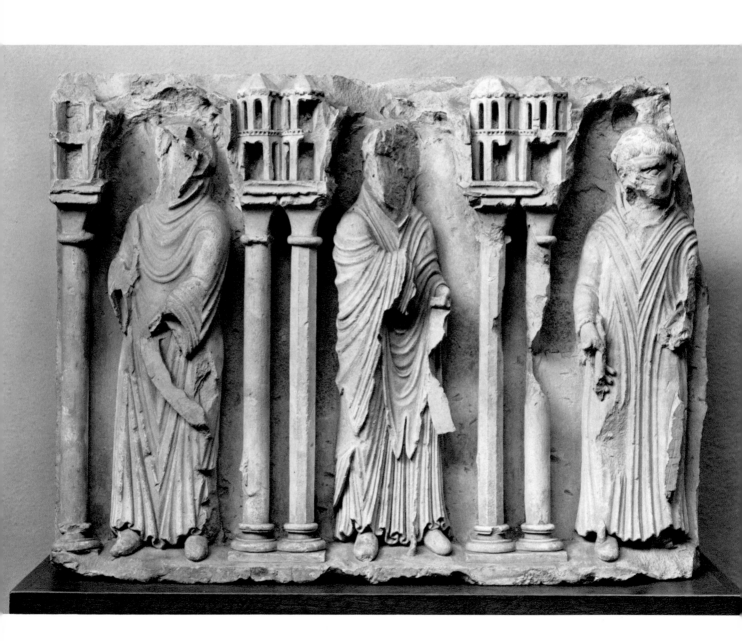

Limestone. H. *19½,* W. *26½ inches*
French, XII century
The Cloisters Collection, Purchase 1947

Three clerical figures stand in niches separated by double columns with capitals composed of two-storied towers. The clerics carry scrolls and, judging by the staff fragment held by the figure to the right, they appear to have once carried croziers used by bishops and abbots.

According to a 1904 publication by Mme Lefrançois-Pillion, this relief was reported to be in the hands of a Parisian antiquary, and to have been bought by him in Reims with the understanding that it originally came from that region, possibly from Soissons. Mme Lefrançois-Pillion associated the relief with sculptures now placed over the right doorway of the north transept of Reims Cathedral, consisting of a deeply recessed round arch, richly carved with figures of angels and clerics, and a relief of the Virgin and Child seated under a baldachino. She believed that these sculptures at Reims came from a recessed tomb inside the cathedral and suggested that The Cloisters relief was also part of a tomb. Indeed, figures under similar arcades are found on the front faces of sarcophagi. Mme Lefrançois-Pillion corectly points out certain resemblances between The Cloisters relief and the cited sculpture at Reims in the similarity of colonnettes and turrets, and of tonsured heads which are like that of the figure to the right in The Cloisters relief, but she prudently does not definitely relate the two. Indeed, as Professor Sauerländer has stated, the drapery of The Cloisters relief is considerably stiffer in style, suggesting a somewhat earlier date than that of the more supple and plastic Reims sculptures. However, the report that the relief came from the region of Reims could well be correct.

94 *Walrus ivory. H. 4⅜, w. 1⅞ inches*
Northern French (Abbey of St-Bertin
at St. Omer), XII century (1050–1150?)
Gift of J. Pierpont Morgan, 1917
Ex coll. Hoentschel

The enthroned figure carved in high relief on walrus ivory represents one of the twenty-four elders of the Apocalypse. The biblical reference can be found in Revelations (4:4): "…I saw four and twenty elders sitting, clothed in white raiment; and they had on their heads crowns of gold." The elder, crowned and clothed in a tunic and mantle, sits on a backless stool. His bare feet are placed on a dome-shaped foot rest. With his left hand he grasps the drapery of his mantle thrown over his left shoulder; his right arm is raised, but the hand in which he probably held a vial is broken off. The cuffs of his tunic have transverse creases, typical for many Romanesque statues. The points of the crown are broken off and the original inlay beads in the eyes are missing. The two large drilled holes, on the chest and on the hem of the tunic, are not contemporary with the carving. Otherwise, the ivory is in very good condition.

Three closely-related figures of similarly seated elders are known. All four must have belonged to a series of twenty-four elders, probably part of a scene of the Last Judgment, and possibly with the Lamb of God in the center. The elders were thus represented in a manuscript, the Liber Floridus, executed in 1120 in the Abbey of St-Bertin. The illuminated pages (missing from the original in Ghent) are known from a twelfth-century copy of the manuscript in the Wolfenbüttel Library (I. Gud. Lat. 2° Fol. 10-v, and 11-r). William Wixom compares the style of the figures to illuminations of the early eleventh century in the manuscript from the Abbey of St-Martin, now in the Morgan Library (PMS M 333) attributed to Abbot Odbert and his assistants, and to a gilt-bronze figure of Christ from the châsse of St. Babolin now in the church at Le

Coudray-Saint-Germer (Oise). He dates the châsse at the end of the eleventh century and believes it to be from St. Omer.

The attribution of the four ivory elders to St-Bertin workshops and their dating in the twelfth century, as well as the comparison to illuminations in the Liber Floridus was first made by Adolph Goldschmidt on the basis of style and also because of the well-known artistic activity in this Benedictine Abbey. The four ivory elders are not only in the same style but have many details in common: the peculiar curls of the hair, the large pointed ears, the eyes originally inlaid with grey-blue beads, the drapery folds indicated by parallel double lines, the borders decorated with rows of zigzags and pearls, and the same type of openwork thrones and foot rests. The three other known ivory elders are at St. Omer (Pas-de-Calais) into Musée Hôtel Sandelin (found at St. Omer during excavation works in the Rue de Corne); in the Library of the British Museum, London, on the twelfth-century (?) cover of a Psalter from the Abbey of St-Hubert in Ardennes (British Museum, Ms. Add. 37768); and in the Lille Museum. The row of folds on the left shoulder of the ivory in the Metropolitan Museum is repeated on the front panel of folds of the elder at St. Omer, while the hair of the Museum elder is closest to that of the elder in the British Museum who also holds his feet in the same position as the Museum figure.

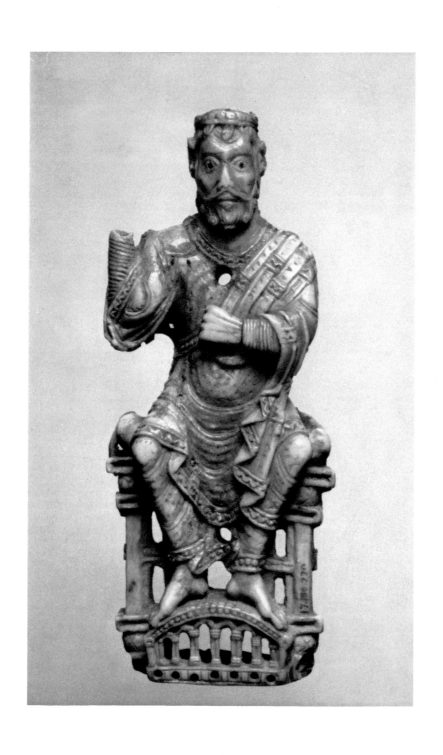

43 Angel

96 *Limestone. H.23, W.16½ inches*
French (Burgundian), XII century (circa 1130)
The Cloisters Collection, Purchase 1947
Ex colls. Architect Roidet-Houdaille;
Abbé Victor Terret, Autun
Provenance: Autun, Cathedral of St.Lazare

The figure of the angel is carved in strongly undercut high relief. His outspread wings and the fluttering hem of his clothing suggest that he is floating in the air. The thin drapery folds are indicated by fine calligraphic lines. Along the hem of his skirt and sleeves runs a beaded border, and at the edge of the halo is a double band of pointed scallops. The sculpture has suffered considerable damages: the face is completely broken off, and the top of the halo and part of the right wing are missing; the surface is also worn off in places.

The angel is a fragment of a left side voussoir from the former north transept portal of the Cathedral of St.Lazare at Autun. This twelfth-century portal had a Raising of Lazarus on the tympanum, and Adam and Eve with Satan on the lintel. Only a few fragments of the portal are known to survive. It was destroyed in 1776 when the sculptures decorating it were declared by the canons of the Cathedral to be "in poor taste". The portal was torn down to make room for a larger one with doors in the baroque style which was more pleasing to eighteenth-century taste.

It is not certain what the angel is holding. Margaret B.Freeman, Curator Emeritus of The Cloisters, as well as Denis Grivot and George Zarnecki see the object as a censer, while Abbé Victor Terret states that the voussoirs of the north portal of St.Lazare consisted of angels with musical instruments.

Such details as the elongated proportions, the thin drapery with folds indicated by fine lines, the feathered wings, and the undercutting relate the angel very closely to the sculpture of the Last Judgment on the west portal of the Cathedral, dated 1120–1132, carved and signed by Gislebertus, one of the finest carvers of Romanesque sculpture in Burgundy.

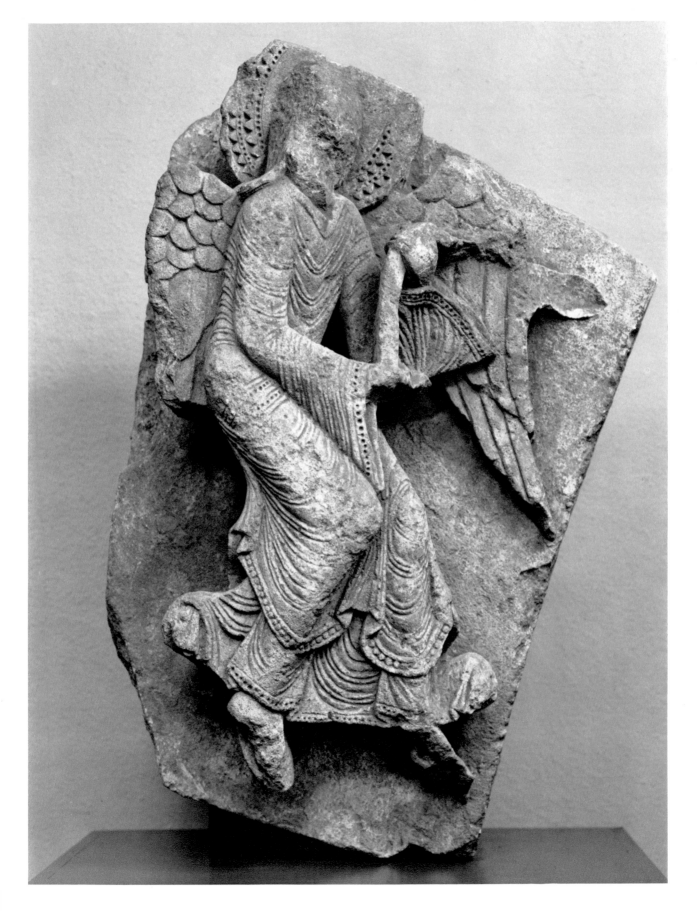

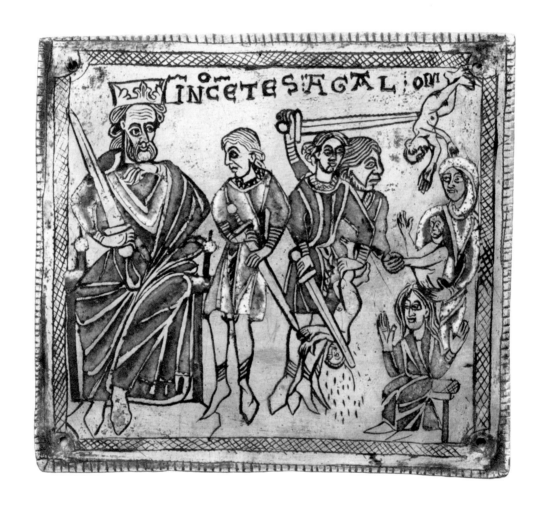

98

Copper gilt and champlevé enamel
H. 4⅝, W. 5⅛ inches
German, late XII century
Gift of J. Pierpont Morgan, 1917
Ex coll. Campe

King Herod, seated on the left of the plaque, is wearing an imposing crown and holds a sword in his right hand instead of the usual royal scepter. He has sent forth three soldiers to kill the male children of Bethlehem under three years of age (Matthew 11:16) in order to destroy the Messiah. One of the soldiers, who has already gored an infant with his sword, is attempting to tear another boy from his mother's arms; the second soldier is killing the child he holds by the leg; and the third, unsheathing his sword, is ready to do the same. Mothers bewail their fate and the loss of their first-born. The scene is brutally frank and full of action. The inscription reads: IN[N]OCENTES : FIGAL (?) : OM[N]ES. The reading of the middle word is not quite clear, but the text can probably be interpreted approximately as "All Innocents were transfixed [by swords]." The Holy Innocents, as the children were called, have been honored since the Early Christian period as the first Christian martyrs.

There are a number of enamels very closely related to the Museum plaque. All probably come from the same workshop and possibly from the same châsse or altar. Among them are two rectangular plaques, the Nativity in the Victoria and Albert Museum, London, and the Adoration of the Magi in the City Art Museum, St. Louis. The sizes and the style are identical on all

three but the borders differ. Only the Museum plaque has the diagonally checkered pattern; the other two have solid black lines. The border used at the edge of the Museum plaque is also used on the cloth hanging from the bed in the Nativity scene and on the hem of the kneeling King in the Adoration.

There are many other similar details: the crown of Herod is almost identical to that worn by one of the Three Magi; the shoes, the drapery, and the incised edges of the plaques imitate beading.

There are at least six other vertical plaques with representations of Apostles executed in the same style. Four of these are in the Metropolitan Museum (acc. nos. 17.190.442 and 443, and 41.190.141 and 142). The fifth, coming from a Frankfurt collection, is in the Art Institute of Chicago and the sixth is in a private collection in the United States. There probably were six additional vertical plaques to complete a series of twelve apostles. Their borders are the same as those of the Massacre of the Innocents. Little doubt is left that the three rectangular plaques must have at one time belonged together. Probably all including the vertical plaques come from the same workshop. The thick lines of metal inside the enamel areas imitate the thin ribbons of the cloisonné enamel technique, but they are executed in champlevé (by gouging out the metal around them). The raised sections to be left exposed are gilded, and the cavities are filled with enamel. Such imitation of cloisonné in the champlevé technique was usual in the twelfth century.

Borenius in 1928 attributed the three rectangular plaques to Godefroid de Claire (?), and in 1929 to the Mosan school. Otto Pächt has verbally suggested a possible

English attribution; nevertheless the five Museum plaques are called German, as is the plaque in Chicago which is dated in the third quarter of the twelfth century.

The style of these plaques is vigorous and crude although with some similarity to finer German work attributed to Hildesheim and northern Germany. A stylistic similarity to works from Cologne and the Meuse is more remote. Twelfth-century enamels are represented by a number of different styles, not all of them associated with the famous Mosan, Rhenish, or Hildesheim centers. Like the workshop which produced the northern German or Danish portable altar (number 39) this workshop cannot be localized.

100 *Bronze gilt.* H.8, W.7¾ *inches*
German (Aachen?), second half
of the XII century
Gift of J.Pierpont Morgan, 1917
Ex colls. Emile Molinier; Hoentschel

This bronze-gilt figure of Christ is one of a great number of such twelfth-century metal figures which originally were attached to metal or decorated wooden crosses (cf.61). Customarily, in the twelfth century, Christ is shown in an almost straight vertical posture, his head upright or only very slightly inclined, and his arms horizontal. In a less obviously Romanesque posture represented in the figure shown here, the hips sway to one side, usually to the right, and the knees bend in the opposite direction, the legs and feet remaining parallel. The arms, raised at an angle, bend at the elbow and more pronouncedly at the wrist, and the hands droop resulting in a double curve. This position of the arms has been compared with the "outspread wings of a heraldic eagle" by Paul Thoby. Although Christ's eyes are still open, the posture begins to suggest the sagging of a dead body, a feature which becomes pronounced in the fourteenth century.

Christ wears only a loincloth which reaches down below his knees. Falling drapery folds with zigzagging hems are formed at the sides of the cloth, while radiating and curving folds are indicated by engraved lines over Christ's left leg. The belt of the loincloth makes several loops and is tied in an intricate knot to

the right, while below the belt in the center a triangular panel is outlined.

Christ's feet bear no nails in this instance but rest on a triangular inclined suppedaneum or foot rest. It has been suggested that the addition of a foot rest to the iconography of the Crucifixion was made by artists influenced by the Byzantine custom of elevating emperors and high officials on pedestals (cf.26).

Strands of hair fall on the shoulders of Christ, while the hair covering the head itself is arranged in a regular pattern of shell-like, convex, little locks. A similar arrangement of hair is found on the bronze-gilt head given by Emperor Frederick Barbarossa to Otto von Kappenberg, which at present serves as a reliquary in the church at Kappenberg. The eyes on this head are treated similarly to the eyes of the figure of Christ with the same protruding eyeballs under heavy lids, outlined above by very pronounced eyebrows. The Kappenberg head, as it is known, is attributed to an Aachen workshop and dated between 1155–1171.

Two related contemporary bronze figures of Christ of unknown origin are in France. The first, dated in the twelfth century, is in a private collection at Belligné, Loire Atlantique; the second, found in Soudan, Loire Atlantique, and dated in the second half of the twelfth century, is now in the Musée Saint-Jean in Angers. This latter figure has unfortunately lost its arms but shows similarities with the Metropolitan Museum figure in the posture of the body and in the drapery of the loincloth. The hair of Christ in the Angers figure is also stylized but in a different manner, while the ribs are indicated by comparable engraving. In both figures in the French collections, the loincloth has a similar play of

drapery folds and a triangular panel in front.

Although the actual iconographic origin of Christ's posture in the Metropolitan Museum figure cannot be pointed out, its development can be traced through the Ottonian period. The oldest representation is possibly found in a late ninth-century illuminated manuscript of the Franco-Saxon School from St.Amand (?) in the Bibliothèque Nationale in Paris (Ms.lat.257, fol.12-v.). The Ottonian manuscripts follow: the Codex Egberti of about 980, a manuscript of the Trier School, in which Christ still wears a collobium (robe); next is the Guntbald Sacramentary of 1014 in the Hildesheim Cathedral, Cod.19, belonging to the Hildesheim Schoool; and finally, the Hitda-Codex of the Cologne School which is dated about 1020. The same posture is seen in several ivories, such as the Crucifixion on the cover of the Echternach Codex Aureus (Trier School) of about 990, now in Gotha, and in another Crucifixion in St.Servais, Maastricht, dated from the tenth to the eleventh century. The same hair arrangement as that of the Museum figure of Christ is seen on the ivory plaque (962–973) from the altar frontal of Magdeburg Cathedral in the Metropolitan Museum, attributed to either Reichenau or Milan. The posture resembles to some extent that of the late tenth-century Christ on the Gero Crucifix in the Cologne Cathedral. The exact relationship of all these comparable pieces has yet to be resolved. However, the posture of the Metropolitan figure is no doubt a survival of an Ottonian type.

An attempt to realistically portray the anatomy and the elegant execution of details combined with Romanesque stylization indicate a date in the second half of the twelfth century for this figure of Christ.

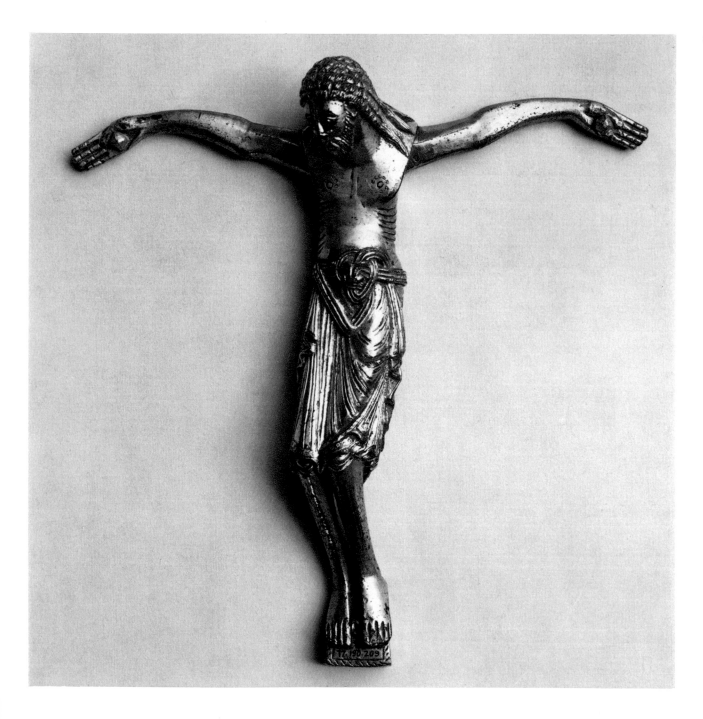

102

Limestone. H. 11 ¼ inches
French (Ile-de-France), circa 1165–1170
Dick Fund, 1938
Provenance: Portal of St. Anne,
Cathedral of Nôtre-Dame, Paris

There is every reason to believe that this fine piece of sculpture in light-grey limestone, identified by James J. Rorimer in 1940 as the head of King David, comes from a twelfth-century statue which stood until the French Revolution on the south side of the portal of St. Anne, Nôtre-Dame Cathedral, Paris.

The crowned head bears a striking resemblance to the heads of King Herod and the Magi still in *situ* on the twelfth-century tympanum from the portal. It has the same flat features and same type of crown as those of Herod and the Magi; there are also similarities in the arched eyebrows, the treatment of the hair, the shape of the crown and the ornamentation of its central band. In several other details the Museum head corresponds to the eighteenth-century engraving of the statue of King David in Bernard de Montfaucon's *Monumens de la monarchie françoise* (Paris, 1729) made after drawings (circa 1725–1728) prepared for Montfaucon by Antoine Benoist. The engraving in Montfaucon's publication shows that, in addition to obvious damages, the head has lost the fleurons of the crown and the irises of the eyeballs which were probably inlaid in lead. Negligible traces of paint and gilding remain on the head, but suggest that the sculpture on the Nôtre-Dame façade was originally polychromed. (The present-day figure of King David on the façade was executed about 1860 by Geoffroy-Dechaume and his workshop, under the direction of Viollet-le-Duc, after drawings prepared for Montfaucon's engravings.)

The portal of St. Anne of Nôtre-Dame is believed to have been begun before 1170, about the same time as the choir of the cathedral, under the direction of Maurice de Sully who became Bishop of Paris in 1160 and died in 1196. In the 1230 building program of Nôtre-Dame much of the sculpture from this early portal was incorporated in the great Gothic façade. In 1793, during the French Revolution, all the portal's large statues were knocked down by order of the Commune. Only a few fragments of drapery from the eight large standing figures from the jambs of this portal remain in the Cluny Museum.

It has been suggested that the decoration of the Romanesque portal of St. Anne was executed by the best of the master carvers who worked on the West Façade at Chartres. The remarkable eloquence of line and form and the solidity of the Romanesque tradition are here softened by delicate modeling and by the beginnings of a naturalistic tendency of the Gothic style.

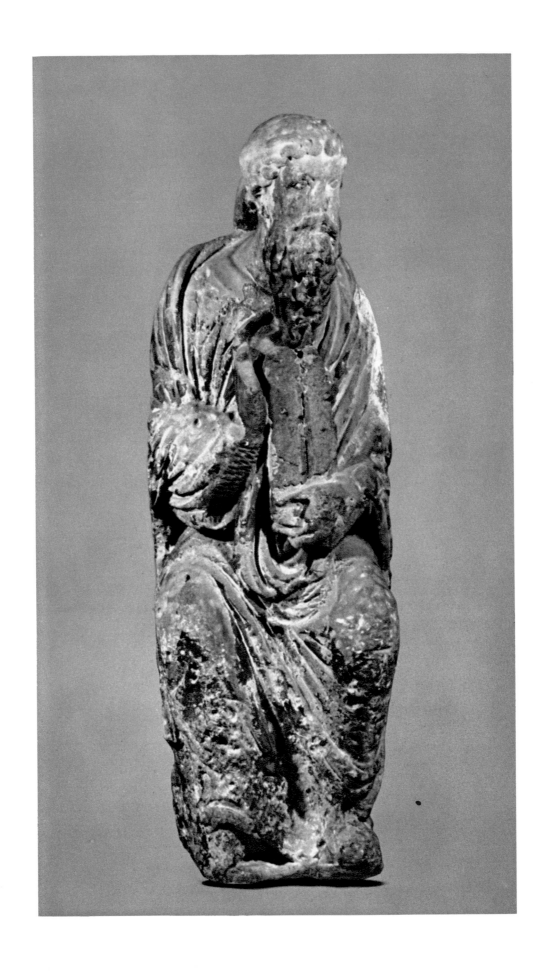

Stone
H.*48⅝, W.15½, D.13½ inches*
French (?), circa 1150–1170
Gift of Raymond Pitcairn
Ex coll. Raymond Pitcairn,
Bryn Athyn, Pennsylvania

Moses is seated on a bench, leaning slightly forward, and he holds the Tablets of the Law in large, heavy hands. His hair and beard are curly and his look intense.

The sleeves of Moses' tunic still show the crinkly folds frequently seen in Romanesque sculpture, and the abundant folds of his mantle fall in a rhythmic, schematic pattern. The arrangement of the folds show a rational sophistication: those from the left shoulder to the right knee are balanced by those running from the right knee to the left ankle. The drapery envelopes the legs, straining tightly over the knees, and curving around the ankle of the left leg. The folds of the mantle under the figure's left arm are twisted in a complicated but logical pattern. Faint traces of what might be yellow and grey polychrome are discernible on this side. The slow process of erosion is clearly indicated in the obliteration of details on the head, arms, and knees. The origin of the darkish stone has not yet been identified.

A metal bar ending in a ring is set into the back of the statue, and a cylindrical hole is drilled into Moses' left arm. Both the ring and the hole for attachment are similar to those one finds on other stone sculptures which were fastened to walls.

The posture of the figure, leaning forward, suggests that the statue was mounted above eye level. And indeed, rows or groups of standing or seated prophets, patriarchs, and apostles were often used to adorn various parts of ecclesiastical architecture—such as façades and portals of churches. The figure was once said to have come from Chartres, but no exact location was given. "Said to come from Chartres" is used too often, confusing the stylistic relationship with the actual provenance, and in certain ways Moses does resemble the sculptures of Chartres. As to the statue's actual provenance, nothing is known. José Manuel Pita Andrada suggests the twelfth-century choir screen of Santiago de Compostella, completed about 1168 and destroyed in the seventeenth century. The remaining fragments, consisting of a series of seated patriarchs and prophets of the Old Testament, are at present incorporated in the Puerta Santa of the Cathedral. Pita Andrada attributes the figure of Moses to the school, or to a follower of Master Mateo, the author of the sculptures on the Puerta de la Platería, of the Cathedral of Santiago de Compostella, and is of the opinion that the dark blackened stone could well come from the Pyrenees region. The similarity in size and in general style of Moses and the choir-screen figures do not contradict such an attribution, but do not supply irrefutable proof either.

The posture of Moses is also similar to that of the seated figures of Sts. Peter and Paul which flank the entrance of the west portal at San Vicente in Avila. Werner Goldschmidt has dated them by style, about 1165–1170, and attributed them to the Master of Avila, whose exact dates and origin are unknown. Goldschmidt is of the opinion that this master is older than Master

Mateo, and that his work shows parallels to that of the Portico della Gloria in Compostella, by Master Mateo. He feels that neither of the two was inspired or influenced by the other, but that their development was parallel. Goldschmidt and Andrada respectively, point out the relationship of the work of the two masters to the sculptures of the Cámara Santa in Oviedo, and indicate Chartres as the derivation point for the Master of Avila, and Chartres and St. Denis for Master Mateo.

Moses has further been compared with a seated prophet in the Metropolitan Museum (acc. no. 22.60.17, bequest of Michael Dreicer, 1921), also said to come from Chartres. This prophet is Romanesque in style, but with signs of transitional trends into Gothic. One must admit that this statue shows some points of similarity to Moses. Its height is about the same (50 inches) and the way in which his left hand holds the scroll is almost identical with the way Moses' left hand supports the Tablets. But many parts of this statue of a prophet have been reworked and therefore a closer comparison cannot be attempted. The unifying factor in all these seated statues of prophets, patriarchs, and apostles appears to be their derivation from a common source, namely, Chartres.

106 *Champlevé enamel on copper gilt*
4 1/16 inches square
Mosan (Meuse Valley); circa 1160; (related
to the workshop of Godefroid de Claire)
The Cloisters Collection, Purchase 1965
Ex colls. Sir Walter Scott; bequeathed
by him to the Birmingham and Midland
Institute in 1863; on permanent
loan to the City of Birmingham
Museum and Art Gallery, 1885–1965

The subject of the enamel is the Pentecost, the Descent of the Holy Spirit upon the apostles on the fiftieth day after Easter. The apostles are seated on a bench before a city which is probably Jerusalem. At top center issuing from the hand of God the Father, or of Christ, are red rays with white highlights. The robes of the apostles are in shades of blue, green, and purple-brown. Their haloes reflect but do not repeat the same scale of colors. The flesh is copper gilt with engraved details.

An inscription near the hand of God: PA / TE, can be read PATE(R). This does not exclude the possibility of identifying it as the hand of Christ: Father, Son, and Holy Spirit as One. The inscription near the head of St. Peter reads: SPS DNI (SPIRITUS DOMINI or the Holy Spirit); that above the trilobed arch reads: DO/Mˢ; on a scalloped band under the feet of the apostles is the word: APOSTOLI.

St. Peter is seated in the center of the group with only five of the other apostles gathered around him. His position in the center of the Pentecost scene represents a western tradition. In the Byzantine tradition the central place is usually occupied by the Mother of God, or it is shared by Sts. Peter

and Paul. This manner of seating in the west may denote deference to St. Peter and consequently to Rome, the see of the saint. This iconography can be found in a number of German manuscripts of the tenth, eleventh, and twelfth centuries, including the Codex Egberti in Trier (Staatsbibliothek). It also appears in a Mosan Lectionary from the Abbey of St. Trond (Mosan, midtwelfth century: J. Pierpont Morgan Library, M. 883, f. 62 vo.) and in a Lectionary from Cluny of the first half of the twelfth century (Bibliothèque Nationale, Paris, NAL 2246, f. 79 vo.).

The representation of the left hand of God, rather than the right, in this composition is unusual. But an explanation for this might be found if one considers the possibility of the derivation of such a gesture from oriental iconography.

In addition to the Pentecost enamel the Museum owns three other plaques which must belong to the same group: the Baptism of Christ, the Crucifixion, and the Three Marys at the Sepulcher (acc. nos. 17.190.430, 431, 419); two more of the group in London are the Cleansing of Naaman (British Museum) and Moses and the Brazen Serpent (Victoria and Albert Museum). All were doubtless part of a series representing the Life and Passion of Christ with parallels from the Old Testament.

Five other plaques slightly more removed in style may have belonged to the same series: a Man Slaying a Dragon and a Centaur Hunting (Louvre, Paris); a Man on a Camel, Samson and the Lion, and the Ascension of Alexander (Victoria and Albert Museum, London). All eleven plaques are of the same size and have similar white and blue borders edged by a row of beading in copper gilt.

The Pentecost plaque is one of the finest Mosan enamels of the twelfth century, outstanding even in this renowned school for brilliance and range of color and for the fluency of its engraving. The spectrum of colors (more than twelve hues appear) is amazingly rich and varied, yet harmoniously balanced. Variations in transparency from opaque to deeply translucent create a jewel-like radiance of color. The faces of the apostles are rendered with vigor, and the postures of heads and figures are carefully designed to avoid mechanical repetition.

Although more than one hand is apparent, the plaques recall the style of Godefroid de Claire or more properly de Huy. One may have done the Pentecost, the Three Marys and perhaps the Crucifixion; the other the Baptism of Christ, Naaman, and the Brazen Serpent plaques. A third hand executed the rest of the group, with representations of Old Testament parallels and those from the world of nature and mythology with theological implications. All the plaques might have been made for an altar, inspired by the twelfth-century retable and altar frontal of the main altar of the abbey church of Stavelot, southeast of Liège. It showed silver-gilt reliefs with scenes of the Passion and the Resurrection, with a relief of the Pentecost on the altar frontal. Unfortunately, it was destroyed in 1794. A further connection exists between these plaques and the Stavelot triptych of 1154–1158 (J. Pierpont Morgan Library, New York), but the Metropolitan Museum plaques seem to be a later phase of the style of this triptych. The association with Stavelot may suggest the influence of Wibald, Abbot of Stavelot, 1130–1158.

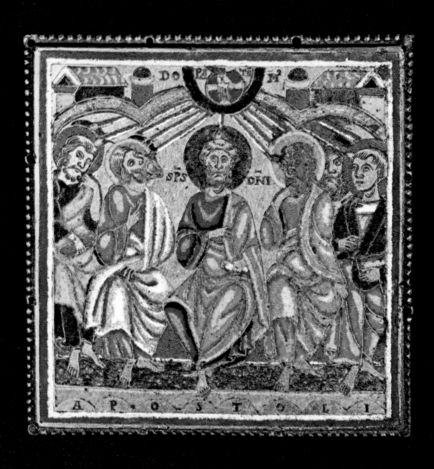

108

Limestone. H. 12¾, W. 9 inches
French, second quarter of the XII century
The Cloisters Collection, 1947
Provenance: The Abbey of St-Martin,
Savigny (Rhône)

This acrobat, once considered a corbel stylistically related to the School of Provence in France, has now been identified by Robert C. Moeller III as a fragment of a capital from the Abbey of St-Martin, at Savigny in the Rhône Valley. Comparisons made by Moeller of this carving to a companion piece, Musician Playing a Viol (Wellesley College Art Museum), and with the figure of King Solomon on a third fragment of another capital still at Savigny leave no doubt that the three pieces have a common origin, possibly from the abbey's church portal. Their sizes and style are the same, and they have the same kind of curling leaves in the background. Moeller, speaking of these fragments in the exhibition catalog *The Renaissance of the Twelfth Century,* Rhode Island School of Design, Providence, Rhode Island, 1969, says of their style: "Common to all figures are the curvilinear ridge which organizes the drapery, the broad blocky faces, the use of the drill to define the eyes, and to embellish the drapery, jewelry, shoes and leg, the carving of the hand and the peculiar treatment of the sleeve at the wrist." Moeller further says that, judging by the fragmentary remains, the Abbey of St-Martin at Savigny (destroyed in the eighteenth century) must have been a powerful monastic foundation which attracted sculptor-masons from other regions. These sculptors represented various styles, and their workshop at Savigny produced new masters who might have later worked on other building programs.

The former attribution of the fragments at Wellesley College and The Cloisters to the Provence School, especially to the style of St-Gilles-du-Gard, may be explained by the exchange of influences of the two closely connected regions of Provence and the Rhône Valley (carried back and forth by itinerant mason-sculptors in the twelfth century) as well as by insufficient study of little-known monuments. The whole problem of the Abbey of St-Martin at Savigny, lying north and west of Lyons, is being studied at present by Mlle D. Cataland of the Ecole des Chartes.

Jongleurs and minstrels appear frequently in medieval art. An acrobat and a dog in the Church of the Madeleine, Vézeley, decorate the sign of the zodiac for the month of July. This was the month when pilgrims congregated for the feast of the Madeleine and their presence probably drew many minstrels. A lady acrobat doing a back bend is portrayed on the corbels of the Fuenti-dueña Apse at The Cloisters. Acrobats appear frequently in Romanesque sculpture in France and Spain. Salomé dancing for King Herod is sometimes shown in the same posture. André Grabar explains the presence of acrobats and jongleurs in representations of the Crowning of Christ with Thorns, as a parallel drawn by the medieval mind between the festive coronations of kings at which such performers would be present, and the placing of the crown of thorns on the head of Christ, the King of Heaven.

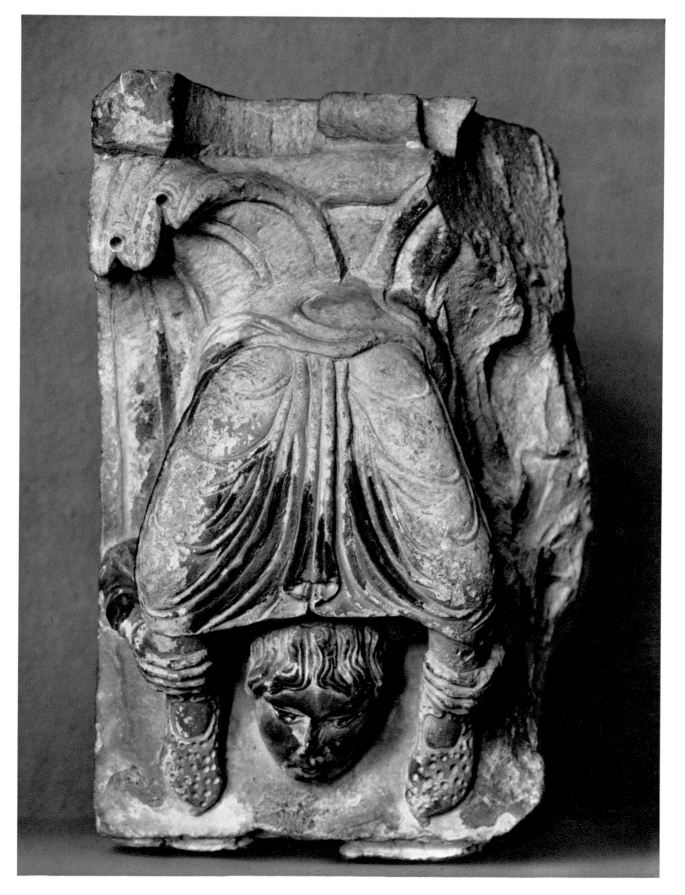

GOTHIC ART

112 *Stone. L.95 inches*
French, late XII century
The Cloisters Collection, Purchase 1939
Said to come from the Abbey of
Saint-Père-en-Vallée, Chartres

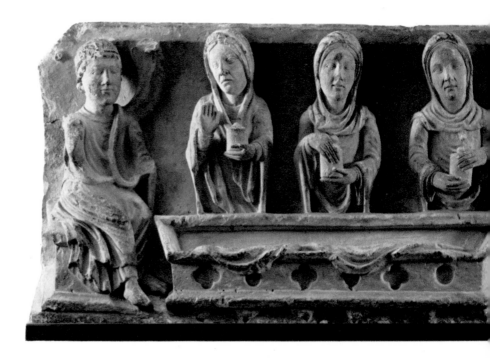

Judging by its size and proportions, this stone relief was probably carved as a lintel to be placed over a portal. The Entombment of Christ is represented in the scene to the right. The body of Christ is being anointed, wrapped in a shroud, and lowered into a stone sarcophagus. The burial is attended by four male figures which include Joseph of Arimathea and Nicodemus at either end of the sarcophagus. To the left, the Three Marys who came to the tomb on Easter morning are shown holding ointment jars; the angel tells them that Christ has risen. The grave cloth is draped schematically over the front side of the empty tomb. The sarcophagi are decorated with concave designs of trefoils and quatrefoils alternating with circles.

In spite of the general similarity of the two scenes, monotony is avoided in the composition by the contrast of the more vertical postures of the figures on the left with the more active diagonal postures on the right. A certain restraint combined at the same time with an implication of arrested motion brings the stiff Romanesque composition to life and presages the coming Gothic style. The subject matter and arrangement of the scenes recalls the lintel on the main portal of the Cathedral of Senlis (about 1180–1190). A stylistic relationship can be found between the face of an angel in the Tobias scene on the north portal of Chartres Cathedral and the face of the angel on The Cloisters lintel. The comparison of this lintel to Senlis on one hand

and to Chartres on the other, can be paralleled by a recent tentative attribution of the twelfth-century statue of a Seated Prophet in the Metropolitan Museum to Senlis, formerly always connected with Chartres (number 47).

According to tradition the relief was formerly in a private collection in Burgundy. It was published by Alfred Scharf in 1929 and by Paul Muratov in 1931, both claiming that it came from the Abbey of St-Père-en-Vallée in Chartres. If this attribution is correct, it must have been removed from Chartres a long time ago. No one could be found who remembered seeing the carving at Chartres.

As is frequently the case with objects for which no sure provenance can be found, doubt has been cast upon the genuineness of the sculpture. The carving has suffered from exposure to the weather and much detail is lost. The paint which probably originally protected the surface is almost entirely gone, and worse, the surface evidently has been scraped to remove the last remnants. An examination under ultraviolet rays shows some modern abrasions and scraping of the surface. These changes appear to be the result of an unskilled restorer rather than the work of anyone attempting to alter the sculpture.

114 *Wood and iron*
L. 10⅝, W. 6¼, H. 4⅜ inches
German (Upper Rhenish),
second quarter of XIV century
The Cloisters Collection,
Rogers Fund and Exchange, 1950
Ex colls. Lorenz Gedon, Munich;
Albert Figdor, Vienna; Oscar C. Bondy, Vienna

This box is decorated on the outside with intarsia work, an inlay of varicolored wood. It has iron mountings: diamond-shaped strap hinges with foliate terminals, a bail handle and corner rosettes with acorn-shaped studs on the lid, and a hinged hasp in center front. The edges of the box are reinforced with iron bands ending in foliate motifs. It stands on four hemispherical wooden feet. The bottom is divided into quarters painted alternately red and yellow.

Inside the lid three Gothic ogee arches with crockets are painted on a red ground. The spaces above are patterned to suggest an open gallery and the upper and lower borders are painted in imitation of Gothic tracery. A painted shield with a coat of arms, doubtless that of the original owner of the box, is placed under the central arch. The coat of arms is: argent (or vert), a lion rampant, sable, langued gules; this means a black rearing lion with a red tongue on a white (possibly faded from green) ground. Above the shield is a crest: a lion sable (black) issuing from a helmet, talons and three bezants (balls) argent (white) on his mane. The arms have been identified by Heinrich Kohlhaussen as those of the Freiherr zu Rhein of Basel, and by

Kurt Martin also as those of the family of the *Truchsessen* (Lord High Steward) zu Rhein of Basel, with a branch in Breisgau (1261–1424).

Under the arch to the left *Frau Minne,* a variant of the goddess of love in Germanic countries of this period, dressed in green is aiming an arrow at a youth standing nearby. The inscription reads: GENAD FROU ICH HED MICH ERGEBEN ("Mercy, my Lady, I have surrendered.") Under the arch to the right the same lady and youth appear again with their right hands interlocked. In their left hands, respectively, the lady holds the bow and the youth a heart pierced by three arrows. The inscription here reads: SENT MIR FROU DROST (?) MIN HERZ IST WUND ("Send me, my Lady, solace (?), my heart has been wounded.")

Medieval boxes of similar type are known under their German name *Minnekästchen* which freely translated could mean "gifts-of-love" coffrets. It is possible that this name was introduced in the romantic period of the early nineteenth century. Usually they are richly and beautifully decorated, mostly with carving. Like their French counterparts in ivory *Minnekästchen* were probably used by ladies for their jewels and trinkets or toilet articles. The custom of decorating wooden boxes of this type may have started in imitation of Islamic examples. The subjects often included gallant scenes, as on the box shown here, or allegories and symbolic representations. Many of these richly ornamented boxes found their way into the treasuries of churches where they served as reliquaries despite the fact that their decorations were purely secular in character. Of the surviving *Minnekästchen* only a few have painted figural decorations, and among them The

Cloisters box is one of the most beautiful and charming. A fourteenth-century colored drawing on parchment shows two gentlemen presenting similar boxes to two ladies, one of them combing her hair (Berlin, Kupferstichkabinett).

The whole idea of *Minne,* or knightly love, was elaborated from the time of the troubadours and was stressed chiefly in courtly circles. Poets and knights, *Minnesänger,* composed appropriate poems to be sung or recited to the accompaniment of fiddles, harps, recorders or other instruments. The theme could be love, religion, or an expression of elevated feelings inspired by the seasons of the year. The greatest collection of such poems, illustrated with full-page illuminations by several contemporary artists, can be found in the fourteenth-century *Manesse Codex,* a quarto-size manuscript in the Heidelberg University Library. The style of some of the illuminations is very close to that of the painting on the lid of The Cloisters box, and both the illuminations and the box were made in the Upper Rhine region.

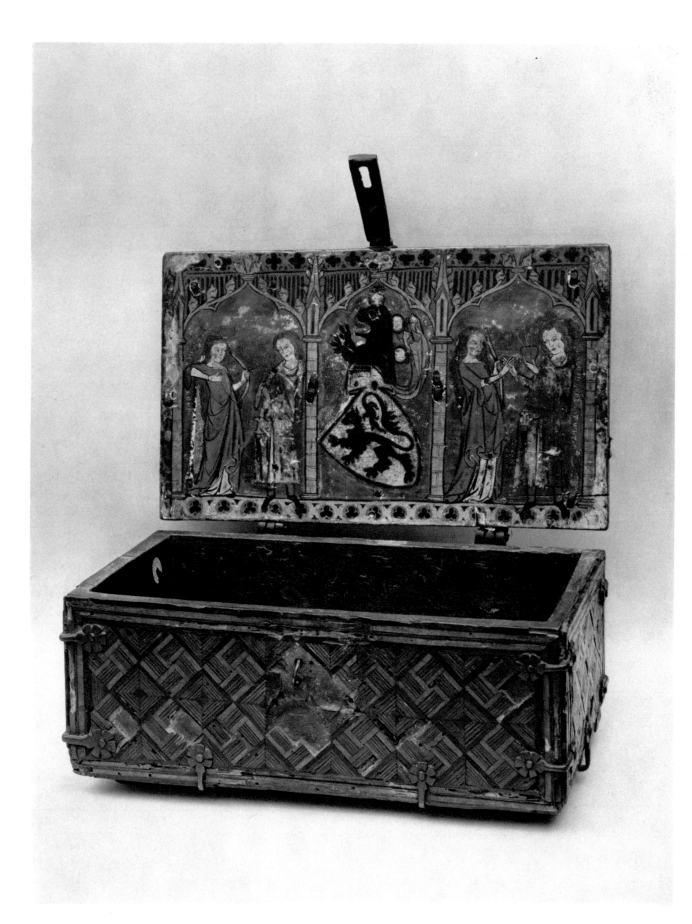

52 Seated Virgin and Child

116 *Ivory.* H. *13¼ inches*
French, late XIII or early XIV century
Gift of J. Pierpont Morgan, 1917
Ex colls. Stein; Odiot; Heckscher;
Léopold Goldschmidt; Hoentschel

The Virgin sits inclined sightly towards the Child, her pointed-oval face enlivened by a smile. She wears a long veil and a mantle falls from her shoulders to continue from left to right across her knees. The folds of the drapery are well designed, even if, in the opinion of Raymond Koechlin, they are somewhat dry and flat.

The Child supported by the Virgin's left arm holds an apple (?) in his left hand and with his right playfully touches the chin of his Mother in a gesture which may derive from the *Eleusa* ("Tenderness") type of Byzantine Virgin. This iconographical variant of the representation of the Virgin and Child was taken over by Italo-Byzantine workshops which might have helped to propagate it among artists of western Europe. The Virgin holds the bare foot of the Child in an equally tender gesture.

Several features of this statuette relate it to thirteenth-century traditions. The belt on the Virgin's dress is rather low, while in the fourteenth century it is usually placed much higher. The breaking of the folds of the dress over the Virgin's feet is also a thirteenth-century tradition. Another thirteenth-century peculiarity not easily noticeable, but pointed out by W. H. Forsyth, is the small radiating creases on the bodice of the Virgin's dress near the armpit.

Ivory statuettes are usually smaller than this one although a number of taller ones exist. When the statuette was received by the Metropolitan Museum, the Virgin was wearing a metal crown and was seated on a metal throne. Both were removed as modern additions or restorations in 1929 by James J. Rorimer. Several fingers of the Virgin's right hand and the toes of both feet of the Child are missing.

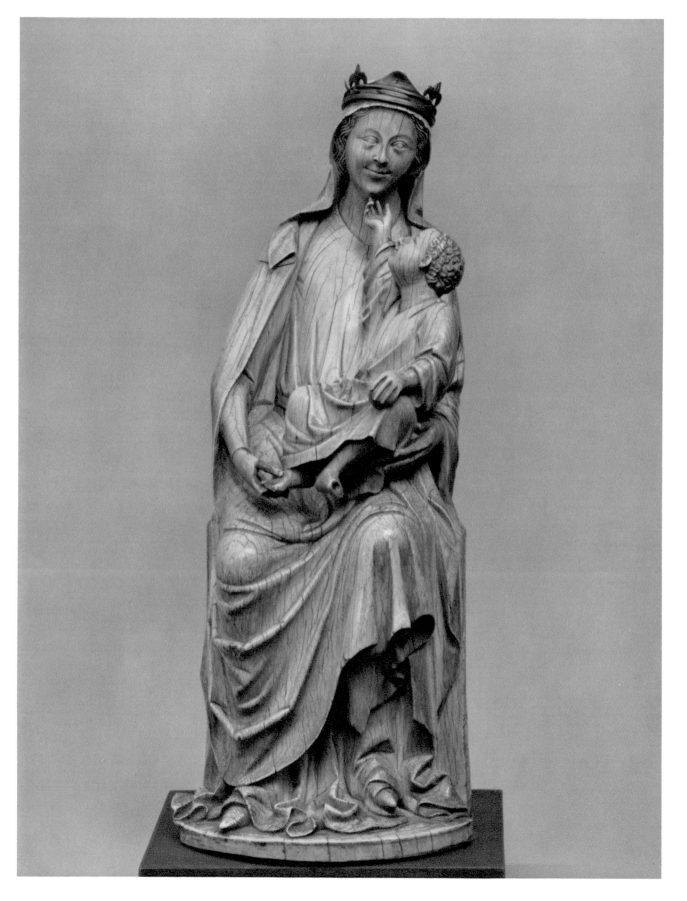

Champlevé enamel on copper gilt
H. *8⅝,* W. *10½,* D. *4¼ inches*
French (Limoges),
late XII or early XIII century
Gift of J. Pierpont Morgan, 1917
Ex colls. Spitzer; Hoentschel

This châsse belongs to the type of Limoges champlevé enamel known as à *fond vermiculé,* with the copper-gilt background incised in a pattern of densely interwoven scrolls of tendrils and leaves. This kind of background decoration became especially fashionable in the second third of the twelfth century, according to Mme M. Gauthier's latest findings.

On the front of the châsse Christ in Majesty is seated on the rainbow arc of heaven within a mandorla. He is surrounded by the symbols of the four evangelists: the angel of St. Matthew, the lion of St. Mark, the bull of St. Luke, and the eagle of St. John. Under arcades supported by multicolored colonettes are four apostles. Above Christ in the center of the roof slope within a medallion is the Lamb of God standing in front of a cross and holding a book. Above the cross are the Greek letters Alpha and Omega, the beginning and the end (see number 38). Four three-quarter-length angels representing the heavenly host flank the medallion.

Mme Gauthier refers to the rhythmic architectural composition of this front face where two central figures, one over the other, form a single vertical axis, evoking the double nature of Christ as God and man. Christ in the mandorla below

represents not only the Last Judgment, but his bodily ascension to heaven; whereas the Lamb of God above, attended by adoring angels, represents the manifestation of his heavenly nature.

The apostles Peter and Paul are represented on the ends of the châsse. St. Peter holding the key of paradise appropriately stands guard at the door of heaven, represented on the châsse by an actual door with a key hole which locks or opens the châsse. Two other, lower keyholes were added later.

The two plaques on the back are covered with a typical repeating pattern of medallions of quatrefoil ornament in contrasting colors of enamel, enriched by smaller quatrefoils incised in the metal background. All the plaques of the châsse have semi-circular borders in contrasting enamel colors, typical of one of the four categories of vermiculé enamels isolated by Marquet de Vasselot.

The copper-gilt crest on top of the châsse is ornamented with a series of keyhole-shaped openings and decorated with three inset crystal cabochons. It is crowned by two terminal metal balls.

The shape of such châsses, or caskets, suggests a tomb in miniature, and this they were indeed since they were made to contain relics of the saints. Their resplendent colors must have shown brilliantly in the light of innumerable candles when they were placed on the altar on feast days.

This châsse can be grouped with a number of others dating for the most part from about 1170 to about 1200. All have the same unusual incised tendril patterns creating a rich background around the figures on the front and the sides. Most of the enamels in the vermiculé group have similarities in style and are of high quality.

Facial features and hair are strongly marked by incised lines, sometimes filled with a black enamel similar in effect to niello. The dark-blue enamel highlighted with edgings of lapis-blue near the folds of the garments forms a striking contrast to the emerald-greens with edgings of white. Grey-blue, yellow, deep red, and white enamel enliven the object.

The vermiculé group, originally formed by the late J. J. Marquet de Vasselot, is now thought by Mme Gauthier to be a more complex series of interlocking groups. The new chronology would place this châsse in the last quarter of the twelfth century. A number of châsses show figures in three-quarter-length, including one in Leningrad and another in the Widener Collection of the National Gallery, Washington, D. C. In a châsse in the church of St. John, Lyons, the same subject matter as that on the Museum châsse is found on the front face.

120 *Bronze.* H. 10½, L. 10½ *inches*
North German (Hildesheim?), middle of the
XIII century
The Cloisters Collection, Purchase 1947
Ex coll. Hubert de Pourtalès

Although greatly stylized, the lion has a well-formed powerful body standing in a defiant pose on firmly planted legs. The fish-tailed monster-dragon which serves as the handle stands on the lion's back biting his neck. The tight, highly stylized curls of the lion's mane cover its neck, chest, and shoulders down to the legs. Its tail swings between the hind legs and curls up over the right flank. The bared fangs and the upward look of the eyes shielded by eyebrows modeled in high relief are very expressive, and the ferocious look on the almost-human face is intensified by shimmering blue eyes inlaid with turquoises. The body of the dragon and the front legs and face of the lion are covered with engraved ornament. A tube inserted in the lion's mouth serves as a spout. The vessel is filled with water through an opening with a hinged cover on his head.

Aquamanile is the name given in the Middle Ages to a pouring vessel, usually provided with a handle. A contemporary text supplies an explanation of the word, stating that it is a vessel *"unde lavandis manibus aqua infunditur"* ("from which water is poured on the hands being washed"). At present, this name is used in reference to a special kind of metal pouring vessel, for the most part in animal shape. Aquamanilia were used both in churches, by acolytes who assisted the priest in washing his hands before celebrating Mass, and in lay house-

holds for the washing of hands before and after meals. Their use in churches was more or less similar to that of the Limoges gemellions, such as number 63. They must have been especially popular in northern Germany where they are found in greater numbers than anywhere else.

To judge by the number that have survived, the most popular animal form for an aquamanile was that of a lion, the fierce and dangerous "royal" animal. The lion was known in western Europe mainly by hearsay, but also from pictorial representations inherited from classical art, and from objects imported from the Near East and the countries of Islam. Bronze aquamanilia and especially incense burners in stylized animal shapes were known in Persian as early as the sixth and seventh centuries. One such bronze aquamanile in the shape of a deer, with ivory inlaid eyes, is now in the Hermitage Museum, Leningrad. The curls on the mane of The Cloisters lion are like those on a Persian silver dish of the fifth century, also in the Hermitage Museum. In western Europe bronze aquamanilia do not appear until the twelfth century, at the time of the crusades. In imitating Islamic prototypes western European masters interpreted them to suit their own tastes and they might also have studied local representations of animals. As a result, the shapes of their aquamanilia are based on realistic forms stylized and mixed with fantastic elements.

The locations of workshops producing the animal-shaped aquamanilia in western Europe must have been influenced to some extent by the availability of the necessary material. An important region for bronze casting was that of the Meuse and lower Lorraine. Other important centers were in several parts of northern Germany, in

northeast France, as well as in England, Scandinavia, and in other places of less importance. The French name "dinanderie" deriving from the name of Dinant (one of the centers on the Meuse river), is sometimes used in connection with such bronze aquamanilia. This is inadequate, because it suggests a restriction of their manufacture to the region of the Meuse. Hildesheim, where bronze casting had reached a very high level in the time of Bishop Bernward (992–1022), was an equally important center. Some of the finest aquamanilia vie for the honor of attribution to the Hildesheim workshops. Among these The Cloisters lion shows the necessary qualifications.

A northern-German lion aquamanile, dated early in the thirteenth century, in the Kaestner Museum, Hanover (inv. no. 1213 : 373), is similar to The Cloisters lion in character. It has the same ears, the same modeling of the mane, the same position of the tail, the same dragon on the back, and also an engraved face. But the Hanover lion stands on shorter legs, his body has a slightly different form, and a human figure serves as a spout. Thus he differs somewhat from The Cloisters lion and may not belong to the same group. Much closer to The Cloisters aquamanile is another lion, formerly in the Schlossmuseum, Berlin, part of a Samson and the Lion group supporting a candlestick, of northern German workmanship of the mid-thirteenth century. The Berlin and The Cloisters lions have similar leg construction, identical modeling of the paws, the same "human" facial expression, and identical ornamental engraving on the front legs. Especially on the face, the Berlin lion has an even richer engraved decoration. Such engraving is considered a characteristic of the Hildesheim workshop.

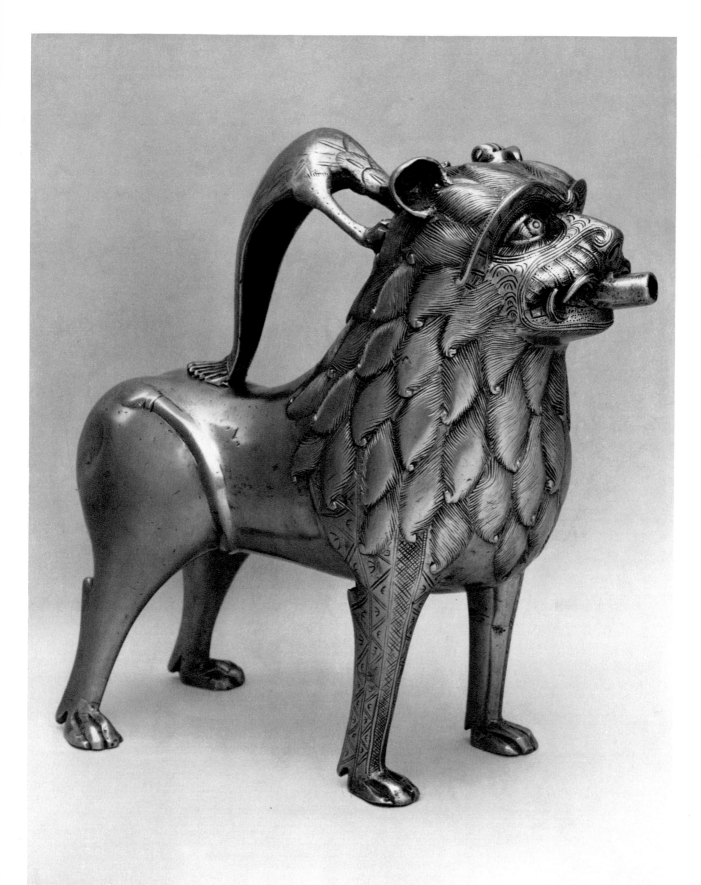

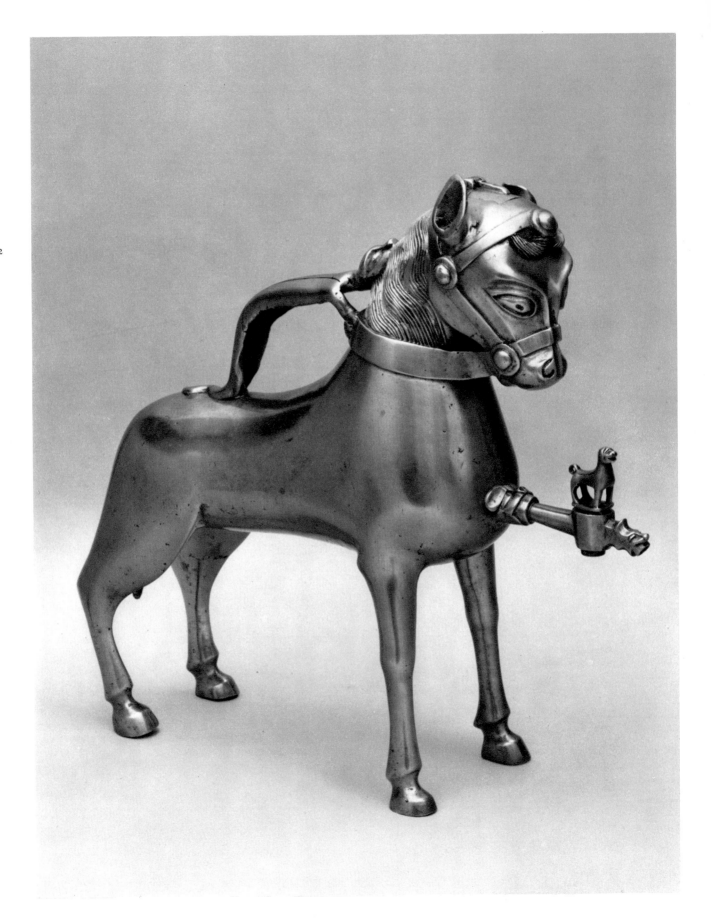

Bronze. H.11 ½, L.12 *inches*

German, circa 1400

The Cloisters Collection, Purchase 1947

Ex colls. Frédéric Spitzer, Paris;

Sir Thomas Gibson Carmichael;

Sir Samuel Montagu Swaythling;

Baron Arthur de Schickler, Martinvast, France

This aquamanile in the form of a horse can be held by a dragon-monster handle very similar to the handle on the lion aquamanile (number 54). The horse's wavy mane is incised and modeled, the strands forming sharp-edged ridges. The various parts of the bridle, including the rein, the front and the cheek and nose pieces, are made of separate strips of metal riveted together, each rivet forming a boss. An additional boss decorates the front, and from beneath it the forelock emerges like a moustache. The eyes are deeply incised and placed obliquely under eyebrows indicated by sharp ridges which continue down between the nostrils; both nostrils and irises are indicated by deep incisions. The hoofs are conscientiously shaped.

The opening hole on top of the horse's head has a hinged cover. From the open mouth of a fantastic animal head on the horse's chest a spout projects which ends in another animal head. A small dog stands on the spigot.

The location of the spout makes one think of an animal-shaped ancient drinking vessel, a rhyton, which had an opening on the chest of the animal. One such horse-shaped rhyton, made of silver, was acquired recently by the Cleveland Museum of Art. It is called Persian, is in full harness, and as most Persian horse figures wears a saddle. This vessel is described as a war-horse dated within the third century A.D. Dorothy G. Shepherd who published this Cleveland rhyton suggests that its shape may derive from early Iranian (about 1000–700 B.C.) pottery rhytons in the shape of standing horses.

Otto von Falke and Erich Meyer illustrate a number of horse aquamanilia which are related to the example in The Cloisters Collection. They all have only reins instead of a complete bridle, and they have the same "oriental" eyes, prominent eyebrows, and similarly indicated mane and forelock. All, including The Cloisters piece, belong to the late Gothic period and are in the North German tradition. Otto von Falke and Erich Meyer consider comparable horses Lower Saxon, North German, or even Scandinavian, and all are dated either about 1400 or in the early fifteenth century. Before the horse aquamanile was acquired by The Cloisters, it had been variously dated, even as early as the thirteenth century.

124 *Bronze. H.21, Diameter (at base) 5⅞ inches*
German, circa 1400
The Cloisters Collection, Purchase 1947
Ex coll. J. Pierpont Morgan

The turret or tower stands on three legs, each ending in an animal paw. At the base of the turret, above each leg, are bearded grotesque heads. Animal heads are placed in the spaces between the legs. These have been described as dogs' heads, and one of them holds the spout in its open mouth. This spout also ends in an animal head and the spigot is surmounted by a small standing dog. The walls of the tower are scored by engraved lines in imitation of rectangular ashlars which would have been used to build the walls of a real tower. The top of the tower is encircled by a crenelated gallery and the peaked roof is topped with a finial.

This type of bronze vessel is sometimes considered an aquamanile, but in reality it does not fit the definition: a vessel held in the hands to pour water over the hands of another person. The turret type usually stands on a shelf or in a niche, with a basin placed under its spout, and is used as one would a laver. The more usual and better-known type of laver is a kettle-shaped bronze vessel, with two spouts on opposite sides suspended over the wash basin by a bail handle. By tilting it one spills water over the hands.

In paintings of the fifteenth century one can see interiors of bed chambers with one or the other type of laver hanging or standing in a corner, sometimes with a towel hanging nearby. A kettle-shaped Flemish laver is represented in the painting of the Annunciation by Robert Campin at The Cloisters, while a turret-shaped laver can be seen in the painting (about 1420) of The Angel Reassuring Joseph, by the Strasbourg Master, in the Musée de l'Oeuvre Nôtre-Dame in Strasbourg.

According to Victor Gay, gemellions

(number 63) were used mostly in church ceremonies, animal-shaped aquamanilia (numbers 54, 55, 57) in the sacristies of churches, and lavers in lay households. But, one can also find many kettle-shaped lavers in church sacristies.

Architectural forms were popular in metalwork of the fifteenth century. Caskets take the shape of buildings. The upper borders of cups or other vessels are decorated with crenelations, and sometimes entire castles surmount the covers of beakers. Silver ostensories, monstrances, and reliquaries are surrounded with flying buttresses and pinnacles (number 84).

Evidence for the German provenance of the turret laver is offered by its representation on the German, Upper Rhenish or Alsatian paintings mentioned above. Falke and Meyer say that all aquamanilia with spigots surmounted by standing animals are German. Very few turret lavers are known to exist, but a second one with the legs missing is in The Cloisters Collection.

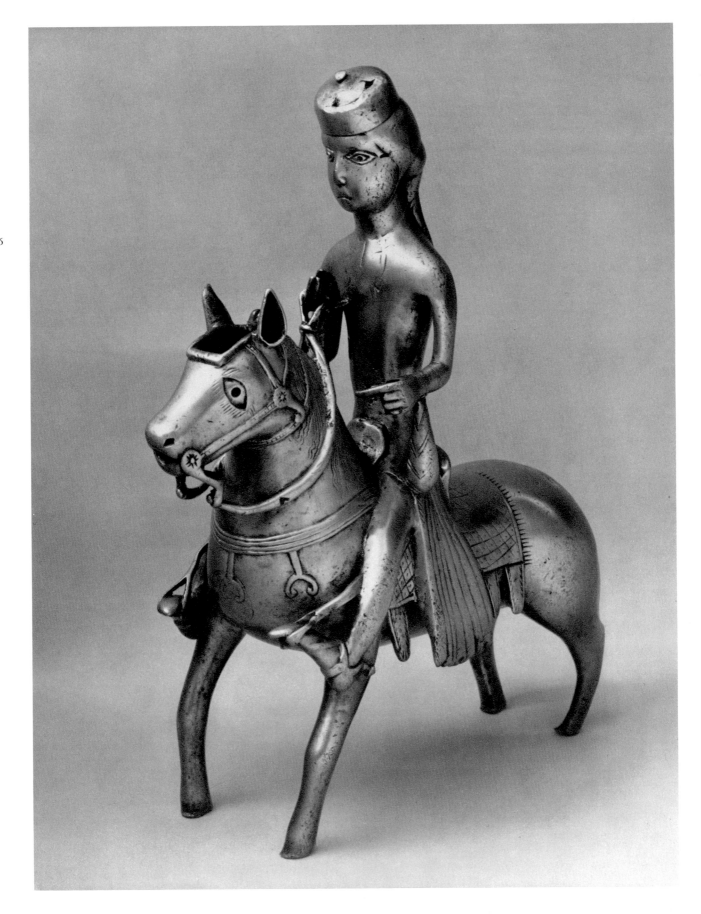

Bronze. H.13¾, L.11 inches
North European (Lorraine-Mosan region),
first half of the XIII century
The Cloisters Collection, Purchase 1947

The figure on horseback is a falconer with legs thrust stiffly forward and feet firmly planted in the stirrups. The position of his left hand indicates that originally he was holding the falcon on his left wrist. Over a tightly fitting garment the rider wears a long surcoat with a small slit at the neck. The skirt of the surcoat is divided into two panels arranged in long parallel folds starting at the hips. On his head the falconer wears a tightly fitting calotte fastened under his chin with two strings tied in a knot. Over this he wears a pillbox-shaped "bonnet" with a knob atop a four-leaf rosette, and his hair is arranged in two thick braids enclosed in tube-like holders. He wears falconer's gloves or gauntlets, decorated with an engraved v-shaped design and a continuous row of small squares along the edges. His boots have pointed tips, and over the boots prick spurs are fastened. The body of the falconer is slim with broad shoulders, long hands and feet, and a round head that is a little too large for the slender body. Plastic details are restricted for the most part to his head and face. The body of the horse on the other hand is rather full. The breed cannot be identified, but knightly lore tells us that thirteenth-century riders were proud of their "Andalusian" mounts and we also know that horses were imported from the Orient by the crusaders. The horse's head is small; the ears and eyes are modeled, but the eyebrows are indicated only by a few engraved lines. The bridle and the rest of the harness is carefully modeled in its details and some parts of it are decorated. The saddlebows are strongly emphasized and the saddlecloth with its hangers is also ornamented. Pendants shaped like "lunulae" (moon crescents) but ending in two volutes hang from the breast collar. The aquamanile is cast of pale golden-yellow colored bronze believed to be typical of the workmanship in the region between the Rhine and the Meuse, called lower Lorraine or Mosan. It was evidently made in the cire-perdue (lost wax) technique, the most suitable method for casting hollow sculpture.

At the top of the horse's head is a square opening, originally provided with a hinged cover, which was used to fill the aquamanile with water. The water was poured out through a round hole in the mouth of the horse. Since no traces of a handle exist and the upper part of the falconer's body shows strong wear, we may assume the rider served as the handle.

George Szabó has made a special study of this aquamanile and has examined various manuscripts, bronzes, and especially seals from the twelfth to the fourteenth centuries, to determine its exact origin and date. His unpublished paper on the subject was prepared in 1961. In generously granting his permission to use this material, Szabo stated that he had not changed his conclusions. He finds that among all examples of western European representations of falconers, beginning with that on the Bayeux tapestry and ending with the French ivories of the fourteenth century, the closest parallels to the aquamanile rider in posture and costume can be found in the copies of the illustrated treatise on falconry by Emperor Frederick II of Hohenstaufen, *De Arte Venandi cum Avibus* (written in the first half of the thirteenth century) and on certain Flemish seals executed by Mosan goldsmiths beginning about 1222. The falconer on the seal of Alice, Duchess of Lorraine, dated 1260, also appears to be very close. Szabo also quotes from the falconry treatise of Frederick II description of various parts of the falconer's costume, including a special type of glove with a long sleeve worn for carrying the falcon on one's hand. These and other details prove that the aquamanile falconer is dressed and holds himself strictly in accordance with the rules set forth by the Emperor.

In comparing The Cloisters falconer aquamanile with a very similar one (Lehman Collection, New York) dated in the fourteenth century, Szabó finds that the latter could be a copy of The Cloisters piece although it lacks the vitality of the prototype. Another falconer aquamanile which may be compared with this piece was found near Grodno, and is now in the Museum of Vilno, Lithuania.

128 *Champlevé enamel on copper gilt*
H. 4¼, Diameter 2¹¹/₁₆ inches
French (Limoges),
second half of the XIII century
The Michael Friedsam Collection, 1931

This round copper-gilt box with cloisonné enamel and a conical cover is called a pyx. The Greek *pyxis,* meaning a box usually made of boxwood, parallels the derivation of the English word box from boxwood. The pyx is ornamented with circular medallions in white enamel with the letters IHS, which stand for the name of Christ (IHESUS), reserved in copper gilt. The blue enamel background is decorated with foliate scrolls also in copper gilt. The cover is hinged, and two loops and a variety of hasp are provided in front for fastening the cover securely. The cross on top of the cover is a modern replacement.

Pyxes (or pyxides) were used to hold the Host, the consecrated wafer of the Mass. It was the custom to place the Host in such containers to be placed either on the altar or to be suspended above it for the veneration of the faithful. Sometimes such containers were made in the form of the Eucharistic dove.

Ernest Rupin has outlined the twofold purpose of these boxes which stems from the Early Christian period: the Host sometimes had to be hidden in private dwellings to prevent its desecration by non-Christians, and it also had to be ready at any hour for administration to the sick and dying. Sometimes the boxes were made of simple materials such as wood, tin, or copper which would not tempt thieves. Later they were made of silver, alabaster, marble, or even of semi-precious stones such as agate, beryl, or onyx.

Customarily two pyxides were kept in a church. One was for the consecrated Host and was usually surmounted by a cross, and the other held unconsecrated wafers for future use and was usually topped by a ball or a leafy finial.

Pyxides similar to this one were made in great quantities in the enamel workshops of Limoges. Most of them are of the same size, adapted to the wafer of the Host. They are decorated in various ways, usually with foliate vines, symmetrical interlaces, geometric designs, and medallions with busts of angels or with the sacred monogram IHS as is this pyx. Sometimes they bear coats of arms, usually reserved in gilded metal against a blue or white enamel background.

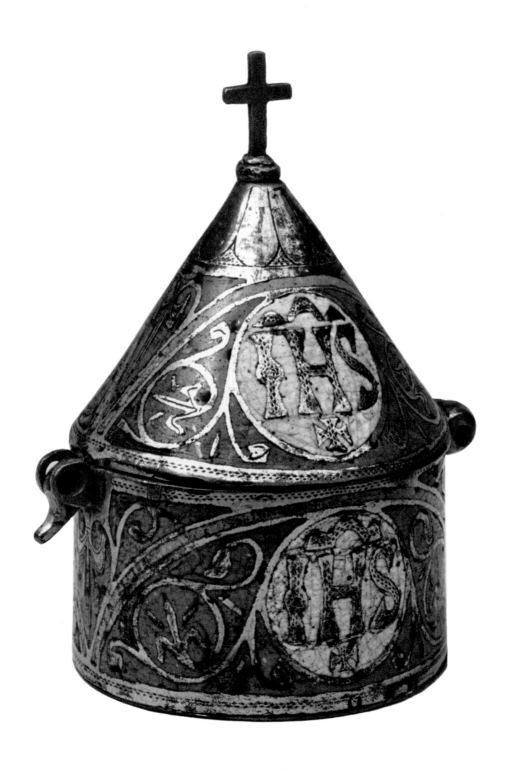

130 *Champlevé enamel on copper gilt*
H. 6½ inches
French (Limoges), XIII century
The Cloisters Collection, Purchase 1947
Ex colls. Marquis of Breadalbane; Pitt-Rivers;
Philip Nelson, Liverpool

Among the liturgical vessels used for the service of the Mass, the most important were of course the chalice and paten. But two small cruets, known also by their Latin name *ampulae* or the French *burettes,* were essential for the preparation of the Eucharist. They were usually made in pairs, one for the wine and the other for the water which were mixed in the chalice by the officiating priest. Cruets were also used for rinsing the chalice afterwards. Since the laity did not usually partake of the wine, the cruets were small. The custom of diluting the red wine used for the eucharist with water has been variously explained. One of the reasons given being that when the spear pierced the side of Christ on the cross (John 19:34) "forthwith came there out blood and water". The Council of Trent confirmed the usage of water to dilute the wine as symbolic of the union of the people with Christ.

Altar cruets were made of such materials as crystal or silver, or, as this one, of copper gilt decorated with champlevé enamel. In the twelfth and thirteenth centuries, the production of champlevé enamel in Limoges, where copper was available near the city, attained the proportions of an industry.

The Cloisters cruet is one of only seven surviving examples, but all show many common traits both in shape and decoration.

At first glance it becomes apparent that both the shape and the decoration of the cruets must derive from Near Eastern prototypes where metal cruets of this shape can still be found. The slightly elongated spherical body stands on a conical foot; a tall cylindrical neck flares slightly at the lip. The s-shaped spout begins very low on the body of the cruet and rises in an elegant double curve.

A rod emerging from the neck of the cruet supports the spout and illustrates the playful imagination of the craftsman; it ends in the shape of a human hand grasping the spout. The handle follows the outline of the body and joins the neck of the cruet at the top forming a swinging curve which provides a perfect balance to the curve of the spout. The lid of the cruet is hinged, the hinge a later restoration.

The body of the cruet is decorated with a frieze of interlaced leaf scrolls arranged in four panels with almond-shaped metal areas separating them. Above, are four ornamental bands, three of enamel and one with engraved ornament. The metal roll on the neck is engraved with foliate scrolls; above and below it are narrow bands of engraved pearls. Below the lip is a blue enameled band with a foliate scroll of copper gilt. Blue enamel covers the background of all decorations; leaves and other details are in pale-blue, green, red, yellow, and white. The lid was formerly decorated with a jewel which formed the center of an elaborate quatrefoil ornament.

The other surviving examples of cruets are one in the Bibliothèque Nationale, Paris, and two in damaged condition in the Budapest Museum. Two more are in the Bargello, Florence, and one in the Belfast Municipal Museum. Finally, one formerly in the Czartoryski Collection, Castle of Goluchov, Poland, is now probably in the Poznan Museum. The decoration on all seven is closely related with some variations in details; medallions with busts of angels appear on five of the cruets, and two medallions with the scenes of the Annunciation and the Visitation are added to the foliate scrolls on the Czartoryski piece. Foliate scrolls are used exclusively on The Cloisters cruet, and the human arm as a support for the spout appears only on this piece.

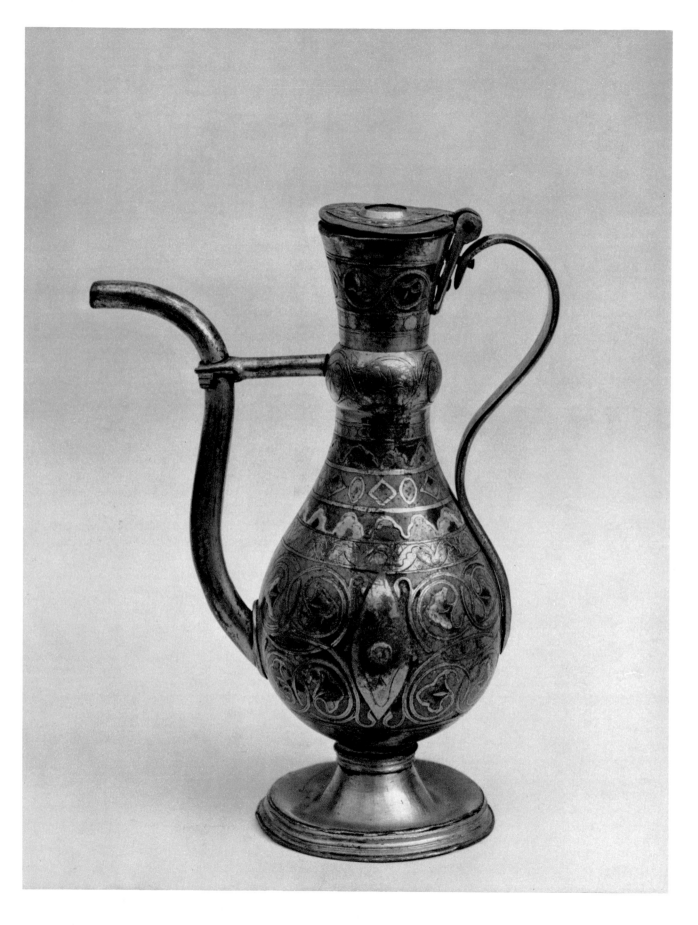

132 *Champlevé enamel and copper gilt*
H. 14½, W. 5¾ inches
French (Limoges), XIII century
Gift of George Blumenthal, 1941
Ex colls. Edouard Warneck, Paris;
George and Florence Blumenthal, New York

Tabernacles made in Limoges and decorated with champlevé enamels are rare: J. J. Marquet de Vasselot lists only six, classifying them as possible reliquaries. However, their square shape excludes this use, and it is now generally agreed that the known pieces are tabernacles. According to the latest findings, they were made to contain a pyx (see number 58) in which the consecrated wafer of the Mass was kept on the altar.

Like rectangular châsses, square tabernacles have gable roofs, which become pyramidal because of the square base. The background of this tabernacle is enameled in dark lapis-blue, with horizontal stripes of a lighter blue and scattered rosettes of various designs and colors. On the front face, against this general background is the Crucifixion, with the Virgin Mary and St. John at the sides of the cross and two half-figures of angels above. On the front gable of the roof, above the Crucifixion, Christ in Majesty in a mandorla is surrounded by the symbols of the four evangelists. The two figures of Christ and the heads of the Virgin, St. John, the angels and the symbols of the evangelists are cast separately in relief and applied over the enamel. The crystal ball and the cross on top of the roof were found to be modern

restorations and were therefore removed. Their presence on the photograph gives an idea of the original outline and the proportions of the piece.

On the back of the tabernacle St. Peter stands before a portal holding a book and the key to Paradise. As on the châsse (number 53) the door for opening the tabernacle is located here. Vine tendrils fill the background and two small medallions with busts of angels are in the upper corners. On each of the two remaining sides of the tabernacle, unidentified pairs of saints stand under arches supported by columnettes. On the back and side of the roof are half-figures of angels in medallions with light-blue enamel backgrounds. Below each of the four side plaques are two square protuberances which form the four feet of the tabernacle.

The figures reserved in gilt copper are delicately engraved as are various details. The flat engraved figures are of extremely high quality and Professor Frederick Stohlman has compared them to those on the big enamel châsse in Girgenti, Sicily.

In Limoges enamels of the twelfth century only the figures are enameled and the metal background is left free. By about 1230, or possibly even earlier, the process begins to be reversed and metal appears only in the figures which are then surrounded by a background of rich enamel patterns. The reserved figures and decorations are usually engraved. The appliqué figures such as those on the front of this tabernacle become more and more popular in the second half of the thirteenth century. Sometimes only the heads are cast in separate pieces, as are those of the figures accompanying the two representations of Christ.

The use of special containers for safeguarding the consecrated wafer of the Mass

developed during the persecution of the early Christians. In 1215, the Fourth Lateran Council prescribed that the wafer should be kept only in a safe place. From the mid-twelfth century it was usual to provide a niche in the choir of the church, or within the structure of the altar, for this purpose. Especially England and France, the Eucharist was hung over the main altar under a baldachino, from the roof of the ciborium, or from a special metal crook shaped like a bishop's crozier. If the Eucharist was kept on the altar, it was placed in a special movable container built in the shape of a reliquary. Only later was a permanent cupboard attached to the altar or built into the retable or its predella.

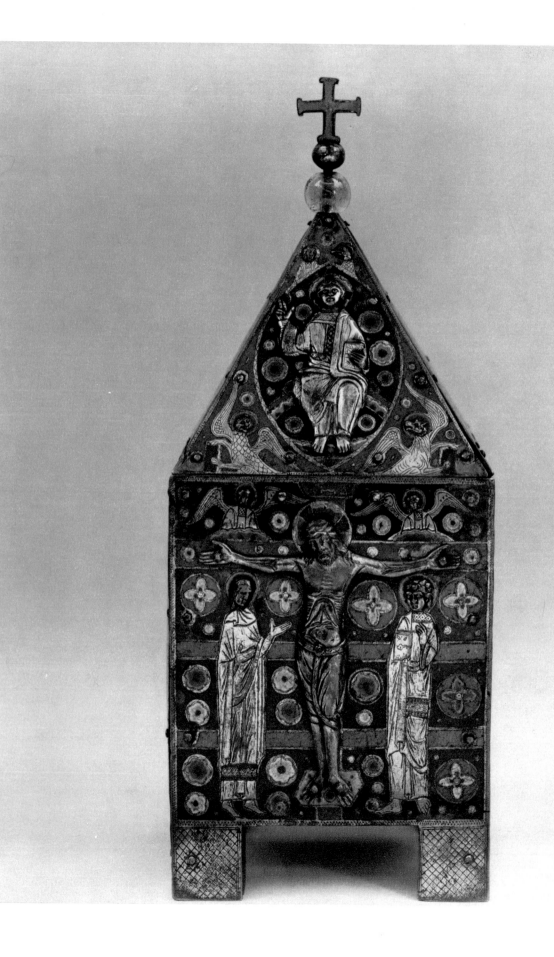

134 *Champlevé enamel on copper*
H. 28⅝, W. 13⅞ inches
French (Limoges), circa 1230–1250
Gift of J. Pierpont Morgan, 1917

This is one of a group of processional crosses with an aureole at the crossing and the ends of the arms "fleuronné", an outline deriving from leaf or flower shapes. The wooden core is covered front and back with enameled and engraved plaques, and there are copper-gilt figures in relief applied on the front.

On the obverse, the figure of Christ in copper-gilt relief, is nailed to a narrow, green enamel cross set against a background of lapis lazuli enamel with a semé of vari-colored rosettes. Small mounds under the feet of Christ symbolize Golgotha, while above his head the Greek monogram of Christ (IHS XPS) is inscribed on a titulus. Above, the hand of God (*Dextera Domini)* issues from rainbow-colored clouds. Christ wears a crown and his open eyes are inlaid with enamel beads. His body is erect, his legs straight, and his feet firmly planted on a suppedanium.

Of the four other figures originally applied at the ends of the arms, only one complete unidentified figure remains at the bottom of the cross; another at the top has lost its head. Traces of attachments remain of the two originally at the ends of the transverse arms. The missing figures were probably the Virgin Mary and St. John the Evangelist. Four rectangular engraved plaques with crystal cabochons, possibly meant to contain relics, are inserted between the enamel-plaque center and the ends of the arms.

The reverse of the cross consists of engraved and enameled plaques; in the center is Christ in Majesty, and on the extremities the symbols of the evangelists. Six other copper-gilt plaques are engraved with figures of angels.

This type of cross was produced in Limoges workshops in the second quarter of the thirteenth century, or about 1230–1250. Paul Thoby, who made a study of the group, notes that crosses on which Christ's body and head are erect are earlier than those on which the figure expresses suffering by a sagging body and drooping head. The earlier figures, in which Christ is not represented dying or dead but with head erect and eyes open, can be referred to as Christ triumphant on the Cross (*Regnavit a ligno Deus).*

Among comparable crosses (each with variations in details) the one from the monastery of St. Maximin in Trier (Trèves), now in the Catholic Parish Church at Pfalzel, should be mentioned first. Other related crosses are in the Münster Cathedral, the Victoria and Albert Museum, London, the Dijon Museum, and the Walters Art Gallery, Baltimore, Maryland.

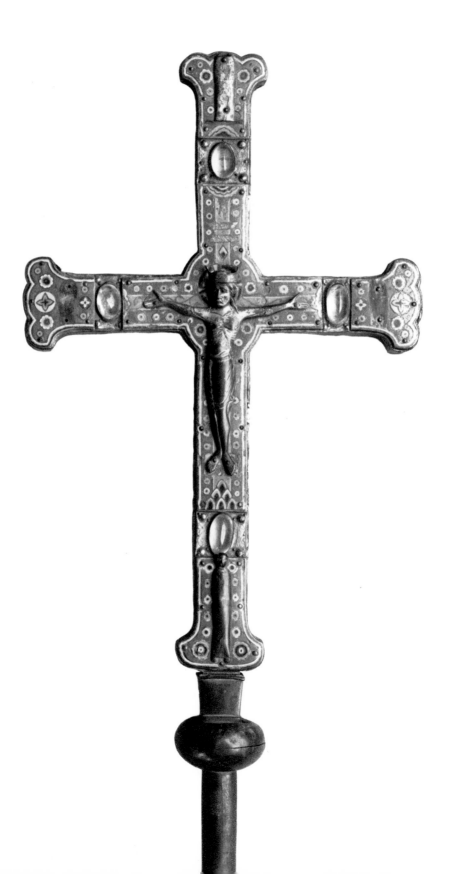

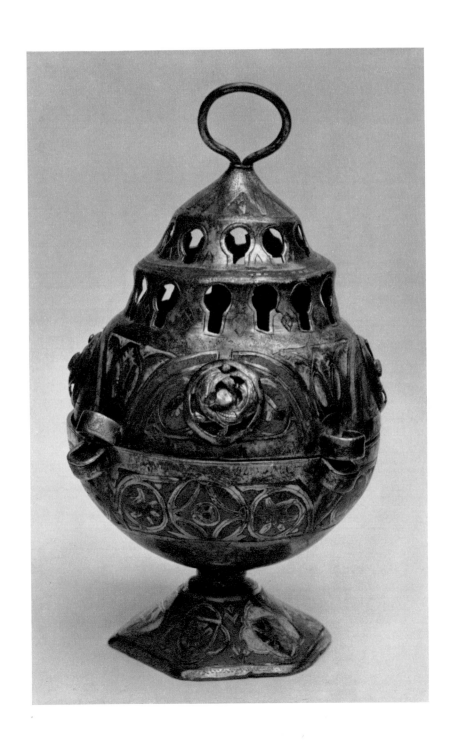

62 Censer

Champlevé enamel on copper gilt
H. 7½ inches
French (Limoges), XIII century
The Cloisters Collection, Purchase 1950
Ex coll. Baron Max von
Goldschmidt-Rothschild, Frankfurt am Main

The copper-gilt censer with a cover decorated with champlevé enamel is one of a few surviving examples. A great number of similar ones were probably in use in the Middle Ages. Not many medieval enameled censers have survived because of the heat and wear to which they were subjected. This one is worn and its enamel is chipped, but its basic appearance is intact.

Most censers were made of bronze or silver, but the desire to have a harmonious and colorful set of liturgical vessels for the altar of a church or chapel must have led to the difficult task of enameling the curved surfaces of a censer. The problem of keeping the molten enamel paste from running before it cooled and hardened must have been aggravated by the shape of the vessel. Enamel had to be used, because there was no other way to give a durable color to metal.

The key-hole shapes of the openings at the vessel's top are the same as those used on the crests of many enameled châsses. The smoke of the burning incense rose from these openings when the censer was swung back and forth during the Mass. The chains are missing but their attachments on the top and the bottom half of the vessel remain: the loops at the lower edge of the cover served as guides for the passage of chains when the cover was raised and lowered; the top central loop was for the chain that raised the cover to replenish the hot coals or incense. The hexagonal foot is of a standard shape for censers.

The leaf, scroll, and geometric patterns are reserved in metal, while the background enamel is of green, yellow, red, white, and shades of blue. Four openwork medallions with a curled basilisk biting himself have been attached to the sides as additional ornament.

On the foot are two unidentified coats of arms repeated in alternating order on each of the six sides. One, gules, a lion rampant or, the other party per pale; and then on the sinister half what appears to be: bendy of four, azure and or.

137

63 Gemellion

138

Champlevé enamel on copper gilt
Diameter 10⅝, H. 1½ inches
French (Limoges),
second half of the XIII century
The Cloisters Collection, Purchase 1947
Ex coll. Arthur Sachs

The word gemellion derives from the Latin *gemellus,* the diminutive of twin. The name was given to a certain type of basin made originally in pairs and used for washing hands. One of them was usually spouted for pouring water, and its mate served to catch the overflow. The spouts were often made in the shape of animal forms. Earlier gemellions mentioned in the ninth century by Pope Gregory IV might have been made of various materials. Occasionally silver ones are listed in inventories. The term gemellion was current about 1000, but the word "bassin" (basin) was often substituted in later centuries for the same type of vessel. Those made in Limoges like this one of copper gilt decorated with champlevé enamel and engraving appear in the thirteenth century. The generally accepted date for their manufacture is about 1230–1300. Their sizes are standard and vary but little from the average of about eight to ten inches. Most of the gemellions known are decorated with secular subjects, even those from churches that were used in the liturgy, although some religious subjects are also encountered.

On the raised center inside this gemellion is a representation of a knight on horseback. He holds a banner and a shield of late thirteenth-century shape with the coat of arms described as a "cross fleurdelisé" (a cross with fleur-de-lis ends). The same arms appear in combination with others on a gemellion in the Cluny Museum, Paris, but they have not been identified. The figure of the knight on the prancing horse is reserved in copper gilt against a white enamel background encircled in red and filled with foliate scrolls of the type used in endless variations in Limoges (cf. Lusignan Mirror Back, number 67). On the inner side of the basin's wide border the foliate scrolls are repeated, and between them stand eleven figures wearing surcoats over what appears to be chain mail. Some of them hold shields and raised swords, others hold only spears. The figures are again reserved in copper gilt with incised details set this time against a light-blue enamel background. Along the edge of the gemellion runs a border of triangles filled with white enamel. The back of the basin was gilt originally and in the center it bears an incised mark of six fleurs-de-lis which has not been interpreted. Some of the enamel is lost and some of the gilding has rubbed off, but in spite of this, the gemellion is in better condition than many of some hundred others in existence. The initial hard use they received, combined with their later use for collecting donations in churches, took a high toll.

Many coats of arms found on Limoges gemellions, as well as on other Limoges works, actually represent those of the owners or donors of the objects. However, most of them are decorative and have been chosen either for their design quality or because of the importance of the families they represent. Still others result from the fantasy of their makers.

Eastern influence in designs used in Limoges workshops has been noted, and this is especially true in cases when pseudo-Kufic inscriptions are included. It is highly probable that the first pieces were made in imitation of metalwork seen in the Near East or in Moorish Spain or brought back possibly by the crusaders. But in spite of the strength of such influence, many designs and shapes made in Limoges originated with local craftsmen.

Gemellions were used both in churches and in lay households. Their use is found illustrated in several manuscripts and in other works of art. A moralized Bible of the thirteenth century shows gemellions used in the scene of Pilate washing his hands: an attendant pours water from a gemellion over Pilate's hands and the water is caught in a second basin placed below. From books on church rituals it is known that the priest was supposed to wash his hands before saying the Mass, and again before distributing the bread and wine. The *Ordo romanus* describes the ceremony in which the cardinal assigned to assist the pope kneels before him carrying two gemellions: he places one below the pope's hands while he pours water over them from the other.

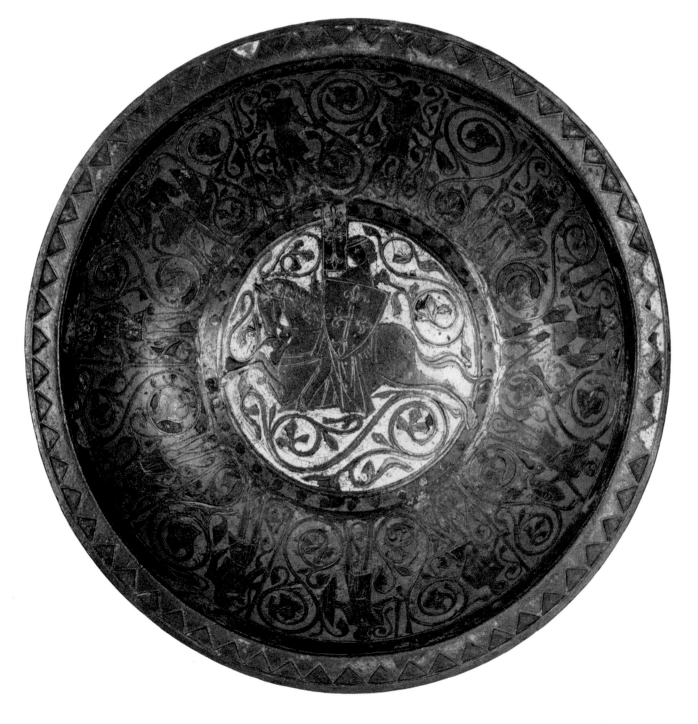

64 Virgin from Strasbourg Cathedral

Sandstone, polychromed and gilt
H. 58½ inches (with base)
French (Rhenish), 1247–1252
The Cloisters Collection, Purchase 1947
Ex colls. J. H. Fitzhenry, London;
Alphonse Kahn, Paris
Provenance: From the former choir
screen in Strasbourg Cathedral

140

This statue of the Virgin, a true Queen of Heaven, expresses the most ennobling qualities of early Gothic art. The relationship of face, veil, and crown is adroitly conceived and the modeling of the gentle features—wide brow, almond-shaped eyes, delicate mouth, and pointed chin—is enlivened by the painting of the flesh. The gilded veil and mantle lined with red, a blue gown with jeweled neckline revealing a narrow line of a white undergarment, and blue slippers are all remains of the original polychrome. The angular Gothic folds of the mantle and the rich borders studded with red and green jewels contrast with the simplicity of the Virgin's gown. The elements of design are organized with imagination and subtlety. The back of the statue is flat and rough, and has an iron bar and ring for attachment.

Stylistic comparisons of such details as the cutting of the eyes and the treatment of the hair with other statues known to come from the choir screen helped James J. Rorimer to identify this statue of the Virgin as one from Strasbourg. The original setting for this sculpture, the choir screen of Strasbourg Cathedral was demolished in 1682. Some of the statues from the screen were placed in niches of the Cathedral's tower. The fate of the Virgin is not known; it was found in Alsace, reputedly at Sarrebourg, and may have been in the Sarrebourg Castle (residence of the bishops of Strasbourg). From there it came into the collection of J. H. Fitzhenry, and in 1913 was bought by Alphonse Kahn.

The whole interior of the Cathedral, with the screen in place, is shown in a 1630 engraving by Isaac Brunn, and a drawing of about 1660 records the position of the sculptures between the gables on the face of the choir screen. The Cloisters Virgin is the fourth figure from the left, and a more detailed drawing of it is repeated above the screen, with a handwritten note saying: "the little Christ Child has its right hand broken off". Though the drawing is a Baroque interpretation of the Gothic sculpture, it provides conclusive evidence of its origin. In the drawing, the Child seated on a rosebush offers his mother what appears to be a fruit, or possibly a bird. In the National Museum in Munich, a fourteenth-century sculpture from Straubing shows a similar composition with the Child on a rosebush. The iconography of the Virgin represented with a symbolic rose, rosebranch, or rosebush, goes back to the text of the bible, Isaiah (11:1); the Virgin's connection with the Tree of Jesse is developed in the play of words: virgo (Virgin) and virga (twig). The iconography of the Virgin of the Rose can also be connected with the writings of St. Bonaventura and of St. Thomas Aquinas, and the "virgo-virga" play of words used by Alain de Lille.

Ten statues, most of them apostles, from the choir screen of the Strasbourg Cathedral are presently in the Musée de l'Oeuvre Nôtre-Dame in Strasbourg. There may be one other in the Toledo Museum in Ohio. Comparative tests of the paint of The Cloisters sculpture proved that the paint corresponds with remains of color on the Strasbourg choir screen fragments. The size of all the statues is comparable: an average of 55¾ inches for the Strasbourg figures and 56 inches for the Virgin.

Otto Schmitt correctly dates the choir screen sculptures in the mid-thirteenth century. He states, after a study of The Cloisters Virgin, that it "explains in part the stylistic basis of the sculpture of the west portal of the Cathedral. The facial type is the same as that of the Wise and Foolish Virgins of the right, south portal of the façade." Hans Haug in his study of the screen dates it between 1247 and 1250, "at all events before 1252", and these must be the dates for the Virgin as well. One must also point out the resemblance of this figure to the sculptures of Ste Chapelle in Paris of a somewhat earlier date (circa 1245).

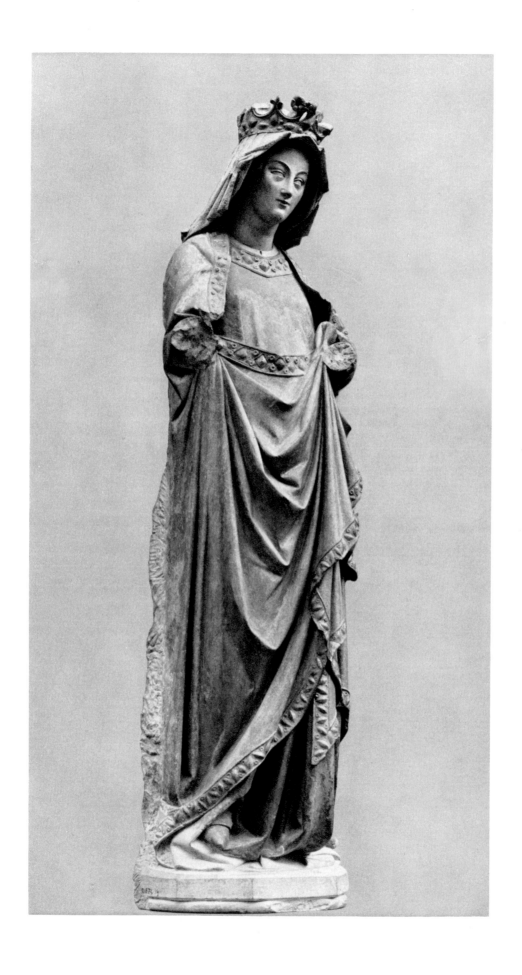

142

Ivory. 4⅛ × 4⅛ inches
French, first half of the XIV century
Gift of J. Pierpont Morgan, 1917
Ex coll. Moentschel

A volute decorated with maple leaves encloses two openwork scenes carved on either side of this crozier head. On one side is the Virgin as Queen of Heaven, and on the other the Crucifixion of Christ.

The standing Virgin and Child are flanked by two angels holding lighted candles as these would be held by deacons during the service of a bishop or as a guard of honor would present arms to royalty. The iconography is the same as that on the ivory tabernacle (number 71). The Virgin wears an elaborate crown over a short veil. Her posture is a Gothic s-curve; the mantle thrown over her shoulders is held up by her right elbow, pulled across the front to her left side where it is held up by her left arm, and then cascades in a series of tubular folds to a point below her knee. In her right hand she holds a flower, possibly a rose, and on her left arm she carries the Christ Child clothed in a long tunic. The Virgin's face is turned to the Child, establishing a mother and child relationship, and he places a hand on her shoulder in the tender gesture of affection used extensively in the fifteenth century especially in Germany and the Netherlands. The Virgin is depicted here as both Queen of Heaven and as Mother.

The drapery of the angels' mantles is similar to that of the Virgin's. The three standing figures are stocky, but their postures and grouping are well balanced

and cleverly arranged within the crook of the volute. The folds of the drapery create a harmonious unified pattern. The very low waistline under the flat bodice of the Virgin's dress helps establish an early fourteenth-century date, for waistlines went higher later in the century. Also the front panel of the Virgin's mantle which usually shows more relief in the thirteenth century has a tendency to flatten in the fourteenth, as it begins to do in this ivory carving; even the tubular folds which give a certain three-dimensionality to the drapery are somewhat flatter in this century than in the preceding one.

The scene of the Crucifixion is represented on the opposite side of the crozier head. The head of Christ falls forward and to the side, the torso swings out to the right, and the knees are bent to the left. His crossed feet are fastened by a single nail to the shaft of the cross in a characteristically Gothic manner. A twisted rope-like coronet on Christ's head suggests the crown of thorns. The sagging figure of Christ emphasizes the suffering he endured before his death. The unusually low position of Christ's body on the cross, his feet almost touching the ground, strengthens this emphasis. The loincloth placed very low is another fourteenth-century characteristic.

To the right and left of the cross stand the figures of the mourning Virgin and St. John the Evangelist. The Virgin's body is bent backward and forms a continuous curve down to her feet, with only her inclined head breaking its sweep and providing a counterbalance. The Virgin's hands are raised half in horror, half in supplication, with the right hand placed on her heart. The apostle holds a book in his right hand, and rests his head on his other hand in sorrow.

He looks up at Christ, although Christ's head is almost on the same level as his own Originally, the ivory crozier was probably painted and gilded as one can still see traces of gilding on the back of the Child's head and further traces on the angels' hair. The hands of one of the angels and the candle he held, the top of the second candle, part of the cross including the right arm of Christ, and some other details are missing.

Koechlin's date for this piece in the first third of the fourteenth century may be correct because it still bears traces of the thirteenth-century style. It might be of interest to compare the naturalistic leaf decoration related to the thirteenth-century decoration on the capitals in the Cathedral of Nôtre-Dame in Paris with the same types of leaves on the fifteenth-century Italian silver crozier head, where they have lost their realistic appearance and have acquired strictly ornamental shapes.

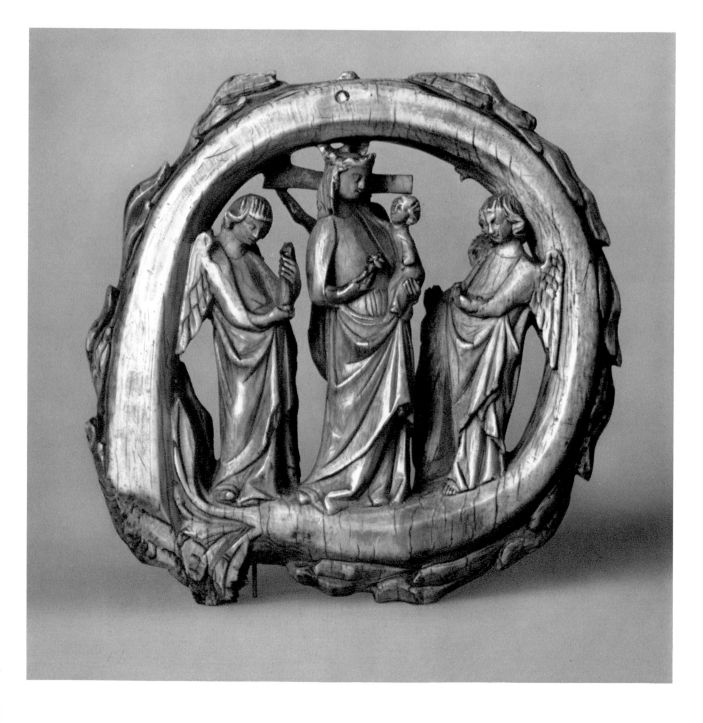

144 *Oak.* H. *29 inches*
French (Artois?), last quarter of XIII century
The Cloisters Collection, Purchase 1952
Ex colls. George Brauer, Florence;
Octave Homberg, and Joseph Homberg, Paris

One of a pair in The Cloisters Collection, this oak angel was originally polychromed and gilded. The wings for which slots are provided on the back are lost. Appearing weightless and as if advancing, the angel rests upon his left leg and at the same time turns slightly to the right in a posture which may derive from a classical model. His mantle is draped over a tunic to form long, classical folds which fall naturally and gracefully to his feet and break at the ground. The sculpture combines the monumentality of stone figures on cathedral portals of the thirteenth century with the delicacy and elegance of ivory carvings.

The finely carved face has a courtly, almost smiling expression. The short nose, elongated eyes, small chin, and neatly curling locks, caught by a narrow ribbon or fillet, have a grace that relates the figure to the idealized classicism of thirteenth-century Gothic. This figure shows the stylistic development of the later thirteenth century from the sturdier and more monumental style seen in the beautiful earlier Virgin from Strasbourg Cathedral (number 64).

There are other thirteenth-century angels of similar type which are related but differ in interpretation. All but one appear to come from the region around Pas-de-Calais in Artois. All are similar to the style of the angels surrounding the Cathedral of Reims, which in turn derive from the smiling angel on the Cathedral's west façade. They were once thought to have come from Champagne (or Reims) but the close relation in style is explained by the close political and ecclesiastical relations that existed at that time between Reims and Artois. The Cloisters angels are particularly close to two other pairs, both from Artois and possibly belonging together originally. One of the pairs was found in a church in Saudemont, a small village between Arras and Cambrai; the other, in the church of Humbert, another small village situated in the center of Artois. The Cloisters angels are slightly smaller than these two pairs, and may not belong to the same group, but they are among the most elegant of all angels known.

Such angels were usually made in groups of four or six and were placed on top of columns around the main altars of churches. They held either candlesticks or carried the instruments of Christ's Passion. By the position of his hands, one sees that The Cloisters angel probably held a long object, a cross or a lance. Both arms are now broken, the left at the elbow, the right just above the wrist. A hole in the top of the head suggests that at some time there was a halo, possibly of gilded metal.

There are a number of drawings and paintings, as well as manuscript illuminations which depict altars surrounded by such angels on columns. Some of these were carved in wood, but others were made in gilt bronze or gilt silver. In old accounts and inventories one can find references to this effect. The angels at Saudemont bear traces of gilding. Those at The Cloisters show traces of red, green, and blue on the drapery, but it is difficult to determine their original polychromy.

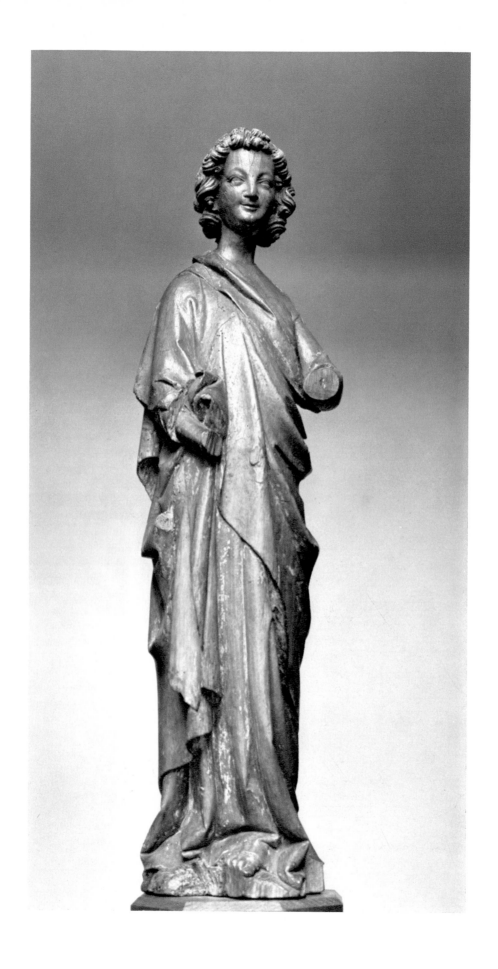

146 *Silver gilt with champlevé enamel*
Diameter 3¾ inches
French (Paris), circa 1300
The Cloisters Collection, Purchase 1950
Ex coll. Baron Max von Goldschmidt-
Rothschild, Frankfurt am Main
Arms: Lusignan of Poitou (France)
and England

The silver gilt and enamelled mirror back is surrounded by a wreath of ivy to which cling six figures, half-men, half-lions. These cheerful personnages remind one of droleries or marginal drawings in French and English manuscripts of the period of the mirror back. On the roundel within the vine frame, against a background of translucent green enamel with reserved silver gilt leaf scrolls, a square area with champlevé enamel is divided into four smaller squares. Each of these bear alternately the arms: gules, three lions (leopards) passants regardants or—the royal arms of England; and: barry argent and azure, four lions rampant gules— the differenced arms of one of the Lusignans of Poitou, France. Such quartered arms could be those of Hugh XI, Le Brun, Sire of Lusignan, who was the first to difference the family arms of the Lusignans (barry argent and azure) with a border of six lions rampant gules (his seal of 1246). He also could quarter his own arms with those of England, either after his mother, Isabel of Angoulême, the widow queen of John the Lackland of England, and wife in second marriage of Hugh X, his father, or he could have done so for his and his brothers' sponsor, their half-brother, Henry III of England. The differenced Lusignan arms were used later: in 1283, by one of the sons of Hugh XI, and in 1301, by his grandson. They also appear on the tomb of his wife, Yolande of Brittany (destroyed, and known only from drawings) and on that of his brother, William of Valance, in Westminster Abbey, London, dated 1296. The male line of this branch of the Lusignans ends in 1302.

Originally there was a mirror, probably a metal one, on the inner side. On this side one can also see how the mirror was closed when not in use, connected as it was to its (now lost) counterpart, with a closure a bayonette, a device also used for closing some of the Greek and Roman box mirrors and many of the French fourteenth-century ivory ones.

The dating of the mirror depends primarily on the identification of its possible original owner, restricted by the coats of arms into the second half of the thirteenth century. The comparison with two objects closely related to it by style and technique, and also dated by coats of arms with greater precision, limits the dating of the mirror to the end of the thirteenth century, or around 1300.

The silver gilt *hanap* cover with enamel (All Souls College, Oxford, England), bearing arms of several persons known to have lived about 1297–1302 is one of the related pieces; and a gold and enamel reliquary box (Museo Nazionale, Cividale, Italy), dated on the same grounds about 1294–1307, is the second. The first of these is attributed to Guillaume Julien (1256–1316), one of the favorite goldsmiths of Philip the Fair, King of France.

As to the young men with half-lion's bodies and tails, they may be a reflection on the French ridicule of Englishmen as having tails: *"Angli caudati."* It could have been brought in by the Lusignans themselves as a taunt because they more often than not espoused the cause of the English Crown against the French, and, belonging to the originally Anglo-Norman states, remained faithful to the Plantagenets.

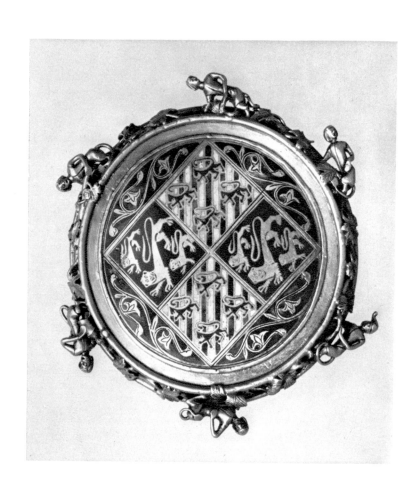

148 *Earthenware.* H.7; H.4½ *inches*
English, London or Surrey (?),
late XV century; XV to early XVI century
Rogers Fund, 1952
Possibly excavated in London
Ex coll. John Ball, London

The tall jug, dated slightly earlier than the small one, has an ovoid body, a funnel-shaped neck, a pinched spout, and a ring handle. It is made of light buff clay, showing reddish color where the upper layer of clay is chipped off. A brilliant green glaze covers its upper half and handle. Several parallel incised rings around its neck may be ornamental. The jug has been tentatively dated in the late fifteenth century, but similar ovoid-shaped jugs were made by English potters as early as the thirteenth.

The small, finely proportioned jug with globular body is modeled of fine-quality light-buff clay and has thinner walls than the tall jug. It is decorated with a thick raised cordon around the slightly expanding neck, an incised line around the stoutest part of its body, and a bright-green mottled glaze on its upper half.

A very similar small jug, five inches tall, has been published by W.B.Honey as a Tudor mug for table use, with an explanation that such green-glazed vessels were used for drinking in the sixteenth century. Discussing the mug, Honey says further that its "graceful lines are of pure English descent," but that the shape might have been inspired by German stoneware.

Another similar vessel, about seven inches tall, in the British Museum (B239) is also called a mug. Although there is no documentary proof that these two vessels were found in London, their previous owner indicated that they were. In another jug, acquired in the same lot as these two, a slip of paper was found with a notation that it was dug up in London in 1892 during excavations for the Chancery Lane frontage of the Public Records Office.

Earthenware vessels and dishes in the later Middle Ages were made principally for common use, the richer houses preferring vessels of metal or other material. Not until the Spanish (Valencian) and Italian potters reached the high level of production of their magnificent wares of the fifteenth century did such earthenware vessels as lusterware from Valencia, and majolica from Tuscany become luxury items highly valued by nobles, ecclesiastics, and rich merchants.

The English potters who made this simple ware were mere artisans not united in guilds, and their pottery represents what one could call now peasant or folk art. Nevertheless, it cannot be called crude for it reached a high level of achievement in the production of attractive shapes and pleasant proportions. Some of the pottery vessels were decorated, but most of them, made for daily use, were plain fired clay possibly with a light slip and with a splash of green glaze.

Many earthenware vessels dating from the thirteenth to the sixteenth centuries, of a kind similar to the two jugs, were found during various earthworks in London. There is no evidence that any pottery was actually made in London, and it is probable that most of the medieval pieces found there were made in Surrey where suitable clay material existed. Traces of several kiln sites have been discovered close to London, within approximately a twenty-mile radius. It is not easy to date earthenware exactly, because most of it was found by chance, unaccompanied by firmly datable objects.

[68 B]

[68 A]

150 *Limestone, painted. H. 62½ inches*
French (Normandy), 1300–1325
Bequest of George Blumenthal, 1941
Ex colls. George and Florence Blumenthal,
New York

In this unusually large and imposing statue a slender Virgin stands in an elegant almost straight posture. But a sharp twist of the waistline throws her shoulders and head out of alignment, and her body forms a gentle curve which is repeated in the parallel folds of her skirt. This movement is not the usual S-curve. The overall graceful simplicity, the posture of the Virgin, and the lively expression of the Child are very much like those found in the statues of Ile-de-France. Here however, the Virgin's bearing is simple and without the artificial suavity or courtly grace of some of the Ile-de-France sculptures.

Traces of a gilt border can be seen on the Virgin's veil. Her blue gown is girdled at the waist; a red mantle bordered in gold and black is thrown over her shoulders. Her waistline is very high, and the difference in proportion between the upper and lower part of the figure is accentuated by the position of the Child whose head is at the same level as hers. The Virgin supports the Child with a hand bent in an almost vertical position. With her right hand the Virgin clutches a bunched edge of the mantle as if she were holding the usual scepter or flower.

The Child is affable, extremely aware, and very similar to many others found in the Ile-de-France. With his right hand he holds one end of his Mother's long sash; his full-length tunic is blue with a red border. The faces and hands of both figures are painted in flesh colors. The left hand of the Child and the tip of the Virgin's foot are broken off and missing.

There are no clues to the actual provenance of the statue, but there is a group of statues in the region of lower Normandy in which one finds similar details: the same sharp bend at the waist, and the same position of the Child held as if his mother were elevating him before the faithful. Parallel, tubular drapery folds on either side of the figure are also a characteristic of this group. The stone of the Museum statue closely resembles the stone from Caen quarries, and geological studies have confirmed the relation and similarity of the two samples in color, grain, and structure. The stone from these quarries was used in Caen, Rouen, and Coutence, and it was also exported as far as England. William H. Forsyth, who made a special study of the regional types of French statues of the Virgin and Child, and who has published this particular statue, suggests the Vexin region, between Normandy and Ile-de-France proper as the most probable location of origin.

A date for the statue in the first quarter of the fourteenth century is supported by comparisons with statues from Normandy and central France dated between 1311 and 1325 where one finds the mantles hanging open in a similar manner and the folds of the gowns falling in long full curves sweeping the ground.

The curious gesture of the Child holding the loose end of his Mother's belt may be just playful, but it also may have a symbolic implication. It may betoken the mystical marriage of Christ and his Mother, often referred to as the Sponsa Filii—the Bride of Christ—in popular hymns and sermons and in commentaries to the Song of Songs e.g., by St. Bernard. In Roman times it was the privilege of a bridegroom to untie the belt of his bride. Its length may refer to the virginity of the Mother of God, since a maiden's belt was supposed to reach the ground. Such a combination of religious and secular themes was natural in an age which accepted the dogmas of Christian religion with a faith as implicit as that of the Early Christians.

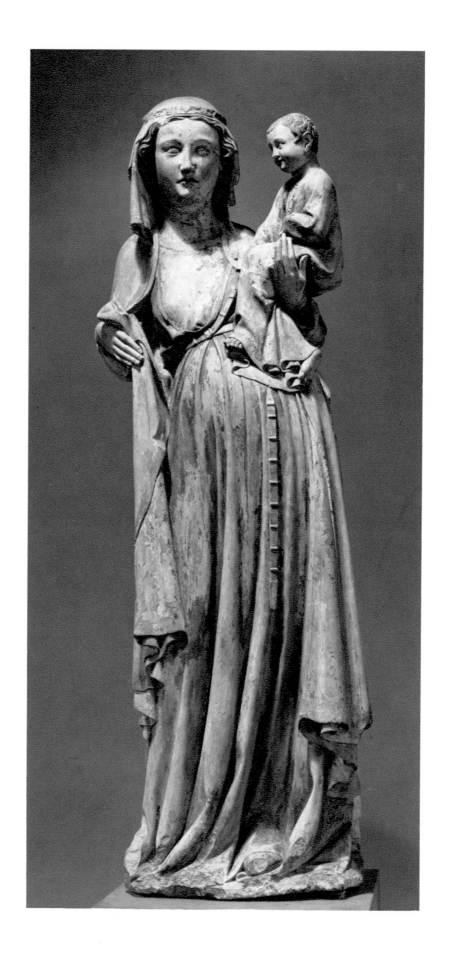

152 *Ivory, champlevé enamel, and copper gilt*
H. 10, W. 7¼ inches
French, second half of the XIV century
Gift of J. Pierpont Morgan, 1917
Ex colls. J. Essingh, Cologne;
Ruhl, Cologne; Eugen Felis, Emden

Probably the front of a book cover, this ivory plaque of the Crucifixion in a frame of repoussé copper gilt is set within a border of gilt copper decorated with champlevé enamel. Judging by traces of hinges on the left side of the plaque, the ivory was originally the right leaf of a diptych.

The Crucifixion is set beneath a trefoil arch and a gable with crockets suggesting church architecture. Over the arms of the cross are the sun and the moon surrounded by clouds. The body of Christ sags on the cross in a typical fourteenth-century manner (cf. number 65). Flanking it are the figures of the Virgin and St. John the Evangelist, each holding a book in one hand and extending the other toward Christ. Their gestures and the inclination of their heads toward the cross express their mourning. In the upper corners of the plaque above the gable, two kneeling angels weep, covering their faces with their hands.

Both the Virgin and St. John are clothed in long tunics and mantles. Hers is drawn over her head, and she holds the book in the manner of a fourteenth-century Virgin holding a bunched end of her mantle. The mantles of both figures are draped over their right arms, the ends gathered under the left arms from which they fall in heavy vertical tubular folds. The whole composition is typical of the period, and the fullness of the drapery suggests a date toward the middle of the century. Since the ivory seems first to have been used as part of a diptych, the book cover was probably made slightly later than this date.

Six attendant figures in niches, three on each side, decorate the copper-gilt frame of the ivory. The figures as well as the scrolls above and below the ivory are executed in repoussé. The decoration on the outer frame consists of a continuous row of diamond shapes with concave sides, rosettes in the centers, and palmettes filling the interstices. Leaves arranged in the pattern of a cross fill the corners.

The sharp blue and strong red enamel of the border plaques is typical of fourteenth-century work. Enamel, metalwork, and ivory were often used together throughout most of the medieval period. The colors of the enamel and the brilliance of the gilt metalwork form a pleasing contrast to the softer texture and creamy color of the ivory.

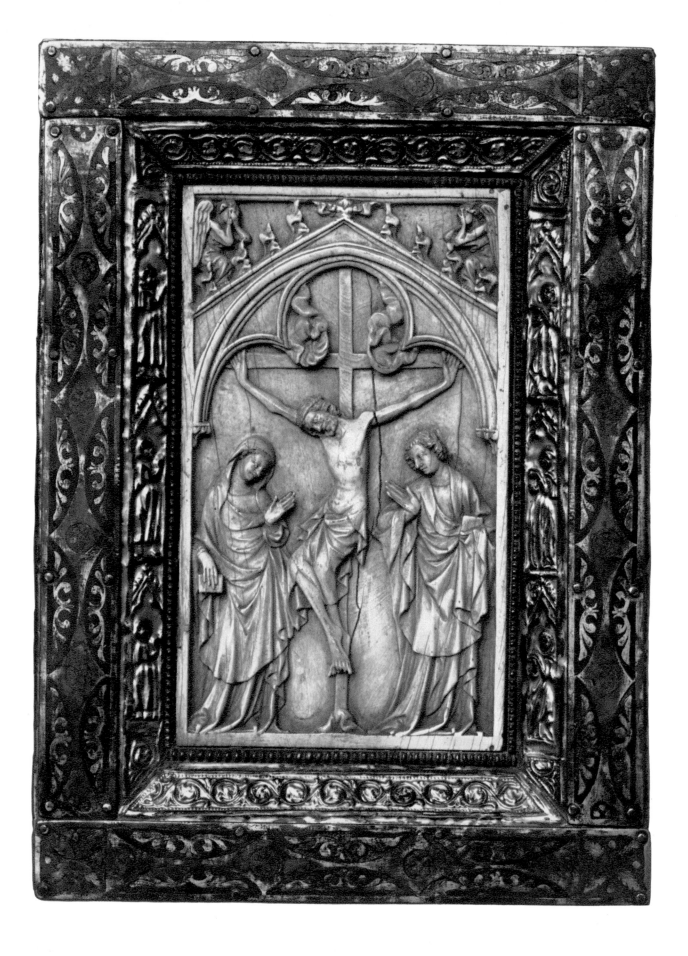

154 *Ivory, with traces of color and gilding*
H. 15½, W. 9 inches (open)
French, second half of the XIV century
Gift of J. Pierpont Morgan, 1917
Ex coll. Baron Albert Oppenheim

In the form of a triptych with pointed gables and ornamental crockets, this tabernacle stands on a rectangular base with poly-chromed gilt decoration. A standing figure of the Virgin and Child is carved in high relief on the central panel in a niche formed by a pointed trefoil arch supported by slim columnettes. On the wings are two attending angels called cerifers carrying lighted candles.

Over a belted tunic, the Virgin wears a mantle which falls in a smooth, easy line below her waist and forms an apron-like panel in front. The border of the mantle forms a diagonal line which balances the upper curve and ends at her right foot. The heavy folds of the Virgin's long dress visible under the mantle form a rhythmical row of tubular broken folds, which almost hide her feet. The Virgin holds the Christ Child in her left arm and a branch with roses in her right.

The Child holds an apple in his left hand—a symbolic reference to the redemption of original sin—and places his right hand on the breast of his Mother, in a gesture related to the maternal nursing type of Virgin and Child.

The Virgin here is not only a mother; she is also the Queen of Heaven, attended by two angels and wearing a crown evident-ly placed on her head by a third smaller angel in the arch above. The floral branch in her hand is like a flowering scepter.

The Virgin stands in the usual Gothic s-curve posture with her weight resting on her left leg. The Gothic mannerism of the figure has not yet reached its overly exag-gerated stage, but is quiet and well balanced, as is the whole architectural setting. The pointed trefoil arches with only slight touches of tracery in the spandrels, and the regular row of leaf crockets along the gable —of the same simple design as the leaves on the capitals of the columnettes—keep the ornamentation on a sober level. The fact that the eyes, hair, and lips of the figures, the drapery, and certain architectural details of this shrine were originally enriched with colors and delicately highlighted with gold does not destroy this sobriety but only en-riches it, giving it a hieratic setting. The quinquefoil rosettes on the background panels and the delicate vine on the frames painted in gold are still visible although some of them may have been retouched.

In fourteenth century France the stand-ing Virgin with the Child is common to both monumental sculpture and small scale carvings in ivory. The fullness of the Virgin's face and figure, popular towards the middle of the fourteenth century, indi-cates a date for the ivory about 1350 or in the second half of the century. Although this fullness of figure and face appears in the Ile-de-France, it becomes charcteristic for the regions east of Paris. Koechlin, in the standard work on French ivories, now somewhat outdated, includes this particular piece among the early tabernacles and notes the slight heaviness of style. There are a few minor restorations on the top of the central gable and on some of the crockets. The gilding and paint might also have been retouched. Small portable shrines, like individual statuettes of the Virgin and Child or of saints, were often made of precious materials such as ivory or silver. They are found listed in inventories of private possessions as well as in those of churches and cathedrals.

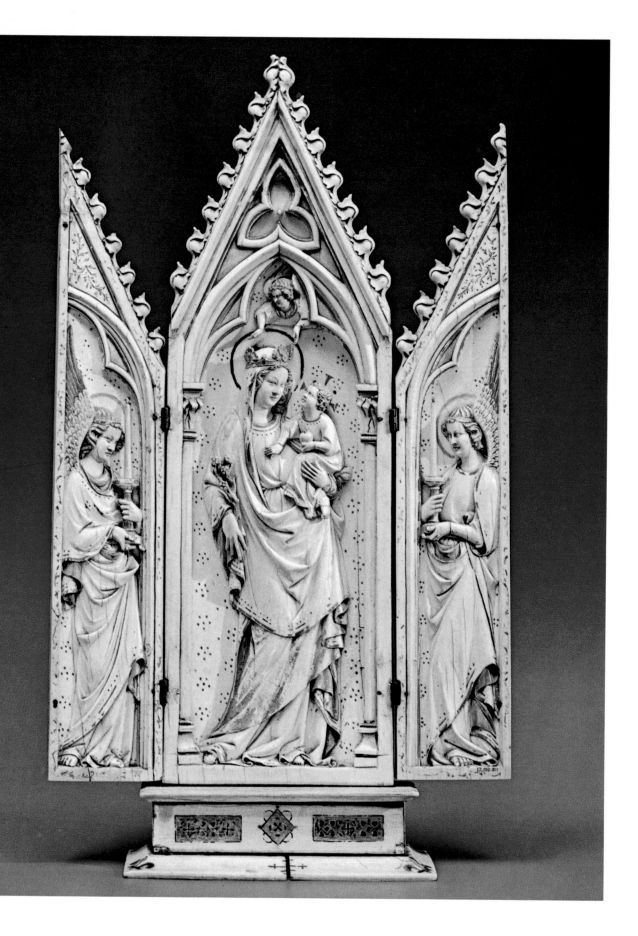

156

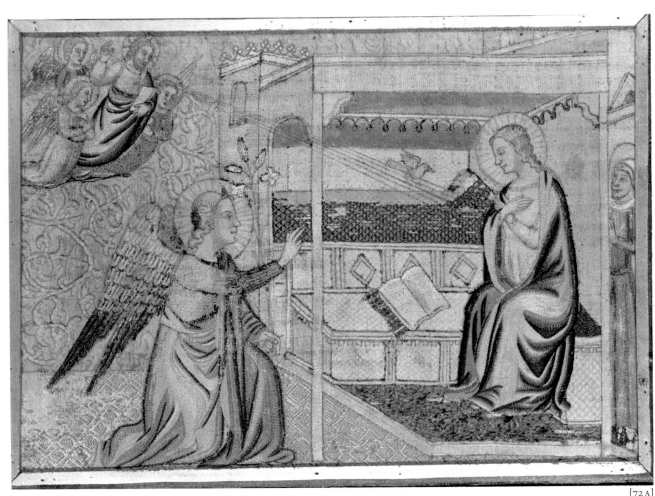

[72 A]

Silk and metal thread on canvas
Average H. *11⅜,* W. *16½ inches*
Italian (Florence),
middle or second half XIV century
Attributed to the workshop of Geri Lapi,
Florence (Opus Florentinum)
Rogers Fund, 1958, [72 B]
The Cloisters Collection, Purchase 1960, 1961
[72 A–C, F–H]
Bequest of Charles F. Iklé, 1964 [72 E]

Eight scenes from the Life and Passion of Christ, executed in embroidery, are represented on these rectangular panels which probably formed part of an altar frontal or retable. The scenes are: the Annunciation of the Virgin, the Presentation in the Temple, Christ among the Doctors, the Baptism of Christ, the Flagellation of Christ, Christ carrying the Cross, the Ascension of Christ, and the Pentecost.

Now somewhat worn, the embroidery was executed in a great variety of stitches and in more than twenty shades of colored silk and metallic thread (silver, and silver-gilt strips of metal wrapped around a core of silk yarn). A relief scroll pattern worked in thick cotton yarn covered with metallic gold threads originally covered the entire background, and metal threads were used everywhere for various details and on the clothing of Christ and the Virgin. When the panels were mounted together the light gliding over the rich and colorful surface must have created an effect comparable only to that of precious metalwork enriched with jewels and enamels.

In places where the embroidery on these panels is worn through, underlying fourteenth-century Florentine drawings have come to light. They are particularly precious because of their quality and rarity. In line and brown wash, the design is free and spontaneous, the shading carefully executed, and a strong plastic effect is achieved. These drawings bring to mind the discovery of underdrawings, or sinopie, beneath Italian frescoes. It has been suggested that the designs for these embroideries might have been based on a series of frescoes or derived from one of the pattern books usually owned by artists and craftsmen in the Middle Ages. (Cennino Cennini in his *Libro dell'Arte* speaks of designs for craftsmen supplied by professional artists.) There are no direct prototypes, but one finds many fourteenth-century parallels and similarities for the details. The drawings have been tentatively attributed to the hand of an artist from Spinello Aretino's workshop or possibly even to the hand of the master himself in his younger years. One finds in these drawings facial types, draperies, and figure proportions very close to known works of his early style. If one accepts this possibility, the embroideries should date about 1385–1390.

These panels, together with four others in private and public collections, are rare survivals of an altar frontal, or possibly of a low retable (retroaltare) in the shape of a predella, of the kind used occasionally on high altars. (Included in the Treasure of the Order of the Golden Fleece are an embroidered altar frontal and a retroaltare forming a set.) The scenes on the panels in other collections are: the Adoration of the Magi (Coll. Robert Lehman), the Betrayal in Gethsemane (Coll. of the late Walter Rosen), the Crucifixon (Museum of Fine Arts, Boston), and the Resurrection of Christ (Cleveland Museum of Art). All twelve panels were reunited in 1965, in the "Exhibition of Italian Panels and Manuscripts from the 13th and 14th Centuries" (Hartford). The suggestion by other authors that the altar frontal might have had a large vertical panel in the center, with the horizontal panels grouped in tiers at both sides, appears logical. For such a central panel, the subjects of a Coronation of the Virgin, or a vertical composition of a Last Supper have been proposed.

Three examples of embroidered altar frontals survive. The most important and most closely related is in the Cathedral (La Seo) of Santa Maria in Manresa, Spain. Here the large central panel of the Crucifixion is flanked by three tiers of eighteen panels, approximately the same size as those in the Metropolitan Museum. This altar frontal is dated about 1346–1348 and is signed: Geri Lapi Embroider in Florence. The Museum panels therefore could be attributed to either Geri Lapi's workshop or to an embroiderer working in his tradition. The second antependium is in Florence, Museo degli Argenti, and another is in the Cathedral of Pisa.

Alejandro Soler y March points out that two great embroiderers' schools competed for first place in Europe during the fourteenth century—the English (Opus Anglicanum) and the Italian (Opus Florentinus). It is only in the latter that one finds complete scenes similar to paintings. Ruth Grönwoldt considers the possibility that the embroidered panels in the Museum were originally part of one of the altar paraments listed in the 1403–1405 inventories of Jean, Duc de Berry. Such a provenance cannot be proven at present.

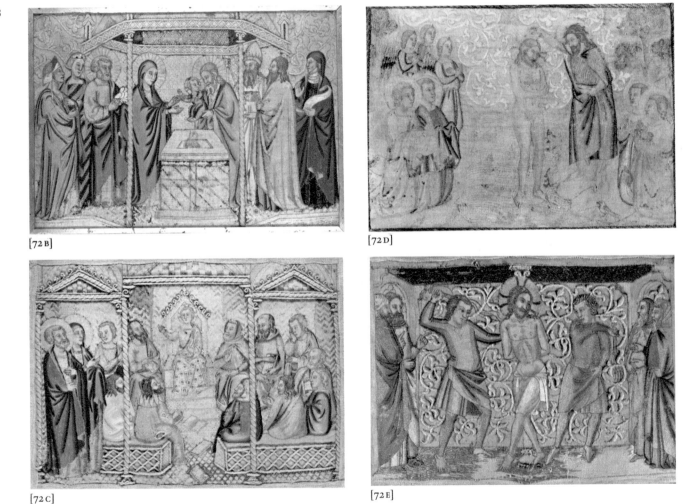

[72 B]

[72 D]

[72 C]

[72 E]

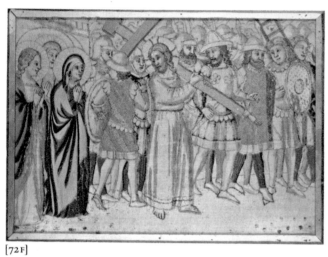

[72F]

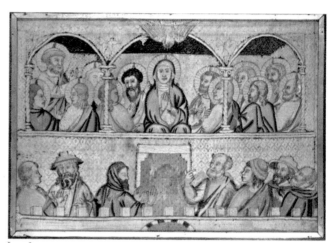

[72H]

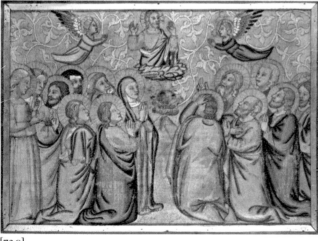

[72G]

160　*Marble.* H. *19 inches*
Mosan, first half (?) of the XIV century
Said to have come from the
Beguinage of Namur

This figure of a seated king belongs to a group of closely related sculptures originating in the middle Meuse Valley. All of these sculptures have the same general style and probably were carved in the same regional workshop, some even by the same hand, of a local variety of marble sometimes confused with alabaster. The head may have been recarved.

The group consists of six sculptures and includes a relief and two almost life-size figures of the Virgin and Child in marble, as well as two parts of a large-scale wood relief. The latter, because of its provenance from a church in Louviers, Normandy, was previously labeled French, but its style shows that it is part of the Mosan group published by William H. Forsyth. He has discovered that these sculptures and a number of related pieces all were either Mosan in origin or were made under strong Mosan influence. Many of the related sculptures come from the vicinity of Lièges. Others can be found in and around Liège, Namur, and Huy.

A number of the pieces can be ascribed to two masters, probably active in the same workshop, of the middle Meuse Valley. An outstanding statue of the Virgin from Diest, just west of the Mosan Valley, belongs to this group, as does the Seated King in The Cloisters. The provenance from the same region is supported by the close similarity in style of details such as the broadness of the forehead, the widely spaced bulging eyes, the wide mouth, and the flat folds of the garments over the chest and around the neck.

The sober verticality of the folds is interrupted by the drapery, or in the case of the king, by the hem or the border of the cloak just under the knees. The severeness of the folds could be called metallic, were there not a softness and smoothness of surface, like that of silk satin.

The importance of the workshops of the middle Meuse Valley is emphasized by the fact that their representatives worked in Paris for royal customers. Slightly later in the fourteenth century, Jean de Liège worked on the royal tombs at St. Denis (see number 76).

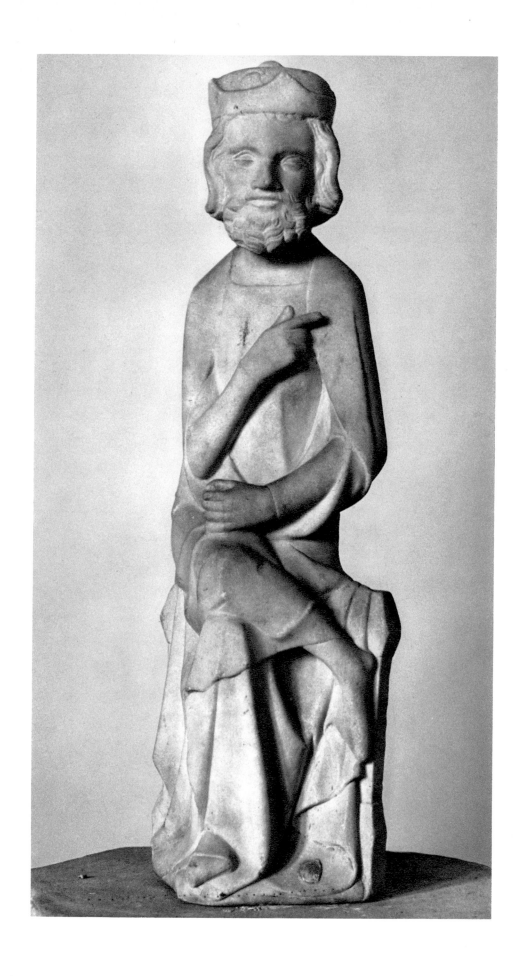

162 *Ivory. Diameter 4⅜ inches*
 French, XIV century
 Gift of George Blumenthal, 1941
 Ex colls. Frédéric Spitzer, Paris;
 Oscar Hainauer, Berlin;
 George and Florence Blumenthal, New York

Among the various ivory objects made for secular use in the later Middle Ages are mirror cases, toilet boxes, jewelry coffrets, and combs. Mirror cases deserve considerable attention. They were usually made in two parts serving as protection for the mirror itself which was of glass or polished metal. A device was provided to permit opening or closing. The two portions could be hinged like a diptych or they could be provided with a spiral clasp to be opened and closed by twisting.

Ivory mirror cases were in great vogue in fourteenth-century France and are often carved with scenes illustrating the pleasurable activities of courtly life such as chess playing, the courtship of lovers, or, as in this case, hunting.

This particular ivory, one half of a mirror case, is decorated with a scene of a hawking party, one of the favorite sports in the Middle Ages. This sport was often represented both in ivory carvings and in a great number of tapestries. Hunting with trained birds of prey such as hawks, falcons or even eagles was an expensive sport largely confined to the upper classes. It provided many colorful subjects for the medieval artist from cavalcades to intimate scenes. On this mirror case a couple and two attendants on horseback with falcons or hawks on their left hands are riding among trees. Their future prey, a rabbit, can be seen in the lower part of the scene. The costumes of the couple reflect contemporary fashions. The tall hat worn by the gentleman is found in many objects of art of the fourteenth century, e.g., on another mirror case in the Carmichael Collection and in the frescoes in the Campo Santo, Pisa (the scene of the three living and the three dead). A similar head appears in the spandrel of an arch on a fourteenth-century relief in the church of St. Andoch, Saulieu.

The crowded composition of the Museum ivory is enclosed by an eight-petaled rosette placed in a circle with grotesque masques in the spandrels. At the four cardinal points of the circle four lions passants transform the circle into a square. The body of one of the lions and the head of another are restored; the tail of a third is missing.

Hunting with trained birds of prey, known as hawking or falconry, was widespread prior to the invention of firearms. The sport seems to have originated in the Near East, and it was strictly regulated. Only certain classes could own favored varieties of birds; the eagle was reserved for the use of royalty.

The Metropolitan Museum ivory and a mirror case published by Raymond Koechlin in 1924 from the Collection Dormeuil, Paris (Koechlin, no. 1014), might form a pair. Both were at one time in the Spitzer Collection.

164

Ivory. H. 10½ inches
French, middle of second half
of the XIV century
Gift of J. Pierpont Morgan, 1917

The rather tall figure of the Virgin curves slightly in a Gothic contrapposto. A low crown of regular points connected by shallow arcs is placed over a short veil which covers the Virgin's head and stops at her shoulders. A mantle is wrapped about the figure and over her lifted right arm it falls in an elaborate series of harmonious folds. On the opposite side of the figure the border of the mantle creates an apron-like panel typical of fourteenth-century French sculpture. The statue is flat, especially in front, compared with thirteenth-century sculpture in which both figure and drapery are usually well rounded. In contrast, the front of the statuette and the drapery in particular become almost a two-dimensional low relief. The fourteenth-century tendency is to make the folds shallower and consequently to flatten the figure itself. The linear interest in the carving of the front plane dominates the modeling.

The Virgin holds the Christ Child on her left arm and offers him a bird whose wings the Child grasps with his right hand; in his left hand he holds a book. The bird is probably the goldfinch often compared in late medieval texts to Christ. A goldfinch can also symbolize Christ's atonement of sins.

The sculpture is conventional in type but it includes certain most attractive elements such as the graceful fall of the drapery over the Virgin's arm, and the intimacy between Mother and Child expressed in their tender gestures. The Virgin, nevertheless, maintains a regal attitude and an aloof expression. Still primarily the Queen of Heaven, she is not yet the affectionate mother which she becomes in a later period. Raymond Koechlin refers to similar ivory statuettes as belonging to the time of transition.

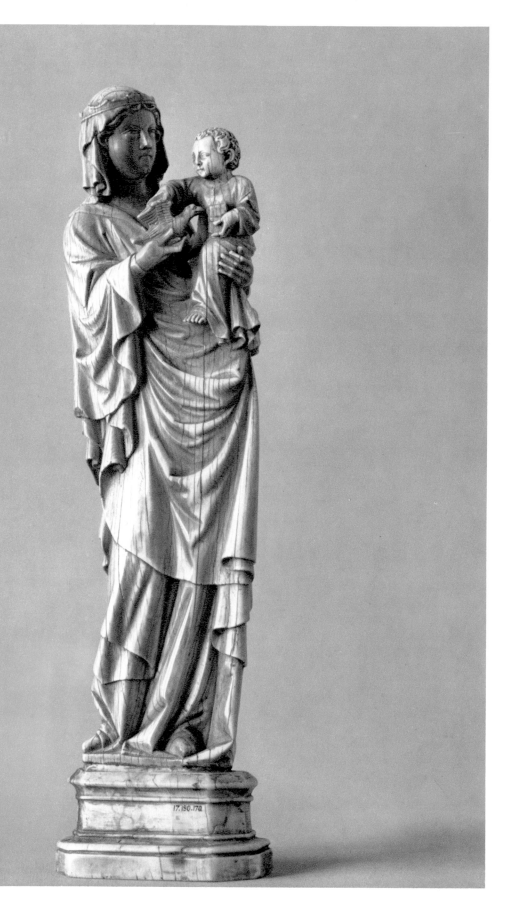

166 *Marble. H. 12¼ inches*
by Jean de Liège
Franco-Flemish, circa 1382
Gift of George Blumenthal, 1941
Ex colls. Dufay, Paris;
George and Florence Blumenthal, New York
Provenance: Chapel of Nôtre-Dame-la-
Blanche, Abbey of Saint-Denis, near Paris

Originally, this bust formed part of a tomb effigy, a *gisant* of the princess Marie de France (1327–1341), daughter of King Charles IV and Jeanne d'Evreux, his Queen. The princess died at the age of fourteen, and was buried in the chapel of Nôtre-Dame-la-Blanche in the Abbey of Saint-Denis. The effigy was not carved until long after her death.

In carving the bust the master reserved a stone band around the head for the attachment of a metal crown. The coiffure was a popular type among ladies of the French court during the reign of Charles V, especially in the 1370's and 80's, as can be seen in a number of plates in Montfaucon's *Monumens de la monarchie françoise,* produced in 1730 after drawings of various tomb monuments and other sculptures. The two small lead plaques visible below the braids, according to Alfred Darcel, served to hold small bands of fabric placed, following the fashion of the time, between the braids and the straight strands of hair falling down on each side along the temples and cut square on the level of the ear lobe. The sloping back surface of the head once rested on a pillow.

Close parallels can be drawn between this bust and two other tomb figures presently in the Abbey of Saint-Denis. One is identified as Jeanne de France (d. 1371), daugher of Philip VI and of Blanche of Navarre, and the other as Marie d'Espagne (d. in 1379), a sister-in-law of Philip VI (originally in the church of the Jacobins in Paris). The same tight braids of hair covering the temple and ears, and the same kind of cloth hanging from the crown between the braids and the short hair covering the cheeks, can be seen on all three sculptures. It is interesting to note that a similar hairdo of the period is represented on the altar frontal from Narbonne (Louvre, Paris). Drawings from the collection of de Gaignières, reproduced by Montfaucon, show these tomb figures of the princesses Jeanne de France and Marie d'Espagne as they appeared in the seventeenth century. Another de Gaignières drawing, showing a coiffure identical to those of the princesses just mentioned, represents the effigy formerly on the tomb of Marie de France in the Chapel of Nôtre-Dame-la-Blanche. Since the effigy of Marie de France is the only figure missing from the Abbey with a coiffure similar to that of the two other figures, the Metropolitan Museum head has been identified by William H. Forsyth as the head from the lost effigy of this third princess. It was missing from the abbey and reported stolen in 1793.

Marie and her sister Blanche were the last direct-line representatives of the Capetian dynasty. Blanche died in 1393, fifty-two years after Marie, and the two effigies were placed side by side over the double tomb they shared in the chapel. They were recorded in the de Gaignières drawing made before 1715. Both effigies were carved by Jean de Liège (worked about 1371–1380), one of the best-known of the Franco-Flemish tomb sculptors of Paris who worked for the royal family. As official portraitist at the French Court after the departure of André Beauneveu, he obtained a number of orders for royal effigies, and was patronized by Jeanne d'Evreux, widow of Charles IV. It was she who commissioned him to make the tombs of her daughters Blanche de France, Duchess d'Orléans, and Marie de France. A record of the time states that the effigies of Marie and Blanche were in his atelier in 1382, and were probably installed later in St. Denis by his pupil and successor, Robert Loisel. In 1382, forty years had elapsed since Marie's death, while Blanche was still living, so that the sculptor could model Blanche's effigy from life, but had to work from some records of Marie's features and possibly made use of the family resemblance of the two sisters.

There are faint traces of old paint on the bust, and it appears from the inventory of the estate of Jean de Liège of 1382 that he painted his work himself. A modern restoration replaces part of the lower left section of the base which was probably lost when the bust was broken off the effigy during the Revolution.

One must note that the features of Marie are extremely similar to those of her sister Blanche and, to a lesser degree to Jeanne de France and Marie d'Espagne. The two latter were probably carved about the same time, but not necessarily by Jean de Liège. In the opinion of Pierre Pradel the head of Marie de France in the Metropolitan Museum is one of only three unquestionably authentic surviving pieces by the hand of Jean de Liège, the other two being the effigy of Philippa de Hainault at Westminster Abbey, London, and the effigy of Marie's sister, Blanche de France, at the abbey church of Saint-Denis.

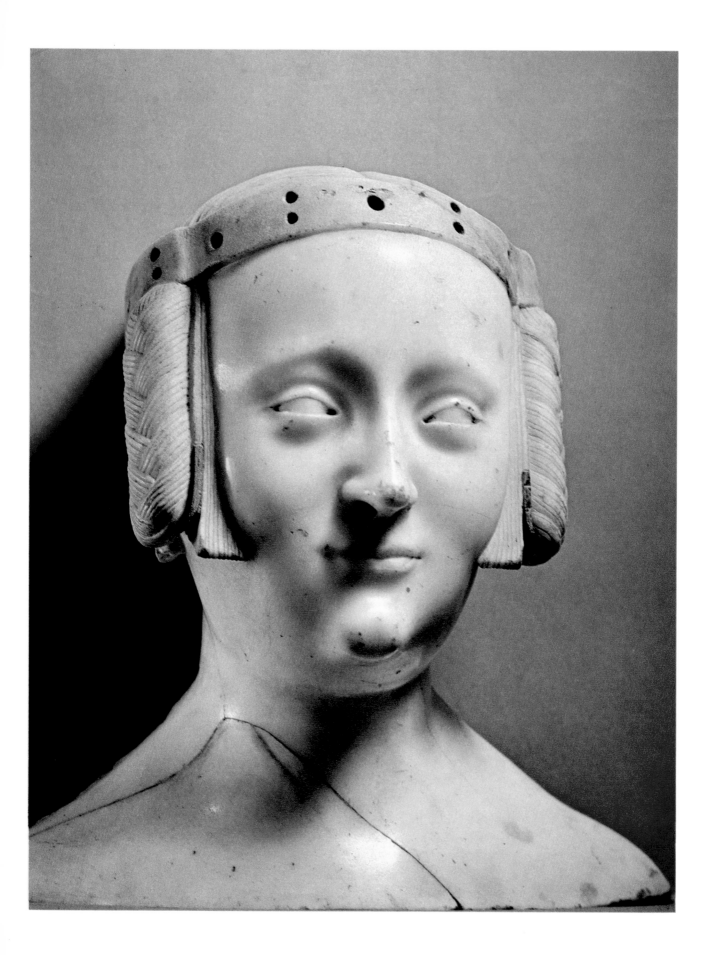

168 *Marble.* H. 57¾ *inches*
Italian (Pisan School), middle or third quarter
of the XIV century
Attributed to Tommaso Pisano
Bequest of Theodore M. Davies, 1915

The Virgin's pose is the traditional one for Pisan sculpture: head slightly inclined toward the Child and brought forward, while the shoulders are pulled back so that her neck forms an angle with the upper torso. The waistline is underlined by a belt formed by two cords knotted at intervals and placed very high over a rather pronounced abdomen. There is just a slight indication of a Gothic s-curve, with the weight of the Virgin resting on her right leg. The hands of the Virgin appear to be disproportionately large. Her head is covered by a long veil, falling below her shoulders and held by a band which formerly represented a crown. A long mantle is thrown over her shoulders and gathered up at each side to form an apron-like panel in front. The borders of the mantle meet under the Virgin's elbow and form a rich group of vertical tubular folds. Another group of similar folds originates under her right arm, while the central panel shows a series of curvilinear transverse folds. The crushed flat drapery of the hem covers her feet. In her right hand the Virgin holds an apple which she seems to offer to the Child. The apple might be a symbol of Christ's redemption of original sin.

On her left arm, the Virgin carries the Child whose very stiff torso leans back-ward. With his left hand he supports a closed book resting on his knee, and with his right he grasps the end of his Mother's veil in a gesture familiar in contemporary French sculpture. This detail is not the only one which relates the statue to French sculpture of the fourteenth century. The Virgin's general posture, the manner in which she holds the fruit, the apron-like panel formed by her mantle are all typical of the French Virgins. But the general aspect of the sculpture, at once more monumental and ponderous yet lacking the refinement of its French prototypes, places this Italian statue in a separate group. The Virgin's posture is stiffer and more vertical; her general character somewhat sleepy and overly detached and the apron-like drapery does not follow the general scheme of the folds, so beautifully integrated into one system in the French statue of the Virgin and Child (number 75).

The white marble of the statue is highly polished and has acquired a creamy tinge, at least in part due to the fact that originally it was painted and gilded. Traces of blue can still be seen in the deeper folds of the Virgin's mantle; other patches of polychromy can be found elsewhere; and some gilding still remains on the back of the Child's head.

According to available undocumented information the statue stood at one time in a private family chapel in the church of San Tomio at Verona. Built in the fourth century, the church was closed by the Napoleonic government in 1805; the building, sold to Count François Morando in 1810, was made into a theater. In the same year, a priest bought a statue of the Virgin and two columns from the church and set up the "Virgin with the apple" in another chapel.

In 1901 this chapel was also destroyed and the Virgin sold to an antiquary in Venice, from whom, evidently, Mr. Davies acquired it. The attribution to Tommaso Pisano was made on the basis of style; it had formerly been attributed to the Schoool of Pisa, and even to Andrea Pisano.

Tommaso Pisano and his brother Nino, the sons of Andrea da Pontedera, known as Andrea Pisano, belonged to the same *bottega* (workshop) which Nino, the more gifted artist, doubtlessly headed. In fact Nino's work greatly influenced that of Tommaso. Nino Pisano is the author of the sepulcher made for Aldobrandini Cavalcante in the church of Santa Maria Novella in Florence, which he signed as: NINUS *(Nino)* ... ANDREAE MAGISTRI DE PISIS (son of Andrea the Pisan Master). In its upper part this monument includes a standing Virgin and Child which is not unlike the Museum statue. Nino's sculpture shows many details found in Tommaso's work: the same overthrow of drapery, a similar passage from the cuff of the long sleeve to the hand at the strongly bent wrist. But Tommaso's carving is much harder, and the similarities no doubt are due to Nino's influence. Tommaso died after 1371. His only signed work is an altar in the church of San Francesco in Pisa. It includes a Virgin and Child between angels with the Sts. Peter, Lawrence, and Francis on the right, and John the Baptist, Andrew, and Anthony on the left. In J. B. Supino's opinion the altar is not very well carved and looks more like the work of a silversmith than of a sculptor which would explain a certain awkwardness in his monumental work. Tommaso is also supposed to have been an architect.

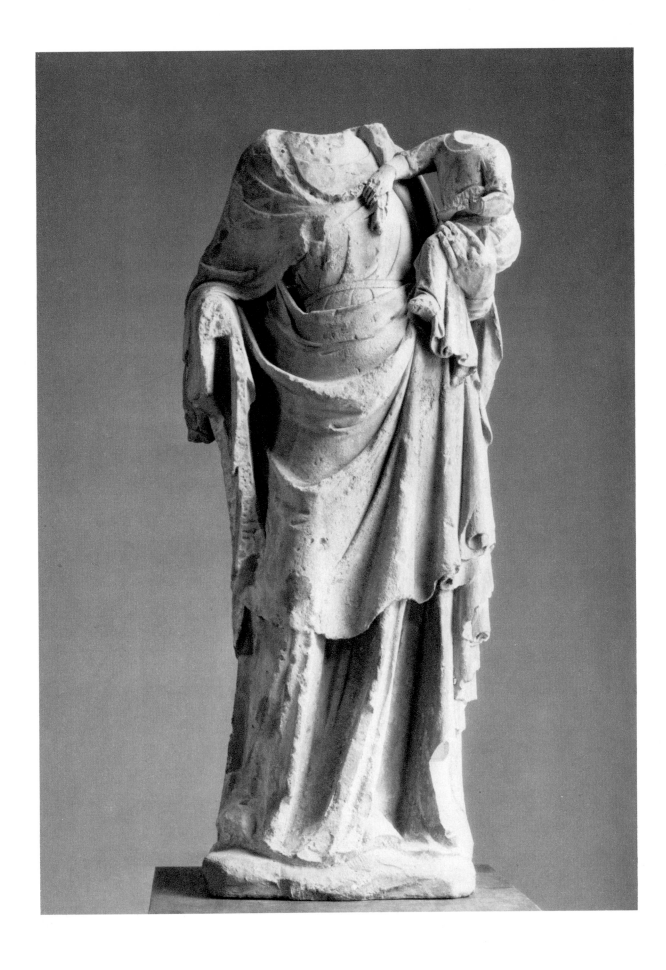

Limestone. H. *52⅝ inches*
French (School of Ile-de-France),
first half of the XIV century
The Cloisters Collection, Purchase 1925
Ex coll. George Grey Barnard

This monumental stone sculpture is a typical fourteenth-century Ile-de-France French statue of the Virgin and Child. The Virgin stands with the weight of her body resting on her left leg; her right leg slightly bent at the knee is outlined under the cloth of her garment. With her left arm she supports the Child; her right, held slightly away from her side, balances the curve of her body and causes her mantle and veil to form a beautiful series of rhythmic folds. The complicated system of drapery folds still retains an element of simplicity compared to that of the ivory statuette of the standing Virgin (number 75). The child held high grasps the end of his Mother's veil —a gesture found on numerous French fourteenth-century statues.

That the drapery is still of the first half of the fourteenth century is indicated by the deep folds on the front panneau. A more precise date might be the second quarter of that century. It was definitely carved before the middle of the century, because later the sculptural qualities tend to disappear. If one compares this statue with the earlier Virgin from the Strasbourg Cathedral, the difference in the interpretation of the subject is striking. The thirteenth-century Queen of Heaven is regal, gracious, and serene; her fourteenth-century counterpart is more relaxed and the softer drapery reveals the form of the body.

When the statue came to The Cloisters it appeared to be almost intact. But in 1932 after the artificial patina was washed off, a number of breaks were discovered. James J. Rorimer undertook a scientific study of the piece, using a new ultraviolet ray machine he had just designed. He found that although in white light the restorations were almost identical in color with the stone of the orig-

inal, a definite difference became apparent under ultraviolet light. Ultraviolet rays made it possible to distinguish between surfaces which had been subjected to long exposure and comparatively new ones. As a result, the heads of both Virgin and Child, her right hand, and portions of the drapery and base were removed as later restorations.

All that is known of the provenance of the statue is that George G. Barnard said he purchased it from a dealer in France.

172 *Limestone with traces of red and blue paint*
H. 16¾, W. 12 inches
French, first quarter of the XIV century
Gift of J. Pierpont Morgan, 1917
Ex coll. Hoentschel

In one of the most appealing statues of the fourteenth century the Virgin sits on a throne, bending slightly to the left while balancing a book with her left hand and holding the end of her veil with her right. Her posture can be explained by assuming that she was originally accompanied by the angel Gabriel who would have stood or knelt to her right as he foretold the birth of Christ. The slight recoil of her body is explained by the Gospel of St. Luke (1:29), where Mary "was troubled" at Gabriel's words. The modesty of the Virgin was a favorite medieval theme. The text of the *Meditations on the Life of Christ,* a manuscript written at the end of the thirteenth century probably by a Franciscan monk, states: "Since humble persons are unable to hear praise of themselves without shame and agitation, she [the Virgin] was perturbed with an honest and virtuous shame." (translation by Isa Ragusa and Rosalie B. Green, Princeton University Press, 1961, p. 17).

Modest though she be, the Virgin is represented in this statuette with a courtly grace worthy of a queen. Her posture recalls the famous painting of the Annunciation by Simone Martini in the Uffizi Gallery, Florence, probably executed more than a decade later than the statuette. The stone on the back of the throne has been left completely rough, suggesting that the statue was originally set against a wall.

Other similar seated French statues of the Virgin, but with the Child, also adopt this swaying posture. The closest is a headless sculpture now in the Museum of Fine Arts, Bordeaux. Others are in the Louvre, one from the Timbal Collection, and another from the work yards of the basilica church of Saint-Denis, just north of Paris.

Because of the downward inclination of the head, the extraordinarily delicate face of the statuette has been well preserved. The face has unusually widely spaced, almond-shaped eyes, a high, very convex forehead, and a sensitive mouth which from certain angles appears to be smiling slightly. The features may be compared to those of the famous ivory Virgin now in the Louvre which is reputed to have come from Ste Chapelle, Paris (where it seems to be the ivory mentioned in several old inventories). This face also appears on a metal statuette in the Jacquemart-André Museum, Paris, which is a derivation of the Ste Chapelle Virgin. The ivory was shown in the Cleveland Museum of Art in 1966 and 1967. The face of the Metropolitan Museum's Virgin and especially that from Ste Chapelle are remarkably similar to that of the tomb effigy at Saint-Denis of Constance of Arles, the wife of Robert the Pious, made in the latter part of the thirteenth century. The veil hangs down from the crown and over the right shoulder in much the same way at Saint-Denis and on the Museum figure. Echoes of this facial type are seen on the Virgin in Nôtre-Dame, Bourges, which probably also came from the Ile de France, and on a number of Parisian ivories of the period. The face of the Virgin holding the Child in Nôtre-Dame, Paris, is an earlier version of it, and one can conjecture that it may derive from some of the sculptures of the Cathedrals of Amiens and Reims.

Prepared by William H. Forsyth

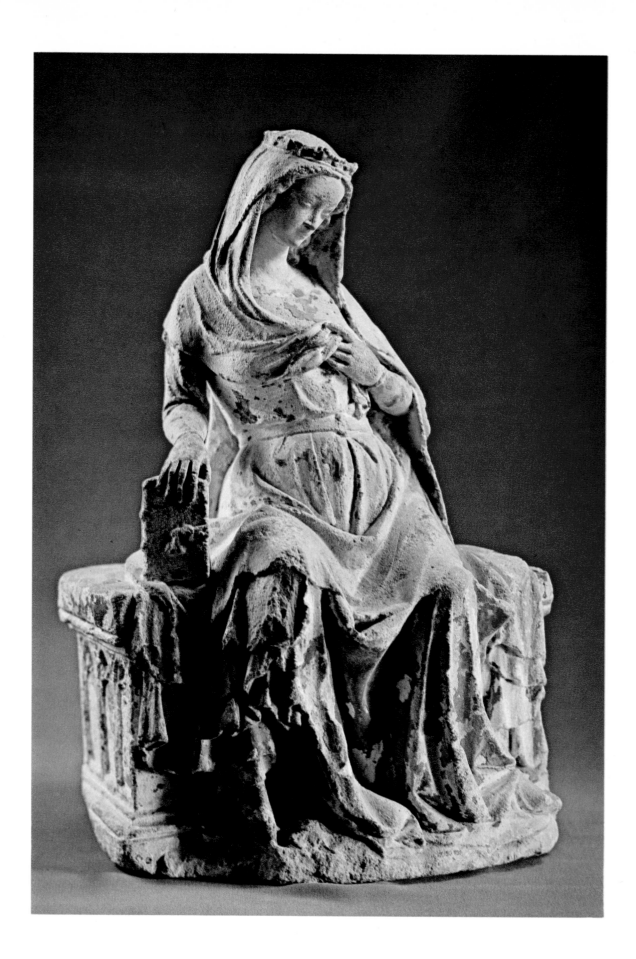

174 *Marble. H. 47 inches*
Italian (Florentine), circa 1390–1396
Attributed to Pietro di Giovanni Tedesco
Gift of J. Pierpont Morgan, 1917

This statue is one of a set of eight almost identical angels carved between 1390 and 1396 for the façade of the Florence Cathedral, Santa Maria del Fiore. They formed four confronted pairs, each pair flanking and facing a larger statue of a martyr saint whom the angels were "adoring". The four groups occupied four niches, two on each side of the main portal on the west façade of the Cathedral.

The folds of the angel's tunic fall in almost parallel verticals breaking over his feet at the ground. The mantle draped over the forearms in flat, fluid folds does not disturb either the outline or the unity of the compact marble block. The smooth surfaces of face and hands correspond to his peaceful expression. Only his curls, brushed upward in regular strands, break the continuous flow of the surface. The whole figure reflects a contemplative quietude. Four square slots on the back of the statue indicate the places where the wings were inserted. The head was broken off and reset at some time, and the surface of the face may have been reworked.

The master carver Pietro (or Piero) di Giovanni Tedesco, to whom this Museum angel is attributed, is believed to have come to Florence in the 1380's from somewhere in northern Europe. Although his place of origin has not been established, Cologne, the Lower Rhine, northeastern France, and the Netherlands have all been suggested. In the accounts of the Florence Cathedral where his name appears for the first time in 1386; he is called variously: "tedesco" or "teutonico" (German), or "de Brabantia" (from Brabant). In accounts from Orvieto, the town of his origin is called "Fierinburgo" without indication of the country. The payments made to him list sculptures of various saints, apostles, and angels: an "angiolotto" in 1386, "two angels" in 1395 and in 1396. His earlier angels belong to the series "with musical instruments", while the "adoring" angels were carved in the 1390's. He may have worked on all these statues in collaboration with Niccolo (or Nicola) di Pietro Lamberti and several other sculptors. It is believed that Pietro di Giovanni Tedesco did not design his own statues but worked after designs prepared for him by Lorenzo Bicci, Agnolo Gaddi, and Spinello Aretino; and that his statues were painted and gilded by the first two named artists and also by others.

During the second half of the fourteenth century in Florence great artistic activity centered around the Cathedral. The plans for Santa Maria del Fiore (the ancient Santa Reparata) were begun by Arnolfo di Cambio in 1294. New designs and plan changes were prepared in 1357 by Francesco Talenti who in 1358 was commissioned to design the project for the decoration of the outside walls. It was on this fourteenth-century façade of the Cathedral that Pietro di Giovanni Tedesco worked during the last two decades of the century. The work was interrupted in 1420 by the rising popularity of the Renaissance style. The statues were taken off the façade in 1587 when it was torn down to be replaced by the present one. Not all scholars agree on the attributions of the various statues which have been dispersed since their removal from the outer walls of the Cathedral.

Of the eight "adoring" angels generally attributed to Pietro di Giovanni Tedesco, six were placed in various gardens in and around Florence; one, now sold, was formerly in the Kaufmann Collection; and the eighth has been in the Metropolitan Museum since 1917. In 1909 it was reported by Giovanni Poggi as in a private collection which could have been Mr. Morgan's. The earlier history of the statue is not known, nor is it known which of the four niches on the west façade the angel occupied. The general aspect of the Cathedral's Gothic façade is known from three records in Florence: a fresco by Poccetti in the cloister of San Marco, a design in the Museo dell'Opera del Duomo, and a low relief by Giambologna showing the façade in the background (Chapel of S. Antonino, San Marco). But these records are not sufficiently clear to establish the exact location of the Museum's angel. A cast of the angel, made in the Metropolitan Museum for the Opera del Duomo Museum in Florence, was placed there to the right of St. Stephen.

Most scholars are of the opinion that all eight angels show the same block-like appearance with unarticulated bodies under the clothing. They also find that the earlier angels with musical instruments show a greater softness in style which becomes stiffer in the later "adoring" angels. The earlier modeling is replaced by a linear treatment of the surface. The artist appears to follow an established pattern and his chief aim is to create an architectonic entity.

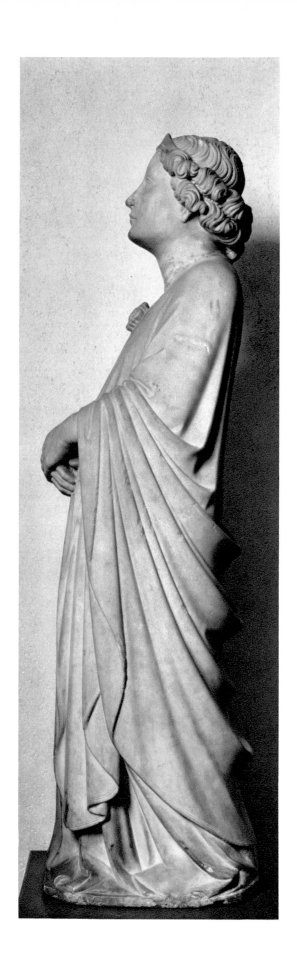

176 *Copper, parcel gilt, and tempera on gesso*
H. 11¹/₁₆ W. 9 inches
Italian, shortly after 1376
The Cloisters Collection, Purchase 1961
Provenance: Convent of Santa Giuliana,
Perugia
Ex coll. Marchese de Villahermosa, Paris

St. Juliana was a young girl of Nicomedia, Asia Minor, beheaded during the persecution of the Christians by the Emperor Diocletian because, having dedicated herself to Christ, she refused to marry a pagan lord. Her story was well known in the Middle Ages and was told and embellished by numerous medieval authors.

The reliquary bust is made of copper, with gilded hair. The face is modeled in gesso over the copper and painted in tempera. A handsome contrast exists between the gold of the softly waved hair and the subtle tones of the smooth complexion; the young face has charm and is full of vitality. On two fragments of a metal band which originally circled the lower edge of the reliquary are the remains of an inscription in Latin tentatively read and interpreted as: (C)APUD SANTE IULIANE... ROMA A D(OMNO) GUILLE(LMO)—"Head of St. Juliana"... and "Rome... by Master William". In view of the fragmentary condition of this inscription, several readings are possible; APUD—"at" and AD—"Anno Domini" have also been suggested. Traces under the gesso indicate that the hair was gilded before the face was fashioned of gesso. Certain places on the lower part of the face have been retouched with oil paint.

The shoulders were cut off at some unknown time for an unknown reason; measurements, with the shoulders intact, prove that the bust fitted easily into its tabernacle.

The reliquary bust was commissioned by the Reverend Mother Gabriella Bontempi for her Convent of Santa Giuliana in Perugia to contain the skull bones of the saint which were obtained for the convent from the Dominican Brothers in Perugia. The reliquary is thought to have been fashioned by a certain Master William of Rome as a "speaking reliquary" (indicating its contents by its shape). The bust was placed in a tabernacle of copper gilt, especially made for this purpose, which is at present in the Galleria Nazionale dell'Umbria in Perugia.

The bust and tabernacle were recorded together in 1645 but were separated in the nineteenth century when the relics of St. Juliana were transferred several times due to various political upheavals, including the Napoleonic invasion of 1822. According to Ettore Ricci, writing in 1913, an 1851 document reports that the "copper masque which contained the skull of the saint was removed because the varnish (inverniciatura) on it was in such a deplorable condition (talmente guasta) as to be considered unsuitable (indecorosa) to contain such a precious thing. A glass (crystal?) bell was substituted for the copper mask, and placed on a wooden pedestal decorated with intarsia." The tabernacle also was restored at the same time and its present upper part added. It is evident that the damaged "varnish" has been removed since. When and how this was done is not clear, because in a report of 1862, made by the Superintendent of Monuments, the reliquary is described as in "superb condition. One of

the very fine reliquary busts of the Middle Ages that still retains all its original paint." The height at this time is given as 27 cm (10⅝ in.). In 1862 the Convent of Santa Giuliana was suppressed and the relic transferred to the church of Santa Maria di Monteluce in Perugia. It appears that in 1910, when the nuns were transferred to Viterbo, both the head and its architectural setting were sold.

Although the face in gesso of the young woman is stylistically consistent with the late fourteenth century and compares with several other metal busts made in Italy in the last quarter of the century, the hair style is typical of masculine figures of the early part of the century. An examination of the inner side of the reliquary (a series of X-rays and a plaster cast made of the inside of the hollow bust) revealed that the original copper head, made of five pieces riveted together, was that of a man over which the features of St. Juliana were modeled in a thick layer of gesso and then painted flesh color in tempera. X-ray photos show that the features of the outer face do not correspond to those fashioned in copper repoussé. The master who made the image of St. Juliana evidently used a copper bust of a man, possibly found unfinished, adding a new cover piece for the cranium.

The re-use and transformation of earlier elements at times when material was either scarce or expensive is not unique in medieval art. The original head of the famous reliquary of Sainte Foy, in Conques, was discovered to be that of a Roman emperor of the fourth or fifth century, re-used and adapted for the statue of the saint.

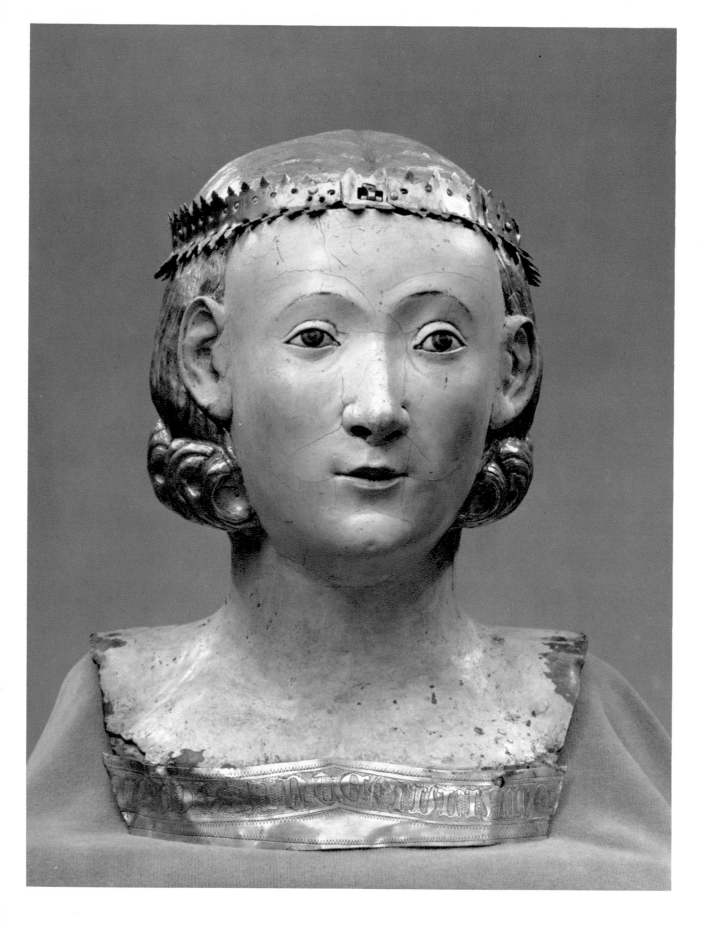

178 *Grisaille and colors on vellum*
Page: H.3½, W.2⅞ *inches*
Illuminations by Jean Pucelle
French (Paris), circa 1325–1328
The Cloisters Collection, 1954
Ex colls. Jeanne d'Evreux, Queen of France;
Charles V, King of France;
John, Duke of Berry;
Baron Louis Jules du Châtelet;
Baron Edmond de Rothschild;
Baronne Adolphe de Rothschild;
Baron Maurice de Rothschild,
Château Pregny, Geneva

Books of Hours are abbreviated versions of service books used by the clergy containing prayers and readings for the eight canonical hours of the day, matins through compline. Such books came into use during the second half of the twelfth century and spread rapidly during the fourteenth to become the most common form of private prayer by the fifteenth.

Although there is only circumstantial supporting evidence, this small Book of Hours is believed to be a gift of King Charles IV of France to his Queen, Jeanne d'Evreux, presented soon after their marriage in 1325. It must be dated between this date and the King's death in 1328.

The manuscript is in Latin and follows the usage of the Dominicans (Predicatores or "Preaching Friars"). It consists of a Calendar with signs of the zodiac and, on the recto, miniatures of the chief occupations of the months; the Hours of the Virgin; the Hourse of St.Louis, seven Penitential Psalms; and the Litanies of the saints. There are in all twenty-five full-page illuminations for the Hours of the Virgin (with text) and

for the Hours of the Passion (without text); there are also illustrations for the Hours of St.Louis, the favorite saint of the royal ladies of the time. There are many decorated initials and gay drolleries embellishing the margins. All are superbly and delicately drawn or painted in grisaille with touches of color. The royal owner is portrayed twice: once in a generalized portrait of a Queen kneeling in prayer, in the initial D under the scene of the Annunciation, and again, wearing a wimple and veil.

There are 209 folios of vellum (418 pages, ten of which are blank); one folio is missing. The manuscript is bound in red morocco leather of the early seventeenth century, with silver-gilt mounts displaying the coats of arms of Louis-Jules du Châtelet and his wife whom he married in 1618. Earlier, it is described in the Duke of Berry's inventory as "covered with blue silk… provided with small gold clasps with [on them] an Annunciation and has two page-dividers with two little pearl knobs".

Although no documentary evidence exists, it must be the "rather tiny little book of Prayers" which the Queen left in 1371 to King Charles V of France, described as "illuminated by Pucelle". Charles V, in turn, gave it to his brother John, Duke of Berry, in whose inventories it is listed three times, in 1401, 1413, and 1416, and called "the Hours of Pucelle", but identified further as "Hours of Our Lady of Preacher Friars' (Dominican) usage… illustrated in black and white".

The *Hours of Jeanne d'Evreux* is a landmark in the history of French painting, not only because of its superb quality, but because it fused all the currents of its time into a new style. The compositions of Italian painting, especially Duccio's; the

most advanced conception of interior space (e.g., the Annunciation); and the humorous marginal illuminations popular in England, the Netherlands, and northern France are all integrated into the Paris tradition of elegance and good taste.

Leopold Delisle, in 1910, was the first scholar to attribute the illuminations of this manuscript to Jean Pucelle, the most gifted Paris master of the period. Stylistic similarities between The Cloisters manuscript and the Belleville Breviary of 1323–1326 which unquestionably includes the work of Jean Pucelle are most important for this attribution. The relationship is clearly seen especially in the marginal figures and the scenes of drolleries.

Very little is known about the life and work of Jean Pucelle. In the accounts of 1319–1324 of the Confraternity of St-Jacques-aux-Pelerins, Paris, he is mentioned as having received payment for the design of their Great Seal. In the Billyng Bible (Paris, Bib. Nat. Ms. Lat. 11935) a colophon, dated 1327, names Jean Pucelle, Anciau de Sens (Cens), and Jacquet Maci as illuminators. And in the Belleville Breviary (marginal notes, vol.1) Jean Pucelle and his collaborators are mentioned in a record of payment that implies that Pucelle was head of the Parisian workshop. The mention of his name in the will of the Queen and in the inventories bears proof that Jean (or Jehan) Pucelle was not only well known but probably famous.

From the consistent high quality of the miniatures and decoration in the *Hours of Jeanne d'Evreux* one can conclude that all are by the hand of the master himself. On the other hand, some of the illustrations in the two other manuscripts mentioned above are definitely the work of his assistants.

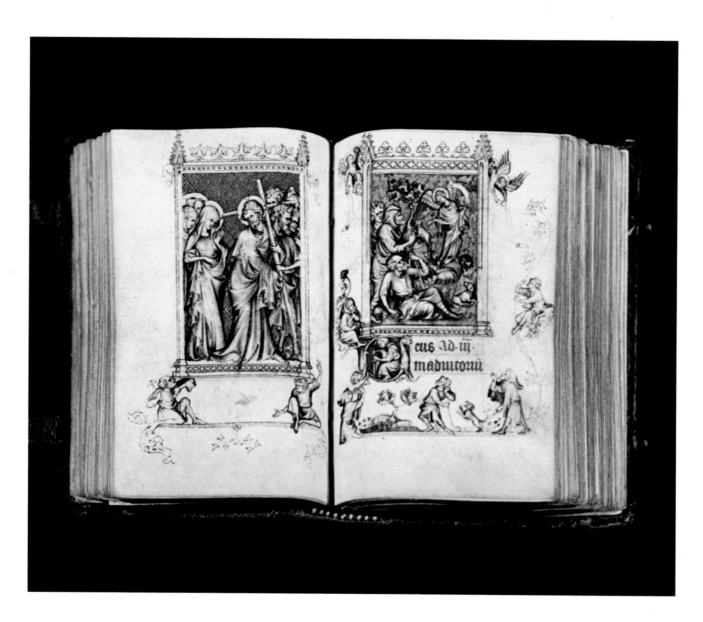

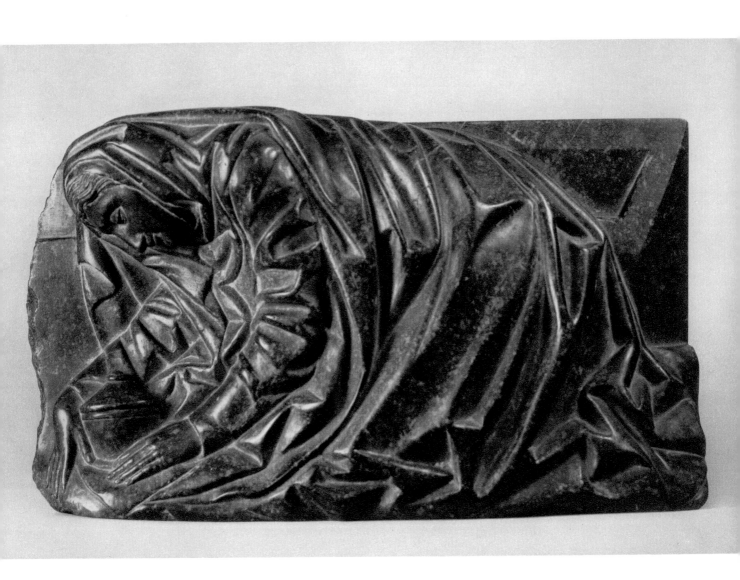

Black marble. H. 7 ¼ , W. 13 ½ *inches*
Franco-Flemish, late XV or early XVI century
The Cloisters Collection

The relief figure on this fragment of black marble represents Mary Magdalen kneeling or crouching in front of an empty sarcophagus. She often occupies this place in Flemish late Gothic scenes of the Entombment of Christ. This compositional peculiarity, says William H. Forsyth in his forthcoming book on Entombments, appears about 1300 in Italy; it becomes typically Flemish in the fifteenth century, and when it appears elsewhere in this period, it is under Flemish influence.

There can be no doubt that here is Mary Magdalen mourning, but since the sarcophagus is empty it can hardly be an Entombment. One can only surmise what was represented on the missing left part of the relief. It may have been the figure of Christ appearing to the Holy Women near his tomb after his Resurrection. This event is represented in Early Christian compositions, and later, with only Mary Magdalen present, it becomes the *Noli me tangere* scene of the Gothic and late Gothic periods. On the other hand, the angel whom the Three Maries found seated on the edge of the empty sarcophagus on Easter morning may have occupied the missing portion. The crouching posture of the Magdalen may have been adapted to the shape of the relief, just as the figure of one of the Holy Women at the Tomb is bent into a curve on the roundel on the roof of the Shrine of Our Lady at Tournai by Nicholas of Verdun.

The carving is most expressive; the self-contained figure is definitely that of a mourner. Her head droops; her hands fall aimlessly near the ointment jar she has brought with her. Her body is almost completely enveloped by the mantle, and the folds of drapery rhythmically follow one another in a series of vertical curves

bunching at her feet. From the mantle emerge only the Magdalen's head, shoulder, and arms; the arms repeat the vertical curves of the drapery but at the same time break the monotony of these curves in the short, crushed folds running across the sleeve.

At the right edge of the relief are incised some unitentified initials: capital letters D and E with a larger-size C separating them.

181

182 *Silver gilt, rock crystal, enamels*
H. 23 inches
North Italian, early XV century (circa 1400)
The Cloisters Collection, Purchase 1953
Ex coll. Victor Rothschild, London

An ostensory like a pyx (see number 58) is a container for the Holy Wafer with the difference that the ostensory has a glass or crystal container to display the wafer to the faithful during the veneration. Ostensories may stand on the altar, and they may also be carried in solemn processions, especially in that of the Feast of Corpus Christi. Sometimes they are called monstrances, and it is difficult to differentiate between the two. Ostensories are at times combined with reliquaries or can be used as such exclusively. Their usual shape is a container surrounded by architectural or other decoration. They stand on a foot with a stem and a knob similar in style to those of a chalice of a comparable date. The rules regarding the proper use of ostensories and similar containers do not affect the exterior appearance of the object.

The North-Italian ostensory shown here is of the tower or steeple type. A tall, central, steeple-like structure rises above the container which is surrounded by row upon row of pinnacles and finials rising from flying buttresses. This architectural framework for the rock-crystal container is reminiscent of Gothic churches. There are windows surmounted by gables with crockets; animal-headed gargoyles project between them. The ribs of the steeple roof are outlined with crockets, and topping off the spire is a finial with silver leaves at the bottom and dark blue enamel above.

The structure is based on a hexagonal plan subdivided into triangles. It stands on a hexagonal base of conical shape with concave sides. Curling leaves support the three protruding flying buttresses. The hexagonal stem is interrupted by a flattened globular knob made hexagonal by the six decorative projections. The face of each projection is engraved with a basilisk. The base of the foot is a flat hexagon with concave sides. Applied to it are six pointed, trilobed, enameled plaques, each with a half-length figure of a saint. The technique of this enamel is known as "basse-taille," that is, translucent enamel applied over an engraved silver background. The engraving seen through the enamel supplies the design. Among the saints are St. Catherine of Alexandria, holding a gold wheel in her left hand and the palm branch of a martyr in her right; St. Peter Damian, Bishop of Ostia, tonsured and bearded, holding a crozier in his left hand and blessing with his right, wearing a lavender cloak with green lining over a blue garment; St. Peter the Martyr, a Dominican, tonsured and bearded, holding a palm in his right hand; St. John the Evangelist (?), and possibly, the Virgin Mary (?). All these figures have red haloes outlined in silver against a dark-blue background, set with three circular floral motifs. The surface of the foot between the enamels is engraved with foliate vine scrolls, against a background pattern of punched circles. There is a further engraved decoration of lancet motifs filled with crosshatching on the stem. On the underside of the base is a scratched inscription giving the weight of the silver ostensory: 5 MARCK, 6 LOT.

The number of pinnacles on this Italian tower ostensory is greater than on similar objects made in other countries, and might be considered typically Italian, as is its hexagonal architectural shape. One finds it in two fourteenth-century reliquaries: that of S. Savino, by Ugolino di Vieri di Siena, in the Orvieto Cathedral; and that of S. Gargano, by Lando di Pietro. Both of these also have pinnacles, gargoyles and a tall spire above. Erich Steingräber has suggested a comparison of the foot of The Cloisters ostensory with that of the Apostles' Monstrance in the Treasury of the Basel Cathedral. It might be of interest to mention that listed in an 1436 inventory of St. Peter's in Rome is a "portable ostensory (tabernaculum) with a crystal surrounded by silver gilt, for the carrying of the Body of Christ, with a large foot with enamels."

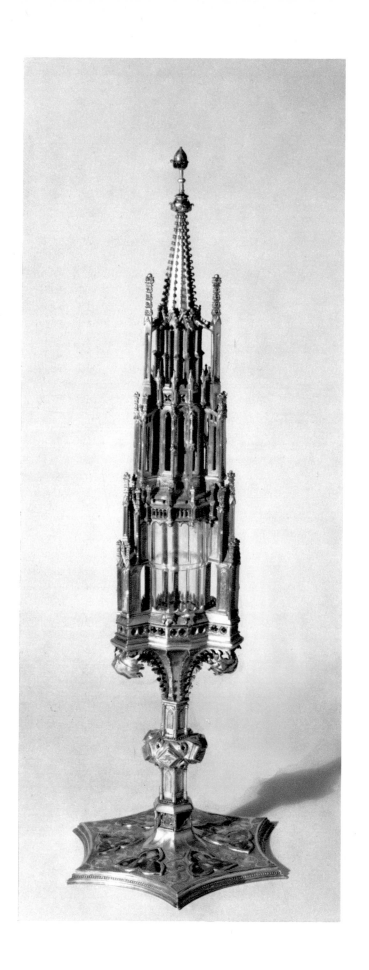

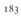

184 *Majolica. H. 8¼ inches*
Italian (Tuscan?), early XV century
Fletcher Fund, 1946
Ex colls. Sigismund Bardac, Paris;
Alfred Pringsheim, Munich;
Mortimer L. Schiff, New York

This jug-like, heavy-set jar with two handles was probably a utilitarian storage container for food or drugs. It is decorated on the front with two birds supporting a shield and on the back with a checkered geometric pattern. The coat of arms on the shield is described as "argent, a fesse between three roundels (besants) sable, 2 and 1." A decoration in green, manganese, and cobalt blue is painted over the dull grey-white glaze slip covering the inside and outside of the jar. As on the Hispano-Moresque lusterware vessels, the heraldic ornamentation may follow the design of a coat of arms but not observe the tinctures.

Gaetano Ballardini, in a review of Seymour de Ricci's catalog of the Schiff Collection, suggests that these arms are possible those of the Guidi of Siena or those of the Della Marchina family of Faenza.

Due to its unusual color combination the origin of this jar cannot be definitely localized. It probably comes from Tuscany, and Florence, Siena, or Faenza have been suggested. It represents an example of Italian majolica which was made for table use and for display on sideboards in wealthy households, or for use in the pharmacies of hospitals.

The word "maiolica" was originally used to describe Spanish lusterware dishes brought to Italy from Valencia by way of the island of Majorca, but it later became a general term for glazed Italian pottery. Its glaze is rendered opaque by the addition of tin.

The Mortimer Schiff Collection, from which this piece comes, has been called unique by de Ricci because of the wide variety and the high quality of the objects it contained. Some of the hundred and eleven pieces were acquired in Europe, but others were added after their exhibition at the Panama-Pacific Exposition in San Francisco in 1915.

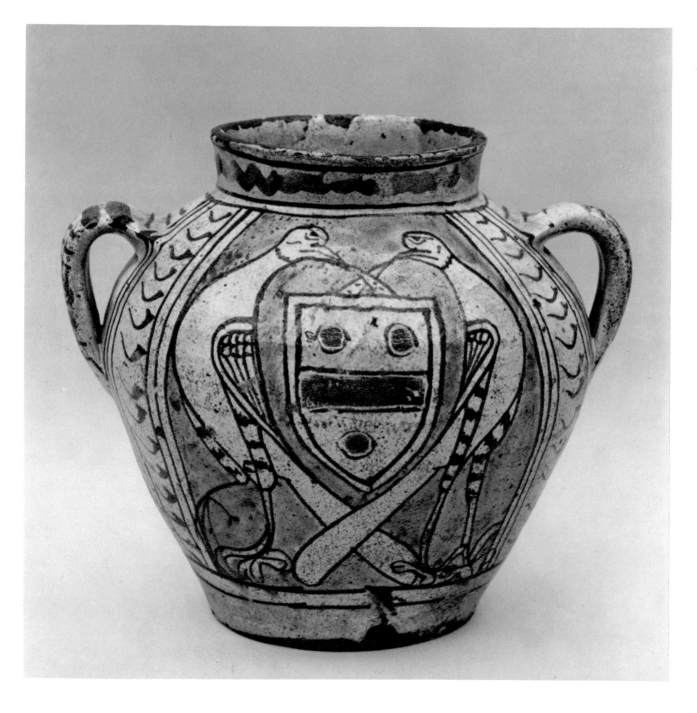

186 *Limestone with original paint. H. 60 inches*
French (Alsatian) 1400–1425
The Cloisters Collection, Purchase 1925
Ex coll. George Grey Barnard

This Alsatian statue of the Virgin has much in common with French statues of the standing Virgin and Child, but at the same time it illustrates many important differences.

The Virgin's solid figure stands firm and straight. The reason for the outward movement of her left hip is the need to support the Child more comfortably and to balance the composition of the sculpture. The Virgin's mantle worn over a dress with a tight bodice is shaped like a large shawl thrown carelessly over her shoulders. Its drapery consists of a logical series of folds carved with precision and great feeling without overloading the surface of the statue. The elaborate small folds of the fourteenth century are replaced by the soft three-dimensional folds of the early fifteenth century.

The face of the Virgin is rounder and more placid than those of French Virgins of this period. It is the face of a young Alsatian woman somewhat similar to those one finds later in the sculpture of Nicholas Gerhaert van Leyden, an artist who came from the Netherlands and worked for several years in Strasbourg about the middle of the century. The longish nose and the small very feminine mouth of the statue are also found in his sculptures.

A low crown with many of its points missing is placed over the soft veil on the Virgin's head. Her right hand is missing as is part of the adjoining drapery, the two hands of the Child, and parts of his foot. The remaining hand with its long straight fingers is well formed. When the statue came to The Cloisters, the Child was holding a bird, but the bird and the hands proved to be restorations and were removed in 1935 following a careful study of the surface of the piece.

The Cloisters statue was acquired by Mr. Barnard near the Alsatian frontier in France. A related statue of the Virgin is on the west façade of the church at Thann (Alsace).

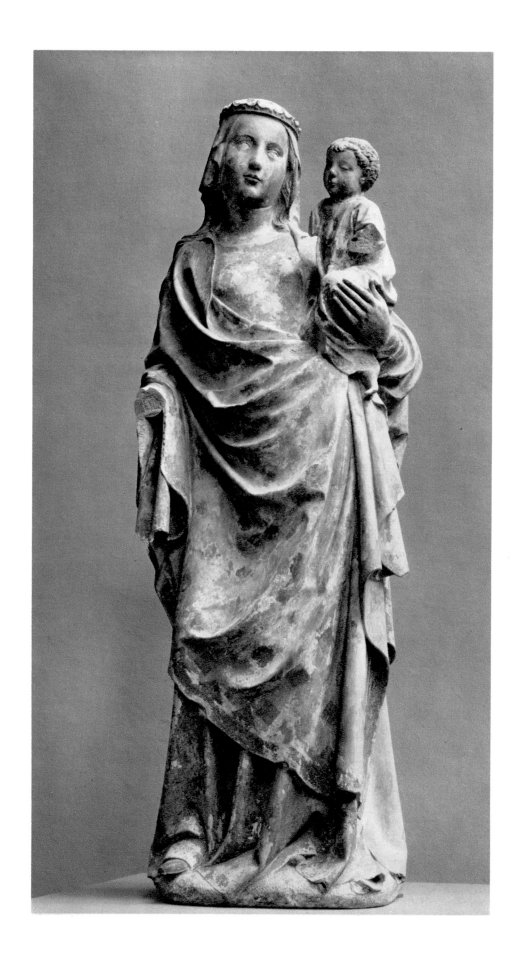

A LATE GOTHIC POSTLUDE

190 *Walnut.* H. 5¾ *inches*
Franco-Flemish School (Burgundian?)
XV century
Gift of George Blumenthal, 1941
Ex colls. T. Schiff, Paris;
George and Florence Blumenthal, New York

The walnut statuette interprets in miniature a subject used extensively in monumental sculpture: the seated Virgin holding the Child on her lap. Here, wrapped in a voluminous mantle, she sits on a bench holding the nursing Child who wears only a cloth over the lower part of his body. This group is an example of the strongly developed maternal type of Virgin which appears in fifteenth-century Gothic art.

Stylistically the sculpture shows a combination of elements which, taken individually, could identify it either as Flemish, Franco-Flemish, or Burgundian. The stocky figures are realistically represented and the heads, especially the rounded head of the Child, are characteristic of many sculptures of the contemporary Burgundian School. The undulating borders of the draperies enveloping the Virgin are typical of the southern Netherlands. The combination of these and other details suggests the possibility that the artist may have been a native of that area working in Burgundy. The influence of such Netherlandish masters as Claus de Werve and Claus Sluter working in Dijon dominated local artistic production for a long time.

Because of certain unexplainable combinations of stylistic elements a group of scholars have begun to doubt the fifteenth-century date for a number of miniature sculptures. They suspect that some may be nineteenth-century imitations of medieval works. The Metropolitan Museum's statuette has been compared with another small sculpture in the Suermond Museum in Aachen, which is now labeled "Burgundian, second half of the XIX century." The whole problem is being studied at present in several European museums, but definite decisions have been reached for only a few pieces.

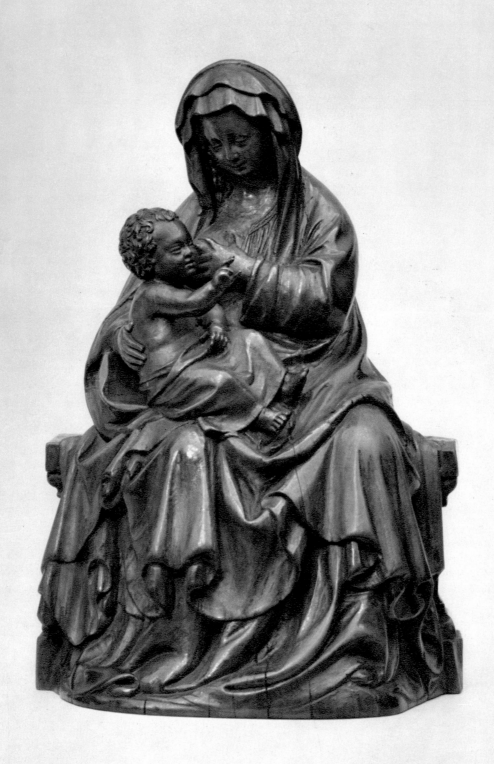

192 *Silver, parcel gilt. 23⅝ inches*
French, Toulouse, circa 1380–1400
Gift of J. Pierpont Morgan, 1917
Ex coll. Charles J. Wertheimer, London

St. Christopher carries the Christ Child over the river, in accordance with the legend told by Jacques de Voragine in the Legenda Aurea. The saint leans heavily on a tall staff, grasping it with both hands. Three small leaves sprouting from the staff's top are a reminder of the miracle promised by Christ—that if the saint, upon his return home, would stick the staff into the ground, it would bear leaves and fruit in the morning. There is extraordinary vitality in the forward stride of the saint, his legs firmly planted in the swelling waters of the river. The firmness of his posture is strengthened rather than weakened by the curves and bends of his body; he twists as he turns to look at the small Child who, according to the legend, grows heavier and heavier. In contrast to the powerful strength of the saint's body, the figure of the Child astride his shoulder seems weightless. Except for the flesh and the water and some details, all surfaces of the statuette are gilded.

The treatment of the material is masterful; the soft, rich folds of the saint's cloak fall as if they were actually made of cloth and not hammered from a sheet of metal. The plain surfaces of the faces are framed by the crisp design of the hair. The engraving of the short curls of the Child, the hair and the flowing beard of the saint, and the fish in the turbulent water is done by a sure hand of a master.

The rectangular box attached to the front of the base which is surrounded by fragmentary flying buttresses was meant to contain the relic. Later additions, the box cover and the Child's halo, were removed.

A silver stamp on the front edge of the saint's cloak: t.o.l. (for Tolosa) in Gothic letters surmounted by a fleur-de-lis, is repeated on the front and, somewhat modified, on the back of the base. It identifies the statuette's provenance from a Toulouse workshop. The letter "s" stamped nearby probably indicates the year in which it was made. The accompanying stamp with initials of the maker has not yet been properly deciphered. The problem of Toulouse year stamps has not been solved. According to Jean Thuile, Montpellier was the first town of the region to introduce a year stamp in 1427, the letter "A," with the stipulation that each following year be marked in alphabetical order. Toulouse followed this example later and not very scrupulously. If the year mark were the same as that of Montpellier, the statuette would date around 1445, and indeed, until recently it was dated in the fifteenth century. (In the catalog of the 1954 exhibition at Montpellier, the fifteenth century was the date given to a replica from Lasbordes shown in the exhibition, then believed to be the original.) Lately, several scholars have suggested an ealier dating—into the second half or the end of the fourteenth century. If one compares the silver statuette with the monumental sculpture of Languedoc, one finds that the elongated stiff torso of the Child is found in a number of local statues of the Virgin and Child of the fourteenth century. Curly flowing beards can be found as early as the fourteenth century in the apostles' statues from Rieux (Toulouse Museum).

On the other hand, the interplay of the drapery folds and the realism of St. Christopher are closer to the southern French God the Father from the church des Célestins at Avignon, dated already in the fifteenth century (Musée Calvet, Avignon) and to the heavily draped figure on the tomb of Cardinal de la Grange who died in 1402.

The statuette was said to have been given to the church at Castelnaudary (Aude), Languedoc, by a Count of Castelnaudary, but no record of such a count could be found. An exact replica of the piece is in the parish church of Lasbordes.

The historical existence of St. Christopher cannot be proven. Possibly a man later known as St. Christopher was among the first martyred Christians, surnamed Christophoros (Christ- or God-bearer meaning "carrying Christ in his heart"). Later, his proper name was forgotten and only the surname remained. In later centuries, the etymological interpretation of the name was embellished by legend and transposed into a pictorial representation—not a unique case in Christian iconography. Thus the figure of St. Christopher carrying the Christ Child, does not appear in western Europe before 1150. In post-medieval times the saint is found represented with a dog's head (kynokephalos). It seems that this was caused by a misunderstanding of the name for the country of his origin: he was referred to as "Canaanus" (from Canaan) and because a like word *canis* means dog, the saint was given a dog's head.

From the early centuries of Christianity, St. Christopher has been highly venerated both in the east and in the west. In the Middle Ages he was the patron saint and protector of pilgrims and travelers; he was also one of the Fourteen Helpers in Need.

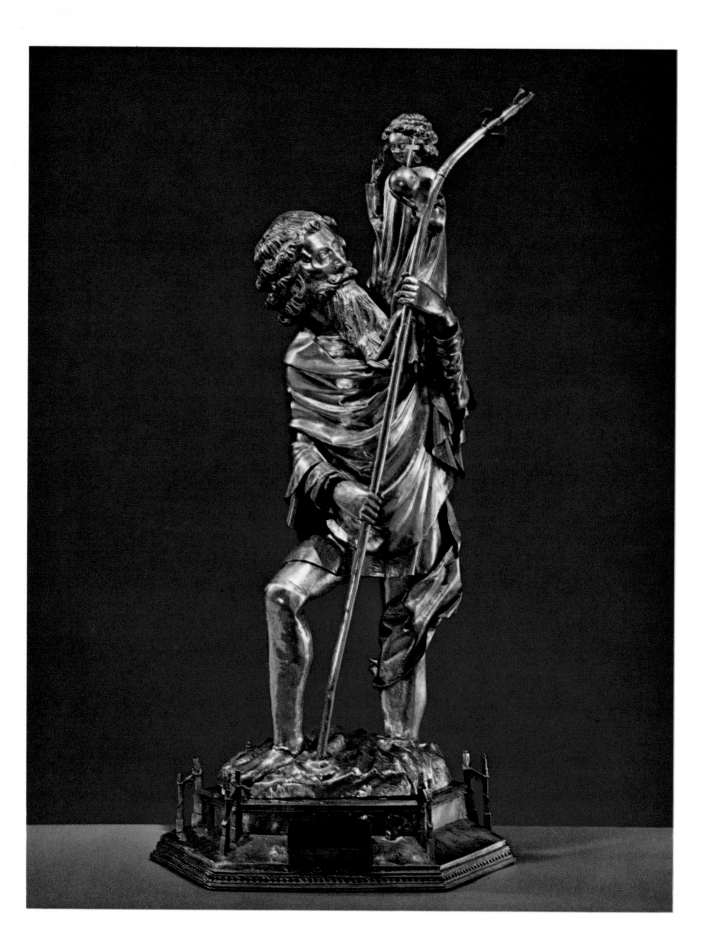

194 *Earthenware, tin-enameled*
 Diameter 18⅛ inches
 Hispano-Moresque, Manises (province of
 Valencia), XV century
 The Cloisters Collection, Purchase 1956
 Ex coll. William Randolph Hearst,
 San Simeon, California

This dish is decorated with the most typical and best-known pattern found on Hispano-Moresque lusterware—of bryony leaves *(ojas de persol)*—probably introduced about 1430. This popular fifteenth-century pattern spread over western Europe and was later imitated in Italy. The bryony leaves are usually combined, as they are here, with five- or six-petaled acacia flowers, and with an interlace of tendrils and leaves of acacia or mimosa used as background filler. All these plant patterns are somewhat stylized, and therefore their identification cannot be positive. It is highly probable that the description *terre de Valence à feuillage pers* (Persian leaves) mentioned in the 1471–1472 inventory of René, Duke of Anjou, referred to pottery decorated with this same pattern of bryony leaves.

In the center of this particular dish, is a shield of a shape current in fifteenth-century Tuscany, with arms resembling those of the Medici of Florence, although they are not the correct Medici arms. They may have belonged to some unknown Spanish family, less prominent than the Medicis, and therefore are not as easily identified.

The pattern of decoration around the shield, enclosed in a rope border, is formed by radiating bands of bryony leaves intertwined with tendrils. On the reverse of the plate are bryony leaves and mimosa.

Many dishes with bryony leaves bear Florentine and Sienese arms. The workers often took license in depicting the arms and one finds fifteenth-century dishes decorated with arms of a family extinct in the fourteenth century. Some arms are purely imaginary; but many can be identified, and the frequent presence of these heraldic shields on Valencian lusterware attests to the number of customers from royal houses and wealthy patrician families of France, Spain, and Italy. Ships carried Hispano-Moresque wares to distant foreign ports, and the demand for them in Italy was so great that Venice exempted lusterware from import duties.

The basic technique of lusterware consisted in forming the chosen shape, firing it to bisque state, then dipping it into vats of liquid white glaze (tin-enamel) which served as background and covered the whole vessel. After the white glaze was fired, the design was painted on it with a feather quill or a brush in shades of blue and copper luster. It was then refired.

The white glaze was composed of a mixture containing tin and lead. Tin gave the intense opacity and whiteness so highly valued. But tin was expensive, so that more tin was used in expensive ware than in the cheaper one. The tints of the blue depended on the purity of the cobalt oxide, and could range from almost pure cobalt-blue to near black. The luster depended on the content of the mixture. The presence of a greater amount of silver produced lighter shades and golden hues; dark and purplish tints were caused by a greater proportion of copper. The finest luster was obtained in the fifteenth century, while later the more coppery hues are frequent.

The fuel for firing was carefully chosen since the heat and smoke it produced had to be considered. The clay used for the pottery was very special, but could be obtained near Manises. These basic elements of the technique are known, but the secret of obtaining the iridescence of the glaze was lost in the seventeenth century.

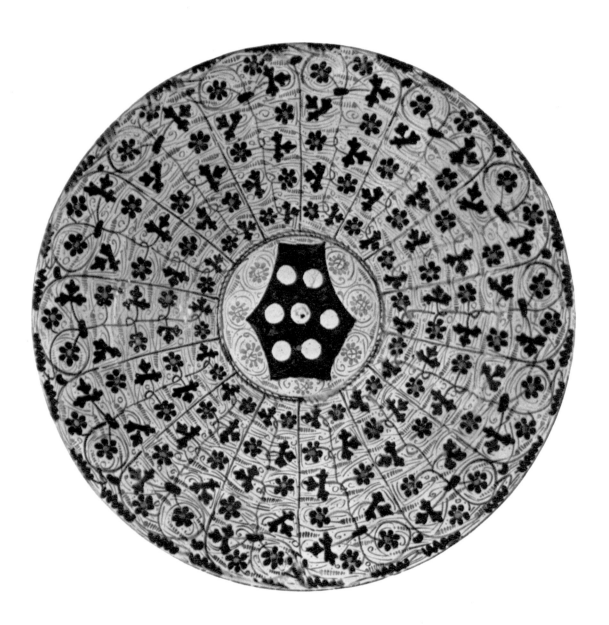

196 *Earthenware, tin-enameled*
Diameter 18⅝ inches
Hispano-Moresque, Manises (province of
Valencia), late XV–early XVI century
The Cloisters Collection, Purchase 1956
Ex coll. William Randolph Hearst,
San Simeon, California

The dish is decorated exclusively in copper luster. A large bull, with the head turned back and upward, is superimposed over a tall tree. Both stand against a background of gadroons, a dot and stalk flower pattern (sometimes referred to as "musical notes"), and a net pattern. The outlines of the bull and of the tree are raised and their shapes also are filled with a net pattern. The painting is in a monochrome copper luster and contrasts are achieved by the sparsity or density of fill-in patterns. The bull and tree motif occupies the entire surface of the plate and their superimposed shapes create an almost abstract design. On the reverse, the dish is decorated with acacia blossoms.

In some instances large animals or birds, spread across the entire surface of the plates, were impressed on the unfired clay and then lustered. The animals chosen for such decoration were usually savage beasts, such as lions, dragons, or bulls.

The dish belongs to the group of late medieval Hispano-Moresque pottery, in which the traditional blue color was often abandoned in favor of copper luster to better imitate metalwork (with which the "golden lustre" ware of Valencia was successfully competing).

The mold-impressed design appears after about 1450. Spanish lusterware from Valencia itself and from its neighboring towns was enormously favored in the fifteenth century. It was commissioned by the ruling houses of distant countries, and special import privileges were granted by Venice and Burgundy. In many Gothic and Italian Renaissance paintings a great variety of lusterware is depicted—serving dishes, platters, plates, bowls, tureens, jugs, pitchers, and albarelos.

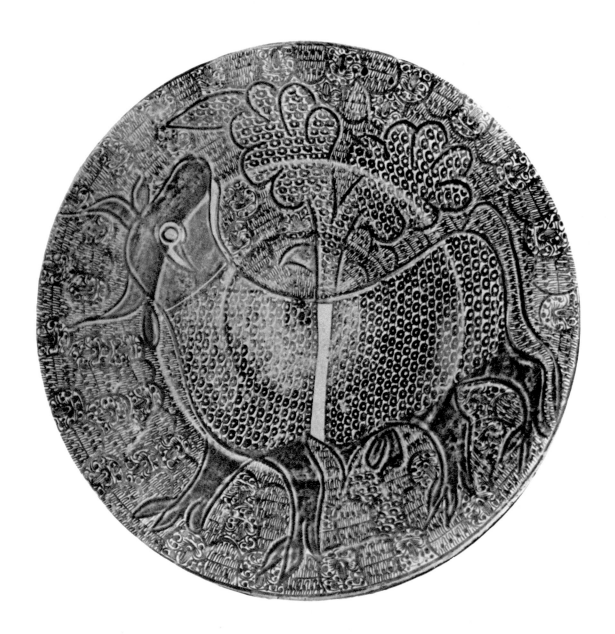

198 *Earthenware, tin-enameled*
Diameter 18⅛ inches
Hispano-Moresque, Manises
(province of Valencia); circa 1420–1430
The Cloisters Collection, Purchase 1956
Ex coll. William Randolph Hearst,
San Simeon, California

The name *brasero,* actually a metal container for hot coals, is given to a flat-bottomed deep dish with perpendicular walls and a wide, horizontal rim. This dish is decorated in cobalt blue and copper luster on a cream-colored background. In the center, an eight-pointed star built of interlace and two superimposed squares, is inscribed in a circle. Four curvilinear zones filled with *alafiás*—stylized, mock-Arabian inscriptions in blue and copper luster—alternate with four pointed ovals which may represent the Tree of Life pattern found on other dishes of about the same date and provenance. Undulating and interwoven blue bands, similar to a design known as the running scroll and possibly also deriving from Arabic calligraphy, decorate the flat rim. The light background is covered with a fine tracery of gold leaves on spiral stems, dots, and palmette tips. A magnificent bull with a bell suspended from the neck is drawn on the reverse of the *brasero* within a scroll border.

A very similar *brasero* (E.634) in the collection of the Hispanic Society, New York, is different only in that its central motif is a shield bearing a coat of arms. A dish of the same kind is represented on the frame of the scene of the Adoration of the Magi in the Book of Hours executed for Engelbert of Nassau by the Master of Mary of Burgundy, about 1485–1490 (Bodleian Library, Oxford. Ms. Douce 219, f. 145-vo).

The shape of the *braseros* was derived from Islamic vessels and they were extremely popular throughout the fifteenth century and even later. Decoration clearly deriving from Moorish prototypes, as well as the manufacture of lusterware, was introduced in Valencia by Moslem artisans from Málaga and Murcia. The name *obra de Malica,* meaning Málaga ware, was still used to designate the gold luster pottery made in Manises in the fifteenth century, although the name *obra de Manises* existed already. Moslem designs imitating the earlier work of Málaga continued in the province of Valencia, and Moorish designs of Tree of Life, palmette, stars, and Kufic inscriptions in blue and copper colors were in great vogue in Manises in the third and fourth decades of the fifteenth century.

The quality and effect of luster depend on the proportions of its chemical composition and the angle at which light falls upon it. Reflections of metallic tones ranging from bright yellow gold to purple and red give great richness and variety to these vessels.

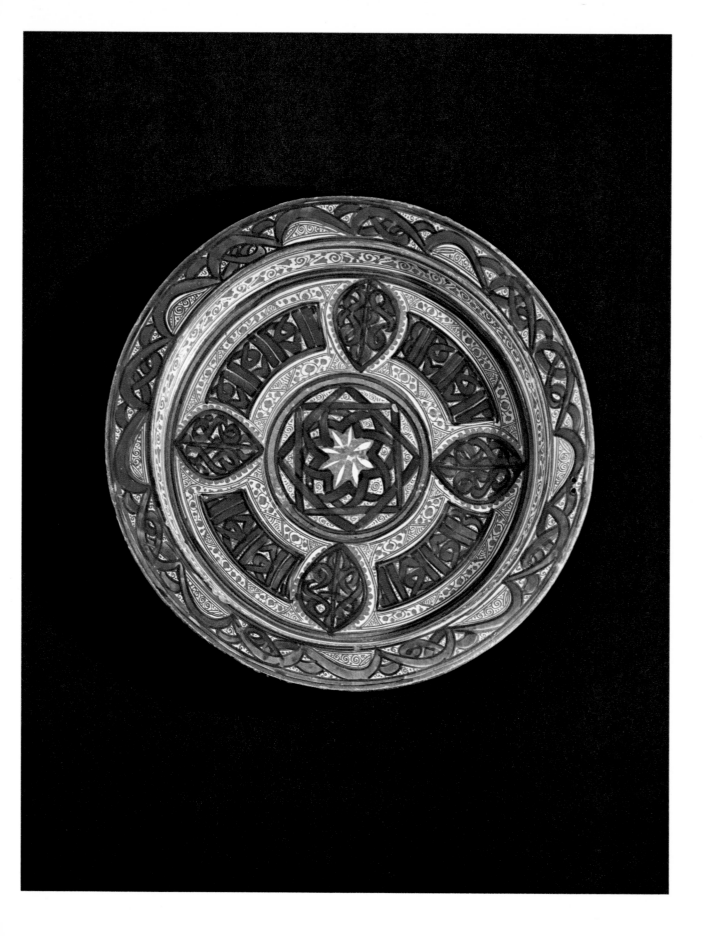

200 *Earthenware, tin-enameled.* H. 10¾ *inches*
Hispano-Moresque, Manises (province of
Valencia), circa 1435–1465
The Cloisters Collection, Purchase 1956
Ex coll. William Randolph Hearst,
San Simeon, California

This tall cylindrical drug jar (Spanish, *albarelo;* Italian, *albarello*) narrows at the collar, stands on a circular foot, and is waisted for convenience in handling. *Albarelos* may differ in shape and proportions, but all have a cylindrical middle section and a narrow sloping shoulder that joins the collar; they are thrown on the wheel and shaped by hand.

The Cloisters *albarelo,* one of a pair, is decorated in blue and copper luster. Horizontal divisions are entwined by vine stems with ivy leaves, their veins indicated in sgraffito; between the ivy leaves are acacia blossoms and pinnate leaves. The ivy leaf and acacia pattern became standard in the workshops of Manises, where it was executed with unequaled skill. Its highest fashion was from about 1435 to about 1465.

A somewhat similar *albarelo* is represented in The Adoration of the Shepherds by Hugo van der Goes in the Uffizi, Florence.

The shape of the *albarelos* derives from covered Arabian jars of the twelfth century. The latter had pottery covers, while those made in Spain were usually closed by a piece of parchment tied tightly around the top of the jar. *Albarelos,* often made in pairs, were frequently made to store balsams, powders, or confections, and could be found ranged in rows on the shelves of a pharmacy.

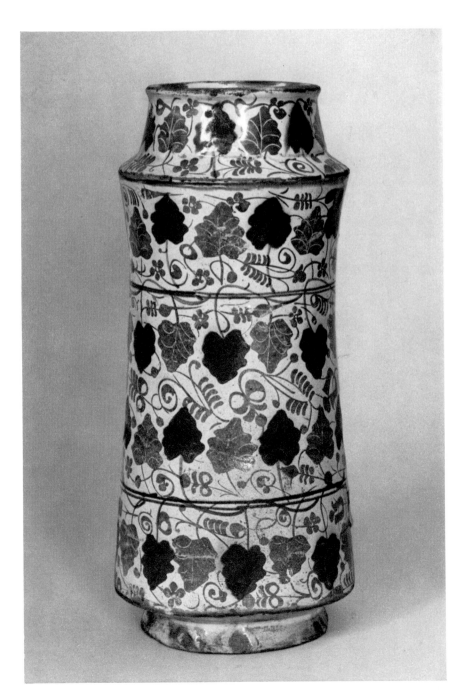

Earthenware, tin-enameled
H. *8⅝ inches*
Hispano-Moresque, Manises (province of
Valencia), second half the XV century
The Cloisters Collection, Purchase 1956
Ex coll. William Randolph Hearst,
San Simeon, California

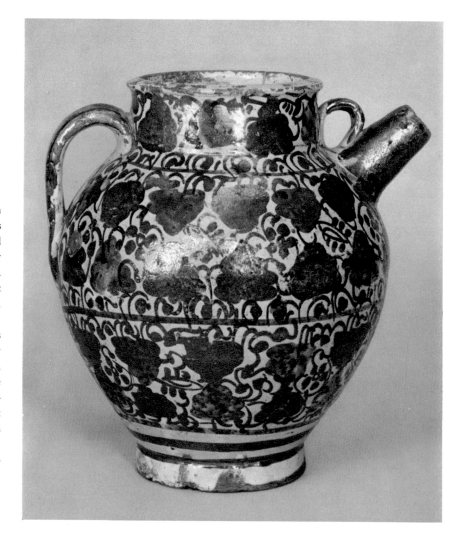

Jugs of this particular shape were used in pharmacies to contain liquids such as honey, syrups and oils. Commonly named *cetrill* or *alcuza*, their shape is probably derived from earlier Iranian sources. A *cetrill* has a globular body, a tubular spout joined to the collar by a reinforcing ring, and a handle.

The decorative design on this *cetrill* is divided into three horizontal bands of ivy leaves in blue and copper luster, with plain copper luster covering the handle and the spout. The crudely drawn decoration reveals that the jugs were hastily turned out in great quantities. Although jugs of this particular shape were not very practical, their manufacture persisted until the mid-eighteenth century.

202 *Earthenware, tin-enameled*
Diameter 17⅜ inches
Hispano-Moresque, Manises (province of
Valencia), circa 1435–1465
The Cloisters Collection, Purchase 1956
Ex coll. William Randolph Hearst,
San Simeon, California

The shield on this dish decorated in blue and copper luster is charged with a heraldic (?) eagle that might represent a coat of arms. A great number of eagles are used as charges and this makes even a tentative identification of the arms difficult. In this case, the eagle on the shield might represent the arms of either the Aguas or Aguilar family (both of Valencia), described as "an eagle displayed to the dexter". This central motif is surrounded by two bands of ivy leaves, each consisting of a branch forming a concentric circle, around which are intertwined twigs with leaves sprouting in opposite directions painted alternately in blue and in copper luster. The background is of a neutral creamy color filled with tendrils, acacia blossoms, and acacia or mimosa leaves. On the reverse of the dish a heraldic eagle is displayed against a pattern of acacia blossoms.

The pattern of vine leaves and of smaller bryony leaves (cf. number 89) intermixed with acacia sprigs was apparently introduced in Valencian ware in the thirties and the forties of the fifteenth century. Although no chronological order for the appearance of various patterns in Valencia and Manises has been established, and many types appear to be current at any given time, it is still possible to indicate approximately the period in which they appear.

The frequent use of ornamental heraldic shields is noteworthy, but at the same time one must keep in mind that some of them were intended as purely decorative motifs and often cannot be identified as belonging to any particular family. One must admit that Valencian potters have achieved a splendid decorative effect by the use of heraldic motifs in combination with the surrounding ornament.

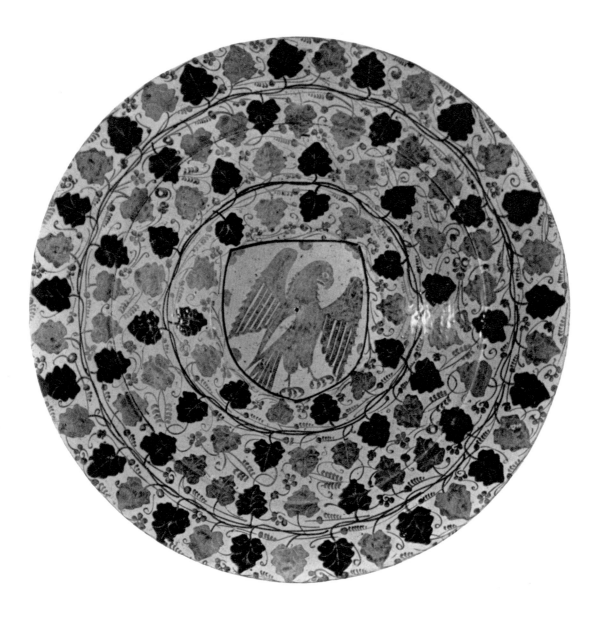

204
Earthenware, tin-enameled
Diameter 17 inches
Hispano-Moresque, Manises (province of
Valencia), circa 1470–1490
The Cloisters Collection, Purchase 1956
Ex coll. Roland Gosselin, Paris (?),
William Randolph Hearst,
San Simeon, California

In the center of the dish is a shield bearing the coat of arms of the Buyl family (reversed). A series of molded ribs divide the surface into sections that radiate from the center medallion. The entire surface of the dish is decorated in copper luster with an allover stalk-and-dot pattern, also known as "musical notes". The back side of the dish is decorated with a pattern of acacia blossoms.

Plain earthenware dishes did not appeal to the rich nobles of the Middle Ages. If they could afford it, they used silver and even gold plate. It was not until the tin-enameled Hispano-Moresque ware decorated with copper luster was brought on the market by Valencian workshops that earthenware dishes became popular among those who could pay their high prices. After 1450, Valencian potters, whose expensive "golden ware" already had enjoyed great popularity in the first half of the fifteenth century, started to compete with silversmiths. They began to imitate metalwork and to copy the repoussé work of the silversmiths by ornamenting the surface of dishes with molded bands. Still later they ornamented the dishes with series of molded gadroons on the borders. This dish represents an example of such imitation.

Several generations of the Buyl family were the lords of Manises, where the greater part of Valencian pottery was produced, and received ten percent of the whole production which they undertook to sell through their own agents. Their coat of arms is: quarterly 1 and 4, an ox statant, 2 and 3, a triple-towered castle. On The Cloisters dish the arms are reversed, probably by mistake, unless it was a manner chosen by some member of the family to difference these arms. Several dishes of various dates with the arms of the Buyl family exist with the correct coat of arms. One of these, of about 1430, is in the Victoria and Albert Museum, London. On a dish in the Lyons Museum, the arms of the Buyl family are reversed as on The Cloisters dish.

The history of the Buyl family is interwoven with that of the industry. Correspondence has been preserved concerning one large order for pottery placed by Queen Maria of Castille in 1454, for Valencia ware, called *obra de Melica*. In it are given names and uses of vessels such as large platters for serving, plates and bowls *(escudillas)* for eating, and others for drinking broth, as well as jars for water and vases for flowers. The order was placed with Pedro Buyl at Manises, "the fountainhead of this industry", to be delivered in five months. The word "imploring" was used by the Queen, expressing the anxiousness of the royal customer to have her order filled.

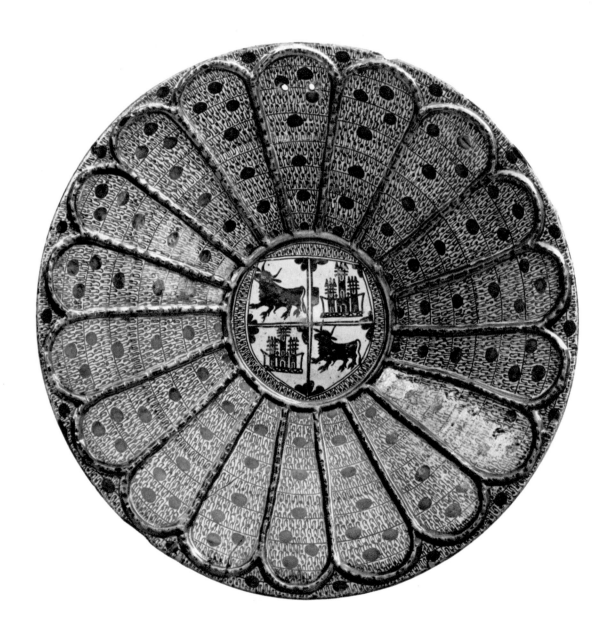

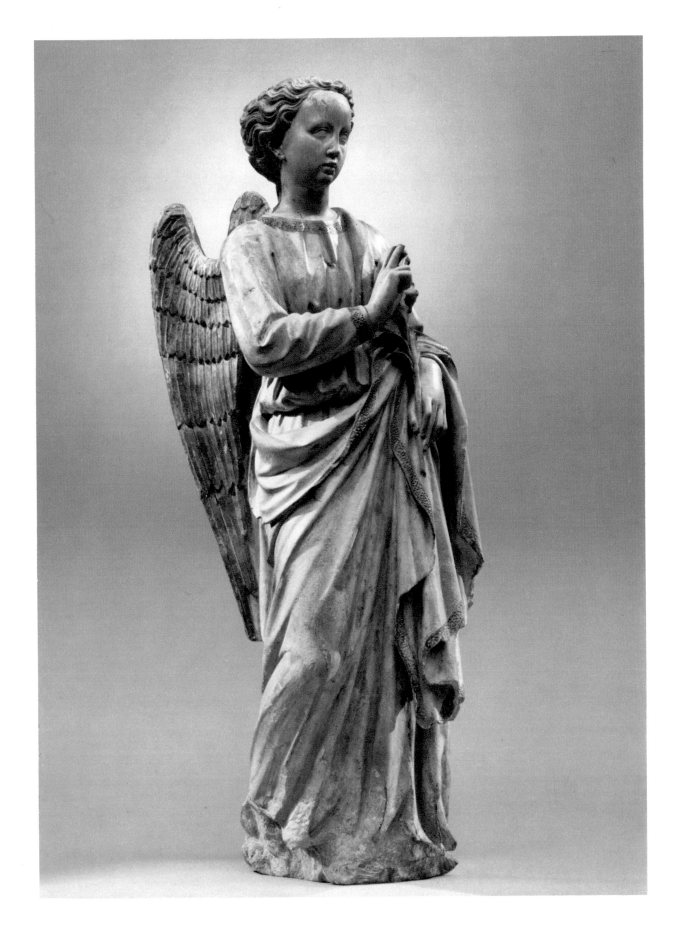

Istrian limestone. H.*37½ inches*
Italian (Venetian), circa 1425–1430
The Cloisters Collection, Purchase 1967
Ex coll. the former King of
Rumania, Switzerland

Standing weightlessly with a slightly flexed right knee, the angel holds a lily in his left hand; his right hand is raised in a speaking gesture (called the "speaking hand" or the "sign of Logos" by H.P. L'Orange). He was doubtlessly carved for an Annunciation of the Virgin group. The uneven, broken edges of the base suggest that originally he might have been part of a larger sculptural monument. There are traces of gilding on the ornamental borders of the angel's clothing, on his hair and wings; and traces of white paint (possibly of later date) on the limestone surface.

All that is known about the statue's history is that it was acquired in Florence, on the advice of Professor Leo Planiscig of Vienna, by H.R.H. Prince Nicholas of Rumania, purportedly for the collection of his mother, Queen Marie, and that it was in the collection of the former King of Rumania, in Switzerland.

Although the original provenance of the statue is not known, it can be dated by style in the first half of the fifteenth century, or about 1425–1430, and attributed to Venice, Italy. The material, a fine-grained Istrian limestone similar to marble, supports this attribution.

The style of the drapery, the elegance of the posture, and the flowing lines of the hair of the angel, are typical of the work of the Venetian masters of the flamboyant Gothic period, and, in particular, of such masters as Bartolommeo di Giovanni Buon (also known as Bono or Bon) who worked with his father on the portal of the Doge's Palace and elsewhere in Venice in the second quarter of the fifteenth century. There is also a resemblance to the work of Piero de Niccoló Lamberti, son of Niccoló di Piero Lamberti, who worked both in Venice and in Florence. The angel can be compared to the statues of Temperance and Fortitude on the Porta della Carta, the main doorway of the Doge's Palace in Venice, attributed to either Bartolommeo Buon, or to Lamberti.

The loose drapery folds can be compared to the work of the so-called Master of the Mascoli Altar, dedicated in 1430, in St. Mark's, Venice. The profile of The Cloisters angel, with its highbridged nose, and the shape of the hands are very similar to those of the angels on the altar frontal in St. Mark's. The Cloisters angel shows a more sophisticated arrangement of drapery folds and a greater feeling of elegance in the execution. However, the posture of the Virgin in the upper part of the altar is just as graceful as that of The Cloisters sculpture.

The Cloisters angel should also be compared with the Venetian Angel of the Annunciation of the first half of the fifteenth century in the Victoria and Albert Museum, London, even if it does not appear to be by the same hand. It is also carved in Istrian stone and although the drapery is different, he is standing in an almost identical posture —the same flexed knee, the same kind of speaking gesture, and the same way of holding the lily. Unfortunately, nothing is known of the previous history of the Victoria and Albert angel. John Pope-Hennessy attributes it to Antonio Bregno (1425–1457), associated with Bartolommeo Buon in the work on the Porta della Carta, Venice. Leo Planiscig regards it as the work of an unidentified Venetian sculptor under the influence of the Master of the Mascoli Altar. Other authors compare it with the work of Dalmatian sculptors.

Another Angel of the Annunciation, in the collection of the Prince of Liechtenstein, Vienna, attributed to the Master of the Mascoli Altar by Leo Planiscig and by W.R.Valentiner, has some similarities to The Cloisters piece but only in certain details.

Considering the debatable identity of the sculptors whose work is comparable, one must, for the present, restrict the attribution of the Angel at The Cloisters to the circle of the Master of the Mascoli Altar or that of Bartolommeo Buon.

208 *Wool, 12 ribs to the inch*
H. 9 feet, 7 inches; W. 10 feet, 11¾ inches
Franco-Flemish (Arras or Tournai),
circa 1435–1450
Rogers Fund, 1909
Ex coll. Sigismond Bardac, Paris

This tapestry panel with its two-dimensional and purely decorative effect is one of three large fragments in the Metropolitan Museum of what was probably a whole series of panels covering the walls of an entire room. In medieval inventories such series of tapestries are often referred to as "rooms" (*chambres*).

The costumes are possibly court costumes of about the mid-fifteenth century. The lady wears a long houppelande cinched tightly in the high-waisted style then popular, with plain long-cuffed sleeves and revers open in front to show the cotte underneath. Over a coif, she wears a v-shaped brocade *bourrelet* (roll) with a veil. Covering her puffed-out hair are nets embroidered in pearls and jewels. The men wear short low-belted houppelandes with vertical slits in the full sleeves, tight long hose, ankle-high piked shoes, and turban-like chaperons with long liripipes.

Although neither the exact meaning nor the subject of the tapestries is known, several interpretations have been offered. When they were acquired by the Museum in 1909 they were called "Baillée des Roses", signifying the yearly homage of the French peers to Parlement. At this festivity splendid dinners were accompanied by music while roses and other flowers were distributed to the guests.

The title was discarded when this name for the festivity could not be found in medieval documents. Another suggestion, that the tapestries illustrated some literary text similar to the *Roman de la Rose*, was rejected when no specific episode could be found. The tapestries might rather belong to the group of *Conversations galantes*. In consideration of the courtly costumes and attitudes shown, they are now entitled Courtiers with Roses.

The history of the tapestries, before they came into the Bardac Collection, is not known. They were shown in 1904 in the *Exposition des Primitifs français* in Paris, where they were greatly admired and declared to be the most representative tapestries of their kind for the fifteenth century. The Musées Nationaux of France petitioned for their acquisition and were refused. They were then bought for the Metropolitan Museum.

The tapestries may belong to a set that was probably made for Charles VII of France. Red, white and green were the colors of his livery, and the rose his badge. Livery colors acquired symbolic meaning in the fifteenth century, and tapestries with striped background *(lymogées* or *à lymoges)* were evidently in fashion. For example, a figure group against a striped green and white ground with a scattering of roses was bought in 1427 by Philip the Good, the Duke of Burgundy, from Jean Walois of Arras. A 1458 bill states a payment for white and green material embroidered with branches of rose leaves "the usual device of the King, our Sire". The cloth was to be distributed among the officers, probably for their uniforms. The illumination by Jean Foucquet in the Munich Manuscript of Boccaccio's *De casibus Illustrium Virorum et Mulierum* (Of noble men and women) shows the *Lit de Justice* held in 1458 by Charles VII for the trial of Jean, Duc d'Alençon. The walls are covered with tapestries which have vertical stripes of red, white, and green, flowering rosebushes, and the arms of France with supporters. Charles VII appears as one of the Magi in the Adoration of the Magi in Foucquet's *Hours of the Virgin* and his attendants wear the King's livery colors. In 1454, Charles VII ordered a number of small golden badges in the shape of a rosebush from his jeweler, Gilbert Jehan, and gave several of them to his officers on New Year's Day.

Stella Rubinstein sees in the lady a portrait of Agnes Sorel; she finds a resemblance between the lady in the tapestry and the King's favorite, painted as the Virgin of Melun by Foucquet, and concludes that the tapestries must have been ordered by the King for Agnes Sorel. The date of about 1435 to 1450 has been reached after considering various possibilities. Joseph Breck in 1909 proposed a date after 1435, or more exactly a date between 1435 and 1440 for the tapestries, which he believed were made for Charles VII. Pierre Verlet sees the influence of Jean Foucquet in the style of the tapestries. Henri Bouchot, first to relate the tapestries to Jean Foucquet's illumination of the Duke of Alençon's trial, finds the tapestries a "transition document for the art of the artists of the Duke of Berry and that of Jean Foucquet." Lily Fischel compares the man's figure on the right to an engraving by the Master of the Playing Cards *(Blumen-Unter)* and thinks that both may derive from the drawing of the Duke of Brabant by Jan van Eyck in a private collection.

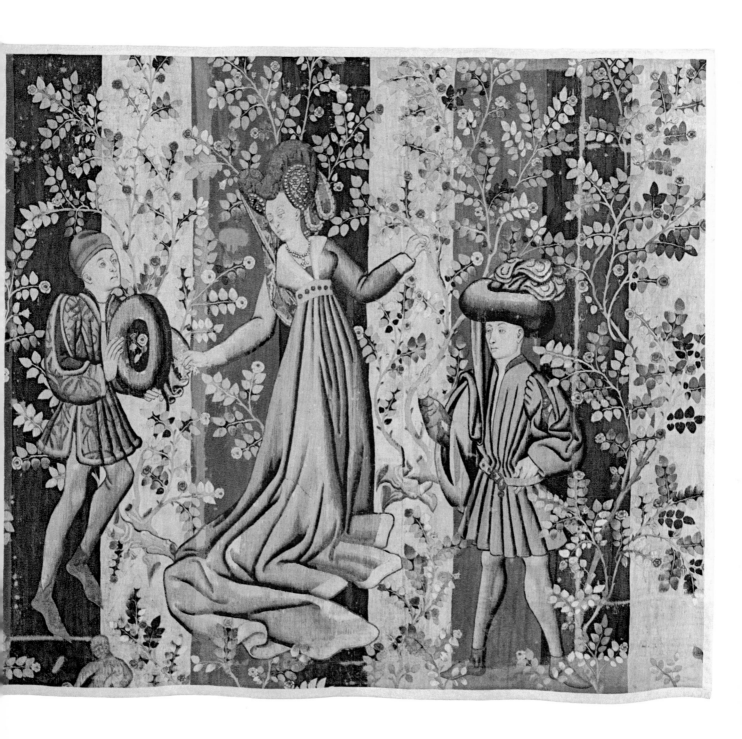

210 *Marble.* H.15⅜ *inches*
French (region of Berry),
second half of XV century
Gift of J. Pierpont Morgan, 1916
Ex coll. Hoentschel
Possibly from the church of Les Aix-d'Angillon
(Cher, province of Berry)

The mourner is a heavily built middle-aged man wearing a long sleeveless cloak slit at the neck and fastened by a single button. His head and forehead are covered by a deep hood emphasizing his heavy-set square chin and the sad outline of his closed mouth. The man's hands are folded at the waist, and the cloak, caught at the bend of the elbows, forms an apron-like panel, criss-crossed by carelessly arranged folds. The whole figure expresses the sadness of mourning.

Despite shortcomings in the technical treatment of this figure, its mood is very successfully interpreted. In Peraté and Brierè's catalog of the Georges Hoentschel Collection, the mourner is appropriately described as "a little stocky and heavy, showing great energy and realism and related to similar statuettes of mourners in Dijon and at Bourges". The sculptures referred to are those on the tombs of Philip the Bold (1342–1404) by Claus de Werve, those by Jean de la Huerta and Antoine le Moiturier on the tomb of John the Fearless (1371–1419), both in the Dijon Museum, and those on the tomb of Jean, Duke of Berry, in Bourges, completed in 1457 by Etienne Bobillet and Paul Mosselman. This last tomb may well have introduced into

Berry the fashion of such monumental tomb sculptures. The Metropolitan Museum figure has also been compared by Henry David to a mourner on a tomb of the Chalons family in Baume-les-Messieurs. By others it has been compared iconographically to the mourner in the Mayer van den Bergh Collection in Antwerp.

When the figure of the mourner came to the Museum, it was described as "Burgundian" or belonging to the "school of Burgundy". More recently, Bella Bessard, in an article in the *Journal* of the Metropolitan Museum, has compared the figure to two mourners presently in the church of Pruniers, which possibly came from the tomb of a canon or prior formerly in the church of Les Aix-d'Angillon eight miles northeast of Bourges in the province of Berry. She places the style of these mourners definitely within the region of Berry. The two mourners at Pruniers may have belonged to M. Dumoutet and later to Abbé Rabier. If the Museum's statuette comes from the same tomb, as Miss Bessard believes, it also might have passed through the same collections before being acquired by Hoentschel.

The man's costume is typical of figures of mourners which were placed around special types of large tomb monuments in the fifteenth century. The idea of surrounding the tomb with such figures is, no doubt, derived from an earlier custom of attaching tokens of sorrowful remembrance of the deceased and of undying faithful alliance to his family. This custom began about 1200 in feudal France at a time when friendship and loyalty meant security for the lord, support for the equal, and protection for the weak. In the thirteenth century, the families of noble mourners were represented by

their coats of arms on shields which were attached to the tomb slab or to the walls of the monument. In the fifteenth century such shields were replaced by sculptures, sometimes representing actual portraits of the bereaved. One of the best-known examples is the group of ten bronze statuettes, now in the Rijksmuseum, Amsterdam, which were commissioned by Philip the Good and cast by Jacques de Gérines about the middle of the fifteenth century. They may have been made for the tomb of Jeanne of Brabant, and the statuettes are believed to be recognizable portraits of members of the Burgundian ducal house. On the more famous tombs of the Burgundian Dukes in the Dijon Museum the features of the mourners are hidden by deep hoods and voluminous cloaks, as they are on this statuette. These costumes must have been copied from those actually worn by mourners at the funerals. The deep hood and cloak was evidently a uniform by which a mourner could be immediately identified and hiding the features was symbolic of the expression of deep grief. The demonstration of sorrow and despair during the funeral ceremonies was an important part of medieval funerary customs, at which not only relatives and friends, and many clerics, but even hired mourners and criers loudly bewailed their loss. The wealthier the family of the dead, the greater was the number of such hired mourners.

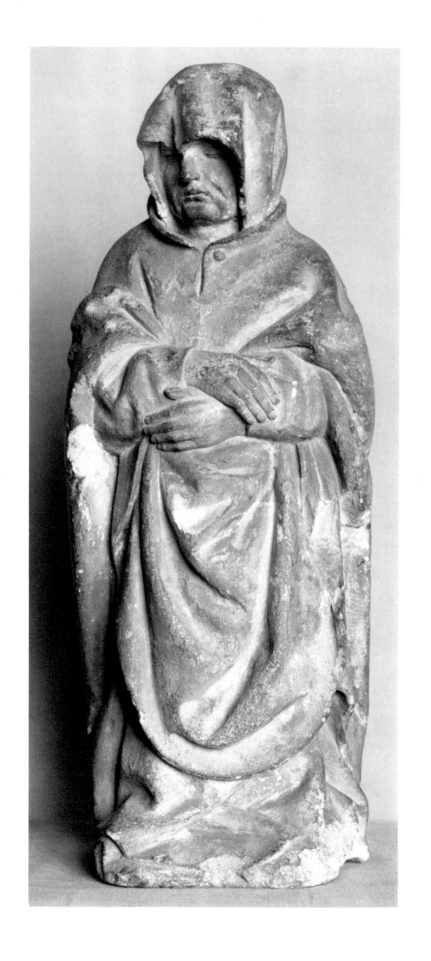

212 *Silver gilt, filigree enamel*
 H. *19 ⅜, W. 6 inches*
 Italian (Naples?), 1457
 Gift of J. Pierpont Morgan, 1917

A simple volute forms the head of the bishop's crozier. Its outer edges are outlined by crockets, possibly of acanthus leaves, the tip of each leaf covering the base of the leaf above. A few additional curls connect the volute's end to the staff. Both sides are decorated in filigree enamel with scrolls in silver wire ornamented with bunches of grapes or berries; spiral tendrils separate the enamel colors. The background is dark-purple, but inside the scrolls it is alternately green or dark-red translucent enamel. Each scroll contains a white and red flower, some in the shape of rosettes, others heart-shaped.

Within the volute, a haloed figure is enthroned above a hexagonal pedestal; he holds a book in his left hand and blesses with his right. Engraved on the back of the throne are the letters DS PR, which could mean: Deus Pater, God the Father. Along the sides of the pedestal runs the inscription: DNS. ANTONIUS. EPS. POTENTINS. FIERI. FECIT. MCCCCLVII ("Anthony Lord Bishop of Potenza ordered [this crozier] to be made [in] 1457"). A segment of the pedestal's top slides out, revealing a space which may have been intended as a reliquary.

Antonius Angelo was Bishop of Potenza, a town in the province of Basilicata, southern Italy, from 1450 to 1463. St. Gerard, to whom the Cathedral of Potenza was dedicated, was himself Bishop there

before his death in 1119. Potenza was included in the Kingdom of Naples where Alphonso of Aragon, the Magnanimous, reigned from 1435 to 1458, a most prosperous period for southern Italy.

There are three bishop's croziers, still in the treasuries of southern Italian cathedrals, which are very closely related to the crozier head in the Metropolitan Museum. There seems to be no doubt that they come from the same workshop, and possibly were made by the same hand.

These croziers are in Reggio Calabria, Tropea, and Troina. The leaf crockets are identical on all four. The enamel decoration on the sides of the one from Reggio Calabria is almost identical to that of the Museum crozier, and those on the other two differ only in details. Each of the four volutes contains the same type of hexagonal pedestal supporting enthroned and kneeling figures. In Reggio Calabria the scene is the Corona-tion of the Virgin; in Tropea and Troina a bishop kneels before Christ in Majesty. On the Reggio Calabria crozier there is an inscription which reads: ARCHIEPISCOPUS ANTONIUS DE RICCI (Ricci was Archbishop of Reggio in 1453–1488). On the knob of the crozier is the silver mark of Naples: NAPL. It has been said that a silver mark of Naples also appears on the Tropea crozier. There could have been a silver stamp on the missing knob of the Museum crozier as well.

The same type of hexagonal pedestal with kneeling figures within crozier volutes is found in at least two Sienese croziers of the preceding century, but their enamel decorations are entirely different. Inside the volute of the crozier in the Cathedral of Città di Castello, Bishop S. Florido is kneel-ing before the seated Virgin and Child. The maker is unknown, but the workman-

ship is related to that of Ugolino di Vieri of Siena. Another fourteenth-century crozier in the Opera del Duomo in Siena has a figure kneeling before a crucifix on the pedestal. A silversmtih trained in Siena may have traveled to Naples and introduced Sienese traditions there.

In the near future Angelo Lipinski is planning to publish this group of southern Italian croziers.

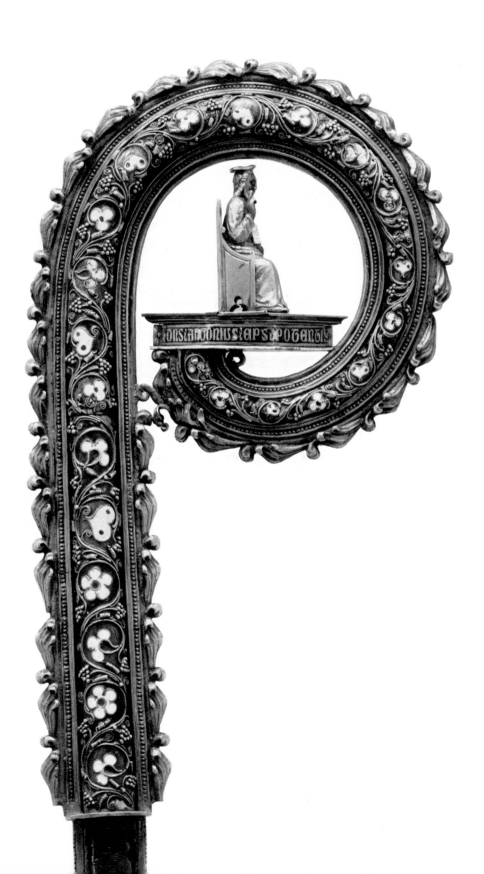

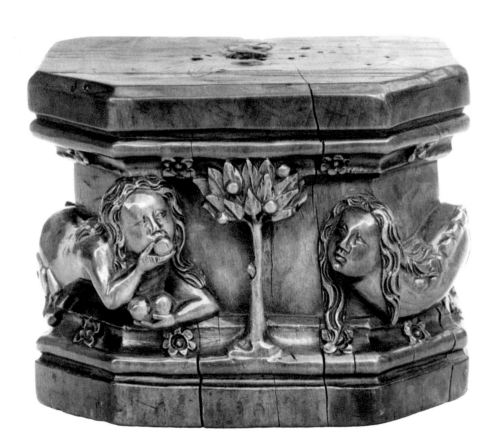

214

Boxwood
H. *3 ½*, W. *4 ¹³/₁₆*, D. *3 ⁹/₁₆ inches*
Flemish, circa 1470–1480
The Cloisters Collection, Purchase 1955
Ex colls. Rodolphe Kann, Paris;
Mortimer Schiff, New York;
Irwin Untermeyer, New York

The prone figures of Eve and the serpent on the boxwood base may be a compositional adaptation to a horizontal space. The Tree of Knowledge between them indicates the garden of Eden. Eve is biting into an apple held in her right hand, and holds two additional fruits in her left. Jeffrey M. Hoffeld believes the half-human, half-reptile creature represents Lilith, the legendary first wife of Adam. (Lilith tempted Eve to taste the fruit of the Tree and thereby commit the original sin of disobedience to God). Or, the creature may simply be the traditional serpent sent by the devil.

Commentaries and interpretations by medieval theologians of the Old Testament and its relation to the New, influenced the iconography of medieval artists. Their texts often provide a solution for otherwise inexplicable representations. Christian authors and artists borrowed freely from certain non-Christian writings. Hoffeld believes that the source for the subject carved on this base is found in the Talmudic interpretation of the text of Genesis 1:27–28 and Genesis 2:21–22. Included in the Mishnah, it told of the creation of Adam and Eve. According to Hoffeld, this image of Lilith was borrowed from the writings of

Jewish mystics known as Kabbalists. The legend recorded in these writings says that Lilith was created from the earth at the same time as Adam (Genesis 1:27–28) and that she was Adam's companion until she rebelled and, abandoning him, disappeared from Paradise. She refused to come back, and hence God created Eve from Adam's rib. Lilith was punished for her disobedience, and in her vengefulness became a predator of infants and pregnant women. In the Middle Ages her image is associated with evil deeds of the night.

A further symbolic meaning can be read into the scene. According to some medieval writings seven vices stemmed from the Tree of Knowledge: pride, envy, wrath, avarice, sloth, unchastity and drunkeness, and there are seven apples represented on this base. However, the fruit of the Tree of Knowledge is not specified in the Bible. In fact, Oswald Goetz in *Der Feigenbaum in der religiösen Kunst des Abendlandes,* Berlin 1965, proves that the fruit was probably meant to be that of the fig tree which appears in a number of Early Christian representations. The identification of the Tree of Knowledge as an apple tree is a later and northern tradition.

The symbolic relationship between Eve, the mother of mankind, and of Mary, the Mother of God, served as a fascinating subject for medieval theologians. One finds an early typological antithesis in Tertullian's writings (d. 220). Later, the idea was introduced that the name Eva and the word Ave, spoken by the Angel of the Annunciation, are the same, only reversed. St. Bernard pointed out that Eve as the cause of original sin was *"radix amaritudinis"* (the root or source of bitterness), while Mary as Mother of the Redeemer was

"radix aeternae dulcendinis" (the source of eternal bliss).

Another favorite contraposition was to identify Eve with the Synagogue, the Old Dispensation, and the Virgin Mary with Ecclesia, the Christian Church. Consequently, Eve is frequently found as an antithetic figure in compositions connected with the image of the Virgin. Thus, an almost identical pedestal serves as a base for a statuette of a seated Virgin and Child, called northern French, of the early fifteenth century in the Victoria and Albert Museum, London. The Cloisters piece might have served as the base for a similar statuette.

A more complicated interpretation is supplied by Ernst Guldan for a crouching female figure under the feet of a standing Virgin and Child, a marble statue of the first half of the fourteenth century in the church of St. Laud, Angers. The crouching figure is very similar to the Eve on The Cloisters base, with the same features and pose, biting into an apple. Guldan calls it Greed or Desire *(die Begierde),* and explains that it illustrates a merging of the identity of Eve with that of the viper-temptress, whom the Virgin usually treads under her feet.

216 *Green glass. H. 2⅛ inches*
German, late XV–early XVI century
(circa 1500)
Munsey Fund, 1927
Ex coll. Jacques Mühsam, Berlin
Provenance: Cologne

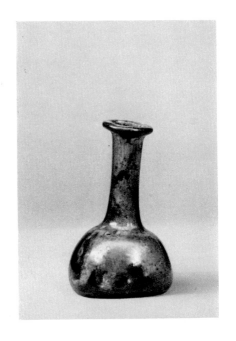

This small green glass bottle was made in a globular shape, and the base was then pushed in to produce the "kick" which reduces the small volume even further. The bottle belongs to a type known as apothecary or pharmacy bottles, although their use was not restricted. They evidently were made for very small amounts of medication—oils, salves, and unguents—widely used in the Middle Ages for various cures. However, they also served as containers for balsams, perfumes, precious aromatic essences and oils, rose water, and holy water. They were also used for "oils of martyrs" (usually mere oil from the lamps lighted at the saint's grave or shrine) brought back from holy places by pilgrims and travelers. Sometimes they contained particles of actual relics—small bits of clothing, hair, or bones of a saint—to be preserved in church treasuries. The bottles were made in various shades of green and their usual height is from about one to three inches.

Many similar bottles have been excavated in Germany and the Lowlands. They were evidently inexpensive, for they have been found discarded in wells and dumping places and often seem to have been used only once. Although they are primarily late medieval, they have often been mistaken for Roman glass; their type was made as late as the eighteenth century.

Glass. H. 4 ¹/₁₆
maximum Diameter 2 ⅞ inches
German, XV century
Munsey Fund, 1927
Ex coll. Jacques Mühsam, Berlin (?)

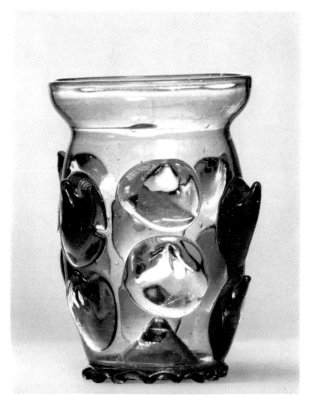

The green glass beaker is barrel-shaped and has a pulled-in neck and a broad, bowl-shaped lip. Its applied foot is made from a narrow glass ring with crimped edges. The base of the beaker is sharply concave, forming a broad conical protuberance inside the beaker. On the outside, the body of the beaker is decorated with two staggered rows of flattened prunts of the same green glass fused onto its surface.

Prunted beakers are usually referred to by their German name, *Krautstrunk,* because they look like denuded cabbage stalks, showing stumps from broken off leaves. Franz Rademacher suggests that the "vegetable" ornament on the beaker reflects the general predilection for decorative vegetable

forms in German late Gothic art. He points out that not only glass but silver beakers as well were similarly ornamented with spiral or lobed bosses which gave their walls a richer light-reflecting surface. He also states that fifteenth- and sixteenth-century inventories list silver beakers with "prongs" (Stacheln) "like in glass".

Barrel-shaped beakers have been found in the Rhineland and in the Netherlands, while the *Krautstrunk* type was extremely popular in these regions around 1500 and can be seen in sixteenth-century German and Netherlandish paintings by Dirk Bouts, Dürer, Holbein, and others, as well as in tapestries.

The native medieval glass is known in

German as *Waldglass* (forest glass), probably because of its peculiar green color, but possibly because glassmakers usually had their workshops in forests. The green tint is caused by the presence of iron in the glass which medieval artisans had not learnt to remove. Changes in the thickness of the glass walls provide pleasing variations in color. German Rhenish beakers of the Middle Ages show dependency on old Roman forms and, in general, Rhenish glass production continues the tradition introduced under the Romans. This tradition was interrupted to a certain extent during the migration period and some techniques had to be reintroduced through Islam and Syria.

218 *Silver. 2 $^{11}/_{16}$ × 2 $^{11}/_{16}$ inches*
German (Upper Rhenish), late XV century
The Cloisters Collection, Purchase 1956

The low relief silver plaque with the scene of the Annunciation depicts the Virgin kneeling at a *prie Dieu*. On the desk is her book, probably the Bible, opened to the words of the prophet Isaiah: *Ecce Virgo concipit...* ("Behold, a Virgin shall conceive and bear a son, and shall call his name Immanuel..."). According to the writings of the Fathers of the Church, Mary was meditating on these words when the angel appeared. The Virgin's hands are folded in prayer and her head is turned slightly in the direction of the angel's voice. The angel wears an alb and holds a scepter in his left hand. On top of the staff three lilies, the symbol of Mary's inviolate virginity, form a cross. The right hand of the angel is raised in the gesture of speech, but at the same time he seems to point to the scroll which curls around his scepter. Although nothing is written on this scroll, it should be inscribed with the words of the angelic salutation: *Ave Maria, gracia plena, Dominus tecum....* ("Hail Mary full of grace, Lord be with you, ..."). Descending from above, and almost touching the Virgin's halo is a dove, the symbol of the Holy Ghost. In this scene the dove is also a symbol of the Incarnation. On the tiled floor, between the Virgin and the Angel stands a vase containing a flower which is meant to be a lily, another symbol of the Virgin's purity. The scene takes place in Mary's room, as indicated by the floor; the background is replaced by a stippled surface. Had an interior been represented in this Annunciation, it would have been the familiar surroundings of a middle-class house, in accordance with the tendency of German art of this period.

The composition and general style of the plaque derive from prints popular in the fifteenth century. Practically every contemporary German artist copied and imitated the printmakers' themes. The prints of the Master E.S. and of Martin Schongauer had the greatest impact. Their influence can be seen clearly in works of the secondary masters of the Upper Rhine and Swabian regions. In most cases, the prints served as inspiration, and the results were imitations rather than exact copies, with details from several prints shifted or combined.

The holes in the corners of the plaque must have served for its attachment to some larger object, possibly a box or book cover. A silver plaque with the scene of the Nativity in the Museum für Kunst und Gewerbe, in Hamburg, closely resembles the style of The Cloisters plaque of the Annunciation. The two plaques may belong to the same series, but the size of the rectangular Hamburg plaque is approximately two and a half by eight inches.

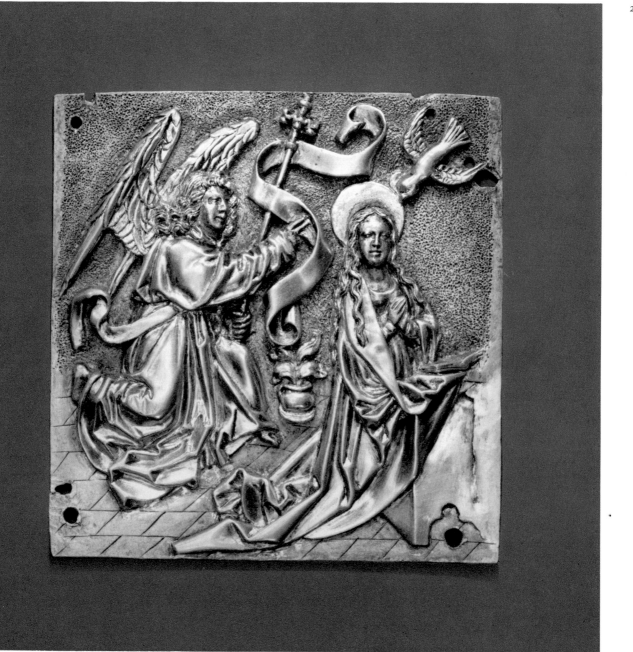

220 *White pine or Swiss stone pine;*
polychrome and gilt
H. *26½,* W. *24½ inches*
Attributed to the Master of the
Sonnenburg-Künigl altar
Southern Tyrolean or Austrian, 1490–1500
The Cloisters Collection, Purchase 1955
Ex coll. Baron van Doorn, Kassel

St. Lawrence wearing the alb and dalmatic of a deacon stands in the midst of a group of pilgrims. The saint blesses a loaf of bread held by the pilgrim standing behind him. To the left a knight in armor is kneeling before him, his missing hands originally folded in prayer. Balancing the composition on the other side is the kneeling figure of a lay pilgrim; he is identified by a shell on his hat the badge of a pilgrim who had been to Santiago in Compostella, the famous shrine at the burial place of the apostle St. James the Great. Several other participants in the scene also wear the shells of pilgrims on their hats.

The relief panel is no doubt a fragment of an altar retable. It is related to several other wood carvings attributed to a sculptor known only as the Master of the Sonnenburg-Künigl altar, active in Bruneck (Pustertal, Tyrol) during the last decade of the fifteenth century. He must have been a pupil of Michael Pacher, possibly from the workshop of the latter in Bruneck. The master's almost constant collaboration with the painter Simon von Taisten, a pupil of Michael Pacher, is another link between him and Pacher's workshop. His name derives from the altar he carved for the convent church of Sonnenburg, commissioned by the Abbess Barbara Künigl and bearing her arms. There is not sufficient evidence to identify the master with any of the names connected with Pacher's workshop in Bruneck such as Christian Permeser or Michael Part. The latter evidently took over the workshop in 1501 after Pacher's departure from Bruneck and was commissioned to work on the new retable for the high altar of the parish church at Bruneck.

The master's main work is the Sonnenburg-Künigl retable now in the City Museum of Bolzano. There are a number of other sculptures by his hand. Among these the most closely related to The Cloisters St. Lawrence relief are the following: (1) The Martyrdom of St. Lawrence, also from Sonnenburg, with a kneeling abbess (donatrice?) and the coat of arms of the Künigl family painted on the back (Innsbruck Museum Ferdinandeum); (2) Pope Sixtus II taken prisoner by the soldiers of the prefect of Rome, in the Bayerisches Nationalmuseum in Munich (m. 1953), which might come from the same retable as The Cloisters panel; (3) a less closely related relief with a scene from the life of St. Lawrence in a private collection in Munich. Theodor Müller, discussing the relief in the Bayerisches Nationalmuseum, says that all sculptures by the master share the same evident delight in carving, and a strong feeling for the shaping of forms by modeling and line. If, as is probable, The Cloisters St. Lawrence relief and the relief with the imprisonment of Pope Sixtus II in Munich are part of the same retable, then the relief at The Cloisters originally must have had the same kind of gold background with stamped and incised ornament and also a similar frame consisting of interlaced foliage scrolls. This would make both panels equal in size, because the Munich panel, including the background above the scene and the frame, measure approximately 38 × 29 inches. Dr. Karol Vaculik has indicated that there is a relief near Bratislava which is very similar to The Cloisters piece.

St. Lawrence was born in the third century in Huesca, Spain. Pope Sixtus II after meeting the saint at Saragossa took him to Rome, made him an archdeacon, and placed him in charge of all treasures of the Church. Sixtus was seized by the prefect of Rome and condemned to die. St. Lawrence expressed the wish to die with him, but Sixtus ordered him to remain alive and distribute the Church's treasures among the poor. When the prefect requested St. Lawrence to turn the treasures over to him, the saint asked him to wait for three days. After the three days had elapsed the prefect came for the money and found that it had all been given away. He then condemned St. Lawrence to death. The saint was martyred by slow roasting on a gridiron. Defiant in the midst of his torture, he shouted to the prefect: "I am roasted on one side. Now turn me over..." At times the southern Tyrol was part of Austria and at the end of the fifteenth century was under the rule of Maximilian of Habsburg, later Emperor of the Holy Roman Empire. Because the Tyrol was located between German and Italian lands, its art was subject to a twofold influence; that of Italy is noticeable in painting and that of Germany, more exactly from the Upper Rhine regions, is evident in sculpture.

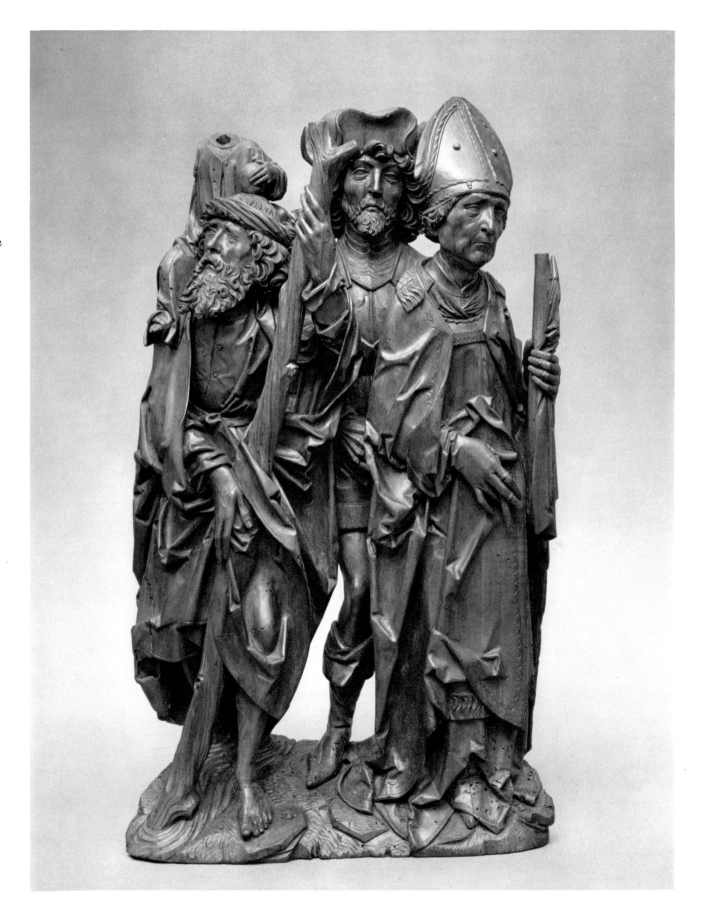

Lindenwood. H.21, W.13 inches
by Tilmann Riemenschneider (1460–1531)
German (Franconian), circa 1494
The Cloisters Collection, 1961
Ex colls. Lord Delamere; Mrs. Mary Saint

The Sts. Christopher, Eustace, and Erasmus in this group are three of the so-called Fourteen Helpers in Need. According to legend, they were assured by God that whoever turned to them in complete confidence would have his needs fulfilled. Their popularity, especially high in times of pestilence, reached a peak in the fifteenth century afer they appeared in 1446 in a vision to a shepherd of the monastery of Langheim. The famous rococo church Vierzehnheiligen was built later on the site of the vision.

Probably never polychromed, the sculpture was once however covered with a heavy layer of brown paint, since removed. One cannot be absolutely certain how the original surface looked, although it is known that Riemenschneider often left his wooden figures unpainted.

The composition is compact. On the left, St. Christopher, patron saint of travelers and pilgrims (see number 88), carries the Christ Child across the swirling waters of a river. The saint's face is turned upward, as he listens intently to the words of the Child. The Child's head and right hand are unfortunately lost; in his left he holds the orb of the world. On the right in bishop's robes is St. Erasmus, a crozier and a sudarium in his left hand and in his right the fragment of a spindle. Originally the patron saint of

sailors, he carried a windlass coiled with rope. In the fifteenth century when worship of the saint spread inland the windlass was misunderstood and replaced by a spindle wrapped with the saint's entrails, because it was believed that he was martyred by disembowelment. The saint thus came to help those who suffered abdominal pains or colic. St. Eustace, almost hidden behind the others, is dressed as an elegant knight. A Roman soldier martyred in the reign of Hadrian, he is the patron saint of hunters.

When the Three Helpers was acquired for The Cloisters, the attribution to Riemenschneider was doubted. Consultations with Guido Schoenberger and with Justus Bier were most reassuring. At present the piece can be attributed with certainty to the hand of the great German sculptor. The work shows the same linearity of design, the complex interweaving of forms, and the restlessness of late Gothic art found in documented works by the master. Deeply expressive somber faces, long sensitive fingers, and skillful realism blended with tense emotional expressiveness all occur repeatedly in Riemenschneider's figures. Bier compares the face of St. Christopher to the faces of the apostles in the Last Supper from the Holy Blood Altarpiece in Rothenburg ob der Tauber (1501–1502); and the face of St. Erasmus to that of Rudolf von Scherenberg on the tomb monument in the Würzburg Cathedral (1496–1499). St. Eustace is compared to Joseph of Arimathea, from the Lamentation Altar (Hessenthal) datable after 1483, and to St. Luke from the Münnerstadt Altar of 1490–1492 (Berlin-Dahlem Museum), both carved in lindenwood. These comparisons also help to date the Three Helpers in Need as an early work of Riemenschneider (1490–1502).

The dating can be further pinpointed: Riemenschneider received a commission in 1494 from Johann von Allendorf, chancellor to the Bishop of Würzburg, to carve Fourteen Helpers in Need for the church altar of the Hofspital. The identification of the Three Saints at The Cloisters as a fragment from this altar has helped to eliminate a confusion: previously, on the basis of the documents referring to the above commission, another relief of the Fourteen Helpers on the outside wall of the hospital's chapel had been attributed to Riemenschneider. This relief must have been commissioned in 1514 by Lorenz von Bibra, Bishop of Würzburg, and it is Renaissance in style. It was made for the Hofspital in the workshop of Riemenschneider but not by the master himself. The date 1514 fits it perfectly just as the date 1494 fits the lindenwood group.

Tilmann Riemenschneider was born about 1460, in Heiligenstadt (Thuringia). In 1480 he had evidently worked in Erfurt with an unknown stonecarver on an Agony in the Garden relief. Then he went to Würzburg and in 1481 he went to Strasbourg as a journeyman where he must have seen the works of Nicholas Gerhaert van Leyden. Bier thinks that the turban of The Cloisters St. Christopher might have been inspired by that of Nicholas Gerhaert's bust of the bearded man in Strasbourg. Riemenschneider became a citizen of Würzburg in 1485, and in his later years served as its mayor (1520–1521). He died in 1531.

Renaissance influences barely touch his work which portray the inner, spiritual life. Highly valued during his lifetime, his work was neglected after his death to be recognized anew by later generations.

223

224 *Brass, cast and chased.* H. 79 ½ *inches*
Mosan (Maastricht), about 1500;
attributed to Aert van Tricht the Elder
(Arnold of Maastricht)
The Cloisters Collection, Purchase 1968
Ex colls. Cathedral of St. Chad, Birmingham;
St. Mary's College, Oscott (England)

A magnificent eagle dominates this impressively large and elaborate lectern. Below stand figures of Christ as Salvator Mundi, St. Peter probably as the patron saint of the church; and a St. Barbara, a later replacement, with her attribute (a tower) at her feet. She was perhaps the patron saint of the donor or donors of the lectern. Above each figure, a canopy supports a seated prophet holding a scroll. At the corners on the top of the pedestal, just under the battlements surrounding the orb, three little lions sit up on their haunches. They probably held shields with coats of arms. The winged dragon, symbol of evil, flattened out under the eagle's claws, is a characteristic of Flemish lecterns.

From the corners of the pedestal, three branches curve outwards. Two bear candlesticks; the central branch supports the figures of a seated Virgin and Child with one of the Magi kneeling before her. The king is probably a nineteenth-century replacement. The columnette in front originally held a seated lion.

According to a tradition which began in the early nineteenth century, the lectern was made about 1500 for the Collegiate Church of St. Peter, in Louvain, Belgium, where it stood on the north side of the high altar.

During the Revolution, the French army occupied Louvain and in 1798 the lectern was sold publicly by the French Commission of National Property with many other precious objects and belongings confiscated by the French. The auction took place on the steps of St. Peter's.

As consequence of this and similar sales, a large number of art treasures came on the art market, and passed into the possession of private collectors both in Belgium and elsewhere. Many of the buyers were Englishmen, who, because of the Gothic revival in England paralleled by the revival of Roman Catholicism, showed great interest in medieval works of art. The greatest number were acquired in the southern Netherlands and in the Rhineland. August Welby Pugin, a proponent of the Gothic Revival, traveled in these regions with his friend and protector, John, the sixteenth Earl of Shrewsbury. The latter gave the lectern to the neo-Gothic St. Chad's Cathedral at its inauguration in Birmingham (1841). In 1851, the lectern was transferred to the chapel of St. Mary's College, at Oscott, near Birmingham, and from here it was acquired for The Cloisters. Although the provenance from St. Peter's at Louvain for the lectern is not documented, the probability is supported by a famous historian from Louvain, who saw the lectern at Oscott in 1858, and confirmed this tradition. Further, a list of objects auctioned in 1798 includes an item which seems to be this piece. Heavy paint which covered the lectern was removed a few years ago and the brass polished to its original brilliance.

One of the largest and most elaborate from the Southern Lowlands, the lectern is attributed to Aert van Tricht the Elder of Maastricht. With his son, Aert van Tricht

the Younger, he made the candelabrum arch for the choir of St. Victor's Cathedral at Xanten. This lectern is similar to two smaller and more modest ones in the churches at Freeren and at Venray, also attributed to a Maastricht workshop of the second half of the fifteenth century.

In size and magnificence the Louvain lectern can be compared with the Paschal Candlestick in St. Leonard church at Léau, by Renier (Aert) van Thienen of Brussels, dated 1481 or 1483. Suzanne Colon Gevaert considers the possibility of attributing The Cloisters lectern to this bronze caster. A comparative study of the lectern's figures with other metal statues and with Mosan sculpture in general may supply additional pertinent information.

It is believed that eagle lecterns derive their shape from the eagle, symbol of St. John the Evangelist; but there are other lecterns on which the birds are pelicans, the symbol of Christ and of the Redemption. A lectern on a pedestal was usually placed at the north side of a church altar. If, as in larger churches, there were two lecterns, they stood at both sides of the high altar— "one for the reading of the Gospels, the other for Epistles." If there were three, the third stood in the middle of the choir and held the choir book.

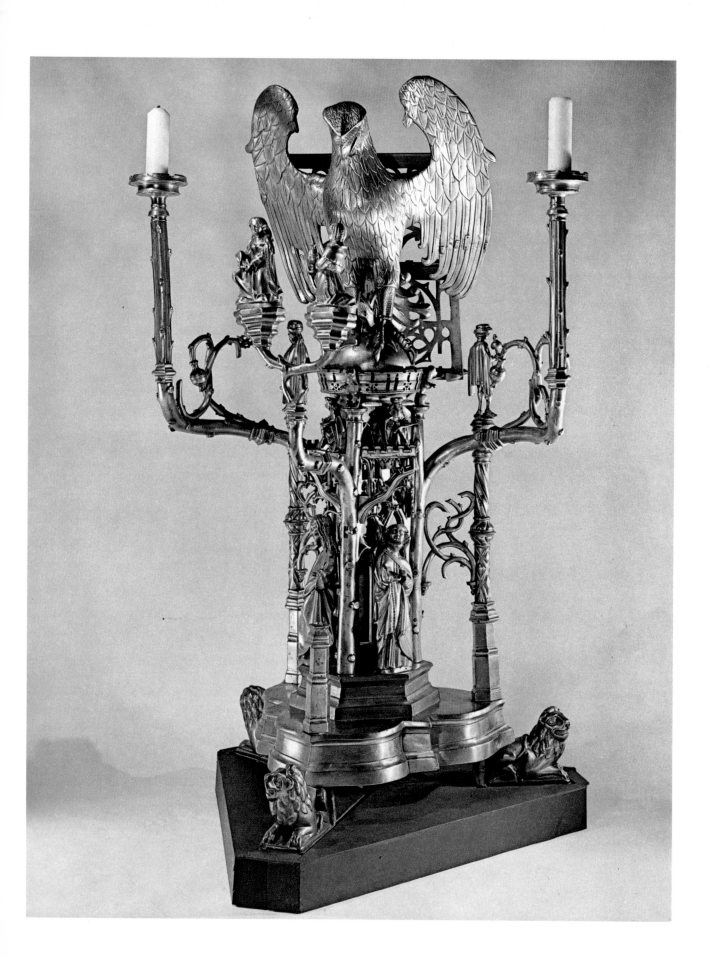

226 *Silver gilt with painted enamels*
H. 25 inches
German (possibly Nuremberg), circa 1500
The Cloisters Collection, Purchase 1953
Provenance: Treasury of the Order of
the Teutonic Knights, Vienna
Ex coll. Mrs. C. von Pannwitz, Amsterdam

The almost globular bodies of the ewers stand on tall conical feet and the meeting points between the body and the foot are decorated with Gothic vine interlace. Inside a cresting, around the mouths of the ewers, rest the bulbous covers surmounted by hexagonal crenellated castles from which rise wild men holding clubs in one hand and shields in the other. The finely chiseled handles are made to represent elegant dragons, with spiraling tails and heads turned back.

The silver ewers are entirely gilt with certain details, such as the figures of the wild men, and the ears, teeth and fangs of the dragons, painted in cold enamel of appropriate colors.

In the inventory of the Teutonic Order Treasure of 1585, these ewers were described as "two silver presentation ewers with the coat-of-arms of Stockheim". Hartmann von Stockheim was the German Master of the Order between 1499 and 1510 or 1513. His arms, now missing, must have been attached to the shields held by the two wild men on the covers of the ewers. The ewers remained in the Treasury of the Order of the Teutonic Knights of St. Mary's Hospital in Jerusalem in Vienna, until about 1937, when they were sold.

Heinrich Kohlhaussen suggests a Nuremberg workshop for the provenance of the ewers, basing his attribution on a comparative study, and, although this attribution is not a firm one, it should be mentioned that von Stockheim is also believed to come from Franconia.

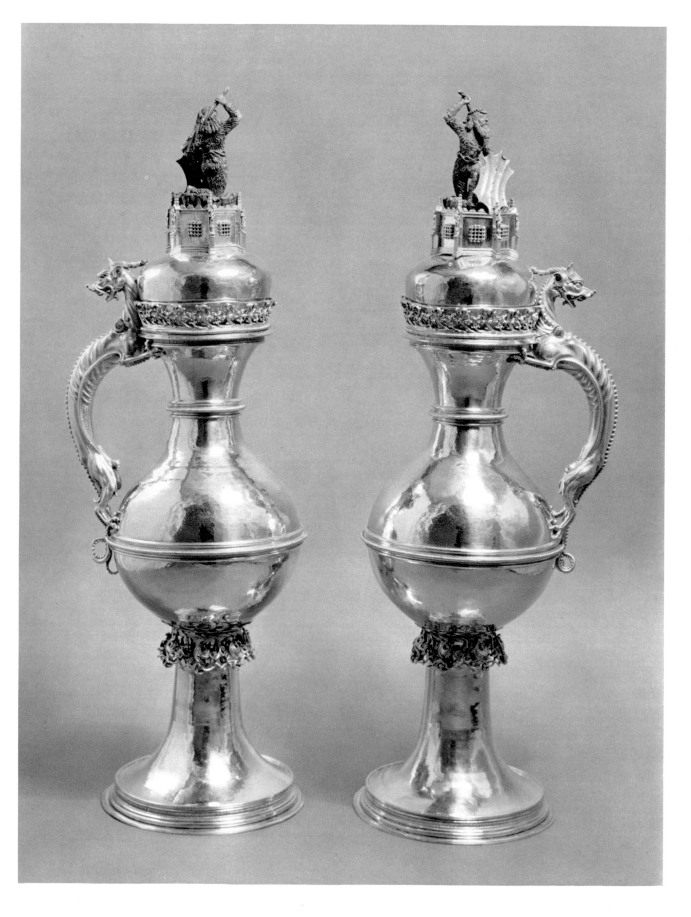

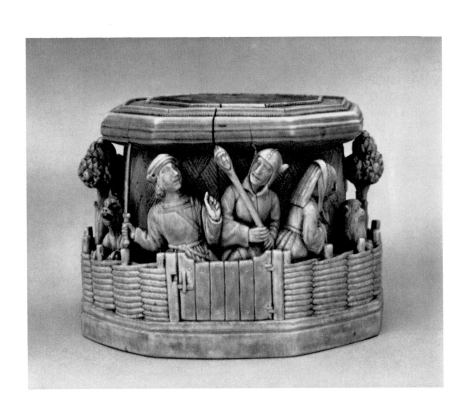

Ivory. H.3⅝, W.5, D.4¾ inches
Northern French or Flemish, early XVI century
The Cloisters Collection, Purchase 1955
Ex colls. Frédéric Spitzer, Paris;
Maurice Kann, Paris

Two amusing scenes from the life of a married couple are depicted around the sides of this octagonal ivory pedestal. On one side of the base, a gentleman with a ring and a lady with a pomegranate are separated by a fool who stands behind a fountain. Behind the lady is a collared and chained monkey eating a pomegranate from a basket, and behind the gentleman a hound, also wearing a collar and chain. On the opposite side of the base a gentleman brandishes his sword as the lady turns away holding her left hand to her head, apparently distraught and about to run away. The fool stands between them. Here the lady has a lap dog (?), and behind the man is a ferocious unchained animal.

In the scenes on the pedestal realism has replaced medieval courtly elegance and expressions of refined feelings. Interest has shifted to the human drama. The figures are carved with a great liveliness and dramatic force; the faces express individuality and varying emotions; and the details of the costumes are done with care. The lady and gentleman are dressed in the style fashionable at the beginning of the sixteenth century. The fool wears the traditional habit of a jester and holds in his hand the *marotte* or bauble. The first scene is definitely one of courtship. The same lady and fool are represented in both scenes.

We cannot be sure if the man is the same especially since his head in this instance is a replacement taken from another old ivory.

The two scenes seem to illustrate the plot of a comic drama popular in this period. The subject may deal with the vicissitudes of wordly love and married life. It might even be a story of an unfaithful wife. Or the scenes may depict changing human behavior: the effort to please during courtship in the first scene and the shift in attitude on the part of the husband after marriage. Whether these scenes are inspired by some text or are the creation of the artist's fantasy, they appear to contain a secular allegory. Episodes of everyday life were moralizing, and such allegorical characters appear in many comic dramas, with the fool playing a prominent part. These themes survived to some extent in the plots of the *commedia dell'arte,* in the comedies of Carlo Goldoni, and even in Molière's plays.

The intensity of the facial expressions of the figures and their dramatic gestures and attitudes give the impression that they are characters playing their parts on the medieval stage and that the scenes they are performing surely have a symbolic meaning. If the fool is the symbol of human folly, the animals may also represent human qualities. The dog usually represents fidelity and the ape man's baser nature, but the meaning could vary. Such symbolism probably applies to the adjacent figures.

Raymond Koechlin relates a pedestal with a statuette, formerly in the Figdor Collection in Vienna, to The Cloisters piece. On the former piece a woman and a skeleton are placed back to back, probably as an allegory of the brevity of life which is related to another favorite subject of the period, the Dance of Death. Or it might

serve as a reminder of the quick passage of youth, the *Vanitas.* It is probable that The Cloisters pedestal at one time supported a statuette with a similar subject. Camille Enlart relates the Figdor piece to a woodcut illustrating, Hercules' dream in the 1515 Paris edition of the *Ship of Fools.* Written in 1494 by Sebastian Brant, a German lawyer, the book was translated into every western European language by the early sixteenth century.

Bonnie Young who published The Cloisters piece in 1956 compares its style with that of some rosary beads carved in Flanders or northern France as were the two pedestals and the Figdor statuette. The two pedestals seem to be unique.

230 *Oak, painted.* H.*14¼ inches*
Southern Netherlands (Brabant), circa 1500
Gift of George Blumenthal, 1941
Ex coll. George and Florence Blumenthal,
New York

St. Ursula wears a red gown with traces of gilding over a blue undergarment and a gilt mantle lined in blue. These colors are repeated in the gowns and mantles of the smaller figures at her feet. Gilt and painted sculpture was very common in this region, and an unpainted statue was considered unfinished. The smaller figures are four of the saint's multiudinous followers who were martyred with her. Originally she may have held the palm of martyrdom, and she once wore a crown.

According to tradition, the Christian St. Ursula was a British princess who went to Rome accompanied by eleven thousand virgins. When they reached Cologne on the return voyage down the Rhine, they were martyred by the Huns who were then ravaging the country. Many of their bones are kept as relics in Cologne where a church is dedicated to St. Ursula. A famous shrine of the saint with panels painted by Hans Memling is kept in the Hospital of St. John in Bruges. St. Ursula is still very popular in this area.

This statuette is one of the finest of a large series of such figures made in Malines in the late fifteenth and early sixteenth centuries. All are about the same size and are characterized by a similar type of drapery, compositional arrangement, and coloring. All of the figures have sweet round faces that are somewhat infantile in character. They are similar to the work of Brussels, but the faces are usually more softly modeled. Malines and Brussels were neighboring cities and often exchanged craftsmen and models.

In this period Malines was far more prominent than it is today. Under the rule of the Burgundian dukes it was a center of finance and government and Margaret of Austria ruled from the city as Regent of the Lowlands.

Another statuette of St. Ursula which is almost identical to this one, but somewhat heavier and a little less elegant, is in the Château of Male in Belgium and belongs to Baron Gilles de Pélichy. Still another is in the hospital of Nôtre-Dame, Malines; and a third is in the Suermondt Museum, Aachen. The Malines figure holds three arrows tightly clutched in one hand. Unfortunately, the attributes are missing from both of the saint's hands at Male.

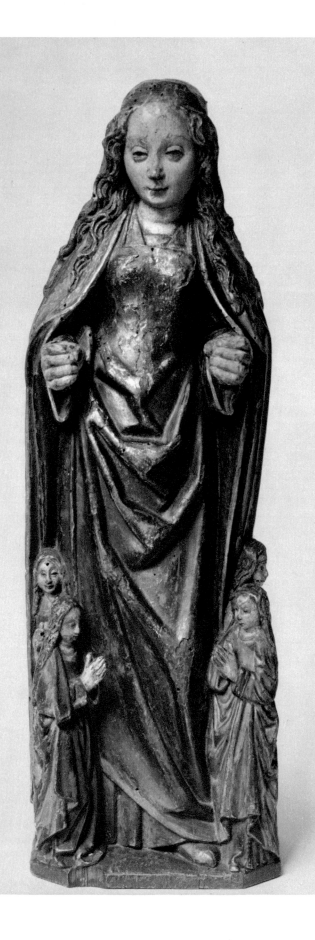

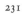

232 *Silver.* H. *7¼ inches*
Flemish (Antwerp), XVI century (circa 1520)
Rogers Fund, 1913

The sober appearance of this chalice is compatible with its date, about 1520, during the time of the Reformation. It has a slightly flaring cup and a hexagonal stem with a flattened knob which is transformed into a hexagonal one by six square protruberances decorated with repoussé rosettes. A flat, wide rosette-shaped foot is formed of six slightly pointed segments. Each segment has a median ridge which corresponds to the corners of the hexagonal shaft. An openwork gallery runs along the edge of the foot. The decoration of the chalice is built on geometric forms with only a few ornamental accents on the knob.

On the underside of its foot the chalice has three silver stamps; one, that of sixteenth-century Antwerp, is a hand with open palm and thumb to the right, placed under a crown; the second, in a cartouche, can be read either as a w or two interlaced vs, and represents the stamp of the unknown maker who seems to have made two other silver objects, one in the British Museum, London; the third, an o in a square or on a shield, is supposed to be the year's mark. If, as is often the case, the years are marked in alphabetical order the letter o would denote a year around 1520, because the letter T is stamped on an object dated in 1524. Since the tentative dating by stamps coincides with the dating by style, it has been accepted, until a more precise documentation can be located.

The chalice is the most important liturgical vessel used at the Christian altar. In it the transubstantiation of the wine takes place during the ritual of the Mass in accordance with Christ's words at the Last Supper as told by Matthew (26:27–28), "and he took the cup, and gave thanks, and gave it to them, saying: Drink ye all of it for this is my blood of the new testament, which is shed for many for the remission of sins." Also in accordance with this text, the name Eucharist given to this sacrament means "thanksgiving" in Greek. From the earliest days of the Christian Church the rite of the Eucharist was performed by the Christians. Bread and wine as sacrificial elements were already known to Judaism in pre-Christian times.

As every other item used for religious services, the chalice developed its shape from prototypes employed for secular use in the first century. At that time cups were made of glass, all kinds of metal, semi-precious stones, or even wood. In the eleventh century the exclusive use of silver or silver gilt for the chalice was decreed. In the beginning, chalices could be of two different shapes: the footed drinking cup or beaker shape as the Antioch Chalice (number 6), or the kantharos shape, a very low-footed cup usually provided with two handles. The use of handles was abandoned in the thirteenth century. Gradually changes in the shape of the cup and in the relative sizes of cup and foot took place. The Romanesque chalice cup is usually bowl-shaped, while the Gothic chalice has a smaller, often tulip-shaped cup. A change also takes place in the relation between the diameter of the cup and the height of the chalice as the whole shape becomes definitely slenderer and taller, its height in-

creased by the introduction of stem sections above and below the knob. At the same time, the knob and the foot become wider to balance the increase in the height of the chalice. During the Gothic period the base of the foot which began as a circle becomes octagonal or hexagonal and the outline is enriched with curves, as on this chalice. The decoration is concentrated on the knob, while the foot is raised by an openwork arcade along its border. The change in the size of the cup occurred when the western Church discontinued the participation of the whole congregation in taking the wine of the Communion. The wine was then taken by the celebrating priest and the faithful received the wafer only.

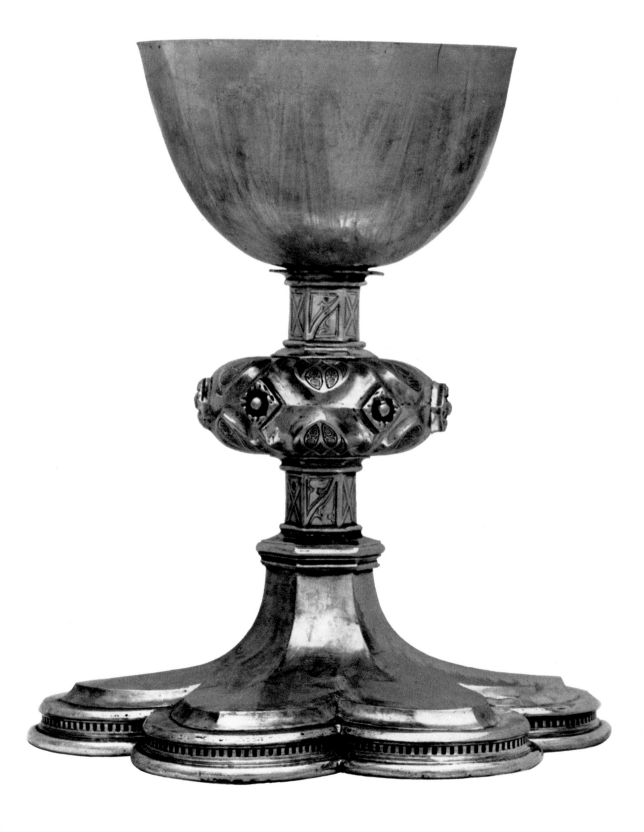

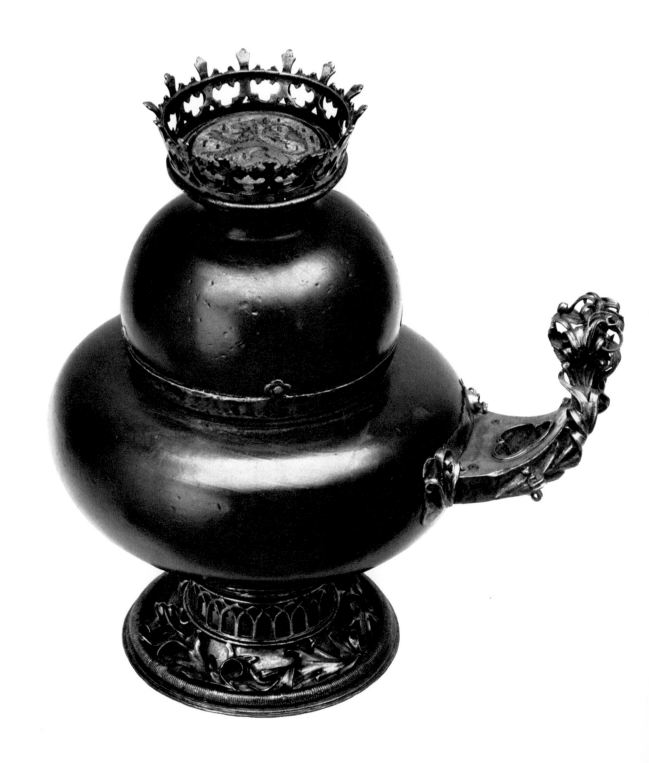

234

111 Mazer Cup

Maplewood and copper gilt
H.*7, maximum diameter 7 inches*
German, late XV or XVI century
Gift of J. Pierpont Morgan, 1917

This vessel consists of two drinking cups and belongs to the late Gothic group of so-called double beakers (Doppelbecher) made in Germanic countries in the fourteenth, fifteenth, and sixteenth centuries. The bottom cup is usually larger than the top one which is placed upside down and serves as a cover when not in use. Both cups have circular feet and the one on the cover cup often develops, as here, into an openwork crown. A loop-shaped handle is attached to the side of the bottom cup in earlier examples. Later the handle develops into the characteristic rectangle, narrowing towards the end and curling up like a volute at the side of the bottom bowl. In some cases, when both cups are of approximately the same size and both have handles, there are two converging volutes.

The decoration of the cups is restricted to their metal settings: the foot, the handle, and the rims. Within the crown-shaped foot of this upper cup, a circular enamel medallion bears a coat of arms which might belong to one of several families, possibly to the Counts of Nassau or to the Counts of Brienne.

The German word *Mazer* means knotty or gnarled wood, or sometimes root wood. The wood used has given its name to these drinking cups. Webster's dictionary defines mazer as an excrescence on a maple tree, or as a large drinking bowl made of maple or other suitable wood. Göran Axel-Nilsson specifies that mazer is *Acer pseudoplatanus* (sycamore). Actually, root wood and various hard woods were used for making medieval drinking vessels which were usually turned on a lathe.

This type of drinking cup, with a hemispherical bowl, could be called in German either *Mazer* or *Kopf* (head) and, parallel to this, Webster gives a second, obsolete meaning for the English word mazer as "head" or "helmet." And indeed, the round, hemispherical shape of such cups of Nordic origin is believed to derive from scull cups said to have been used for drinking by the pagan Gauls and Germanic peoples. Some of the mazer cups with metal settings, often the work of outstanding silversmiths, were luxury items and served as presents to visiting kings and nobles; other were ultimately used as reliquaries in church treasuries. The shapes of the mazers were sometimes imitated in silver and in rock crystal, or in such hard and semi-precious stones as serpentine.

In addition to its other attractions mazer wood not only improved the taste of the drink, but was also supposed to possess the same property as unicorn's horn to neutralize any possible poison in it—an ever-present danger in the Middle Ages. A number of customs, beliefs, and superstitions are connected with the use of these drinking cups. All mazer cups have much in common with each other, but each has sufficient individuality to show that there was not a standard pattern. Their popularity was great and a considerable number of them survives; most of these are from the fifteenth and sixteenth centuries, and at least half come from South Germany and Switzerland, where they were especially popular. Heinrich Kohlhaussen lists some thirty mazer cups and illustrates over twenty.

236 *Boxwood.* H. 5⅞, w. *(closed) 2¼ inches*
Flemish, early XVI century
Gift of J. Pierpont Morgan, 1917
Ex coll. Baron Albert Oppenheim

The upper part of this miniature triptych opens like an altar retable, and in the center is a Crucifixion carved in high relief. The crowded composition includes a number of men on horseback, some holding spears, and various other figures, fitted into the very restricted space. The inscription in Gothic letters on the frame reads: Christus Passus est [pro] nobis (I Peter 2:21). The Crucifixion is set into a deep niche under a northern late Gothic trefoil arch filled with tracery of intertwined bare branches. Three of four curling leaves serve as ties. The same bare branches appear as crockets along the outer edge of the frame.

The scenes carved in low relief on the inside of the left and right wings represent the Sacrifice of Isaac with the inscription: Ge[nesis] cap. 22, and Moses and the Brazen Serpent with the inscription: Nu[meri] cap. 21.

The upper part of the triptych stands on a foot somewhat similar in outline to the foot of a chalice. Corresponding to the knob of a chalice, a small circular triptych in the shape of a rosary bead opens to reveal the Resurrection of Christ in the center; on the left is Samson carrying away the doors of Gaza; and on the right is Jonah and the whale. Below the circular triptych, the base is ornamented with moldings and other carved details; very little of the Gothic style remains. A square opening protected

by a grill on the front as well as on the back of the triptych base might have served as a container for a relic.

The compositions of both triptychs follow the pictorial pattern created in medieval books known as *Biblia Pauperum,* or *Biblia Picta* (the Bible of the Poor, or the Picture Bible), originating in the beginning of the fourteenth century, but based on earlier writings of the church fathers and on traditions existing in Early Christian times. In these bibles the illustrations consist of a central scene from the text of the Gospels, flanked by two of its prefigurations taken from the Old Testament. These scenes are accompanied on the page by the portrait of prophets who predicted the event and by various other details. Typological cycles, already found in the early centuries of Christianity, flourished in the late Middle Ages.

Such minutely carved tabernacles and rosary beads were popular about 1500 and 1530, and, judging from the number surviving today, were manufactured in considerable numbers even though they must have been luxury items. The usual material was boxwood—especially suitable for miniature sculptures because of its extremely fine grain and excellent density. Ivory and occasionally mother-of-pearl were used. The use of small tabernacles as miniature altar retables is evident. The prayer beads were usually spherical and opened like triptychs. They could also serve as portable tabernacles; or closed, as a pendentive hanging from a chain or from a rosary in place of a crucifix. Small tabernacles and large triptych rosary beads could have been owned both by laymen and by ecclesiastics.

In its general structure this triptych is related to the large and elaborate contempo-

rary Brabantine altar retables which have the same crowded compositions showing great richness of detail and a most lively expression of emotions. On these large retables the central panel is usually surmounted by Gothic tracery. Most of the known boxwood tabernacles and triptychs in the shape of rosary beads seem to have been made in Flanders.

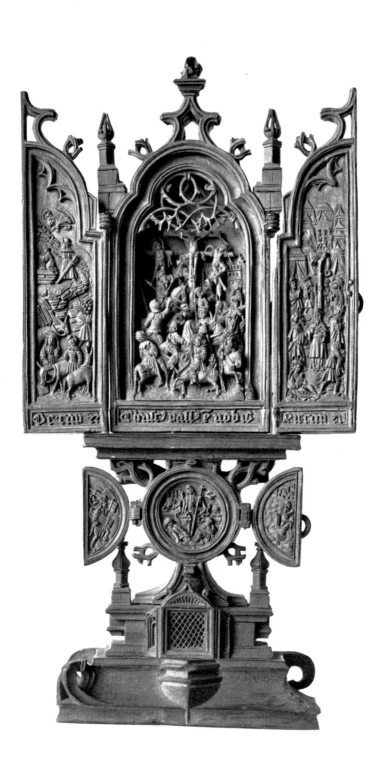

238 *Wool and silk. 11 to 13 ribs to the inch*
H. 138, W. 190 inches
German, circa 1530–1540
Gift of the Hearst Foundations, Inc., 1960
Ex colls. Marquis de Sambola, Catalonia;
J. Pierpont Morgan; William Randolph Hearst

The fifteen scenes of this tapestry illustrate the Apostles' Creed. Shorter than the Nicean Creed (adopted at the Council of Nicaea in 325 and used at present throughout Christendom), the Apostles' Creed has been used in western Europe since the fourth century. According to medieval tradition, it was first recited by the twelve apostles at Pentecost, each apostle saying one of the twelve articles under the inspiration of the Holy Ghost. Three clauses of the articles have been omitted: "suffered under Pontius Pilate," "sitteth at the right hand of God the Father Almighty," and "the Communion of Saints". The scenes read horizontally beginning at the upper left corner:

(1) God the Father creating Heaven and Earth ("I believe in God, the Father Almighty, Creator of heaven and earth")

(2) Baptism of Christ ("and in Jesus Christ His only Son our Lord")

(3) Annunciation ("who was conceived by the Holy Ghost")

(4) Nativity ("born of the Virgin Mary")

(5) Crucifixion ("was crucified")

(6) Entombment ("dead and buried")

(7) Descent into Limbo ("He descended into hell")

(8) Resurrection ("the third day He rose again from the dead")

(9) Ascension of Christ ("He ascended into heaven")

(10) Last Judgment ("from thence He shall come to judge the living and the dead")

(11) Pentecost ("I believe in the Holy Ghost")

(12) The Pope, carrying the Keys of St. Peter and wearing a triple tiara, kneels before a church ("the Holy Catholic Church")

(13) A penitent at confession, accompanied by a guardian angel, kneels before an officiating priest ("the forgiveness of sins")

(14) The dead arise at the sound of the trumpet of Last Judgment Day ("the resurrection of the body")

(15) The Virgin Mary and St. John the Baptist interceding for mankind before God the Almighty, surrounded by cherubium and a group of the blessed admitted to paradise ("and life everlasting").

In medieval art, the Credo was generally illustrated by a number of individual scenes, sometimes less than twelve but often more. In surviving fifteenth-century woodcuts, so popular in Germany and especially valuable for the illiterate majority of that time, one usually finds twelve or more separate scenes, each so explicit that the meaning can be conveyed without the words of the text which sometimes accompany them.

The arrangement of the tapestry is very similar to these woodcuts, but one cannot ascribe any of the scenes to a definite source. Medieval craftsmen and artists repeated basic compositions and symbolic details borrowed from popular earlier prototypes, or were inspired by the writings of contemporary medieval authors or productions of mystery plays. Their pictorial language was so familiar to everyone that it spoke to the viewer more immediately than words.

The tapestry is woven in strong colors —three shades of blue, three of red, a golden-yellow and green—with a tan ground for the conventionalized foliage border of the frame. The figures are firmly outlined and plainly modeled as were black and white woodcuts which were often later filled in with color. Only the main figures are represented, less significant details are left out, while other elements are introduced.

William H. Forsyth, who published the tapestry in 1963, indicates some close comparisons for several scenes (e. g., the Ascension), as well as other scenes which are found in woodcuts. A number of these are to be seen in an illustrated book containing the Credo, *Erklärung der zwölf Artikel des Christlichen Glaubens* printed by Konrad Dinckmuth in Ulm in 1485.

The general style of the tapestry is German. Like many other contemporary German tapestries, it has directness and naiveté. The allover workmanship of the tapestry is conservative and provincial; nevertheless, it discloses details which show Renaissance influence from Italy: the drapery flows smoothly, there are no angular folds. Some scenes are more expertly designed than others, especially those on the left of the tapestry, and Forsyth feels that the weaving was started here but finished by a less expert workman. The mingling of late Gothic elements with others belonging to the Renaissance indicates a probable date in the second quarter of the sixteenth century.

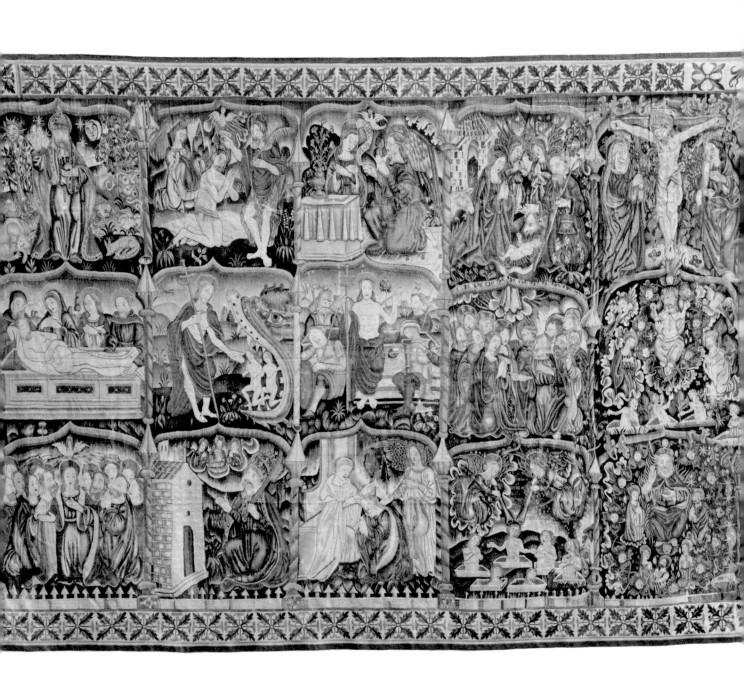

240 *Wool. 14 ribs to the inch.* H.*8,* W.*10 feet*
Flemish (possibly Brussels), circa 1500
Gift of George Blumenthal, 1941
Ex colls. Schutz, Paris; George and Florence
Blumenthal, New York

The scene represented on this tapestry may illustrate a pastoral play or poem. It appears that a swain, making advances to a young maiden, is chastised by an older woman. The background is the so-called millefleurs tapestry with the representation of "thousands of flowers". These flowery tapestries were often made in sets called "chambers" to adorn a room or hall of a château. They must have brought pleasant relief to the grimness of a medieval winter as well as helped protect people from the damp chill of unheated stone walls.

Pastoral tapestries showing scenes of country life were extremely popular in the fifteenth and sixteenth centuries. These scenes often show the lord and his lady taking the air in holiday spirit, enjoying polite sports and games, dancing and making music, hunting birds with falcons, or stag hunting with hounds. Sometimes gentlefolk are even shown carrying shepherds' crooks, much as Marie Antoinette did later when she played at being a shepherdess with her ladies-in-waiting in her romantically rustic mansion at Versailles. Sometimes, however, these shepherds are authentic rustics, shown either gaping at the gentry as they carried on their polite country pursuits or cavorting with each other. The background was usually covered with flowering plants or it could be "sown with sheep" in the words of one inventor of such millefleurs or flowery mead tapestries.

In some pastoral literature the poet's subject is the quarrels and scuffles of such country people. Some French pastoral verse is full of such rough, rustic humor and buffoonery. Obviously there has been a lover's tiff in this tapestry. A woman roughly collars a shepherd and holding him at arm's length keeps him from approaching a younger shepherdess. Perhaps he has been making love to the maiden. He may be the husband of the older woman who has come upon him at an awkward moment.

Göbel compares this tapestry to one in the Victoria and Albert Museum, London, in which a peasant woman has dropped her crook and grasps another shepherd by his clothing. The Metropolitan Museum hanging is closer in style to another shepherd and shepherdess millefleurs tapestry in the Gobelins Museum, Paris.

Although no documentary evidence exists, it has been assumed that many of these millefleurs tapestries were woven in the valley of the lower Loire, notably in Touraine, by wandering workshops which supplied the needs of the great châteaux in the region. This assumption is questioned by the recent work of Mme Schneebalg-Perelman who has uncovered many fifteenth-century documentary references to verdure tapestries woven in Brussels. However, Brussels was not the only center producing millefleurs tapestries, as Francis Salet has observed. Their popularity and variety of style indicate that they doubtless were also made in other workshops of Flanders and the southern Netherlands.

Prepared by William H. Forsyth

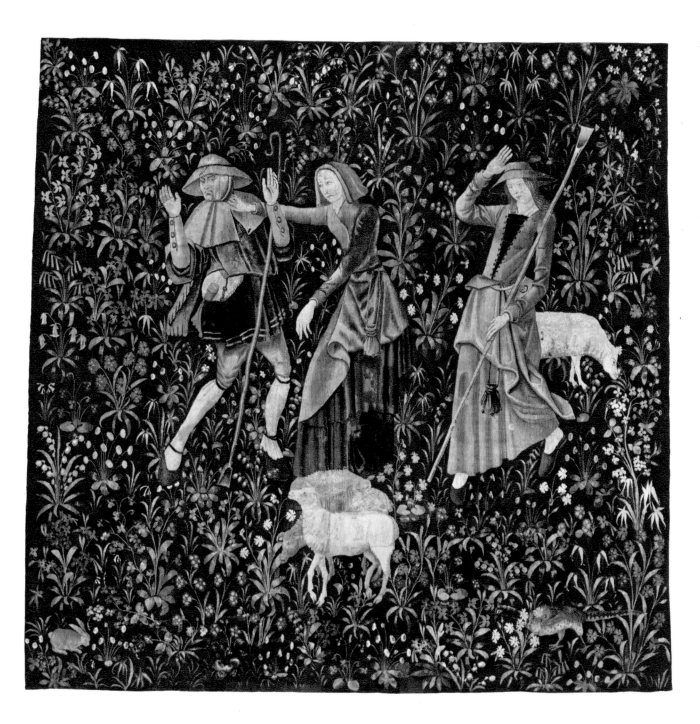

242 *Wool, silk, gold and silver thread*
18 to 20 ribs to the inch
H. *79½,* W. *110 inches*
Flemish (Brussels), circa 1510–1530
Bequest of Michael Dreicer, 1921
Ex coll. Oscar Hainauer, Berlin

In the center Christ is crucified between two thieves. On the right amidst dark clouds a demon carries off the soul of the bad thief. A dead tree stands near his feet, perhaps to suggest a comparison between the thief and the fig tree cursed by Christ because it did not bear fruit. The soul of good thief on the left is gently carried to heaven by an angel.

To the left of the cross the blind centurion, with closed eyes, is about to pierce Christ's side with a spear. In accordance with medieval belief he will receive his sight from the blood that trickles from the wound.

Below the soldiers are quarreling violently over Christ's garments, while to the left the sinking Virgin watches, supported by the Holy Women and St. John.

The tapestry gives a panoramic view of the whole spectacle. On the left a soldier is depicted kicking Christ on the road to Calvary. Behind the procession is the city of Jerusalem with one of the city gates and beyond it the temple, represented by a tower. Its onion-shaped dome was a way of showing that Jerusalem was an eastern city. However, between the twin towers of the gate is the familiar stepped gable front that appears in so many Flemish paintings. To the right is a ruler of the people and other horsemen accompanied by one of the

high priests riding a mule in the manner of a medieval ecclesiastic of importance. In the bottom right corner is the burial of Christ in a sarcophagus, although the traditional cave tomb is shown behind. In the distance above is Calvary with the three crosses now empty and Christ's body laid in his mother's lap, a group known as the *Pietà,* literally the "pity". At Christ's feet is a kneeling figure, apparently tonsured and with a monk's cowl and hood, who may represent the donor of the tapestry.

Such panoramic Crucifixion scenes are represented in tapestries by the first part of the fifteenth century, and they appear earlier in paintings. The fantastic landscape, in particular the rocky hill on the left and the hill of Golgotha on the right, is an impossible exaggeration of landscapes appearing in Flemish paintings which were, in turn, inspired by earlier Italian paintings such as those by Mantegna.

The Museum's tapestry presents a curious contrast between the animated figures in the foreground crowded together as in fifteenth-century medieval tapestries, and the distant landscapes scene typical of the Renaissance, the farthest hills dim in the haze of distance. The fringe of flowering plants in the foreground is derived from medieval verdure tapestries, such that of number 114.

The general composition seems to be inspired by Flemish altarpieces, called retables, which were placed behind and above the altar. They could be carved or painted. In the carved retables of Antwerp and Brussels, the Crucifixion usually towers high above the other scenes. However, in this horizontal tapestry panel the high cross looks somewhat crowded againt the top of the panel, suggesting that there were diffi-

culties in adjusting to a horizontal area. The progression of scenes from the Road to Calvary at the left to the Crucifixion and Burial of Christ at the right is similar to that of retables. Retables were usually framed and placed in an architectural setting. Here the architectural frame consists of a flattened arch supported by elaborate columns on pedestals. Both sides, and a bit of the bottom edge have been cut down, but one can guess that originally the panel was the central part of a much wider tapestry strip with another scene on each side of it; to the left perhaps Christ before Pilate and related scenes, and to the right his Resurrection and appearance to his disciples.

There is just such a long tapestry strip in the Dijon Museum with three scenes, each framed by flat arches and colonettes almost identical to those of our tapestry. It is said to represent the siege of Dijon by the Swiss in 1513. Although the compositions are naturally quite different, their similarities such as the peculiar cloud formations and the details of the frames, are close enough to suggest a similar date and perhaps a similar place of manufacture in the southern Netherlands.

The two oval shields in the upper corners of the Metropolitan Museum tapestry have been added later and bear quarterly the arms of the Brunavillani of Treviso and of the Alvarotti of Rovigo, with the chief charged with a cross. Treviso and Rovigo are both in Venetian territory. Flemish tapestries were popular in Italy and this panel must have been brought in no later than the seventeenth century, doubtless after it had already been separated from its two outer parts.

Prepared by William H. Forsyth

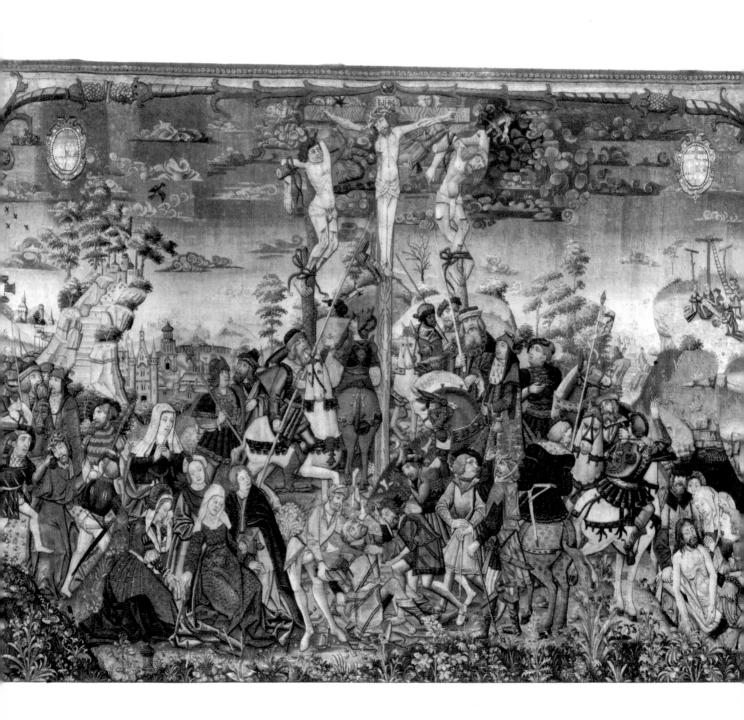

244 *Wool. 16–18 ribs to the inch*
H. 3 ½, W. 5 ¹/₆ feet
French or Flemish, second half of the XV century
Bequest of George Blumenthal, 1941
Ex colls. Dupont-Auberville, Paris;
Charles Mège, Paris;
George and Florence Blumenthal, New York

Tightly crowded into the limited space of the tapestry fragment are several men and one woman wearing the magnificent costumes fashionable in the middle and the second half of the fifteenth century. In true two-dimensionality typical of the best tapestries of the Gothic period, space is indicated by placing the figures one above the other. The original tapestry, of which the piece shown is only a fragment, must have represented a courtly gathering. In fact it must have had the same general aspect as the scene of a marriage feast in the book *Renaud de Montauban* by Loiset Liédet dated in 1465.

The tapestry is a most interesting document of the fashions of the period, many of which, it is believed, were created under influences from the Orient and Islam. The lady is wearing a very tall hennin, a headdress of conical shape. It could be made of starched material or even supported by whalebones, and has a diaphanous veil attached to its peak. These exaggerated hennins gave rise to many popular jokes at the time, and the ladies wearing them were compared to unicorns. Enlart says that this type of headdress was introduced by a lady from Hénin, and this fact gave the headdress its name. Their fashion started probably under oriental influence and became widespread in the second half of the fifteenth century. Barbara van Vlanderbergh in a portrait by Hans Memling, in the Musées Royaux de Bruxelles, has such a hennin. Above the low neckline of her dress, the lady of the Noble Company wears a sumptuous necklace.

The gentlemen wear high velvet hats. The tassel hanging from the hat of the man on the left may be fastened by a brooch similar in type to that described in number 118. The long brocaded coats of the gentlemen have heavily padded sleeves with vertical slits on their outer sides. Some men wear heavy necklaces, studded with jewels; the one worn by the man in the upper center has a pendant. While the hair of the lady is barely visible in a widow's peak under the hennin, the gentlemen's hair is long, and in most instances in frizzy curls.

The background to the left with millefleurs—an array of various flowers and low plants so popular in fifteenth-century tapestries. The drapery in the background on the right probably belongs to figures in the piece cut off from this fragment.

The style is that found on many contemporary tapestries, with costumes inspired by the splendor developed especially at the court of the Burgundian dukes. The faces have delicately outlined individualized features and according to Charles Sterling show French rather than Flemish characteristics. The design of the drapery and of the brocades is treated with great skill and feeling. The count of sixteen to eighteen ribs to an inch indicates very fine workmanship. The provenance of the tapestry fragment is not known, but there can be no doubt that it was woven for a demanding and discriminating customer.

Gaston Migeon called the tapestry French, period of Charles VII (1422–1461) and related it to those at Nôtre-Dame de Nantilly. Sigismond Bardac suggested that the original subject might have been an historical one, while Georges Demotte preferred to see in it the representation of a scene from a romance. Betty Kurth groups the tapestry with those of the School of Tournai and dates it about 1460–1470. Stella Rubinstein-Bloch says that the tapestry "most probably belongs to the series called 'Conversations galantes'", and finds the costumes to be of the reign of Louis XI and Charles VIII. She compares the costumes to those in the illuminations by Jean Foucquet.

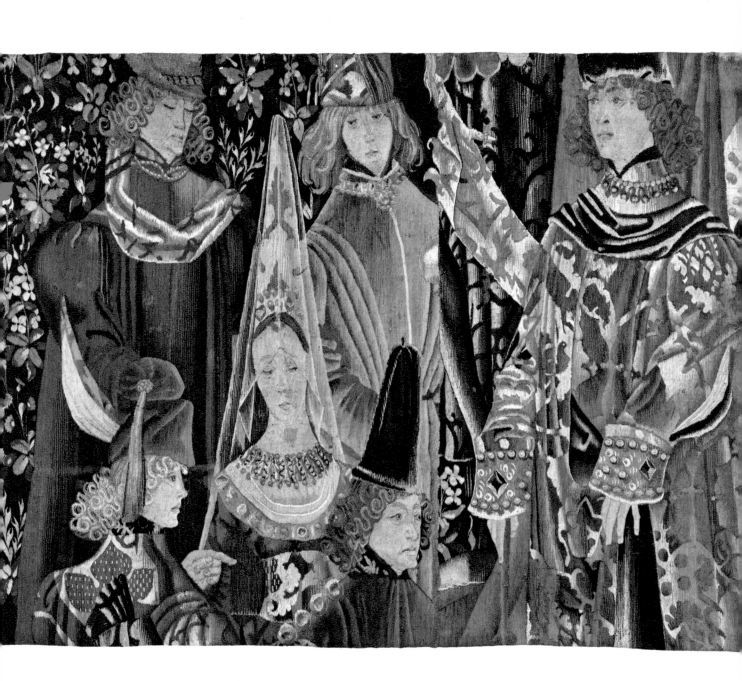

246 *Wool. 11 to 13 ribs to the inch*
[117A] H.141½, W.126;
[117B] H.146, W.148 inches
French or Flemish, early XVI century
Bequest of George D.Pratt, 1941
Ex coll. Baron d'Ezpleta,
Château de Septmonts, France

The idea of a triumphal procession goes back to the Roman period, when the Senate granted triumphs to victorious generals and emperors. They were revived in fifteenth-century Italy. Our modern festival and circus parades are far-off echoes of their splendor.

The Italian poet Petrarch (d.1374) established the great vogue for this subject in the fifteenth and sixteenth century in paintings, book illustrations, prints, and tapestries by his allegorical poem I Trionfi (the Triumphs) which describes the six successive triumphs: of Love over Mankind, of Chastity over Love, of Death over Chastity, of Fame over Death, of Time over Fame, and finally of Eternity over all. In sixteenth-century France, Petrarch's *Triumphs* became as popular as they had been in fifteenth-century Italy. They were translated a number of times, once in Rouen for Louis XII of France.

The Triumph of Fame tapestry shows a winged figure, labeled Renommée or Fame, blowing a trumpet with its flaring bells pointing in four different directions toward the four corners of the world. Beneath Fortune's girdle hang feathers with eyes, mouths, and tongues, all of which refer to the image of Rumor or Fame so

vividly described by Virgil in the Aeneid (Book IV, 11.74–185): "Fame, swift of foot and fleet of wing... who for the many feathers in her body has as many watchful eyes, as many tongues, as many mouths." Virgil was well known in the fifteenth and sixteenth centuries; in fact, Caesar Ripa refers to this very passage in his popular book on iconology. As late as 1604, James I on his triumphant entry into London was met by a winged figure of Fame in a robe embroidered with tongues and eyes, and with a trumpet in her hand.

Fame stands on a triumphal chariot drawn by two elephants who signify her irresistible force. Attached to the front of her chariot are a flying bat and a cock, signifying Fame's sleepless vigilance by night and by day. Prostrate beneath the chariot are the figures of Lachesis and Atropos, two of the three fates who spin man's destiny and terminate his life.

Thus is symbolized the triumph of Fame over Death since Death has not the power to kill the memory of great men kept alive by Fame. Thus in Petrarch does Fame avenge the triumph of Death over Chastity. Above Fame's head is the bottom line of a quatrain, freely translated as: "From earth comes mighty Fame—to crush Atropos and her two sisters—For so she wished to avenge Chastity—by her great power, a lady formidable."

Accompanying Fame and ahead of the other figures is Plato pointing the way. Petrarch mentions him first, and then places Aristotle with his intent gaze: "Plato majestic in the front appeared—Then came the Stagyrite [Aristotle] whose mental ray —Pierced through all nature like the shafts of day" (a free translation by Boyd).

In the tapestry, however, Alexander

comes between the two Greeks, and not later as in Petrarch, "Alexander, that brought down the Persians' mighty power." This change of position may arise from the desire to portray here Louis XII as Alexander, wearing the regalia of a French king. Louis XII probably reigned as King of France when the tapestry was woven. Alexander's features may also be meant to suggest those of St.Louis, the ancestor and patron saint of Louis XII. Louis had the *Triumphs* of Petrarch as well as the works of St.Louis translated into French in the early sixteenth century.

In front of the chariot strides Charlemagne, whom Petrarch places at the end, but who is probably included here as another distinguished predecessor of the French king. He wears the imperial crown of the Holy Roman Empire, the imperial mantle with the French fleur-de-lis, and the imperial double eagle which later continued to be the symbol of the German emperors. He carries the orb and sword of state. Now missing from the left end of the tapestry are the figures of Clotho, one of the fates, and of Virgil and Cicero who are mentioned by Petrarch and who also appear in another similar tapestry in Vienna.

In the Triumph of Time the aged figure of Time sits facing backward but looking forward, signifying that time "turns back on itself and never sees the end" in the words of a Venetian book of 1580 by Vincenzo Centari, called *Le imagini de i Dei*. The stags who draw his chariot are reputed to live long. They also look forward and back. On Time's head are the signs of the zodiac in a circle around a mirror and in his right hand a clock, all symbols of the passage of time. Beneath the chariot of Time lies Fortune with her trumpet broken. The

quatrain above Time's head explains her downfall. A free translation reads: "Time, roused after noisy debate,—Old and weak, not fearing to bear arms,—Has given several alarms—to Fame and from the summit—He has laid her low."

Around Time's chariot are Nestor, Noah, and Methusalah, famous old men of history. Sections of the left end and of the bottom of the tapestry are missing.

The Austrian National Collection in Vienna possesses a complete set of six Triumph tapestries, two of which are nearly identical to these in the Metropolitan Museum. They were probably woven after the same cartoons, those of Vienna being slightly finer in detail. The Musée du Cinquantenaire in Brussels also has a Triumph of Fame tapestry woven after the same cartoon. Other sets of Triumph tapestries exist, most of them different in style. These tapestries have been variously called School of Touraine, of Tournai, and of Brussels. Their flowery background associates them with large groups of millefleurs tapestries made in the Lowlands or in France.

Prepared by William H. Forsyth

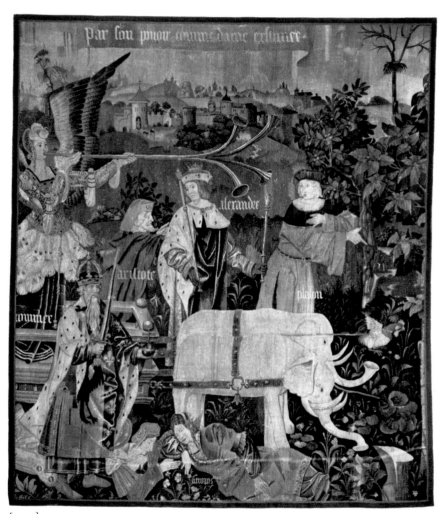

[117A]

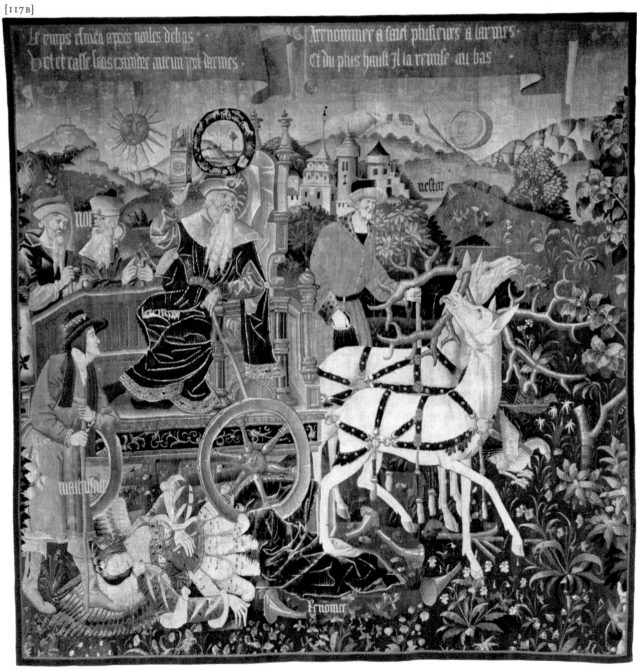

Gold, pearls, and glass paste
H. 1 ⅛, W. ¹⁵/₁₆ *inches*
French, XV century (circa 1450–1475)
The Cloisters Collection, Purchase 1957
Ex coll. Said to be from the
Figdor Collection, Vienna

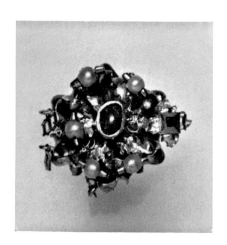

The central cabochon of this gold pendant, an "emerald" of green glass paste, is surrounded by small, thin, gold leaves rising on very thin wires. Five pearls form a wreath around the outer edge of the pendant. At the top is a "jewel" of clear glass paste, simulating a chip diamond. The word AMOR in gold Gothic letters hangs from the lower rim. A gold loop for suspension is attached at the top back of the pendant.

Some of the mentions of *jouel* or *joyau* found in French inventories probably refer to similar pendants or brooches which were very popular among the nobles of the late medieval period. Many of the brooches or pendants were decorated not only with pearls and jewels but with gold figures in high relief or enameled figures in full round. Sometimes religious representations, these figures more often were the emblems or symbolic allegories so popular in medieval courtly society. The pendants and brooches were worn attached to clothing or to hats and can be seen on a number of contemporary paintings. Many of them ultimately became ornaments on reliquaries, as gifts from devout former owners.

This type of pendant or brooch is usually called Burgundian, but there does not seem to be any direct evidence for the place of origin. H. Clifford Smith calls them Flemish-Burgundian, but speaks of them as though they were made in Flanders. Erich Steingraber on the other hand uses the term "Franco-Burgundian" and quotes from French inventories.

All of the related pieces are of circular construction and a gold tube often serves as the main structural element. They are usually set with pearls, as is this pendant. Some of the known pendants and brooches date from the first half of the fifteenth century; others are somewhat later in date. Closely related to The Cloisters pendant is a brooch formerly in the Figdor Collection (found in Lublin, Poland) with an angel, pearls, and precious stones. Richard Randall finds that the relationship becomes more evident when the two pieces are compared from the back to observe the mounting of the central stone and the pearls. Somewhat less closely related are three pieces, dredged from the river Meuse, now in the British Museum.

BIBLIOGRAPHY AND NOTES

1 Sarcophagus Relief Figure

ACC. NO. 18.108

W. Frederick Stohlman, "A Group of Sub-Sidamara Sarcophagi," *American Journal of Archaeology*, XXV, no.3 (July–September, 1921)
Charles Rufus Morey, *The Sarcophagus of Claudia Antonia Sabina and the Asiatic Sarcophagi*, Princeton, 1924 (American Society for the Excavation of Sardis. Publications, V, part 1, Roman and Christian Sculpture), p.46, fig.81, with bibl.
Marion Lawrence, "Columnar Sarcophagi in the Latin West," *Art Bulletin*, XVI (1932), p.116, fn.14
Gloria Ferrari, *Il Commercio dei Sarcofagi Asiatici*, Rome, 1966, p.64

2 Portrait Medallion of Gennadios

ACC. NO. 26.258

F. de Mély, "Le Médaillon de la croix du Musée Chrétien de Brescia," *Arethuse*, (January, 1926), no.10, pp.1–9
J. Breck, "The Ficoroni Medallion and Some Other Gilded Glasses in the Metropolitan Museum of Art," *Art Bulletin*, IX (1927), pp.353–356
Charles R. Morey, *Gold Glass Collection of the Vatican Library*, Vatican City, 1959, no.454, p.XXXVI
Axel von Saldern, "Glass Finds at Gordion," *Journal of Glass Studies*, I (1959), p.45ff.
Andrew Oliver, Jr., "A Gold Glass Fragment in the Metropolitan Museum of Art," *Journal of Glass Studies*, XI (1969), p.9ff.

3 The Apostles Peter and Paul

ACC. NO. 16.174.3

Raffaele Garrucci, *Storia dell'arte*, III, Prato, 1876, pp.107, 110–111, 147, 180, 182–183, 185
Herman Vopel, *Die Altchristlichen Goldgläser*, Freiburg i. B., 1899, pp.23, 50
British Museum Guide, London: The British Museum, 1903, cf.pp.19–20 (Early Christian Antiquities)
Louise C. Avery, "Early Christian Gold Glass," *Metropolitan Museum of Art Bulletin*, XVI (1921), pp.173–174, ill. fig.3 with bibl.
M. Sulzberger, "Le Symbole de la Croix," *Byzantion*, II (1925), p.345 ff.
Gustavus A. Eisen, "Art of Gold Glass," *International Studio*, LXXXV (1926), p.231
Gustavus A. Eisen, *Glass: Its Origin, History, Chronology...*, II, New York, 1927, p.569, pl.138
Charles R. Morey, *Gold Glass Collection of the Vatican Library*, Vatican City, 1959, no.455

4 Dolphin

ACC. NO. 55.135.9

Marquis d'Anselme de J. M. E. Puisaye, *Rapport sur des Objets Antiques trouvés à Cartage*, 1910
Sir E. A. Wallis Budge, *Amulets and Superstitions*, London, 1930
J. B. Frey, "Il delfino col Tridente nella catacomba giudica de Via Nomentana," *Rivista di Archeologia Cristiana*, VIII (1931), p.301 ff.
Liselotte Stauch, "Delphin," *Reallexicon zur Deutschen Kunstgeschichte*, III, Stuttgart (1954), clmn.1233 ff.

Exhibition:
Early Christian and Byzantine Art, Walters Art Gallery, Baltimore, 1947, p.111, ill.no.538

5 Jonah and the Whale

ACC. NO. 77.7

Walter Lowrie, "A Jonah Monument in the New York Metropolitan Museum," *American Journal of Archaeology*, V (1901), pp.51–57, figs.1, 2
Joseph Strzygowski, *Kleinasien ein Neuland der Kunstgeschichte*, Leipzig, 1903, p.197
Ormonde Maddock Dalton, *Byzantine Art and Archeology*, Oxford, 1911, p.143
Oskar Wullf, *Altchristliche und Byzantinische Kunst*, Berlin-Neubabelsberg, 1914, p.149
Karl Lehmann-Hartleben, "Bellerophon und der Reiterheilige," *Römische Mitteilungen*, XXXVIII–XXXIX (1923–1924), pp.264 ff., esp. p.269
"Notes on Current Art," *International Studio*, LXXXV (1926), p.84 ill.
Henri Leclerq and Fernand Cabrol, *Dictionnaire d'archéologie chrétienne et de liturgie*, VII, part 2, Paris, 1927, clm. 2572–2631, fig.6287 and esp. clm.2588
Hans von Schoenebeck, "Die Christliche Sarkophagenplastik unter Konstantin," *Römische Mitteilungen*, LI (1936), pp.238 ff., esp. p.332, ill. pl.48
Walter Lowrie, *Art in the Early Church*, New York, 1947, pp.8, 84
Campbell Bonner, "The Story of Jonah on a Magical Amulet," *Harvard Theological Review*, XLI (1948), pp.31–32
A. Ferrua, "Paralipomeni de Giona," *Rivista de Archeologia Cristiana*, XXVII (1962), pp.7 ff. and fig.2, with bibl.
André Grabar, *Sculpture Byzantine de Constantinople*, Paris, 1963, p.46, no.1

Karl Lehmann-Hartleben finds a close relation between the Metropolitan Museum sculpture and certain table-like tomb monuments on columnar pedestals with the sculpture placed against the pedestal found in Asia Minor. There is little doubt that the Museum Jonah was made for one of these. Such table-like monuments were used by the Early Christians for their "trapezai" at the tombs, or to mark the graves of martyrs and confessors, and for the partaking of the eucharistic meal near the burials. A fragment of such a grave monument on a columnar pedestal of the fourth to the fifth century from Ktesiphon, the shape of which Lehmann-Hartleben describes as an *arula* (a small altar) with the sculpture of Orpheus below, is in Berlin (Inv. Nr. 1.4795). Another example is in Athens. Oskar Wullf calls the Museum piece "Jonah-cippus" (a small tombstone), while Ernst Kitzinger suggests in a lecture that, judging by its base, the piece might have been used as an ornament on a fountain.

6 The Chalice of Antioch

ACC. NO. 50.4

G. A. Eisen, "Preliminary Report on the Great Chalice of Antioch Containing the Earliest Portraits of Christ and the Apostles," *American Journal of Archaeology*, 2nd series, XX (1916)
G. A. Eisen, "The Plate with the Seven Loaves and Two Fishes on the Great Chalice of Antioch and the Date of the Great Chalice of Antioch," *American Journal of Archaeology*, XXI (1917)
Georg Stuhlfauth, *Die ältesten Porträts Christi und der Apostel*, Berlin, 1918, p.243
Louis Bréhier, "Les trésors d'argenterie syrienne et l'école artistique d'Antioche," *Gazette des Beaux-Arts*, LXII (1920), pp.173–196

Charles Diehl, "L'école artistique d'Antioche et les trésors d'argenterie Syrienne," *Syria*, II (1921), pp.81–95, pl.IX
W. F. Volbach, "Der Silberschatz von Antiochia," *Zeitschrift für Bildende Kunst*, LVI (1921), pp.110–113
Gustavus A. Eisen, *The Great Chalice of Antioch*, 2 vols. New York, 1923
B. W. Bacon, "Eagle and Basket on the Antioch Chalice," *The Annual of American Schools of Oriental Research*, V (1923–1924), pp.1–22
A. B. Cook, "The Chalice of Antioch," *The Cambridge Review*, XLV (1924), no.1113, pp.213–216, ill.
Joseph Strzygowski, "Der Silberkelch von Antiochia," *Jahrbuch der Asiatischen Kunst*, I (1924), pp.53–61, pls.28 and 29
Ormonde Maddock Dalton, *East Christian Art, a Survey of the Monuments*, Oxford, 1925, p.329
Charles R. Morey, "The Chalice of Antioch," *Art Studies: Medieval, Renaissance and Modern. Harvard and Princeton Universities*, III, Cambridge (1925), pp.73–80
Louis Bréhier, "A propos du grand calice d'Antioche," *Rivista di Archeologia Cristiana*, III (1926), pp.269–286, ill. p.271
Charles Diehl, "Un nouveau trésor d'argenterie Syrienne," *Syria*, VII (1926), pp.105–122
Guillaume de Jerphanion, "Le calice d'Antioche; les théories du Dr. Eisen et la date probable du calice," *Orientalia Cristiana*, VII, Rome (1926), no.27
Joseph Wilpert, "Early Christian Sculpture: its Restoration and its Modern Manufacture," *Art Bulletin*, IX (1926), pp.110–141, ill.
Georg Stuhlfauth, "Review of Jerphanion's le calice d'Antioche," *Byzantinische Zeitschrift* (1927), pp.404–406
Joseph Strzygowski, "The Authenticity of Early Christian Silver," *Art Bulletin*, X (1928), pp.307–376
Guillaume de Jerphanion, *La voix des monuments*, Paris and Brussels, 1930, pp.120–137, pl. XXIII
René Dussaud, "Les monuments Syriens à l'exposition d'art Byzantin," *Syria*, XII, Paris (1931), pp.305–315, figs.3–6, pls.LIX, LX
Hayford Peirce and Royall Tyler, *L'Art Byzantin*, I, Paris, 1932, pp.69–71, pls.99, 100
G. A. Eisen, *The Great Chalice of Antioch*, New York, 1933, p.20 (color plates)
H. Harvard Arnason, "The History of the Chalice of Antioch," *The Biblical Archaeologist*, New Haven: The American Schools of Oriental Research, IV (1941), V (1942)
Bayard Dodge, "The Chalice of Antioch," *Bulletin of the Near East Society*, III (May and June 1950)
James J. Rorimer, "The Treasury at The Cloisters," *Metropolitan Museum of Art Bulletin*, n.s., IX (1951)
Art Treasures of the Metropolitan, New York: Metropolitan Museum of Art, 1952, p.51, no.41, ill. p.221, no.41
James J. Rorimer, "The Authenticity of the Chalice of Antioch," *Studies in Art and Literature for Belle da Costa Green*, Princeton (1954), ed. Dorothy Miner, pp.161–168, figs.127–132
Thomas P. F. Hoving and James J. Rorimer, *A Medieval Treasury: Calender for 1966*, New York: Metropolitan Museum of Art, 1965, no.2

Exhibitions:
Exposition Internationale d'Art Byzantin, Musée des Arts Décoratifs, Paris, 1931, cat.no.335, pl.I

Century of Progress, Hall of Religion, World's Fair, Chicago, 1933–1934
The Chalice of Antioch and Associated Objects, Brooklyn Museum, New York, 1935–1936, and the Franklin Institute, Philadelphia, 1936
The Dark Ages, Worcester Art Museum, Worcester, 1937, cat. no. 71, pl. LXXI
Religious Art, Baltimore Museum of Art, Baltimore, 1938–1939, and St. Thomas Episcopal Church, New York, 1940
Ecclesiastical Arts, Springfield Museum of Fine Arts, Springfield, 1941
Early Christian and Byzantine Art, Baltimore Museum of Art, Baltimore, 1947, cat. no. 388, pl. LIV
Mission Exhibition, Boston, 1949 (sponsored by His Excellency the Rev. Richard J. Cushing, Archbishop of Boston)

The excitement created by the Chalice of Antioch, since its discovery in 1910 by local Arab laborers digging a well near Antioch, has been great. The original owner, Fahim Kouchakji, spent a fortune having it elaborately published by Gustavus A. Eisen. As often happens, the reputation of the Chalice was damaged rather than enhanced by overzealous admirers who claimed unbelievable things for it. Practically every outstanding scholar in the fields of archaeology, ecclesiastical history, and even theology, has had something to say. Some considered the chalice unusual and therefore suspected forgery. Others presumed it was the Holy Grail—with the inner cup having been used at the Last Supper, and the outer, ornate shell added in the first century to enshrine the precious vessel. Both extremes have now been abandoned, but in their time many bitter accusations, tinted with personal acrimony, were exchanged between specialists. The names involved in the arguments pro and con included Wilpert, Volbach, Diehl, Jerphanion, Morey, Conway, Strzygowski, Stuhlfauth, and many others. The most vicious attack came from Wilpert, who has systematically doubted the authenticity of every silver treasure found, including the Boscoreale and Cyprus silver. He also rejected all Syrian silver, without exception, on the ground that Syria could not produce any worthwhile silverwork. (Later, Wilpert retracted his accusations).
Arnason, in 1942, made a summary of all important literature on the subject. James J. Rorimer, who acquired the Chalice for The Cloisters in 1950, had previously secured records of several technical analyses of the metal and of its condition before the removal of the corrosion by André in Paris. The results were positive; the silver and its corrosion were old. Although certain technical and iconographical questions remain, none cast a shadow on the authenticity of the Chalice of Antioch. Its authenticity is an accepted fact and its uniqueness enhances its importance.

7 Tyche

ACC. NO. 47.100.40
Sale catalog: *Mme Edouard Warneck Collection,* Hôtel Drouot, Paris, June, 1905, no. 115, pl. 11
Sale catalog: *Arthur Sambon Collection,* Galerie Georges Petit, Paris, May, 1914, no. 81
Arthur Sambon, *Aperçu général de l'évolution de la sculpture depuis l'antiquité jusqu'à la fin du XVI siècle,* Paris, 1931, pp. 36–37, pl. XXXIII
Kurt Weitzmann, "Byzantine Art and Scholar-

ship in America," *American Journal of Archaeology,* 2nd series, LI (1947), p. 404
Cornelius C. Vermeule, *The Goddess Roma in the Art of the Roman Empire,* Cambridge, 1959, pp. 96, 100, note 96 with bibl.
Tobias Dohrn, *Die Tyche von Antiochia,* Berlin, 1960
Cornelius C. Vermeule, "The Colossus of Porto Raphti in Attica," *Hesperia* (1962), pp. 62 ff., 75, 76, and footnote 7

Exhibitions:
Exposition de Sculpture; Arthur Sambon, Paris, 1928, cat. no. 68, pl. XLVIII
Early Christian and Byzantine Art, Baltimore Museum of Art, Baltimore, 1947, cat. no. 205, pl. XXXV

8 Architectural Fragment

ACC. NO. 69.15 Unpublished

9 Plaque from a Book Cover

ACC. NO. 47.100.36
W. F. Volbach, "Der Silberschatz von Antiochia," *Zeitschrift für Bildende Kunst,* XXXII (1921), pp. 110–113, fig. 2
Gustavus A. Eisen, *The Great Chalice of Antioch,* I, New York, 1923, p. 3
Gustavus A. Eisen, "The Art of Book Covers Dating from the Early Years of the Christian Era," *International Studio,* LXXX (1924), pp. 91–98, ill.
Charles Diehl, "Un nouveau trésor d'argenterie Syrienne," *Syria,* VII (1926), p. 121
Glanville Downey, "A Processional Cross," *Metropolitan Museum of Art Bulletin,* n. s., XII (1954), p. 276, ill. p. 279
André Grabar, "La Sedia di San Marco a Venice," *Cahiers Archéologiques,* VII (1954), pp. 22, 30–31, pl. XI, 3 (the chair in San Marco, Venice)
The History of Bookbinding, Baltimore: Baltimore Museum of Art, 1957–1958, p. 3
Etienne Coche de la Ferté, *L'Antiquité Chrétienne,* Paris: Louvre, 1958, pp. 45, 104–105, no. 42 (the fragment in the Louvre)
Helmut Buschhausen, "Ein Byzantinisches Bronzekreuz in Kassandra," *Jahrbuch der Österreichischen Byzantinischen Gesellschaft,* XVI (1967), p. 282 (mentioned)

Exhibitions:
Exposition d'Art Byzantin, The Louvre, Paris, 1931, no. 395
The Dark Ages, Worcester Art Museum, Worcester, 1937, no. 85, ill.
Early Christian and Byzantine Art, Baltimore Museum of Art, Baltimore, 1947, no. 391, pl. LIV with bibl.

10 Insert from a Tunic (?): Labors of Heracles

ACC. NO. 89.18.244
M. Dimand, *Die Ornamentik der Ägyptischen Wollwirkereien,* Leipzig, 1924 (Hermitage piece)
Xenia S. Lyapounova, "Koptskaya tkan' s myfom o Gherackle" ("A Coptic Textile with the Myth of Heracles"), *Trudy otdela istorii kul'tury y iskusstva Vostoka,* I (1939), (with summary in French), pp. 211 ff.
Xenia S. Lyapounova, "Izobrajeniye Dionysa na tkanyakh Vizantiyskogo Eghipta," *Trudy otdela istorii kul'tury y iskusstva Vostoka,* III (1940), pp. 149–159 (Hermitage piece)

Paul Friedländer, *Documents of Dying Paganism. Textiles of Late Antiquity in Washington, New York and Leningrad,* Los Angeles, 1945, p. 41 and pl. XIV
Militsa Matthieu and Zenia Lyapounova, *Khudoshestvenniye tkani koptshogo Eghipta (Figurative Textiles of Coptic Egypt),* Moscow-Leningrad, 1951, pp. 53–55, 98, 99, no. 35, pl. XVIII, 3 (pair to Metropolitan Museum of Art piece in the Hermitage, Leningrad)

11 Two Decorative Squares from a Tunic

ACC. NO. 90.5.148.149 Unpublished

12 The Goddess of Earth—Euthenia (?)

ACC. NO. 90.5.848
Sir C. Purdon Clark, "A Piece of Egyptian Tapestry," *Metropolitan Museum of Art Bulletin,* XI (1907), pp. 161–162, fig. 162
W. Sherwood Fox, "Hellenistic Tapestries in America," *Art and Archaeology,* V (1917), pp. 161 ff., fig. 10
M. S. Dimand, "Early Coptic Tapestry," *International Studio,* LXXVIII (1923), pp. 245 ff., ill. p. 246
Sale catalog: *Die Sammlung Dr. Albert Figdor,* Erster Teil—Erster Band, Wien and Berlin, 1930, pl. I
Charles R. Morey, *The Mosaics of Antioch,* London and New York, 1938, pp. 37, 38, pl. XVI
Georges Duthuit, *La Sculpture Copte,* Paris, 1939, p. 38, no. 5, p. 42, pl. XXIII
L. A. Matzulevitch, "Vizantiyskiy Antik i Prikamye" ("Byzantine Antiquity and the region of Kama"), *Materialy i issledovaniya po Arkheologii U.S.S.R.,* I (1940), p. 139, pl. IV. (in Russian with summary in French)
M. E. Matthieu, "Drevne-eghipetskiye motivy na tkanyakh Vizantiyskogo Eghipta" ("Ancient Egyptian motifs on textiles of Byzantine Egypt"), *Trudy otdela istorii kul'tury y iskusstwa Vostoka,* III, Leningrad (1940), pp. 117 ff. (in Hermitage)

Exhibition:
Pagan and Christian Egypt: Egyptian Art from the First to the Tenth Century A.D., Brooklyn Museum, New York, 1941, ill. no. 184

13 Fragment of a Wall Hanging (curtain?)

ACC. NO. 90.5.905
Hayford Peirce and Royall Tyler, *Art Byzantin,* II, Paris, 1934, p. 138, pl. CCVI
Sirarpie Der Nercessian, "Some Aspects of Coptic Paintings," *Coptic Egypt,* New York (1944), pp. 43–50
Ernst Kitzinger, "The Horse and Lion Tapestry," *Dumbarton Oaks Papers,* no. 13, Cambridge, 1946, pp. 34–36
Militsa Matthieu and Xenia S. Lyapounova, *Khudozhestvenniye tkani kiptskogo Eghipta (Figurative Textiles of Coptic Egypt),* Moscow and Leningrad, 1951, pp. 74–80, fig. 17 and pl. VI (Hermitage fragment and reconstruction; Metropolitan Museum of Art fragment discussed)

14 Fragments of a Wall Hanging

ACC. NO. 31.9.3
H. E. Winlock, "A Roman Tapestry and a Ro

man Rug," *Metropolitan Museum of Art Bulletin*, XXVII (1932), p.157, fig.1

"The Harkness Collection: Illustrations of Outstanding Harkness Gifts," *Metropolitan Museum of Art Bulletin*, n.s., X (1951), p.78, ill.

Klaus Wessel, *Coptic Art*, New York, 1965, p.105, pl.CXV

Dorothy G. Shepherd, "An Icon of the Virgin," *Bulletin of the Cleveland Museum of Art*, LVI (1969), pp.108, 110, figs.14, 15 and 19

Exhibition:
Pagan and Christian Egypt: Egyptian Art from the First to the Tenth Century A.D., Brooklyn Museum, New York, 1941, p.76, ill.no.238

The hanging shows a considerable number of losses and minor repairs and only very recently a rearrangement of the medallions has revealed its original length, and its proportions of three horizontal tiers of five medallions each. The figure formerly occupying the uppermost left corner has been transferred to the new central location between the second and third medallions of the same tiers. This move has revealed that the vertical fifth (central) row, entirely missing in the previous mounting of the fragments, was all that was needed to complete the length of the hanging.

15 St. Peter

ACC. NO. 41.100.156

Friedrich Schneider, "Deutsche Elfenbeinskulpturen des Frühen Mittelalters," *Kunstgewerbeblatt*, II (1887), pp.242–243

Frédéric Spitzer, *La Collection Spitzer: Antiquité, Moyen-Age, Renaissance*, I, Paris and London, 1890, pp.29–30, pl.I; ("Les Ivoires" by Alfred Darcel)

Hans Graeven, "Fragment eines Frühchristlichen Bischofsstuhls im Provincial-Museum zu Trier," *Bonner Jahrbücher*, CV (1900), pp.152–154

Joseph Destrée, *Catalogue des Ivoires, des Objets en Nacre, en Os Gravé et en Cire Peinte*, Brussels: Musées Royaux des Arts Décoratifs et Industriels, 1902, pp.1–4

Marcel Laurent, *Les Ivoires Prégothiques Conservés en Belgique*, Brussels, 1912, pp.15–17 (reprinted from the *Annales de la Société Archéologie de Bruxelles*, 1911)

Ormonde Maddock Dalton, *Catalogue of the Medieval Ivories: Fitzwilliam Museum, McClean Bequest*, Cambridge, 1912, pp.84–87

Kurt Weitzmann, "Byzantine Art and Scholarship in America," *American Journal of Archaeology*, 2nd series, LI (1947), p.403

Wolfgang Fritz Volbach, *Elfenbeinarbeiten der Spätantike und des Frühen Mittelalters*, 2nd ed., Mainz: Römisch-Germanisches Zentralmuseum, 1952, p.75, no.155

Wolfgang Fritz Volbach, *Frühmittelalterliche Elfenbeinarbeiten aus Gallien*, I, Mainz: Römisch-Germanisches Zentralmuseum, 1952, pp.45ff.

Henri Stern, "Quelques Ivoires d'Origine supposée Gauloise," *Cahiers Archéologiques*, VII (1954), pp.111ff.

Exhibitions:
Masterpieces in the Collection of George Blumenthal, The Metropolitan Museum of Art, New York, 1943–1944

Early Christian and Byzantine Art, Baltimore Museum of Art, Baltimore, 1947 (catalog no.102, ill.pl.XIV)

16 Head of the Goddess Luna (?)

ACC. NO. 10.130.1076 Unpublished

Exhibition:
Pagan and Christian Egypt: Egyptian Art from the First to the Tenth Century A.D., Brooklyn Museum, New York, 1941, ill.no.183

BYZANTINE ART

17 Bust of Athena

ACC. NO. 61.112

Silvio Ferri, *Arte Romana sul Danubio*, Milan, 1933, p.356, p.360, fig.482

F.O.Waagé, "Bronze Objects from Old Corinth", *American Journal of Archaeology*, XXXIX (1935), pp.79ff.

18 Bust of a Lady of Rank

ACC. NO. 66.25

Emile Espérandieu, *Recueil général des bas-reliefs de la Gaule romaine*, II, Paris 1908, p.103

Richard Delbrueck, "Porträte byzantinischer Kaiserinnen," *Mitteilungen des Kaiserlichen deutschen archäologischen Instituts, Römische Abteilung*, XXVIII (1913), pp.310–352

Richard Delbrueck, "Bronzener Frauenkopf, um 400 n.Chr.," *Bonner Jahrbücher*, CL (1950), pp.87–90

J.M.C.Toynbee, "A Roman (?) Head at Dumfries," *The Journal of Roman Studies*, XLII (1952), pp.63–65

Klaus Wessel, "Das Kaiserinnenporträt im Castello Sforzesco zu Mailand," *Jahrbuch des deutschen archäologischen Instituts*, LXXVII (1962), pp.240–255

"Reports of the Department of Medieval Art and The Cloisters," *Metropolitan Museum of Art Bulletin*, XXV (1966), p.88, ill.

W.H.Forsyth, "Byzantine Bust of a Woman (Metropolitan Museum of Art)," *The Burlington Magazine*, CIX (1967), p.304

Elisabeth Alföldi-Rosenbaum, "Portrait Bust of a Young Lady of the Time of Justinian," *Metropolitan Museum Journal*, I (1968), pp.19ff.

19 Hanging Lamp

ACC. NO. 62.10.2

Martin P.Nilsson, "Lampen und Kerzen im Kult der Antike," *Opuscula Archaeologica*, VI (1950), p.96ff.

Exhibition:
Let There Be Light, Wadsworth Atheneum, Hartford, 1946, p.18, no.9

20 Gold Necklace With a Cross

ACC. NO. 17.190.151

A. Sambon, "Trésor d'orfévrerie et d'argenterie trouvé à Chypre et faisant partie de la collection de M M.P.Morgan", *Le Musée*, III (1906), p.127

O.M.Dalton, *Byzantine Art and Archaeology*, Oxford, 1906, pp.541–542

C.H.Smith, *Collection of J.P.Morgan; Bronzes, Antiques—Greek, Roman, etc.... including Antique Objects in Gold and Silver...*, Paris, 1913

Hayford Peirce and Royall Tyler, *L'Art Byzantin*, II, Paris, 1934, pl.179

James J.Rorimer, *Medieval Jewelry. A Picture Book*, New York: The Metropolitan Museum of Art, 1944, fig.3

James J.Rorimer and Thomas P.F.Hoving, *A Medieval Treasury. Calendar for 1966*, The Metropolitan Museum of Art, New York, 1965, no.7

21 David Anointed by Samuel
22 David Slaying the Lion

ACC. NO. 17.190.394 and 17.190.398

Adolf Goldschmidt, *Die Kirchentür des Heiligen Ambrosius in Mailand*, Strassburg, 1902, pl.II

O.M.Dalton, "Byzantine Plate and Jewellery from Cyprus in Mr.Morgan's Collection," *Burlington Magazine*, X (1906–1907), pp.361, pl.I, no.1, and pl.II, no.4

O.M.Dalton, "A Second Silver Treasure from Cyprus," *Archaeologia*, LX (1906), pp.1–8, 13–17, figs.3 and 4

A. Sambon, "Trésor d'orfévrerie et d'argenterie trouvé à Chypre et faisant partie de la collection de J.P.Morgan," *Le Musée*, III (1906), pp.122–123, pl.XX, figs.3 and 4

Marc Rosenberg, *Der Goldschmiede Merkzeichen*, Frankfurt am Main, 1911, pp.1141 and 1143

O.M.Dalton, *Byzantine Art and Archaeology*, Oxford, 1911, pp.572–576

L. Brehier, "Les trésors d'argenterie syrienne et l'école artistique d'Antioche," *Gazette des Beaux-Arts* (1920), part 1, p.181

C.R.Morey, "The Sources of Medieval Style," *Art Bulletin* (1924), pl.XXVIII, figs.23

J.Wilpert, "Early Christian sculpture: its restoration and its modern manufacture," *Art Bulletin* (1926), pp.115–117, pl.27

J.Strzygowski, "The Authenticity of Early Christian Silver," *Art Bulletin*, X (June 1928), pp.375, 376

L. A. Matzulevitch, "Vizantiyskiy antik i Prikamye" (Byzantine Antiquity and the Region of Kama), *Materialy i issledovaniya po arkheologii U.S.S.R.* (1940), no.1, fig.6 and pl.III

Ejnar Dyggve, *Ravennatum Palatium Sacrum*, Kopenhagen, 1941, pl.XIV, fig.33

Einar Gjersted, "Decorated Metal Bowls from Cyprus," *Opuscula Archaeologica*, IV (1946), pp.11ff., pl.X

Kurt Weitzmann, "Byzantine Art and Scholarship in America," *American Journal of Archaeology*, LI (1947), pp.397ff., pl.CVI

C.R.Morey, *Early Christian Art*, 2nd ed., 1953, p.97, fig.94

P.Dikaios, *A Guide to the Cyprus Museum*, 2nd ed., Nicosia, 1953, pp.140ff.

Wilhelm Grünhagen, "Der Schatzfund von Gross-Bodungen," *Röm.-Germ. Kommission, Forschungen*, Berlin, 1954, p.29, ill. pl.11 (one of Cyprus plates)

E.Kitzinger, "Byzantine Art in the Period between Justinian and Iconoclasm," *Berichte zum XI*, Internationalen Byzantinisten-Kongress, Munich, 1958, pp.57ff.

John Beckwith, *The Art of Constantinople*, Greenwich, Conn., and London, 1961

Erica Cruikshank Dodd, *Byzantine Silver Stamps*, Washington, D.C., 1961, pp.186–189

P.J.Nordhagen, "The Mosaics of the Great Palace of the Byzantine Emperors," *Byzantinische Zeitschrift*, LVI (1963), p.53ff.

The Byzantine town of Lambousa was completely destroyed by the Arabs during their attack on the island in 653–654. On its site two towns were built: Karavás and Lapethos. During the quarrying of building material from the ruins of Lambousa by the inhabitants of Karavás the "First" (British Museum, London) and the

"Second" Cyprus Treasures were found. The treasure could not have been buried before 668, because it contained coins of Constantine IV (668–685). According to the control stamps it must be dated between 613 and 630. Dalton states that the date cannot be later than 632, because a fibula represented went out of fashion at that date. Grünhagen, by details of clothing, dates the plates in the second or third decade of the seventh century.

23 Cup, or Chalice

ACC. NO. 17.190.1710
Josef Strzygowski, *Altai-Iran und Völkerwanderung*, V, Leipzig: Vienna University Kunsthistorisches Institut, Arbeiten, 1917, pp. 3–10, pl. II
Exhibition:
Byzantine Art, an European Art, Zappeion Exhibition Hall, Athens, 1964 ("Byzantine Goldsmith Work" by Marvin Chauncey Ross, p. 362)
Thomas P. F. Hoving and James J. Rorimer, *A Medieval Treasury. Calendar for 1966*, New York: The Metropolitan Museum of Art, 1965, no. 4
Vera K. Ostoia, "Byzantium," *Metropolitan Museum of Art. Bulletin*, n.s., XXVI (January, 1968), p. 203, no. 12

24 Deësis Plaque

ACC. NO. 52.54.1
Mikhail Petrovich Botkine, *Collection M. P. Botkine* (catalog), St. Pétersbourg, 1911, pl. 63
Sergéi Makovski, *Russkaya Ikona*, C. Tletepõурm, 1914, p. 80
Helmuth Theodor Bossert, *Geschichte des Kunstgewerbes aller Zeiten und Völker*, V, Berlin: E. Wasmuch, 1932, p. 138, ill. fig. 2, p. 139
W. Frederick Stohlman, *Gli Smalti del Museo Sacro Vaticano*, Città del Vaticano: Biblioteca Apostolica Vaticana, 1939, p. 48, pl. XXVII, fig. S. 104
Kurt Weitzman, "Byzantine Art and Scholarship in America," *American Journal of Archaeology*, 2nd series, LI (October, 1947), p. 405

25 St. George Medallion

ACC. NO. 17.190.674
Johannes Schulz, *Die Byzantinischen Zellen-Emails der Sammlung Swenigorodskói*, Aachen, 1884
Johannes Schulz, *Der Byzantinische Zellenschmelz*, Frankfurt am Main, 1890
Nikodim Pavlovich Kondakov, *Geschichte und Denkmäler des Byzantinischen Emails*, Frankfurt-am-Main, 1892, p. 271 note 1, p. 273, 297 ff.
Franz Bock, *Die Byzantinischen Zellenschmelze der Sammlung Dr. Alexander von Swenigorodskói*, Aachen, 1896
Ormonde Maddock Dalton, *Byzantine Art and Archaeology*, Oxford, 1911, p. 529, fig. 314
Ormonde Maddock Dalton, "Byzantine Enamels in Mr. Pierpont Morgan's Collection," *Burlington Magazine*, XXI (1912), p. 70, pl. VI, no. 2
James J. Rorimer, "A Twelfth-Century Byzantine Enamel," *Metropolitan Museum of Art. Bulletin*, XXXIII (November 1938), p. 244 ff.

26 Deësis Plaque

ACC. NO. 17.190.133
Jean Baptiste Giraud, *Recueil descriptif et raisonné des principaux objets d'art ayant figuré*

à l'*Exposition rétrospective de Lyon* (catalog), Lyon, 1878, pl. III and IV, no. 4
A. I. Kirpichnikov, "Deisus na Vostoke i Zapade," *Zhurnal Ministerstva Narodnago Prosveshcheniya*, (1893)
Adolph Goldschmidt, *Die Byzantinischen Elfenbeinskulpturen des X–XIII Jahrhunderts*, II, Berlin, 1934, p. 66, no. 154 and no. 152, fig. 30 (plaque in Georgia)
Ernst Kantorowicz, "Ivories and Litanies," *Journal of the Warburg Institute*, V (1942), pp. 70–71
Certain ceremonials of the Byzantine Court might have influenced the arrangement of the figures in the composition. Christ is usually shown enthroned, or, as on the ivory plaque, placed on a pedestal which may reflect a privilege of rank; the Virgin and St. John are usually standing, and sometimes kneeling. One of the various symbolic interpretations given to the group was that the Mother of God represents the New Dispensation, or the Christian Church, while St. John represents the Old Law, both united in Christ.

THE MIGRATION PERIOD

27A Openwork Plaque

ACC. NO. 17.191.254
Seymour de Ricci, *Catalogue of a Collection of Gallo-Roman Antiquities belonging to J. Pierpont Morgan*, Paris, 1911, p. XIII, no. 254
Walther Veeck, "Die Durchbrochenen Bronzezierscheiben aus Reihengräberfeldern Württembergs," *Ipek* (1929), p. 85 ff.
Herbert Kuhn, *Die Vorgeschichtliche Kunst Deutschlands*, Berlin, 1935, pl. 415
Herbert Kuhn, "Die Reiterscheiben der Völkerwanderungszeit," *Ipek* (1938), p. 95 ff.

27B Openwork Plaque

ACC. NO. 17.192.155
Seymour de Ricci, *Catalogue of a Collection of Merovingian Antiquities belonging to J. Pierpont Morgan*, Paris, 1910, pl. XIII, no. 155
Walther Veeck, "Die Durchbrochenen Bronzezierscheiben aus Württemberg," *Ipek* (1929), p. 85 ff.
Herbert Kuhn, "Die Reiterscheiben der Völkerwanderungszeit," *Ipek* (1938), p. 95 ff.

27C Openwork Plaque

ACC. NO. 17.193.62
Seymour de Ricci, *Catalogue of a Collection of Germanic Antiquities belonging to J. Pierpont Morgan*, Paris, 1910, pl. III, no. 62
Walther Veeck, "Die Durchbrochenen Bronzezierscheiben aus Reihengräberfeldern Württembergs," *Ipek* (1929), p. 85 ff.
Herbert Kuhn, *Die Vorgeschichtliche Kunst Deutschlands*, Berlin, 1935, pl. 419
Herbert Kuhn, "Die Reiterscheiben der Völkerwanderungszeit," *Ipek* (1938), p. 95 ff.

28 Bow Fibula

ACC. NO. 47.100.19
Nándor Fettich, "Der Zweite Schatz von Szilágy-Somlyó," *Archeologia Hungarica*, VIII (1932), Pls. I–XIV, XVI, XVII, XX, XXIII, XXV

Sale catalog: *A Gentleman*, Sotheby & Co. London, July 28, 1936, no. 79
Herbert Kuhn, "Eine Neue Fibel aus Szilágy-Somlyó," *Ipek* (1936–1937), pp. 142–143
E. Thurlow Leeds, "Visigoth or Vandal?," *Archeologia*, XCIV (1951), pp. 195–212
Vera K. Ostoia, "A Ponto-Gothic Fibula," *Metropolitan Museum of Art Bulletin*, n.s., II (1953), pp. 146 ff.
James J. Rorimer and William H. Forsyth, "The Medieval Galleries," *Metropolitan Museum of Art Bulletin*, n.s., XII (February, 1954), p. 124 ill.
Thomas P. F. Hoving and James J. Rorimer, *A Medieval Treasury: Calender for 1966*, New York: The Metropolitan Museum of Art, 1965, no. 10

29 Low Cups

ACC. NO. 17.193.404 and 406
Gustavus A. Eisen, *Glass: Its Origin, History, Chronology...*, II, New York, 1927, pp. 640 ff., pp. 647–649 cf. pls. 160 and 161

30 Belt Buckle

ACC. NO. 95.15.104
Alfred Götze, *Gotische Schnallen*, Berlin, 1865
James J. Rorimer, *Medieval Jewelry: A Picture Book*, New York: The Metropolitan Museum of Art, 1944, fig. 9 (top)

31 Large Belt Buckle

ACC. NO. 17.191.325
Seymour de Ricci, *Catalogue of a Collection of Gallo-Roman Antiquities belonging to J. Pierpont Morgan*, Paris, 1911, pl. XIX, no. 325
Wilhelm Holmquist, *Kunstprobleme der Merowingerzeit*, Stockholm, 1939 (re: Germanic and Coptic interlace)
Edouard Salin and Albert France-Lanord, *Rhin et Orient*, II, Paris, 1943, pp. 131–201 (Le Fer dans la Parure)

32 Disc Fibulae

ACC. NO. 17.191.20 and 34
Seymour de Ricci, *Catalogue of a Collection of Gallo-Roman Antiquities belonging to J. Pierpont Morgan*, Paris, 1911, pl. II, no. 20 and no. 34
Edouard Salin, *La civilisation Mérovingienne d'après les sépultures, les textes et le laboratoire*, Paris, 1952, p. 300 ff. (fibules rondes et quadrilobées, pp. 300–307 and pl. B)

33 Disc Fibula

ACC. NO. 17.192.92
Seymour de Ricci, *Catalogue of a Collection of Merovingian Antiquities belonging to J. Pierpont Morgan*, Paris, 1910, pl. VII, no. 92
Wilhelm A. von Jenny and W. F. Volbach, *Germanischer Schmuck des Frühen Mittelalters*, Berlin, 1933
Herbert Kuhn, *Vorgeschichtliche Kunst Deutschlands*, Berlin, 1935, p. 423, no. 2 (Gersheim fibula), also pp. 447, 448 and 561
Hertha Rupp, "Eine Merowingische Goldschmiedewerkstatt," *Ipek* (1938), pp. 116 ff.

34 Roundel with Millefiori Inlay Decoration

ACC. NO. 66.16
Françoise Henry, "Emailleurs d'Occident", *Préhistoire*, II (1934), pp. 123–128

35 Gold Disc Fibula

ACC. NO. 52.30

G. Sergi, "La Necropoli Barbarica di Castel Trosino," *Monumenti Antichi*, XII (1902)

Sale catalog: *The Sieck Collection*, Weizinger, Munich, 1918, lot 839

Nils Åberg, *Die Goten und Langobarden in Italien*, Uppsala, 1923, pp. 81–83

Joachim Werner, *Die Beiden Zierscheiben des Thorsberger Moorfundes*, XVI, Berlin, 1941

Siegfried Fuchs and Joachim Werner, *Die Langobardischen Fibeln aus Italien*, Berlin, 1950, pls. 41–44 (similar disc fibulae)

Thomas P. F. Hoving and James J. Rorimer, *A Medieval Treasury. Calendar for 1966*, New York: The Metropolitan Museum of Art, 1965, no. 11

ROMANESQUE ART

36 Plaque with Agnus Dei

ACC. NO. 17.190.38

Arthur Haseloff, *Pre-Romanesque Sculpture in Italy*, New York, 1930, pls. 47, 49, 60, 61, 64

Hermann Schnitzler, *Rheinische Schatzkammer*, Düsseldorf, 1957, no. 47, p. 33 (Evangeliary, fol. 29 b, end of eighth century, Essen Münster Treasury)

Kunstgeschichtliche Sammlungen (catalog), Württembergisches Landesmuseum, Stuttgart, 1959, p. 8, fig. 1 (Hirsau relief, circa 830)

Jean Porcher, "Les débuts de l'art carolingien et l'art langobard," *Atti dell'ottavo Congresso di studi sull'arte dell'alto Medioevo*, I, Milan, 1962, pp. 56 ff. (Autun, ms. 3 – circa 754)

Ivo Petricioli, "La scultura preromanica figurativa in Dalmazia ed il problema della sua cronologia," *Atti dell'ottavo Congresso di studi sull'arte dell'alto Medioevo*, I, Milan, 1962, pp. 368 ff., fig. 11 (transenna in Biskupija)

Franke Steenbock, *Der kirchliche Prachteinband im frühen Mittelalter...*, Berlin, 1965, no. 29, fig. 44 (St. Gauzelin Evangeliary); no. 30, fig. 46 (Langobardic ivory, first half tenth century, Cologne, Schnütgen Museum); no. 79, fig. 107 (Evangeliary from Helmarshausen)

The composition of a cross surrounded by evangelists' symbols is seen on book covers, such as, for example on the Evangeliary of St. Gauzelin of the third quarter of the tenth century (Nancy, Cathedral) and on the Evangeliary from Helmarshausen of about 1100 (Trier, Cathedral Treasury, cod. 139), the latter with a jewel in the center as another symbol of Christ.

37 Capital from Cuxa Cloister

ACC. NO. 25.120.588

James J. Rorimer, *The Cloisters*, New York: Metropolitan Museum of Art, 1963, pp. 65 ff.

38 Christ in Majesty

ACC. NO. 17.190.696

Collection G. Hoentschel (catalog), introduction et notices de André Pérate, Paris, 1911, Emaux du XII au XV siècles, no. 28

Helmut Schlunk, "Observaciones en torno al problema de la miniatura visigoda," *Archivo Español de Arte*, XVII, 1945, pp. 241 ff., ill. fig. 17

O. K. Werckmeister, "Three Problems of Tradition in Pre-Carolingian Figure Style," *Pro-ceedings of the Royal Irish Academy*, LXIII, Sect. C, p. 167 ff.

Marie-Madeleine S. Gauthier, *Emaux Limousins champlevés des XII^e, XIII^e, et XIV^e siècles*, Paris, 1950, pp. 12, 60, 66, 151, and pl. I

39 Portable Altar or Reliquary

ACC. NO. 17.190.401

Otto von Falke and Heinrich Frauberger, *Deutsche Schmelzarbeiten des Mittelalters*, Frankfurt am Main, 1904, p. 107, pp. 113–114, fig. 41

Edith B. Dawson, *Enamels*, London, 1906, pp. 100, 104, pl. XV

Otto von Falke, Robert Schmidt, and Georg Swarzenski, *Der Welfenschatz...*, Frankfurt am Main, 1930, pp. 73–74, 142–144, pls. 56–58, mentioned with no. 23

Poul Nørlund, "An Early Group of Enamelled Reliquaries," *Acta Archaeologica*, IV, fasc. I, Copenhagen, 1933, fig. 14

Joseph Braun, *Die Reliquiare*, Freiburg i. B., 1940, pp. 151–152

William M. Milliken, "A Danish Champlevé Enamel," *The Bulletin of the Cleveland Museum of Art*, XXXVI, no. 6, part I, 1949 (June), pp. 101 ff.

Lucia Bertolini and Mario Bucci, *Mostra d'arte Sacra*, Lucca, 1957, no. 15 (Lucca casket)

Erich Steingräber, "Email," Otto Schmitt, *Reallexikon zur Deutschen Kunstgeschichte*, IV, Stuttgart, 1958, clm. 28

Exhibition of Romanesque Art (catalog), Manchester City Art Gallery, 1959, no. 115, fig. 11 (Sir Harold Wernher's casket)

40 St. Mark the Evangelist

ACC. NO. 17.190.36

J. O. Westwood, *A Descriptive Catalogue of the Fictile Ivories in the South Kensington Museum*, London, 1876, p. 401

Adolph Goldschmidt, *Die Elfenbeinskulpturen aus der Romanischen Zeit*, Berlin, 1919–1926, II, no. 45, pl. XIV; IV, no. 103, pl. XXXVI

Exhibition:

Spanish Medieval Art: loan exhibition in honor of Dr. Walter W. S. Cook, The Cloisters, New York, 1954–1955, no. 27

41 Three Clerics

ACC. NO. 47.101.22

Louise Lefrançois-Pillion, "Le portail roman de la cathédrale de Reims," *Gazette des Beaux-Arts* (1904), pp. 177–199

Louise Lefrançois-Pillion, *Les sculpteurs de Reims*, Paris, 1928, pp. 8–10

Willibald Sauerländer, "Beiträge zur Geschichte der frühgotischen Skulptur," *Zeitschrift für Kunstgeschichte*, XIX (1956), p. 29, no. 30

James J. Rorimer, *The Cloisters*, New York: Metropolitan Museum of Art, 1963, p. 48

Exhibition:

Arts of the Middle Ages: a loan exhibition, Boston Museum of Fine Arts, Boston, 1940, no. 170

42 Elder of the Apocalypse

ACC. NO. 17.190.220

Collection G. Hoentschel (catalog), introduction et notices de André Pérate, Paris, 1911, Les ivoires..., no. 16, pl. XIV

Adolph Goldschmidt, *Die Elfenbeinskulpturen aus der Romanischen Zeit*, IV, Berlin, 1926, no. 37, and nos. 36, 38, 39, p. 16, pl. XI

Joseph Breck and Meyrick Rogers, *The Pierpont Morgan Wing*, 2nd ed., New York: Metropolitan Museum of Art, 1929, p. 50, fig. 27

Hanns Swarzenski, *Monuments of Romanesque Art*, London, 1953, no. 67, fig. 154 (the Elder in the British Museum)

Exhibition:

Treasures from Medieval France, Cleveland Museum of Art, Cleveland, 1967 (by William D. Wixom), nos. II–3, II–2 (the Elder at Saint-Omer)

43 Angel

ACC. NO. 47.101.16

Victor Terret, *La sculpture bourguignonne...*, II, Autun, 1925, p. 50, pl. XLVIII

H. L. Hamann, "Das Lazarusgrab in Autun," *Marburger Jahrbuch für Kunstwissenschaft*, VIII–IX, 1936, pp. 182 ff. (p. 194 quotes text of an "inquest" of 1482, describing the portal)

Denise Jalabert, "L'Eve de la Cathédrale d'Autun," *Gazette des Beaux-Arts*, Sixth Series, XXXV, 1949, part I, pp. 246 ff.

Margaret B. Freeman, "A Romanesque Virgin from Autun," *Metropolitan Museum of Art Bulletin*, n.s., VIII (1949), pp. 115 ff., ill. p. 116

Denis Grivot and George Zarnecki, *Gislebertus, sculpteur d'Autun*, Paris, 1960, pp. 28, 138, pl. VII

Exhibitions:

Arts of the Middle Ages, a loan exhibition, Boston Museum of Fine Arts, Boston, 1940, no. 169

Treasures from Medieval France, The Cleveland Museum of Art, Cleveland, 1967 (by William D. Wixom), no. III–10

44 Massacre of the Innocents

ACC. NO. 17.190.444

Tancred Borenius, "Enamels from the Sigmaringen Collection," *International Studio*, XCI (1928), pp. 28–29

Tancred Borenius, "Two Mosan Enamel Plaques," *Burlington Magazine*, LIV (1929), pp. 93–94 (similar plaques)

45 Figure of Christ Crucified

ACC. NO. 17.190.209

Collection G. Hoentschel (catalog), introduction et notices de André Pérate, Paris, 1911, Les ivoires..., no. I, pl. I

Hanns Swarzenski, *Monuments of Romanesque Art*, London, 1953, nos. 18, 22, 23, 165, figs. 42, 50, 51, 363

Hans Jantzen, *Ottonische Kunst*, Munich, 1947, figs. 106, 107, 120–121, 135

Paul Thoby, *Le crucifix des origines au Concile de Trente*, Nantes, 1957, pp. 95 ff., nos. 37, 75, 144, 145; pls. XVII, XXXII, LXIV

Hermann Schnitzler, *Rheinische Schatzkammer*, Düsseldorf, 1957, nos. 11, 28, 32, 35; figs. 34, 69, 92, 106, 107

46 Head of King David

ACC. NO. 38.180

Dom Bernard de Montfaucon, *Les monumens de la monarchie françoise*, I, Paris, 1729, pl. 8

Wilhelm Vöge, *Die Anfänge des Monumentalen Stiles im Mittelalter*, Strassburg, 1894, p. 33, figs. 10, 10–A

Emile Mâle, "Le Portail Sainte-Anne à Notre-Dame de Paris," *Revue de l'Art Ancien et Moderne* (1897)

Robert De Lasteyrie, *Etudes sur la sculpture française au Moyen-Age*, Paris, 1902, pp. 36 ff.

Marcel Aubert, *Notre-Dame de Paris,* Paris, 1920, pp. 11-13

Marcel Aubert, *Notre-Dame de Paris; architecture et sculpture,* Paris, 1928

André Rostand, "Notes et documents. La documentation iconographique des monuments de la Monarchie française de Bernard de Montfaucon," *Bulletin de la Société de l'Histoire de l'art français* (1932), pp. 104-149

James J. Rorimer, "A Twelfth-Century Head of King David from Notre-Dame," *Metropolitan Museum of Art Bulletin,* XXXV (1940), pp. 17-19, ill.

James J. Rorimer, "Forgeries of Medieval Stone Sculpture," *Gazette des Beaux-Arts,* XXVI (1944), pp. 195-210, fig. 10

Jacques Vandier, "Têtes de statues-colonnes du portail occidental de Saint-Denis," *Bulletin Monumental,* CIII (1945), p. 247, f.n. 2

James J. Rorimer and William H. Forsyth, "The Medieval Galleries," *Metropolitan Museum of Art Bulletin,* n.s., XII (1954), pp. 128, 130

Willibald Sauerländer, "Die Marienkrönungsportale von Senlis und Mantes," *Wallraf-Richartz-Jahrbuch,* XX (1958), pp. 126-127, ill.

Louis Grodecki, "La première sculpture gothique...," *Bulletin Monumental,* CXVII (1959), pp. 279, 282 ill.

Yves Bottineau, *Notre-Dame de Paris et la Sainte-Chapelle,* Paris, 1966, p. 34

Exhibitions:
Sculpture Portraits; A special exhibition of heads in sculpture from the Museum collection, The Metropolitan Museum of Art, New York, 1930 (cat. by Lucien Demotte), no. 9, pl. 9

Treasures from Medieval France, The Cleveland Museum of Art, Cleveland, 1967 (cat. by William D. Wixom), no. III-25 ill.

The Renaissance of the Twelfth Century, Rhode Island School of Design, Providence, 1969 (cat. text by Stephen K. Scher), no. 55

47 Moses

ACC. NO. 65.268

Pennsylvania Museum Bulletin (March 1931)—illustrated on cover

Werner Goldschmidt, "The West Portal of San Vicente at Avila," *Burlington Magazine,* LXXI (1937), pp. 110-123, ill.

Manuel Chamoso Lamas, "El coro de la Catedral de Santiago," *Cuadernos de estudios Gallegos,* V-VI (1950-1951), pp. 189 ff.

Jesus Carro García, "La imagen sedente del apostol en la Catedral de Santiago," *Cuadernos de estudios Gallegos,* V-VI (1950-1951), p. 198

José Manuel Pita Andrada, "Una escultura del estilo de Maestro Mateo," *Cuadernos de estudios Gallegos,* VI (1951), pp. 389 ff. (Moses)

Exhibition:
Pennsylvania Museum of Art, Philadelphia (on loan from Raymond Pitcairn, 1931-1964)

48 Acrobat

ACC. NO. 47.101.25

Fiske Kimball, "The Display Collection of the Art of the Middle Ages," *Pennsylvania Museum Bulletin,* XXVI (1930-1931), p. 4 pl. II (ill. in gallery view)

Sale catalog: *Joseph Brummer Collection,* Parke-Bernet Galleries, New York, April 22, 1949, no. 562 (fragment from the same capital: David, as musician, Wellesley College, Art Museum)

Walter Cahn, "Romanesque Sculpture in American Collections. Part III, New England University Museums", *Gesta,* VIII (1969), p. 57, fig. 7 (Wellesley College fragment)

Exhibition:
The Renaissance of the Twelfth Century, Rhode Island School of Design, Providence, R.I., 1969 (cat. text by Stephen K. Scher), no. 48 (no. 47 is the other half of the same capital from Wellesley College; Jean Pressouyre has recognized that the two fragments came from the same capital)

49 The Pentecost

ACC. NO. 65.105

Jules Helbig, *La sculpture et les arts plastiques au pays de Liège et sur les bords de la Meuse,* Bruges, 1890, pp. 54-58, 62

Otto von Falke and Heinrich Frauberger, *Deutsche Schmelzarbeiten des Mittelalters...,* Frankfurt am Main, 1904, pp. 63-87

H. P. Mitchell, "Some Enamels of the School of Godefroid de Claire," *Burlington Magazine,* XXXIV (1919), pp. 85-92, 165-171; XXXV (1919), pp. 34-40, 92-102, 217-221; XXXVI (1920), pp. 18-27, 128-134; XXXVII (1920), pp. 11-18

Suzanne Collon-Gevaert, *Histoire des arts du métal en Belgique,* Brussels, 1951, (text) pp. 158-161, 170-173, 187; II (plates), pl. 27 (Cluny retable)

Hubert Landais, "Essai de groupement de quelques émaux autour de Godefroid de Huy," *L'Art Mosan,* ed. by Pierre Francastel, Paris, 1952, pp. 139-145

Jacques Stiennon, "Du lectionnaire de Saint-Trond aux Evangiles d'Averbode," *Scriptorium,* VII (1953), pp. 37-50

Hanns Swarzenski, *Monuments of Romanesque Art,* London, 1953, no. 401

Meyer Shapiro, "The Parma Ildefonsus, a Romanesque Illuminated Manuscript from Cluny...," *Monographs on Archaeology and Fine Arts* (sponsored by the Archaeological Institute of America), XI (1964)

Thomas P. F. Hoving, "Medieval Art and The Cloisters," *Metropolitan Museum of Art Bulletin,* n.s., XXIV (1965), pp. 70-71 ill.

Peter Lasco, "The Pentecost Panel and Godefroid de Claire," *The Connoisseur Year Book* (1966), pp. 45-51 ill.

William H. Forsyth, "Around Godefroid de Claire", *Metropolitan Museum of Art Bulletin,* n.s., XXIV (1966), pp. 306-314 ill.

Exhibition:
Romanesque Art 1050-1200 (catalog), Manchester City Art Gallery, 1959, p. 43, no. 100

GOTHIC ART

50 Entombment of Christ and the Three Marys at the Sepulchre

ACC. NO. 39.82

André Rhein, "Notre-Dame de Mantes," *Congrès Archéologique de France...,* Paris, 1919, 1920, pp. 223 ff., ill. opp. p. 224

Alfred Scharf, "Eine französische Grablegung des 12. Jahrhunderts," *Cicerone,* XXI (1929), pp. 477-478, ill.

Marcel Aubert, *French Sculpture at the Beginning of the Gothic Period, 1140-1225,* Florence, New York, ca. 1929, pp. 5, 17-18, 20, 21 ff.

Paul Muratov, *La sculpture gothique,* Paris, 1931, p. 28, pl. XIII

James J. Rorimer, "A Late Twelfth-Century Lintel," *Metropolitan Museum of Art Bulletin,* n.s., I (1943), pp. 249 ff., ill.

51 Minnekästchen

ACC. NO. 50.141

Sale catalogue: *Lorenz Gedon Collection,* Munich, 1884, p. 109, no. 1088

Jacob von Falke, *Mittelalterliches Holzmobiliar,* Vienna, 1894, p. 10, pl. XXVII, no. 1

Otto von Falke, *Deutsche Möbel des Mittelalters und der Renaissance,* Stuttgart, 1924, p. 34

Heinrich Kohlhaussen, "Rheinische Minnekästchen des Mittelalters," *Jahrbuch der Preussischen Kunstsammlungen,* XLVI (1925), p. 227, f.n. 3, fig. 20

Heinrich Kohlhaussen, *Minnekästchen im Mittelalter,* Berlin, 1928, p. 76, no. 31

Dora Landau, "Forthcoming Sales," *Burlington Magazine,* LVII (1930), p. 39

Sale catalog: *Albert Figdor Collection,* Vienna and Berlin, 1930, Part I, V, no. 305

Heinrich Kohlhaussen, "Die Minne in der deutschen Kunst des Mittelalters," *Zeitschrift des deutschen Vereins für Kunstwissenschaft,* IX, issue 3-4, Berlin, 1942, pp. 147-148, fig. 2

Kurt Martin, Introduction to *Minnesänger,* II, Baden-Baden, 1964, p. 24, fig. 25, cf. I, pls. 11-12

Exhibitions:
Mittelalterliches Holzmobiliar, K.K. Österreichisches Museum für Kunst und Industrie, Vienna, 1892-1893, no. 132

52 Seated Virgin and Child

ACC. NO. 17.190.181

Sale catalogue: *Charles Stein Collection,* Galerie Georges Petit, Paris, 1886, p. 8, no. 22, pl. I

Sale catalogue: *Ernest Odiot Collection,* Hôtel Drouot, Paris, 1889, pp. 34, 36, ill.

Collection G. Hoentschel (catalog), introduction et notices de André Pératé, Paris, 1911, Les Ivoires... no. 22, pl. XIX

Raymond Koechlin, *Les ivoires gothiques français,* Paris, 1924, II, p. 34, no. 76

Joseph Breck and Meyric Rogers, *The Pierpont Morgan Wing: a handbook,* New York: The Metropolitan Museum of Art, 2nd ed., 1929, p. 113, fig. 63

53 Châsse

ACC. NO. 17.190.523

Ernest Rupin, *L'Oeuvre de Limoges,* Paris, 1890, p. 423

Frédéric Spitzer Collection (catalog), I, Paris, 1890-1892, no. 20, p. 103, pl. VIII

J. J. Marquet de Vasselot, "Les émaux limousins à fond vermiculé," *Revue archéologique,* VI (1905), pp. 15-18, 231-245, 418-431

Collection G. Hoentschel (catalog), introduction et notices de André Pératé, Paris, 1911, Les émaux du XII au XV siècle, no. 48, pl. XXIII

William H. Forsyth, "Medieval Enamels in a New Installation," *Metropolitan Museum of Art Bulletin,* n.s., IV (1946), p. 238

Marie-Madeleine S. Gauthier, "Les décors vermiculés dans les émaux champlevés limousins et méridionaux," *Cahiers de Civilisation médiévale,* I, 3, 1958, pp. 349-369

Marie-Madeleine S. Gauthier, "Une châsse limousine du dernier quart du XIIe siècle: Thèmes iconographiques, composition et essai de chronologie," *Mélanges offerts à René Crozet,* Poitiers, 1966, pp. 937-951, esp. p. 946

256

Exhibitions:
The Pierpont Morgan Treasures, Wadsworth Atheneum, Hartford, 1960, p. 9, no. 12

54 Lion Aquamanile

ACC. NO. 47.101.52

Carolus Dufresne du Cange, *Glossarium mediae et infime latinitatis*, I, Paris, 1840, s.v. "Aquamanile," p. 350
Otto von Falke and Erich Meyer, *Bronzegeräte des Mittelalters*, I, Berlin, 1935, pp. 60–61, nos. 227 ab, 329, 343–345
Erich Meyer, "Romanische Bronzen und ihre islamischen Vorbilder," *Aus der Welt der islamischen Kunst, Festschrift für Ernst Kühnel*, Berlin, 1959, pp. 317 ff.
Thomas P. F. Hoving and James J. Rorimer, *A Medieval Treasury, Calendar for 1966*, New York: The Metropolitan Museum of Art, 1965, no. 35

Islamic objects serving as prototypes for the aquamanilia could have reached western Europe by trade or they could have been brought back by crusaders, or sent by members of the royal Frankish Courts established in lands of the Near East (Syria, Palestine, and Cyprus) liberated by the crusaders from the "infidels." Thus the royal house of Cyprus was established by a cadet branch of the Lusignans of Poitou, whose family coat-of-arms appears on the late thirteenth century mirror back (number 67).
A recent theory suggests that prototypes for aquamanilia may originate farther east, in Asia, or even China. These might have reached the West through Mongolian tribes, sometimes miscalled "Tartars", which invaded the southern plains of ancient Russia. This theory should be treated with caution. Mongols did not invade Russia until 1238, while aquamanilia were already made in western Europe in the twelfth century. The isolated animal-shaped aquamanilia found in Russia could have been imported either from the Near East or from the West, or they could have been cast by Russians in imitation of such imports.

55 Aquamanile

ACC. NO. 47.101.53

Frédéric Spitzer, *La Collection Spitzer; Antiquité, Moyen-âge, Renaissance* (catalog), IV, Paris, 1890–1892, p. 196, p. II, fig. 10
Sale catalog: *Sir Thomas Gibson Carmichael Collection*, Christie, Manson and Woods, London, May 12, 1902, p. 21, no. 58
Heinrich Reifferscheid, "Über figürliche Giessgefässe des Mittelalters," *Mitteilungen aus dem Germanischen Nationalmuseum*, Nuremberg, 1912, pp. 1–93, cf. p. 62, fig. 36
Sale catalog: *Sir Samuel Montagu Swaythling, 1st Baron, Catalogue of the Collection...*, Christie, Manson and Woods, London, May 8, 1924, p. 13, no. 91
Otto von Falke and Erich Meyer, *Bronzegeräte des Mittelalters*, I, Berlin, 1935, cf. fig. 466
Dorothy G. Shepherd, "Two Silver Rhyta," *The Bulletin of the Cleveland Museum of Art* (October 1966), pp. 289 ff., figs. 6 and 7

Exhibition:
Exhibition of Brass, Rhode Island School of Design, Providence, 1941

56 Turret Laver

ACC. NO. 47.101.56 ab

Catalogue des peintures anciènnes, Strasbourg: Edition des Musées de la Ville, 1938, fig. 2 (painting by the Strasbourg Master)
James J. Rorimer, "A Treasury at The Cloisters," *Metropolitan Museum of Art Bulletin*, n.s., VI (May 1948), p. 253 ill.

Exhibition:
Arts of the Middle Ages, Boston Museum of Fine Arts, Boston, 1940, no. 294

57 Falconer Aquamanile

ACC. NO. 47.101.55

Otto von Falke and Erich Meyer, *Bronzegeräte des Mittelalters*, I, Berlin, 1935, pp. 43–47
James J. Rorimer, "A Treasury at The Cloisters," *Metropolitan Museum of Art Bulletin*, n.s., VI (May 1948), p. 253
George Szabó, "The Falconer Aquamanile in The Cloisters Collection," Unpublished manuscript, New York, 1961

Exhibitions:
The Horse: Its Significance in Art, Fogg Art Museum, Cambridge, 1938, no. 22
Arts of the Middle Ages, Boston Museum of Fine Arts, Boston, 1940, no. 292

58 Pyx

ACC. NO. 32.100.282

Ernest Rupin, *L'Oeuvre de Limoges*, Paris, 1890, pp. 201–222

59 Altar Cruet

ACC. NO. 47.101.39

J. B. Waring, *Art Treasures in the United Kingdom*, London, 1848, Section on Vitreous art, p. 26, pl. VIII, no. 2
Ernest Rupin, *L'Oeuvre de Limoges*, Paris, 1890, p. 529, fig. 593 (another cruet)
Philip Nelson, "Limoges Enamel Altar-Cruets of the 13th Century," *Antiquaries Journal*, XVIII (1938), pp. 49–54, pl. XXI
James J. Rorimer, *The Cloisters*, New York: Metropolitan Museum of Art, 1963, p. 142, fig. 70

Exhibition:
Manchester Art Treasure Exhibition, Manchester City Art Gallery, Manchester, 1857

60 Tabernacle

ACC. NO. 41.100.185

George and Florence Blumenthal Collection (catalog), comp. by Stella Rubinstein-Bloch, III, 1926, pl. XIV (right)
J. J. Marquet de Vasselot, "Une Châsse limousine du XIIᵉ siècle au Musée du Louvre," *Monuments Piot*, XXXVI (1938), p. 123 ff.

Exhibition:
Masterpieces in the Collection of George Blumenthal: A Special Exhibition, The Metropolitan Museum of Art, New York, 1943–1944, pl. 33

Besides the six examples listed by Marquet de Vasselot, a smaller (about six inches high) but similar square piece was exhibited in 1961 in the Santiago de Compostella section of the great Romanesque Exhibition in Barcelona.

61 Processional or Altar Cross

ACC. NO. 17.190.332 Unpublished

Comparable crosses:
Paul Thoby, *Les Croix Limousines de la fin du XIIᵉ au début du XIVᵉ siècle*, Paris, 1953, pp. 47 ff., pls. XXXI–XXXIII

Paul Clemen, *Die Kunstdenkmäler der Rheinprovinz*, XV, part II, Düsseldorf, 1936, p. 281, fig. 186 (Pfalzel cross)

62 Censer

ACC. NO. 50.7.3 a, b

Ernest Rupin, *L'Oeuvre de Limoges*, Paris, 1890, pp. 531–541

63 Gemellion

ACC. NO. 47.101.40

Jacques Paul Migne, *Patrologia Latina*, LXXVIII, 1844–1855, cols. 1121–1274 (for Ordo Romanus)
Ernest Rupin, *L'Oeuvre de Limoges*, Paris, 1890, pp. 543–550
Alexandre de Laborde, *La Bible moralisée illustrée*, Paris, 1911–1927, II, pl. 265; III, pls. 440 and 528
Willy Burger, *Abendländische Schmelzarbeiten*, Berlin, 1930, p. 123, cf. no. 73
Joseph Braun, *Das christliche Altargerät*, Munich, 1932, p. 550
Marvin C. Ross, "An Enamelled Gemellion of Limoges," *Bulletin of the Fogg Art Museum*, II (November 1932), pp. 9–13, p. 10, fig. 1, and p. 11, fig. 2 (on loan to the Fogg Museum from Arthur Sachs)
Hugo Buchthal, "A Note on Islamic Enameled Metalwork and its Influences in the Latin West," *Ars Islamica*, XI–XII (1946), pp. 195–198
J. J. Marquet de Vasselot, "Les gémellions limousins du XIIIᵉ siècle," Paris, 1952, extract from: *Mémoires de la Société Nationale des Antiquaires de France*, LXXXII

64 Virgin from Strasbourg Cathedral

ACC. NO. 47.101.11

Franz X. Kraus, *Kunst und Alterthum in Elsass-Lothringen*, Strassburg, 1876–1892, 4 vols., I: Unter-Elsass, pp. 347–349, 442, fig. 145
Joseph Knauth, "Der Lettner des Münsters...," *Die Denkmalpflege*, no. 4 (October 15, 1902), pp. 102–105
Sale catalog: *J. H. Fitzhenry Collection*, Christie, Manson and Woods, London, November 18, 1913, no. 148
Otto Schmitt, *Gotische Skulpturen des Strassburger Münsters*, Frankfurt am Main, 1924, II, p. IX; I, pls. 42–53
Erwin Panofsky, *Die Deutsche Plastik des elften bis dreizehnten Jahrhunderts*, München, 1924, pls. 117–118
Otto Schmitt, "Ein unvollendetes Strassburger Münsterbüchlein...," *Elsass-Lothringisches Jahrbuch*, IX (1930), pp. 228–253
Hans Haug, "Les œuvres de miséricorde du jubé de la cathédrale de Strasbourg," *Archives Alsaciennes d'histoire de l'art*, Xᵉ année (reprint), (1931), pp. 99–122, ill. 107
La Cathedrale de Strasbourg ... par un groupe d'historiens alsaciens, Première partie (1015–1240), (Etudes sur l'art décorative en Alsace, Strasbourg, 1932), pl. XI
Hans Haug, *Le musée de l'œuvre Notre-Dame à Strasbourg...*, 1939, pp. 18, 19, 20
Otto Schmitt, "Zwei verlorene Muttergottesstatuen des 13. Jahrhunderts vom Strassburger Münster," *Archiv für Elsässische Kirchengeschichte* (reprint), (1941), pp. 1–24, fig. 3
James J. Rorimer, "The Virgin from Strasbourg Cathedral," *Metropolitan Museum of Art Bulletin*, n.s., VII (April 1949), pp. 220–227, ill.
Hans Reinhardt, "Le jubé de la cathédrale de Strasbourg," *Bulletin de la Société des Amis de la*

257

Cathédrale de Strasbourg, 2ᵉ série, no.6, Strasbourg (1951), pp.18 ff.
Ewald M.Vetter, *Maria im Rosenhag*, Düsseldorf, 1956, p.13 ill.
Hans Haug; Robert Will; Theodore Rieger; Victor Beyer; Ahne Paul, *La Cathédrale de Strasbourg*, Strasbourg, 1957, pp.79, 93, f.n.6, pl.68, fig.97
Barbara Chabrowe, "Iconography of the Strasbourg Cathedral Choir Screen," *Gesta*, VI (January 1967)

65 Crozier Head

ACC.NO.17.190.278
Georges Hoentschel Collection (catalog), introduction et notices de André Pérаté, Paris, 1911, Les Ivoires…, no.32, pl.XXV
Raymond Koechlin, *Les Ivoires gothiques*, II, Paris, 1924, no.753

66 Angel

ACC.NO.52.33.2
James J.Rorimer, "Two Gothic Angels for The Cloisters," *Metropolitan Museum of Art Bulletin*, n.s., XI (1952), pp.105 ff.
Richard H.Randall, Jr., "Thirteenth Century Altar Angels," *Record of the Art Museum*, Princeton University, XVIII, no.1 (1959), pp.2–16
James J.Rorimer, *The Cloisters*, New York: Metropolitan Museum of Art, 1963, p.155
Françoise Baron, "Les Anges au sourire d'Arras," *Connaissance des Arts* (December 1966)

67 Mirror Back

ACC.NO.50.7.4
Père Anselme, *Histoire généalogique et chronologique de la Maison Royale de France*, III, Paris, 1726, pp.78–81
Vera K.Ostoia, "The Lusignan Mirror," *Metropolitan Museum of Art Bulletin*, n.s., XVIII (Summer 1959), pp.18–27
Lilian M.C.Randall, "A Medieval Slander," *The Art Bulletin*, XLII (1960), pp.25 ff., esp. p.33

68 Two Jugs

ACC.NO.52.46.7 and 52.46.4 Unpublished

For the best books on the subject see:
W.B.Honey, *The Art of the Potter*, London, 1946, figs.9-A and 9-B
W.B.Honey, *European Ceramic Art*, London, 1949, I, pl.1; II, p.199

69 Virgin and Child

ACC.NO.41.190.279
George and Florence Blumenthal Collection, II (catalog), comp. by Stella Rubinstein-Bloch, Paris, 1926, pl.I
William H.Forsyth, "A Medieval Statue of the Virgin and Child," *Metropolitan Museum of Art Bulletin*, n.s., III (November 1944), pp.85–88

Exhibitions:
Masterpieces in the Collection of George Blumenthal, A special exhibition, Metropolitan Museum of Art, New York, 1943–1944

70 Book Cover

ACC.NO.17.190.856
Sale catalog: *Antoine J.Essingh, Catalogue illustré de sa collection…*, Cologne, 1865, no.852

Sale catalog: *Christopher R.Ruhl, Catalogue de sa collection de tableaux et objets d'art*, Cologne, 1876, no.320
Alexander Schnutgen, "Elfenbeinrelief in Metallfassung als Buchdeckel," *Zeitschrift für christliche Kunst*, IV (1891), clm.331–334, ill.
Raymond Koechlin, *Les ivoires gothiques français*, II, 1924, no.555 bis

71 Folding Tabernacle

17.190.211
Marcou, "L'exposition retrospective de l'art français," *Gazette des Beaux-Arts*, 3ᵉ période, XXIII (1900), pp.487, 489
Baron Albert Oppenheim Collection (catalog), comp. by Emile Molinier, Paris, 1904, p.31, no.70, pl.LIII
Raymond Koechlin, *Les ivoires gothiques français*, II, Paris, 1924, no.118
Joseph Breck and Meyric Rogers, *The Pierpont Morgan Wing: a handbook*, 2nd ed., New York: Metropolitan Museum of Art, 1929, p.108, fig.61
James J.Rorimer, and William H.Forsyth, "The Medieval Galleries," *Metropolitan Museum of Art Bulletin*, n.s., XII (1954), p.143, ill.
Thomas P.F.Hoving, *A Medieval Treasury, Calendar for 1966*, New York: Metropolitan Museum of Art, 1965, no.41

Exhibitions:
L'exposition retrospective de l'art français, Exposition universelle, Paris, 1900, no.116
Kunsthistorische Ausstellung, Düsseldorf, 1902, no.1208, fig.79
The Pierpont Morgan Treasures, Wadsworth Atheneum, Hartford, 1960, no.15

72 Eight Scenes from the Life and Passion of Christ

ACC.NOS.58.139, 60.148.1–5, 61.31, 64.27.19
Jules Guiffrey, *Inventaires de Jean Duc de Berry*, II, Paris, 1896, p.163, item 1312
Adolph Fäh, *St.Gall (Switzerland) Industrie-und Gewerbemuseum. Textile Vorbilder aus der Sammlung Iklé in St.Gallen*, Kunststickereien, Zürich, 1908, pl.3, p.11
Alejandro Soler y March, "El frontal bordado de Manresa," *Museum*, VI (1918), p.411 ff.
Louis de Farcy, *La Broderie du XIᵉ siècle jusqu'à nos jours…*, II, Supplement, Angers, 1919, p.151, pl.187
Sale catalog: *Marczell von Nemes Collection* (Budapest and Munich), Frederick Müller and Co., Amsterdam, 1928, p.26, no.74a, pl.74
M.Salmi, "Il paliotto di Manresa e l'Opus Florentinum," *Bolletino d'Arte*, X, series II (1930), pp.385 ff.
Gertrude Underhill, "Old Embroideries in the Museum," *The Bulletin of the Cleveland Museum of Art*, XVII (1930), pp.151–154
Sale Catalog: *Marczell von Nemes Collection* (Budapest and Hungary), Munich, 1931, p.89, no.271, pl.58 (Christ among the Doctors)
Betty Kurth, "Florentiner Trecento-Stickereien," *Pantheon*, VIII (1931), p.455 ff.
Maria Hague, "Notes on some Fourteenth-Century Embroideries in Judge Untermyer Collection," *Bulletin of the Needle and Bobbin Club*, XVIII, no.1 (1933), pp.39 ff.
Betty Kurth, "Genres of European Pictorial Embroidery in the Middle Ages," *Ciba Review*, no.50 (1945), p.1816

Sale catalog: *Irwin Untermyer Collection*, Parke-Bernet Galleries, New York, 1958, no.45 (Baptism of Christ)
Sale catalog: *Otto Bernheimer Collection* (Munich), Weinmüller, Munich, 1960, no.385, p.40
Antonio Santangelo, *Tessuti d'Arte Italiani*, Milano, 1959, p.19
Adolph Salvatore Cavallo, "Newly Discovered Trecento Orphrey from Florence," *Burlington Magazine* (December 1960), p.505
Ruth Grönwoldt, "Florentiner Stickereien in den Inventaren des Herzogs von Berry und der Herzöge von Burgund," *Mitteilungen des Kunsthistorischen Institutes in Florenz*, XX, no.I (May 1961), pp.33 ff.

Exhibition:
The Cloisters. Medieval Art from Private Collections: a Special Exhibition, The Metropolitan Museum of Art, New York, October, 1968–January, 1969 (cat. by Carmen Gomez-Moreno), no.202 (Adoration of Magi, Robert Lehman Collection)
ACC.NO.58.139 (Baptism of Christ), Ex colls.: Herbert L.Griggs, New York; Irwin Untermyer, New York
ACC.NO.61.31 (Christ among the Doctors), Ex colls.: Léopold Iklé, St.Gall, Switzerland; Marczell von Nemes, Budapest and Munich; Otto Bernheimer, Munich
ACC.NO.64.27.18 (Flagellation of Christ), Ex colls.: Jean Duc de Berry (?); Léopold Iklé, St.Gall, Switzerland; Marczell von Nemes, Budapest and Munich; Charles F.Iklé, New York

73 Seated King

ACC.NO.26.63.34
Joseph Breck, "New Acquisitions at The Cloisters," *Metropolitan Museum of Art Bulletin* XXI (1926), p.119
William H.Forsyth, "A Group of Fourteenth-Century Mosan Sculptures," *Metropolitan Museum of Art Journal*, I (1968), pp.41 ff., esp. p.50, fig.18

Exhibitions:
Religious Art of the Western World, Dallas Museum of Fine Arts, Dallas, 1958, no.46, ill. p.9

74 Mirror Case

ACC.NO.41.100.160
Frédéric Spitzer, *La Collection Spitzer; Antiquité, Moyen-âge, Renaissance* (catalog), I, 1890–1892, no.69, pl.XIX
Wilhelm von Bode, *Die Sammlung Oscar Hainauer*, Berlin, 1897, no.131, ill.p.83
Raymond Koechlin, *Les ivoires gothiques français*, Paris, 1924, I, p.384, note 4; p.385, notes 1 and 6; II, p.378, no.1032
George and Florence Blumenthal Collection (catalog), comp. by Stella Rubinstein-Bloch, III, 1926, pl.V
James J.Rorimer and Thomas P.F.Hoving, *A Medieval Treasury, Calendar for 1966*, New York: The Metropolitan Museum of Art, 1965, no.42

Exhibitions:
Ausstellung von Kunstwerken des Mittelalters und der Renaissance, Berlin, 1898, pl.XIV, fig.2
Seventh Loan Exhibition: French Gothic Art, Detroit Institute of Arts, Detroit, 1928, no.65, ill.
Arts of the Middle Ages, Boston Museum of Fine Arts, Boston, 1940, no.139, pl.LIII

75 Statuette of the Standing Virgin and Child

ACC. NO. 17.190.170

Raymond Koechlin, *Les ivoires gothiques français*, Paris, 1924, II (text), p.244, no.660, pl. CIX, p.252, no.699

76 Marie de France

ACC. NO. 41.100.132

Michel Félibien, *Histoire de l'abbaye royale de Saint-Denys en France*, Paris, 1706, pp.529, 559
Bernard de Montfaucon, *Les monumens de la monarchie françoise*, II, Paris, 1730, pl.49, no.6, p.287
A. Vidier, "Un tombier liégeois à Paris au XIVe siècle," *Mémoires de la Société de Paris et de l'Ile-de-France*, XXX, 1903
Jean Despois, *Le vandalisme révolutionnaire*, Paris, 1868, p.214
Alfred Darcel, "Le moyen-âge et la renaissance au Trocadéro," *Gazette des Beaux-Arts*, XVIII, part I, 1878, p.521
Louis Gonze, ed., *L'art ancien à l'Exposition de 1878*, Paris, 1879, pp.209–210
Henri Bouchot, *Inventaire des dessins exécutés par Roger de Gaignières*, Paris, 1891, I, no.259, no. 2011; II, no.7063
Joseph Breck, "Medieval and Renaissance Decorative Arts and Sculpture," *Metropolitan Museum of Art Bulletin*, V (1910), p.154; XV (1920), pp.182 ff.
Paul Vitry and Gaston Brière, *L'église abbatiale de Saint-Denis*, Paris, 1925, p.151
George and Florence Blumenthal Collection (catalog) II, comp. by Stella Rubinstein-Bloch, Paris, 1926, pl. V
M. Devigne, *La sculpture mosan du XIIe au XVIe siècle*, Paris et Bruxelles, 1932, p.84
William H. Forsyth, "A Head from a Royal Effigy," *Metropolitan Museum of Art Bulletin*, n.s., III (May, 1945), pp.214–219
Pierre Pradel, "Notes sur la vie de Jean de Liège," *L'Art Mosan*, Paris (1953), pp.219 ff.
Pierre Pradel, "Les tombeaux de Charles V," *Bulletin Monumental*, CIX (1951) p.286
Art Treasures of the Metropolitan Museum, New York: Metropolitan Museum of Art, 1952, pp.55, 221, no.45 ill.
Pierre Pradel, "Les tombiers français en angleterre," *Société des Antiquaires de France, Mémoires*, 1955
William H. Forsyth, "A Group of Fourteenth-Century Mosan Sculptures," *Metropolitan Museum of Art Journal*, I (1968), p.56

Exhibition:
Exposition Universelle Internationale, Paris, 1878

77 Standing Virgin and Child

ACC. NO. 30.95.138

A. Venturi, *Storia dell'arte italiana*, IV, Milan, 1906, *La scultura del trecento*, p.478
Phila Calder Nye, "The Davis Madonna at the Metropolitan Museum of Art," *Art in America*, VI (1918), pp.82–87
James J. Rorimer, "The Theodore M. Davis Bequest," *Metropolitan Museum of Art Bulletin*, XXVI (March 1931), pp.24–25

78 Standing Virgin and Child

ACC. NO. 25.120.197

James J. Rorimer, *Ultra-Violet Rays and Their Use in the Examination of Works of Art*, New York, 1931

James J. Rorimer. "The Restoration of Medieval Sculpture," *Metropolitan Museum of Art Studies*, V (1934–1936), p.176, figs.4-A, 4-B
James J. Rorimer, "Forgeries of Medieval Stone Sculpture," *Gazette des Beaux-Arts*, XXVI (1944), pp.195–210, figs.3, 4

79 Seated Virgin of the Annunciation

ACC. NO. 17.190.739

"The Pierpont Morgan Gifts," *Metropolitan Museum of Art Bulletin*, XIII (1918), p.6 ill.
Joseph Breck and Meyric Rogers, *Pierpont Morgan Wing: a Handbook*, New York: Metropolitan Museum of Art, ed.2, 1929, p.129
Francis H. Taylor, "The Archaic Smile: A Commentary on the Arts in Times of Crisis," *Metropolitan Museum of Art Bulletin*, n.s., X (1952), p.229 ill.

80 Angel from the Cathedral of Florence

ACC. NO. 17.190.752

W. Schmarsow, *Festschrift zu Ehren des Kunsthistorischen Instituts in Florenz*, Leipzig, 1897, p.51
Marcel Reymond, "L'antica facciata del Duomo," *L'Arte*, VIII (1905), pp.171 ff.
A. Venturi, *Storia dell'arte italiana*, IV, Milan, 1906, pp.699, 705; VI, Milan, 1908, p.7 (note)
Giovanni Poggi, *Il Duomo di Firenze. Italienische Forschungen, Kunst-Historisches Institut Florenz*, II, Berlin, 1909, p.39, fig.36 (document)
K. Rathe, *Der figurale Schmuck der alten Domfassade in Florenz*, Wien-Leipzig, 1910, pp.98–107
Sale catalog: *Richard von Kaufmann Collection*, 1917, no.275, pl.30
Hans Kaufmann, "Florentiner Domplastik," *Jahrbuch der Preussischen Kunstsammlungen*, LVII (1926), pp.141 ff., 153, 157, fn.1
Georg Troescher, *Die Burgundische Plastik*, Frankfurt am Main, 1940, pp.32, 153, 159, pl. XXIX, figs.79, 80, 82–84 ("adoring" angels)

Kaufmann ascribes several sculptures from the façade to Pietro di Giovanni Tedesco. He points out two center front folds which break in opposite directions at the ground and which he calls the "typical twin folds" of the master. Venturi seems to question some of these attributions and is undecided whether one should not attribute all eight "adoring" angels to Niccoló di Pietro Lamberti who is believed to have carved the kneeling angels on the tympanum over the Porta dei Canonici of the cathedral. One of these angels, kneeling to the left, shows a certain resemblance to the Museum statue. Cavalucci believes that one of the eight "adoring" angels, specifically, that in the Museum is not by Pietro di Giovanni Tedesco but by Niccoló di Pietro Lamberti. Professor Seymour at one time expressed the opinion that two of the eight angels were not by the hand of Pietro di Giovanni Tedesco, and that one of these was the Museum angel. Some scholars find a similarity between the master's work and the sculpture in the choir of the Cologne Cathedral and suggest that the treatment of the folds at the ground is a detail brought from the north, either from northeastern France or northwestern Germany. Georg Troescher compares the Florentine angels to those at Bourges.

81 Reliquary Bust of St. Juliana

ACC. NO. 61.266

C. Crispolti, *Perugia Augusta*, Perugia, 1648, pp.167–168 (inscription on tabernacle)
Serafino Siepi, *Descrizione topologico-istorica della città di Perugia*, II, Perugia, 1882, p.691
Joannes Bollandus and Godefridus Henschenius, *Acta Sanctorum, Februarii*, II, Oarusuus, 1865, pp.868
Il Palazzo del Popolo. L'Antica arte umbra alla mostra di Perugia, Perugia, 1907, p.69
Umberto Gnoli, *L'Arte umbra alla mostra di Perugia*, Bergamo, 1908, pp.59–60 (tabernacle)
Ettore Ricci, *Donna Montesperelli e il reliquario di Sa. Giuliana*, Perugia, 1913, pp.16 ff.
Giovanni Cecchini, *La Galleria Nazionale dell'Umbria* (catalog), Rome, 1932, p.57, no.53
Francesco Santi, *La Galleria nazionale dell'Umbria* (catalog), Rome, 1955, no.762
Pantheon (May 1960), p. XXXVIII, ill., (advertised by Brimo de Laroussilhe)
Thomas P. F. Hoving, "The Face of St. Juliana," *Metropolitan Museum of Art Bulletin*, n.s., XXI (January 1963), pp.173–181

82 Book of Hours of Jeanne D'Evreux, Queen of France

ACC. NO. 54.1.2

Léopold Delisle, "Les Heures dites de Jean Pucelle," *Gazette des Beaux-Arts*, XXIX (1884), pp.108 ff.
Léopold Delisle, *Les Heures dites de Jean Pucelle; Manuscrit de M. le Baron Maurice de Rothschild*, Paris, 1910
Jules M. J. Guiffrey, *Inventaires de Duc de Berry*, Paris, 1894–1896, I, p.223, no.A 850; II, p.31, no.171, p.275, no.1078
Rudolf Blum, "Jean Pucelle et la miniature parisiènne du XIV siècle," *Scriptorium*, III (1949), pp.211–217
Erwin Panofsky, *Early Netherlandish Painting*, New York, 1953, I, pp.29–32, Notes: pp.271, 301, 369, 376; II, pl.3, figs.5, 7
The Hours of Jeanne d'Evreux, Queen of France, at The Cloisters (with introduction by James J. Rorimer), New York: Metropolitan Museum of Art, 1957
R. H. Randall, Jr., "Frog in the Middle," *Metropolitan Museum of Art Bulletin*, n.s., XVI (1958), pp.269 ff.
Emanuel Winternitz, "Bagpipes for the Lord," *Metropolitan Museum of Art Bulletin*, n.s., XVI (1958), pp.276 ff.
S. V. Grancsay, "Medieval Armor in a Prayer Book," *Metropolitan Museum of Art Bulletin*, n.s., XVI (1958), pp.287 ff.
Kathleen Morand, *Jean Pucelle*, Oxford, 1962, pp.13 ff., cat.no.6, pp.41–42, pls. VIII–XI, XXVII-d
James J. Rorimer, *The Cloisters*, New York: Metropolitan Museum of Art, 1963, pp.149–150 ill.

Exhibitions:
Treasures from Medieval France, The Cleveland Museum of Art, Cleveland, 1966–1967, no. V–15
In the Presence of Kings, Metropolitan Museum of Art, New York, 1967, no.10, ill.
La Librairie de Charles V, Bibliothèque Nationale, Paris, 1968, no.133, p.69, ill. pl.13

83 Mary Magdalen Kneeling

ACC. NO. 36.79.3

William H. Forsyth, "Four Fifteenth-Century Sculptures Showing Flemish Influence," *Metropolitan Museum of Art Bulletin*, XXXII (March 1937), pp. 66–69

84 Ostensory

ACC. NO. 53.63.3
Joseph Braun, *Das Christliche Altargerät...*, München, 1932, p. 351
W. F. Volbach, "Oreficeria Sacra," *Settimana d'Arte Sacra per il clero*, Città del Vaticano, I–II (1933–1934), pp. 79 ff. (XIV c. reliquaries)
Sale catalog: *Victor Rothschild Collection*, Sotheby & Co., London, April 1937, p. 85, no. 268, pl. IX
James J. Rorimer, "Acquisitions for The Cloisters," *Metropolitan Museum of Art Bulletin*, n. s., XI (June 1953), p. 279

85 Two-Handled Jar

ACC. NO. 46.85.7
Alfred Pringsheim, *Die Majolikasammlung*, I (text by Otto von Falke), 1914–1923, p. 5, no. 6
Seymour de Ricci, *A Catalogue of Early Italian Maiolica in the Collection of Mortimer L. Schiff*, New York, 1927, no. 7
B[allardini], G[aetano], "La Collezione di ceramiche italiane del Signor Mortimer L. Schiff," *Faenza, Bollettino del Museo delle Ceramiche in Faenza*, XVI (1928), pp. 44–48, fig. 7
C. Louis Avery, "The Mortimer L. Schiff Collection," *Metropolitan Museum of Art Bulletin*, XXXIII (1938), pp. 10–13
Sale Catalog: *Mortimer L. Schiff Collection*, Parke-Bernet Galleries, Inc., New York, May 4, 1946, no. 12

Exhibition:
On loan at the Metropolitan Museum of Art in 1917–1919, and 1937–1941

86 Virgin and Child

ACC. NO. 25.120.208
G.-P. de Frayre, "L'art de l'Alsace reconquise," *Les Arts*, XIII (1916), p. 8 (cf. statue on west façade at Than)
The Cloisters Guide, New York: Metropolitan Museum of Art, 1926, p. 46, fig. 25; 1931, p. 46, fig. 26
James J. Rorimer, *Ultra-Violet Rays and Their Use in the Examination of Works of Art*, New York, 1931

A LATE GOTHIC POSTLUDE

87 Seated Virgin and Child

ACC. NO. 41.100.203
Sale catalog: *T. Schiff collection*, Hôtel Drouot, Paris, March 13–17, 1905, no. 439
George and Florence Blumenthal Collection (catalog), II, comp. by Stella Rubinstein-Bloch, Paris, 1926, pl. II

Exhibitions:
Masterpieces in the Collection of George Blumenthal: A special exhibition, Metropolitan Museum of Art, New York, 1943–44
The International Style, Walters Art Gallery, Baltimore, Maryland, 1962, no. 86, pl. LXXIV

88 St. Christopher

ACC. NO. 17.190.361
Marc Rosenberg, *Der Goldschmiede Merkzeichen*, 2nd ed., Frankfurt am Main, 1911, p. 727, no. 4472
Hans-Friedrich Rosenfeld, *Der Hl. Christophorus... Acta Academiae Aboensis, Humanoria*, X: 3. Abo, 1937
Trésors d'orfèvrerie des églises de Roussillon et du Languedoc méditerranéen, Montpellier; Musée Fabre, 1954, no. 29 (replica of the Metropolitan Museum of Art statuette)
James J. Rorimer and Thomas P. F. Hoving, *A Medieval Treasury, Calendar for 1966*, New York: Metropolitan Museum of Art, 1965, no. 53

Exhibitions:
Treasures from Medieval France, The Cleveland Museum of Art, Cleveland (cat. by William D. Wixom), 1966–1967, no. VI–7

89 Dish

ACC. NO. 56.171.149
Albert Van de Put, "Fifteenth-Century Hispano-Moresque Pottery," *The Burlington Magazine*, III (1903), pp. 36 ff., cf. fig. 7
Albert Van de Put, *Hispano-Moresque Ware of the XV Century*, London, 1904, pls. XVII, XVIII, XX, XXII (plates with bryony design and various Tuscan arms)
Herbert Weissberger, "Hispano-Moresque Treasures in the Hearst Collection," *The Compleat Collector* (September 1943), pp. 14–17, fig. 4 (Van der Goes painting)
M. Gonzáles Martí, "Loza," *Cerámica del Levante Español; siglos medievales*, Barcelona-Madrid, 1944 (passim)

90 Dish

ACC. NO. 56.171.144
Alice Wilson Frothingham, *Lustreware of Spain*, Hispanic Notes and Monographs, New York: The Hispanic Society of America, 1951, p. 163, cf. fig. 126 (plate with "all-over" lion)

91 Deep Dish

ACC. NO. 17.190.127
Alice Wilson Frothingham, *Lustreware of Spain*, Hispanic Notes and Monographs, New York: The Hispanic Society of America, 1951, p. 101, cf. figs. 61–62 (but with coat of arms in center)

92 Albarelo

ACC. NO. 56.171.95
Herbert Weissberger, "Hispano-Moresque Treasures in the Hearst Collection," *The Compleat Collector* (September, 1943), pp. 14–17, fig. 2 ("rim-leaf motif")
Alice Wilson Frothingham, *Lustreware of Spain*, Hispanic Notes and Monographs, New York: The Hispanic Society of America, 1951, cf. fig. 83

93 Pharmacy Jug

ACC. NO. 56.171.84
Manuel Gonzáles Martí, *Cerámica del Levante Español*, I, Barcelona, 1944, p. 245, fig. 314 (cf. jug in Instituto Valencia de Don Juan, Madrid)
Alice Wilson Frothingham, *Lustreware of Spain*, Hispanic Notes and Monographs, New York: The Hispanic Society of America, 1951, p. 186, cf. fig. 152

W. Gordon Tyrwhitt, "Glowing Lustre Ware of Spain," *International Studio*, LXXX (Dec. 1926), cf. ill. p. 47

94 Dish

ACC. NO. 56.171.108
Alice Wilson Frothingham, *Lustreware of Spain*, Hispanic Notes and Monographs, New York: The Hispanic Society of America, 1951, cf. figs. 85–86 (plate with arms of Despujol [?])

95 Dish

ACC. NO. 56.151.104
Albert Van de Put, *Hispano-Moresque Ware of the XV Century*, London, 1904, pp. 72–74 (Buyl family)
Albert Van de Put, *Hispano-Moresque Ware of the Fifteenth Century...*, London, 1911, pp. 17–26 (Buyl family)
R. H. Randall, Jr., "Lusterware of Spain," New York: *Metropolitan Museum of Art Bulletin*, n. s., XV (June, 1957), p. 220

96 Angel of the Annunciation

ACC. NO. 67.236
Leo Planiscig, *Die Venezianischen Bildhauer der Renaissance*, Vienna, 1921, p. 3, ff.
J. W. Prince Liechtenstein, *A Catalogue of Seven Marble Sculptures of the Italian Trecento and Quattrocento, from the Collection of His Highness the Prince of Liechtenstein*, New York, 1954
John Pope-Hennessy, *Catalogue of Italian Sculpture in the Victoria & Albert Museum*, London, 1964, no. 372, ill. fig. 370

97 Courtiers with Roses

ACC. NO. 09.137.2
Henry Bouchot, *L'exposition des primitifs français*, Paris, 1904, pl. XXXIX
"Fifteenth Century Tapestries," *Metropolitan Museum of Art Bulletin*, IV (1909), p. 149, pl. A
Paul Durrieu, *Le Boccace de Munich*, Munich, 1909, pt. I, folio 2 B, ill. (Le Lit de Justice de Vendôme en 1458, the Trial of the Duke of Alençon)
Betty Kurth, "Die Blütezeit der Bildwerkerkunst zu Tournai und der Burgundische Hof," *Jahrbuch der Kunsthistorischen Sammlungen des Allerhöchsten Kaiserhauses*, XXXIV (1918), pp. 53–110
Stella Rubinstein, "Three French Gothic Tapestries Hitherto Known as the 'Baillée des Roses'," *American Journal of Archaeology*, 2nd series, XXII (1918), no. 2
Paul Durrieu, *La miniature Flamande*, Brussels and Paris, 1921, pl. XXXI
G. L. Hunter, "Tapestries in the Metropolitan Museum," *International Studio*, XLV, no. 180 (February 1912), lxxxiii
Betty Kurth, *Gotische Bildteppiche aus Frankreich und Flandern*, Munich, 1923, pp. 10, 13, 14
Pierre Verlet, *Le grand livre de tapisserie*, Lausanne, 1965

98 Mourner

ACC. NO. 16.32.173
André Pératé and Gaston Brière, *Collection Georges Hoentschel* (catalog), Paris, I (1908), p. 4, pl. V
Joseph Breck and Meyric Rogers, *The Pierpont*

Morgan Wing: a handbook, New York: Metropolitan Museum of Art, 2nd. ed., 1929, p. 129
Bella Bessard, "Three Berry Mourners," *Metropolitan Museum Journal,* I (1968), p. 172

99 Crozier Head

ACC. NO. 17.190.590
Gams, *Series episcoporum...,* Ratisbonne, 1873, p. 914
A. Venturi, *Storia dell'arte italiana,* IV, Milan, 1906, figs. 753, 754
Inventario degli oggetti d'arte d'Italia, II, Calabria, 1933, pp. 259–260 ill.
Erich Steingräber, *Der Goldschmied,* München, 1966, p. 73–74, fig. 72

100 Base for a Statuette

ACC. NO. 55.116.2
Rodolphe Kann Collection (catalog), I, Paris, 1907, no. 16
Sale catalog: *Joseph Brummer Collection,* Parke-Bernet Galleries, New York, May 11–14, 1949
Jeffrey M. Hoffeld, "Adam's Two Wives," *Metropolitan Museum of Art Bulletin,* n. s., XXVI (1968), p. 430 ff.

Exhibition:
Arts of the Middle Ages, a loan exhibition, Boston Museum of Fine Arts, Boston, 1940, no. 186

101 Bottle

ACC. NO. 27.185.219
Robert Schmidt, *Die Gläser der Sammlung Mühsam,* II, Berlin, 1926, no. 20, ill. p. 16
Frantz Rademacher, *Die deutschen Gläser des Mittelalters,* Berlin, 1933, p. 55, pl. 4

102 Prunted Beaker

ACC. NO. 27.185.207
Robert Schmidt, *Die Gläser der Sammlung Mühsam,* II, Berlin, 1926, no. 27, pl. 2
Comstock, "The Mühsam collection of glass. Part II," *International Studio,* LXXXVI (January 1927), p. 44
Frantz Rademacher, "Gotische Gläser in den Rheinlanden," *Wallraf-Richartz Jahrbuch,* III–IV (1926–1927), p. 97, cf. fig. 7
Frantz Rademacher, *Die deutschen Gläser des Mittelalters,* Berlin, 1933, pl. 42, pp. 111 ff.

103 The Annunciation

ACC. NO. 56.43 Unpublished

104 St. Lawrence with Pilgrims

ACC. NO. 55.27
Theodor Müller, "Zur Erforschung der Spätgotischen Plastik Tirols," *Veröffentlichungen des Museum Ferdinandeum in Innsbruck,* vol. 20/25, 1940–1945, Innsbruck, 1949, pp. 85–86
Sale catalog: *Baron van Doorn Cassel Collection,* Hôtel Drouot, Paris, April 9, 1954, no. 72, pl. V
Theodor Müller, *Die Bildwerke in Holz, Ton und Stein, von der Mitte des XVI Jahrhunderts,* Kataloge des Bayerischen Nationalmuseums, XIII, Munich, 1959, part 2, p. 80, no. 70
James J. Rorimer, *The Cloisters,* New York: Metropolitan Museum of Art, 1963, p. 126

Exhibition:
Gotik in Tirol, Malerei und Plastik des Mittelalters, Museum Ferdinandeum, Innsbruck, June–September, 1950, p. 54 (Master of Sonnenburg Künigl Altäre)

105 Three Helpers in Need

ACC. NO. 61.86
Justus Bier, *Tilmann Riemenschneider,* II, Augsburg, 1930, pl. 104, p. 197 (Dettwang Altar)
Kurt Gerstenberg, *Tilmann Riemenschneider,* Wien, 1943, p. 163, figs. 101–104 (Dettwang Altar)
Theodor Müller, *Katalog... Die Bildwerke in Holz, Ton und Stein... Bayerisches Nationalmuseum, München,* Munich, 1959, p. 146, fig. 134 (St. James the Elder)
Kurt Gerstenberg, *Tilmann Riemenschneider,* Munich, 1950, cf. figs. 22, 24
"Review of the year 1960–1961," *Metropolitan Museum of Art Bulletin,* n. s., XX (October 1961), p. 49, ill.
Kurt Gerstenberg, "Riemenschneider Sankt Jacob in Stuttgart," *Pantheon,* II (1961), pp. 88–93 (cf. St. James in Stuttgart to St. Eustace)
Welstkunst, XXX (October 1, 1960), no. 19, p. 4 b, ill.
Sale catalog: Sotheby & Co. London, Oct. 14, 1960, no. 52, ill. frontispiece
Justus Bier, "Riemenschneider's Helpers in Need," *Metropolitan Museum of Art Bulletin,* n. s., XXI (1962–1963), pp. 317–326

Exhibitions:
Victoria and Albert Museum, London, on loan in 1951 and 1956
Art Treasures of Staffordshire, City Art Gallery, Stoke on Trent, May 1960
Sculptures of Tilmann Riemenschneider, North Carolina Museum of Art, Raleigh 1962, pp. 44–47, no. X (important text), ill. pp. 45, 46, 47

106 Eagle Lectern

ACC. NO. 68.8
Edward van Even, *Louvain monumental,* Louvain, 1860, p. 199, pl. I
A. Welby Pugin, *Glossary of Ecclesiastical ornament,* 3rd ed. London, 1868, p. 168, s. v. "lectern"
Victor Gay, *Glossaire Archéologique du moyen-âge et de Renaissance,* I, Paris, 1887, s. v. "aigle", p. 13 ill.
Jan Crab, "The Great Copper Pelican in the Choir: the Lectern from the Church of St. Peter in Louvain," *Metropolitan Museum of Art Bulletin,* n. s., XXVI (June 1968), pp. 401 ff.
William H. Forsyth, "Medieval Art and the Cloisters," *Metropolitan Museum of Art Bulletin,* n. s., XXVII (October 1968), p. 113 ff. ill.

Exhibition:
Ars Sacra Antiqua, Stedelijk Museum, Louvain, 1962, p. 189, no. Eng/32 (ill. detail)

107 Pair of Ewers

ACC. NO. 53.20.1, 2
B. Dudik, *Kleinodien des Deutschen Ritterordens,* Vienna, 1865, p. 13 and passim
Alfred Stange, *Deutsche Malerei der Gotik,* V, Berlin, 1952, fig. 197, and fig. 216 (cf. similar ewers in paintings)
James J. Rorimer, "Acquisitions for The Cloisters," *Metropolitan Museum of Art Bulletin,* n. s., XI (June 1953), pp. 270–276
Walter Borchers, "Der Deckelbecher der Familie von Bar-Altbarenaue," *Westfalen,* XXXVI (1958), p. 225
James J. Rorimer, *The Cloisters,* New York: Metropolitan Museum of Art, 1963, pp. 183–184, fig. 92
Heinrich Kohlhaussen, *Nürnberger Goldschmiede-*

kunst des Mittelalters... 1240 bis 1540, Berlin, 1968, nos. 261–262, figs. 294–296

108 Base for a Statuette

ACC. NO. 56.168
Frédéric Spitzer, *La Collection Spitzer, Antiquité, Moyen-âge, Renaissance,* I, Paris, 1890–1892, p. 67, no. 134
Sale catalog: *Frédéric Spitzer Collection,* I, Paris, 1893, Les Ivoires, p. 30, no. 169
Sale catalog: *Maurice Kann Collection,* Galerie Georges Petit, Paris, 1910, p. 37, no. 227
La collection de Maurice Kann..., pref. by Wilhelm von Bode, Paris, 1911, p. 37
Raymond Koechlin, *Les ivoires gothiques français,* Paris, 1924, I, p. 457, no. 1246; II, pp. 435–436
Bonnie Young, "Scenes in an ivory garden," *Metropolitan Museum of Art Bulletin,* n. s., XIV (June 1956), pp. 252–256

109 St. Ursula and Four Virgin Martyrs

ACC. NO. 41.100.149
George and Florence Blumenthal Collection, II (catalogue), comp. by Stella Rubinstein-Bloch, Paris, 1926, pl. XVII
Count J. de Borchgrave d'Altena, "Récente acquisition. Une Sainte Barbe malinoise," *Bulletin des Musées royaux d'art et d'histoire,* 1940, pp. 61–64, ill.
Willy Godenne, *Préliminaires à l'inventaire général des statuettes d'origine malinoise présumées des XVe et XVIe siècles,* Bruxelles, A. C. L., 1959, 2me partie, pp. 54–56; 1963 (fin), pp. 129–130, pl. CXXXIII (MMA statuette)

110 Chalice

ACC. NO. 13.222.2
Marc Rosenberg, *Der Goldschmiede Merkzeichen,* 2nd ed., Frankfurt am Main, 1911, cf. nos. 3875, 3876

111 Mazer Cup

ACC. NO. 17.190.363
Göran Axel-Nilsson, "Ein Doppelbecher von 1585...," *Röhsska Konstslöjd Museet,* Arstryck, 1955, pp. 49 ff.
Hans Martin von Erffa and Dora Fanny Rittmeyer, s. v. "Doppelbecher," *Reallexikon zur deutschen Kunstgeschichte,* IV, Stuttgart (1958), clm. 161 ff.
Heinrich Kohlhaussen, "Der Doppelbecher auf der Veste Coburg und seine Verwandten," *Jahrbuch der Coburger Landesstiftung,* 1959, pp. 109 ff.
Heinrich Kohlhaussen, "Der Doppelkopf...," *Zeitschrift für Kunstwissenschaft,* XIV, Heft 1–2, 1960, pp. 24 ff.
Heinrich Kohlhaussen, *Nürnberger Doppelkopf-gefässe im Spätmittelalter* (offprint from Festschrift "Dr. Bock," n. d., no. pp.); f. n. 17, compares this mazer to a serpentine double-beaker of XV C. in the Grünes Gewölbe Dresden, both possibly Nürnberg work

112 Miniature Triptych

ACC. NO. 17.190.453
Baron Albert Oppenheim Collection (catalog), comp. by Emile Molinier, Paris, 1904, no. 95, p. 42, pl. LXII
John Pierpont Morgan, Collection of Jewels and

Precious Works of Art (catalog), comp. by G.C.Williamson, London, 1910, no.43, pl. XXVI

Kurt Dingelstedt, "Betnuss," *Reallexikon zur deutschen Kunstgeschichte,* II, Stuttgart (1948) pp.371–377

113 The Credo Tapestry

ACC. NO. 60.182

Seymour de Ricci, *J.Pierpont Morgan: Description d'une série de tapisserie gothiques... exposées à la Galerie J.Seligmann,* Paris, 1912, pp.48–57, no. XII

Seymour de Ricci, *Catalogue of twenty Renaissance tapestries from the J.Pierpont Morgan Collection,* Paris, 1913, no.19, pp.44–48

D.T.B.Wood, "The Credo Tapestries," *The Burlington Magazine,* XXIV (February–March 1914), pp.247–254, 309–316, esp. p.248, ill. pl.V, figs.G and H

Sale catalogue: *William Randolph Hearst Collection,* New York, Hammer Galleries, 1941, p.278, ill. p.81 (no.592–9)

William H.Forsyth, "A 'Credo' Tapestry: a Pictorial Interpretation of the Apostles' Creed," *Metropolitan Museum of Art Bulletin,* n. s., XXI (March 1963), pp.240–251

Exhibitions:

Tapisseries gothiques appartenant à M.J.Pierpont Morgan, exposées au bénéfice de la Société des Amis du Louvre, Galerie J.Seligmann, Paris, 1912, no. XII

Loan Exhibition of the J.Pierpont Morgan Collection, Metropolitan Museum of Art, New York, 1914 (Guide: pp.10–11)

Exposition universelle et internationale, 1935. Cinq siècles d'art, Brussels, May–Oct. 1935, Catalog (deuxième partie) par Paul Lambotte: dessins et tapisseries, no.685

114 Country Life

ACC. NO. 41.100.196

Jules Guiffrey, *Les tapisseries du XII à la fin du XVI siècle* (Histoire générale des arts appliquées à l'industrie, pt.VI), Paris, n.d., p.57, fig.28

Stella Rubinstein-Bloch, "Two late French Gothic tapestries," *Art in America* (December 1916), fig.2, p.31

George and Florence Blumenthal Collection, IV (catalog), comp. by Stella Rubinstein-Bloch, Paris, 1927, pl.IV

Joseph Breck, "The Tapestry Exhibition,"

Metropolitan Museum of Art Bulletin, XXIII (July 1928), pp.178–185, ill. p.182

Heinrich Göbel, *Wandteppiche II, Teil: Die Romanischen Länder,* Leipzig, 1928, I, p.281; II, fig.316

Francis Salet, *La Tapisserie française du Moyen-Age à nos jours,* Paris, 1946, pl.26

Francis Salet, "La Tapisserie bruxelloise au XVe siècle," *Bulletin Monumental* (1966), Chronique, pp.433–437

Sophie Schneebalg-Perelman, "La Dame à la licorne a été tissée à Bruxelles," *Gazette des Beaux-Arts* (November 1967), pp.253–278, esp. p.258

Exhibitions:

French Gothic Tapestries: Loan Exhibition, Metropolitan Museum of Art, New York, May–Sept.1928, no.13

Masterpieces in the Collection of George Blumenthal: A special exhibition, Metropolitan Museum of Art, New York, 1943–1945

Collector's Choice: fifty years of collecting for the Museum, 1890–1940, Metropolitan Museum of Art, New York, November 1957–January 1958

115 Scenes from the Passion of Christ

ACC. NO. 22.60.34

Wilhelm von Bode, *Die Sammlung O.Hainauer* (catalog), Berlin, 1897, no.450

Joseph Breck, "The Michael Dreicer Collection, Part II, Sculpture and the Decorative Arts," *Metropolitan Museum of Art Bulletin,* XVII (May 1922), p.106

Phyllis Ackerman, "Joas Huet of Audenarde," *Art in America,* XIII (June 1925), p.188, fig.1

116 A Noble Company

ACC. NO. 41.190.229

Sale catalog: *Dupont-Auberville Collection, Paris,* Chevallier, April 3–4, 1891, p.18, no.60

Gaston Migeon, "Collection de M.Charles Mège," *Les Arts,* 86 (February 1909), p.11 (ill.) and pp.16–17

Camille Enlart, *Manuel d'archéologie française,* II, *Le Costume,* Paris, 1916, 3 vols., III: Le Costume, p.205, fig.222, pp.211–212 (Hénnin)

George and Florence Blumenthal Collection, IV (catalog), comp. by Stella Rubinstein-Bloch, Paris, 1927, pl.II

G.I.Bratianu, "Anciennes Modes Orientales à la Fin du Moyen-Age," *Seminarium Kondakovianum,* VII (1935), pp.165 ff.

Medieval Tapestries: A Picture Book, New York: Metropolitan Museum of Art, 1947, fig.6

Joan Evans, *Dress in Medieval France,* Oxford, 1952, cf. fig.56

Exhibition:

Masterpieces in the Collection of George Blumenthal: a special exhibition, Metropolitan Museum of Art, New York, 1943–1944

117 The Triumphs of Fame and Time

ACC. NO. 41.167.1, 2

Vincenzo Cartari, *Le imagini de i Dei,* Venice, 1580, p.30

Cesar Ripa, *Iconologie...,* Paris, 1677, p.96

A.N.Didron, "Les Triomphes," *Annales Archéologiques,* XXIII (1863), pp.283 ff.; XXIV (1864), pp.144 ff.

Eugène Muntz and V.M.d'Essling, *Petrarch: ses études d'art, son influence sur les artistes, ses portraits et ceux de Laure, l'illustration des écrits,* Paris, 1902

Petrarch, *Triumphs,* translated by Henry Boyd, London, 1906

Raimond van Marle, *Iconographie de l'art profane...,* II, The Hague, 1932, pp.111–135, esp. p.120, note 1, figs.142–144, 154, pl.124

Leo Planiscig and Ernst Kris, *Katalog der Sammlung für Plastik und Kunstgewerbe, Kunsthistorisches Museum, Wien,* Vienna, 1935, p.10

James J.Rorimer, "The Triumphs of Fame and Time," *Metropolitan Museum of Art Bulletin,* XXXV (December 1940), pp.242–244

Medieval Tapestries: A Picture Book, New York: Metropolitan Museum of Art, 1947, fig.17 (Triumph of Time)

Pierre Verlet, *Le grand livre de tapisserie,* Lausanne, 1965, p.22, p.74

Exhibition:

French Gothic Tapestries, Metropolitan Museum of Art, New York, 1928, no.16

118 Pendant

ACC. NO. 57.26.1

Harold Clifford Smith, *Jewellry,* London, 1908, pp.127–146, pl.XXIV

Marc Rosenberg, "Studien über Goldschmiedekunst in der Sammlung Figdor, Wien," *Kunst und Kunsthandwerk,* XIV (1911), pp.329 ff.

Erich Steingräber, *Alter Schmuck,* München, 1956, pp.54–67

NOTE: the gold pin attached to the solid back mount of this pendant is a modern addition.

4

Library of Congress
Catalog Card Number 72-106813

Copyrighted 1969 by
The Metropolitan Museum of Art
S.B.N. 87587-036-8

Published by the
Los Angeles County Museum of Art

Printed in Switzerland

THE MIDDLE AGES

Treasures from
The Cloisters
and The Metropolitan
Museum of Art

Los Angeles County
Museum of Art

January 18–March 29, 1970

The Art Institute
of Chicago

May 16–July 5, 1970

THE MIDDLE AGES